Arts-Based Research in Education

This text introduces readers to definitions and examples of arts-based educational research, presents tensions and questions in the field, and provides exercises for practice. It weaves together critical essays about arts-based research in the literary, visual, and performing arts with examples of artistic products of arts-based research (arts for scholarship's sake) that illuminate by example. Each artistic example is accompanied by a scholARTist's statement that includes reflection on how the work of art relates to the scholar's research interests and practices.

Arts-Based Research in Education: Foundations for Practice:

- helps the reader understand what arts-based research is – tracing the history of the field and providing examples;
- includes end-of-chapter questions to engage students in practicing arts-based inquiry and to generate class discussion about the material;
- features a diverse range of contributors – very established scholars in educational and social-science research as well as those new to the field;
- represents a variety of voices – scholars of color, queer and straight orientations, different ages, experience, and nationalities; and
- presents beautiful illustrations of visual art, data-based poems, plays, short stories, and musical scores.

The first of its kind, this volume is intended as a text for arts-based inquiry, qualitative research methods in education, and related courses, and as a resource for faculty, doctoral students, and scholars across the field of social-science research methods.

Melisa Cahnmann-Taylor
University of Georgia, Athens, Georgia
Richard Siegesmund
University of Georgia, Athens, Georgia

Inquiry And Pedagogy Across Diverse Contexts
Kathleen B. deMarrais, Series Editor

Arts-Based Research in Education
Foundations for practice
Edited by Cahnmann-Taylor and Siegesmund

Teachers as Collaborative Partners
Working with diverse families and communities
Tutwiler

Geographies of Girlhood
Identities in-between
Edited by Bettis and Adams

Foundations of Research
Methods of inquiry in education and the social sciences
Edited by deMarrais and Lapan

Arts-Based Research in Education

Foundations for Practice

Edited by Melisa Cahnmann-Taylor
and Richard Siegesmund

 Routledge
Taylor & Francis Group

NEW YORK AND LONDON

First published 2008
by Routledge
270 Madison Ave, New York, NY 10016

Simultaneously published in the UK
by Routledge
2 Park Square, Milton Park, Abingdon, Oxon OX14 4RN

Routledge is an imprint of the Taylor & Francis Group, an informa business

Typeset in Sabon and Gill Sans by Wearset Ltd, Boldon, Tyne and Wear
Printed and bound in the United States of America on acid-free paper
by Walsworth Publishing Company, Marceline, MO

Permission to reprint an adapted version of an earlier article has
been granted:
Irwin, Rita L. Springgay, S. (2007). A/r/tography as practice-based
research. In Springgay, Stephanie, Irwin, Rita L., Leggo, Carl &
Gonzonasis, P. (Eds.) *Being with A/r/tography* (pp. xiii–xxvii).
Rotterdam, the Netherlands: Sense Publishers. Tom Barone's
chapter is adapted from "Making educational history: Qualitative
inquiry, artistry, and the public interest." In Gloria Ladson-Billings
and William F. Tate (Eds.) *Education research in the public interest:
Social Justice, action, and policy* (pp. 213–230). New York: Teacher's
College Press, 2006.

Cover Artist: Erin McIntosh

Library of Congress Cataloging in Publication Data
Arts-based research in education: foundations for practice/[edited
by] Melisa Cahnmann-Taylor, Richard Siegesmund.
p. cm. – (Inquiry and pedagogy across diverse contexts)
Includes bibliographical references and index.
1. Education–Research–Methodology. 2. Art in
education–Philosophy. I. Cahnmann-Taylor, Melisa. II. Siegesmund,
Richard.
LB1028.A68 2008
370.7'2–dc22

2007024388

ISBN10: 0-8058-6379-6 (hbk)
ISBN10: 0-8058-6380-X (pbk)
ISBN10: 1-4106-1839-0 (ebk)

ISBN13: 978-0-8058-6379-6 (hbk)
ISBN13: 978-0-8058-6380-2 (pbk)
ISBN13: 978-1-4106-1839-9 (ebk)

To our spouses, mentors, and loved ones for their support and encouragement as we tested our wings in a new field of educational research

Contents

Figures

Meet the editors

Melisa Cahnmann-Taylor is Associate Professor in the Department of Language and Literacy Education at the University of Georgia, Athens, Georgia. Her research and teaching address bilingualism, second-language acquisition, arts-based approaches to research, and multicultural education. Her articles have appeared in journals such as *Educational Researcher, Language Arts, Critical Inquiry in Language Studies,* and *Anthropology and Education Quarterly.* Her poems have appeared in national literary magazines such as *APR, Quarterly West, Puerto del Sol, Barrow Street,* and *Bellevue Literary review* as well as in a chapbook of poems titled, *Reverse the Charges.* Her prize-winning poetry has been recognized by the Dorothy Sargent Rosenberg Foundation, the Leeway Foundation, and the Waging Peach Poetry Prize. In January 2007 she completed a low-residency MFA program in poetry at New England College. Her most recent arts-based research concerns the use of

Augusto Boal's *Theater of the Oppressed* techniques with bilingual, ESOL, and foreign-language teachers. Born in Chicago, Illinois, Cahnmann-Taylor has also called the following places home: Boston, Massachusetts; Mexico City; Los Angeles and Santa Cruz, California; Philadelphia, Pennsylvania; and now Athens, Georgia. In spring 2007, she and her husband, Jason Taylor, welcomed their first-born son, Oren Ben, into the world.

Richard Siegesmund is Associate Professor of Art Education in the Lamar Dodd School of Art at the University of Georgia, Athens, Georgia. He has a BA in Studio Art and completed graduate work in painting and printmaking at the University of Hawaii under the direction of Lee Chesney, who first introduced him to the concept of visual art as the inscription of qualitative reasoning through the affordances and constraints of different visual media. Following a fourteen-year career in arts administration, he completed his Ph.D. in Art Education at Stanford University under the direction of Elliot Eisner. While at Stanford, he also studied extensively with Alan Peshkin, Denis Phillips, and Nel Noddings. Since 1994, he has served as an advisor to the Performing Arts Workshop in San Francisco where he studies the classroom practice of teaching artists to refine his theory of qualitative reasoning and applies theory to

the improvement of educational practice. His research on qualitative and symbolic learning through the arts has been published in *Phi Delta Kappan*, the *Journal of Aesthetic Education*, *International Journal of Education and the Arts*, *Studies in Art Education*, *Arts and Learning Research Journal*, and *Kappa Delta Pi Record*.

Preface

Arts-based Research in Education: Foundations for Practice is designed to introduce students to definitions and examples of arts-based educational research (ABER), to present tensions and questions in the field, and to provide exercises for practice. The book weaves together critical essays about arts-based research in education and other related social-science fields in the visual, literary, and performing arts. The book also features artistic products of arts-based research, which we refer to as *arts for scholarship's sake*, that illuminate by example. Each artistic example is accompanied by a scholARTist's statement that includes reflection on how the piece of art (e.g. poetry, drama, fiction, photography, sculpture, music, etc.) relates to the scholar's research interests and practices.

Following the introduction to the book, chapters by Elliot Eisner and Tom Barone in Section I continue to lay the foundation for the text, presenting questions regarding how ABER might change minds and what the persistent tensions are in the field today.

Section II introduces examples and reflections on poetry in anthropology and educational inquiry, including a critical reflective essay by Ruth Behar in Chapter 4 and poetry by Adrie Kusserow, Kristina Lyons, Kakali Bhattacharya, and Carl Leggo. The poetic presentation of data in anthropology constitutes a critical antecedent to ABER and so examples of that tradition are featured here.

The visual arts are explored in Section III, including a reflective essay on A/r/t/ography by Rita Irwin and Stephanie Springgay, followed by examples of performative visual art, sculpture, and photography from Barbara Bickel, Springgay, and Joanne Elvy. These essays and examples of scholARTistry, explore the visual arts as a tool for generating and reporting data.

Examples of performative arts and fiction appear in Section IV beginning with Terry Jenoure's journey of educational discovery through art and performance, and followed by excerpts from a novel by Douglas Gosse on queer youth identity in rural Canada. The last three

chapters are examples of data-based performance pieces. Joni Jones/ Olomo describes her ongoing struggles to reinvigorate her 1993 performance piece, *sista docta*. In Chapter 16, Kathy Roulston, Roy Legette, Monica DeLoach, and Celeste Buckhalter demonstrate the incorporation of live musical interpretation into a work of readers' theater. Johnny Saldaña's dramatic interpretation of the research of Harry Wolcott closes the section.

We then return in Chapter 18 to the larger themes that guide the book and revisit the enduring tensions in ABER raised by Elliot Eisner in Chapter 2. The text concludes with our final reflections on the field of arts-based educational research, encouraging readers to build upon what has come before, opening up avenues for high quality, creative approaches to research.

Each chapter ends with a set of discussion questions that are designed to extend inquiry into controversies within ABER, including the conduct of research and the meanings the methodology reveals. We also provide concrete examples of graduate classroom activities we have practiced in our own qualitative research courses that can be used for discussion or to further exercise the techniques of the artistic/scientific disciplinary merger. These activities will help readers explore what the arts can do in opening new windows for data collection, analysis, and presentation that may not be possible through more traditional approaches to educational research – thereby provoking new insights into how educational research can be conceptualized and conducted.

Acknowledgments

The editors would like to give a special thank you to the many collaborators and conspirators who have joined us on the path of arts-based research and have influenced the development of this book. We want to thank the qualitative research faculty at the University of Georgia for giving us the opportunity to chair the annual QUIG conference with arts-based research as a theme, helping us to connect with many international contributors in this field. A special thank you to colleagues Kathleen deMarrais, Jude Preissle, Jobeth Allen, Joel Taxel, and Carole Henry for their support and encouragement of our work as arts-based tenure-track faculty at the University of Georgia. Another expression of deep gratitude to Dorine Preston and Kelli Bivins for their assistance on this manuscript and to arts-based research students at the University of Georgia for their thought-provoking questions, enthusiasm, critical reflections, and creativity.

Section I

Challenges to the definition and acceptance of arts-based inquiry as research

There is a great deal of mystery surrounding what it means to conduct arts-based research in education, some suspicion, and a good deal of intrigue. What does "arts-based research in education" mean? Does the phrase refer to teachers using the arts in their classrooms? Does it refer to researchers using the arts with participants in a study? Is it a group of educational researchers writing poems, painting pictures, and performing one-act plays? The short answer is: *Yes*. Arts-based research in education refers to all the above and probably many other ways in which the arts have moved into the realms of teaching, research, and art. The primary approach to arts-based research in this volume refers to how the arts are used by social-science researchers. This first section in the book explores how the field of arts-based research came to be and describes the existing tensions and potential possibilities.

In the introduction, Melisa Cahnmann-Taylor establishes the history of arts-based research in education, creating a typology of approaches including *hybrid forms* and *arts for scholarship's sake*. She identifies those early arts-based researchers in education and related fields – those who may have been reluctant or unconscious of themselves as artists as well as scholars. The first chapter outlines the many different terms applied to arts-based research and clarifies them by example, pointing the reader to the sections and chapters that follow in the volume.

The next two chapters in Part I are written by Elliot Eisner and Tom Barone, who both coined the field of arts-based educational research (ABER). Eisner addresses the many tensions related to using the arts as a form of educational inquiry. How can a piece of research include poetry or sculpture and still be substantive and useful to academic and lay audiences in education? Can a poem about a field experience also be truthful? Having examined these and other tensions, Eisner shares his views on the utility and validity of the arts in educational research.

In Chapter 3, Tom Barone challenges educational researchers to make history by carrying out research that is "epistemologically humble," promotes dialogue, and raises more questions than answers.

The arts-based research Barone admires is that which does not moralize or proselytize, but invites readers/viewers into conversation and reflection. It is through these "conspiratorial conversations" that educational change is possible. Barone describes two examples of arts-based work that both have the potential to make educational history because they are accessible and meaningful to diverse audiences that include and go beyond peer academics.

Despite historical mergers between the arts and sciences, arts-based research is still considered a new methodology in educational inquiry. The authors in this section introduce readers to where we've come from, where we're going, and the questions and considerations we might ask as we explore the tensions, hopes, and possibilities for future mergers between the arts and sciences.

Chapter 1

Arts-based research

Histories and new directions

Melisa Cahnmann-Taylor
University of Georgia, Athens, Georgia

With the acceptance of postmodern approaches to educational research in the last few decades including feminism, post-structuralism, critical theory, and semiotics, assumptions about what counts as knowledge and the nature of research have dramatically changed. Not only have multiple qualitative research methodologies gained more widespread acceptance, but also the tools we employ to collect data and display findings have been diversified to include artistic as well as traditionally scientific methods. As researchers deploying a range of literary, visual, and performing arts through all stages of our own research, we begin this text with the assumption that the arts have much to offer educational researchers – challenging us to think creatively about what constitutes research; to explore even more varied and creative ways to engage in empirical processes; and to share our questions and findings in more penetrating and widely accessible ways.

When working with our students, we find it helpful to draw on examples of the arts in educational research and related fields in the social sciences, particularly anthropology, to understand how they have been used, by whom, for whom, in what contexts and to what end. Therefore, this volume merges essays about arts-based research from both anthropology and education, along with specific examples of practice, to provide a lens for what arts-based educational research (ABER) looks like – i.e. when poetry, visual images, drama, music and other artistic forms become integral to the empirical project. Together with readers we ask: what do the arts add to a researcher's project and to our general understanding of the topic under study? In other words, how are the arts used, by whom, for whom, for what purpose and to what possible ends?

Our aim in this text is to simultaneously explore what arts-based researchers do and identify what is to be gained from blurring the boundaries between the arts and the sciences. While we advocate the increased application of the arts in educational research by highlighting some of the most fresh and exciting contemporary work, we do not

pose arts-based approaches to inquiry as an either-or proposition to more traditional, scientific research paradigms. We believe arts-based researchers do no service to themselves to define their methods in opposition to more traditional approaches to inquiry. Rather, the literary, visual, and performing arts offer ways to stretch a researcher's capacities for creativity and knowing, creating a healthy synthesis of approaches to collect, analyze, and represent data in ways that paint a full picture of a heterogeneous movement to improve education. Every research methodology is a way of seeing the world – and every way of seeing is a way of not seeing (Eisner, 2002). No methodology is perfect; each comes with trade-offs. It is incumbent on each researcher to know what is gained – and what is lost – in the methods one chooses to employ.

That said, new forms that challenge traditional conceptions of research, can also change "the rules of the game;" and whenever the rules change, there is the possibility of new outcomes on the playing field. New talents are revealed; old talents may not seem as essential as they once appeared. It is our purpose in this book to explore this new playing field and to candidly look at what these new possibilities might reveal, increasing our attention to complexity, feeling, and new ways of seeing.

EARLY DEVELOPMENTS

Educational research has its roots in the late nineteenth and early twentieth centuries when innovators such as Elwood P. Cubberly envisioned building a science of education that emulated industrial practice (Tyack & Cuban, 1995). However, the modern field of education began at the beginning of the nineteenth century, particularly with the work of the Swiss educator Johann Pestalozzi and his German follower, Johann Friedrich Herbart. Both Pestalozzi and Herbart were influenced by the new field of aesthetics that had emerged in German philosophy. As Friedrich Schiller (1802) suggested, aesthetics sought to explore the dimensions of experience that were hidden in the push to impose reason on all levels of human endeavor. For Schiller, aesthetics was a pre-rational understanding that formed the base for the sound and moral application of reason. Pestalozzi and Herbart – as well as followers like Friedrich Froebel and Maria Montessori – were to build educational theory and curricula on these ideas. Thus, the beginnings of educational curriculum theory and research are profoundly arts-based.

This connection is made even more explicit in the work of John Dewey. Writing early in the twentieth century, Dewey (1934/1958) argues that the impulse towards learning begins with *an* experience. However, Dewey is concerned that the kind of artistic experiences that

Schiller, Pestalozzi, Herbart, and Froebel envisioned could no longer be termed aesthetic. Dewey feared that effete formalistic appreciation had ossified aesthetic experience (which T. S. Eliot captured so poignantly in "The Love Song of J. Alfred Prufrock"). Therefore, although writing in the spirit that animated the early nineteenth-century theorists – arguing for an emotional, experiential basis of knowing as critical to learning – he suggests that what was now called aesthetic experience was dysfunctional.

Dewey's concept of human beings being actively sentient creatures who assemble sensory experience has resonated across other disciplines concerned with the dynamics of learning. For example, the Sapir–Whorf (Carroll, 1956) theory of linguistic relativity, although largely discredited, had tremendous influence on early studies of language and culture, influencing the emergence of *ethnopoetics* as a field of study. Ethnopoetics, a field coined by poet-ethnographer Jerome Rothenberg in 1968 (Brady, 2000) focused largely on differences in aesthetics between Indigenous verbal artists and Western literary traditions. Ethnopoetics was of central concern to linguistic anthropologist, Dell Hymes in his research among Native American communities. Hymes (1964), an anthropological linguist and poet, was the first to propose the "ethnography of communication" as a merged field between linguistics, education, anthropology, and, implicitly, poetry.

Despite the unspoken connections between the arts and early research in education, anthropology, and linguistics, there were few, if any, explicit references to the arts in research before 1980. As to artistic products, there were fewer still. In fact, one of the first female anthropologists, Ruth Benedict (1934), whose book, *Patterns of culture*, was one of the first to introduce the public at large to cultural diversity, published her poetry under pseudonyms in order to keep them hidden from her mentor, Franz Boas, and other academic colleagues (Behar, Chapter 4). By mentioning the arts in academic study, one risked the impression that one's research was less a piece of scholarship than a fictive invention. For some researchers, these fears gave way to a postmodern turn in research, one that became disenchanted with absolute knowledge and objectivity in favor of "an epistemology of ambiguity ... [celebrating] meanings that are partial, tentative, incomplete, and sometimes even contradictory and originating from multiple vantage points" (Barone, 2001, pp. 152–153).

In the field of education, Elliot Eisner, with his graduate students at Stanford University, actively began to build on the discipline of art criticism to develop a new arts-based research methodology for conducting inquiry in the social sciences. This new methodology, which was applied to numerous dissertations, was called *educational criticism* (Eisner, 1991). Eisner's student, Tom Barone, took educational criticism

and developed it into a new arts-based methodology, *narrative story-telling*. Where educational criticism called on the researcher to function as a connoisseur to see deeply into a situation and to reveal details that the causal observer would miss, narrative storytelling cast the researcher as a raconteur, who – if necessary – created facts to fill the holes in the story. Barone's (2001) landmark work of arts-based research, *Touching Eternity*, documents his personal research journey from educational criticism to narrative storytelling.

Eisner's work was controversial within the educational community, but provided a beacon that others followed. Within a short time, Sara Lawrence-Lightfoot (1983) published her arts-based methodology of portraiture that described her method of combining systematic, empirical description with aesthetic expression to describe the qualities of "goodness" in learning communities.

However, even with the growing adoption of arts-based methods by qualitative researchers, there was continued hostility to embracing the arts in the field of education – which since the time of Elwood P. Cubberly held aspirations of being considered a social science. Consequently, a special panel assembled by the National Academy of Science (Shavelson & Towne, 2002), which was charged with defining the new Federal mandate for scientific-based research, specifically denounced Eisner and Lawrence-Lightfoot's arts-based methods. Thus, by attempting to follow mechanistic models of inquiry from the early part of the twentieth century, educational researchers denied the intellectual arts-based origins of the discipline of education as represented in the work of Rousseau, Pestalozzi, Schiller, and Froebel.

MAJOR CONTRIBUTIONS, "BLURRED GENRES"

Nevertheless, education researchers and others in the social sciences began to embrace this postmodern turn, leading to the origins of what later came to be called "blurred genres," "arts-based inquiry," "scholARTistry," and "a/r/tography." In the last few decades, researchers and theorists have begun to explicitly draw upon blurred genres of the arts and sciences to analyze data and present their findings. In the 1980s these frontrunners in arts-based research – though not identified as such – paved the way for present-day arts-based researchers to take even greater risks, crossing entirely into artistic genres of fiction, poetry, painting, and drama. Because writing is a vital element of research inquiry, most of the initial contributions concentrated on the use and analysis of literary art forms in the human sciences with nods to music and the visual arts.

Other examples, besides Eisner and Lawrence-Lightfoot, include

Heath's (1983) classic ethnography of children learning to use language in two different communities, one of the first studies in education to adopt a literary approach to ethnography that drew upon narrative structures and metaphor. Clifford and Marcus's (1986) book *Writing Culture* collected the first group of essays to address the poetic and political nature of cultural representation, drawing attention to the literary and rhetorical dimensions of ethnography.

Music theory and technique have also influenced some of the most noteworthy discourse studies in education, analyzing speech for its rhythm, meter, pitch, and tone. For example, Erickson and Shultz's (1982) study of counselor and student interactions used musical notation in analysis to discover that distorted rhythms in communication were heavily associated with cultural and racial differences. Erickson, who has experience in music composition and theory, used his creativity to enhance his ability to hear and make sense of discordance and harmony in everyday talk. Similarly, Foster's (1989) study analyzed the musical qualities of an African American teacher's classroom discourse to shed light on the qualities of her success in an urban community-college classroom. In particular, Foster focused on the teacher's use of Church-influenced discourse patterns such as vowel elongation, cadence manipulation, and repetition. Edelsky (1981) addressed the visual as well as aural aspects of transcription, identifying areas of concern as to how to best represent the authenticity and dimensionality of an observed interaction for conversational analysis.

WORKS IN PROGRESS, "ARTS-BASED RESEARCH" IS BORN

The 1980s and early 1990s were critical for the expanded directions of arts-based inquiry today. However, arts-based research methodologies are still in conflict with conservative scholarly and political climates that emphasize traditional, scientific definitions of research. Thus, modern-day Ruth Benedicts may still exist: education researchers may still be invisibly producing poems as Benedict had, or, worse yet, discouraged from exploring creativity in their scholarship at all.

Despite plentiful deterrents, qualitative researchers in the social sciences, many of whom are represented in this volume – confident that alternative arts-based methods are rigorous, relevant, and insightful – continue to take even greater risks, exploring new dimensions of arts-based methods that experiment at the scientific perimeter to push research questions and methodologies outward and enhance the field.

There is tremendous variety in the ways the arts are incorporated into educational inquiry. For schematic purposes, we identify two major

strands in contemporary arts-based research methodology today: those that embrace *hybrid forms* of artistic and scientific scholarship and those that produce *art for scholarship's sake*.

Hybrid forms

The hybrid arts-based research text was described by Barone and Eisner (1997) when they first introduced the concept of "arts-based educational research" in Richard M. Jaeger's co-edited book with Barone, *Complementary methods for research in education* that was published by the American Educational Research Association. In this book chapter, Barone and Eisner focused largely on contributions of the literary arts in educational research producing blurred genres between the arts and sciences. Barone and Eisner laid out a theoretical framework for arts-based research, describing the qualities of arts-based texts: the creation of a virtual reality and a degree of textual ambiguity; the presence of expressive, contextualized, and vernacular forms of language; the promotion of empathetic participation in the lives of a study's participants; and the presence of an aesthetic form through the unique, personal signature of the researcher.

In the spirit of hybrid genres of arts-based research, one of the best-known book-length examples is Tom Barone's (2001) merger of fiction and scholarship in *Touching Eternity*. The hybrid form allowed Barone "to play two games at once" in his study of a high-school art teacher and his former students:

> On the one hand, I assuaged a felt need to speak in an analytical voice about motifs confronted within my conversation with former students. On the other, I wanted to honor the life stories of participants before transforming them into life histories. So I experimented with a format in which life stories were presented extensively and physically distanced from the commentary of the researcher.
>
> (2001, p. 171)

Similarly well known, Ruth Behar's (1993) feminist ethnography, *Translated Woman*, is a blurred genre that integrates artistry and anthropology. Behar shares long, uninterrupted stretches of discourse from her informant, Esperanza's, *testimonio* about life experience as a single mother and peddler in Mexico. In addition, Behar shares her own reflections as an anthropologist *del otro lado* – literally from the other side of the border and figuratively from the other side of life in terms of race and class status. Behar's work as well as that of Carolyn Ellis (1999) has opened the territory of "autoethnography," a merger between autobiography and ethnography, highlighting the extent to

which the researcher foregrounds his or her own reflections and experiences in a given study.

Blurred genres of arts-based research contextualize the creation of art – story, poetry, printmaking, sculpture, autobiography, ethnodrama – within their experimental science, perhaps, as Barone (2001) suggests, "because many postmodernist innovators began their careers as ethnographers and sociologists (rather than as artists, literary critics, or art theorists)" (p. 153). Nielsen (2005) identified blurred-genre work as "scholARTistry," a hybrid practice which combines tools used by the literary, visual, and/or performing arts with tools used by educators and other social scientists to explore the human condition. Nielsen (2005) addresses three goals of scholARTistry: "to make academic writing an area where virtuosity and clarity are valued, to make educational research an area where the arts are legitimate inquiry, and to infuse scholarship with the spirit of creative connection." Varieties of teacher research and action research also constitute forms of scholARTistry where an educator uses narrative portraits to document her own literacy classroom (e.g. Hankins, 2003) or where an administrator autoethnographically documents her process to begin the first dual-immersion charter school in Georgia (e.g. Perry, 2005). In visual arts, Irwin and de Cosson (2004) published *A/r/tography*, a collection of work that explores curriculum as aesthetic text through visual renderings as well as prose interpretations.

Blurred genres share many of the same goals in their work. First, to incorporate tools from both the sciences and the arts to make new, insightful sense of data during and beyond the research project. New insights and questions take precedence over a desire for absolute answers to educational and linguistic questions. Second, these blurred genres all share an explicit recognition of the self–other continuum, where the researcher is explicitly recognized as the primary instrument for documenting and interpreting knowledge from participants or from a specific context which ultimately informs the researcher about him or herself as well. Third, blurred genres tend to have the goal to speak to diverse audiences both within and outside the academy. The use of accessible, vernacular, and aesthetic language and image, helps to explicitly reach out to larger, more diverse audiences and to engage in what Barone (Chapter 3) calls "truly dialogical conversation[s] about educational possibilities" (p. 44).

Art for scholarship's sake

If hybrid art forms exist between two ideal forms of "art" and "science" then *art for scholarship's sake* as we define it exists just beyond hybridity in a place that plants itself more squarely in the realm

of stand-alone artistry – poems, short stories, paintings, dance, and drama among other forms of artistic expression. Unlike those creating hybrid forms, most creators of art for scholarship's sake have years of training in their art form in addition to their studies in the social sciences. These scholARTists use their experiences during education fieldwork to create pieces of art that capture the essence of their findings in emotionally penetrating ways. What distinguishes this work from art for *art's* sake is often the context in which this type of scholARTistry is found and that the scholARTistry's content is typically grounded in the experience of data collection and analysis.

Johnny Saldaña (Chapter 17) has used his twenty-five years of experience as a theater artist to produce what he calls "ethnodrama," transforming fieldwork data into scripts for live theater. One of Saldaña's best-known ethnodramas is his adaptation of educational anthropologist Henry Wolcott's research into a play called *Finding my place: The Brad Trilogy* (Saldaña, in Wolcott, 2002). In this ethnodrama Wolcott, the researcher, and Brad, his research participant, become characters in a script that dramatizes the research findings as well as the complicated and, at times, controversial nature of the research process when the researcher becomes intimately involved with a participant.

Adrie Kusserow (Chapter 5) and Kristina Lyons (Chapter 6) are two cultural anthropologists who have extensive backgrounds as poets. Both use poetry and ethnographic writing separately to share findings from their studies in different ways with different audiences. Kusserow's research has appeared in traditional ethnographic books and journals; she regularly publishes ethnographically inspired poetry in a blurred-genre journal, *Anthropology and Humanism*, and has also written an acclaimed book of poetry, *Hunting Down the Monk* (Kusserow, 2002), which illuminates themes from her fieldwork in Nepal and northern India. Likewise, Lyons has placed her work in a range of venues from conventional ethnographic writing to her published poetry (Lyons, 2005; 2006). Through poetry Lyons's research in Central America comes alive through scintillating and unexpected language.

Stephanie Springgay is a visual artist working on projects that explore women's subjective experiences of bodied space through community-engaged art. Springgay (Chapter 11) describes her academic curriculum vitae which includes international shows of her art work alongside published papers and conference presentations. Springgay's two recent bodies of work are titled *Nurse-in* and *Spillage* (Chapter 11). These sculptures created from felted human hair, glycerin soap, and parts of a breast pump are designed to illuminate the contemporary feminist negotiations between motherhood, breastfeeding, and work.

In sum, art for scholarship's sake is grounded in extensive artistic

training and aims to imbue art with socially engaged meaning from research and imbue socially engaged research with art. Increasingly, education research journals such as the *Qualitative Inquiry*, *Harvard Educational Review*, *Journal for Latinos and Education*, and *Anthropology and Education Quarterly* formally exhibit creative reflections on fieldwork in non-traditional forms such as poetry and autobiographical prose. Other journals such as the *International Journal of Education and the Arts* and the *Journal of Curriculum and Pedagogy* feature an even wider array of representational forms and formats including musical, pictorial, and videographic, as well as verbal/print and multimedia. There are poetry readings, performances, and arts exhibitions at major research meetings such as those of the American Education Research Association (through the arts-based educational research special-interest group) and the American Anthropology Association (through the Society for Humanistic Anthropology). Examples of art for scholarship's sake in education research share renderings of inquiry in ways that are unexpectedly memorable due to their emotive and visceral impact.

PROBLEMS AND DIFFICULTIES

Due to degrees of risk – professional and personal – involved, the artistic aspects of education research have often been implicit, seldom acknowledged as such, and have often been achieved through luck rather than purposeful development. Consequently, there is very little explicit training for current and future researchers to practice methods of inquiry that embrace tools and techniques from the arts as well as the sciences. Without explicit training, there can be no critical community to establish what constitutes quality in arts-based research.

The problem that arises by not creating a critical community is that there are few measurements of quality in arts-based research. Without a critical community, arts-based research is at risk for an "anything goes" criteria, making it impossible to distinguish what is excellent from what is amateur. Accompanying the demand for arts-based approaches to inquiry must also be a call for tough critics, those who advocate alternatives but will not substitute "novelty and cleverness for substance" (Eisner, 1997, p. 9). To foster a tough critical community, more arts-based educational researchers need to share the techniques and aesthetic sensibilities they use to prepare other researchers to understand, sensibly critique, and further develop arts-based approaches to scholarship.

Jane Piirto (2002) has been especially critical in regards to the question of quality in arts-based research. She distinguishes arts-based exercises for personal creativity enhancement versus a higher level of

scholartistry that requires extensive and disciplined training. Piirto prescribes a minimum of an undergraduate minor, preferably a major, and/or evidence of peer-reviewed success for those who wish to make art for "high-stakes" research purposes such as dissertations, theses, or publications (2002, p. 443). Critical of anthropologist Ruth Benedict's "cloying" attempts at verse, contemporary anthropologist, Ruth Behar (Chapter 4), advocates that scholars stick to genres that they know well, enhancing their artistic quality as she does in her own hybrid genre, which she describes as a *poetic anthropology*: "After all, we have a lot of poetic poets out there, but tell me, how many poetic anthropologists do you know?" (p. 63).

Aside from quality, another tension in arts-based research concerns the metaphoric novelty of the work versus its literal utility in a climate where our audience requires answers for practice rather than an additional set of ambiguous, beautifully stated questions (Eisner, Chapter 2). Eisner contends:

> Novelty is a part of creativity and creativity is important to have, but when it trumps instrumental utility ... namely that it contribute to the enrichment of the student's educational experience, it loses its utility as a form of educational research.
>
> (Chapter 2, p. 24)

Thus, an important concern for arts-based researchers in education is how to make the process and products of scholARTistry valid and useful to other researchers, educators, politicians, and others wishing to benefit from the outcomes of inquiry.

The challenges of distinguishing quality in arts-based research and creating arts-based forms of inquiry that matter, especially in a political climate insistent upon definitive, unambiguous, generalizable answers, are not to be taken lightly. There are still more researchers writing *about* arts-based research criteria than those producing examples of what it looks like in each area of the literary, visual, and performing arts. Thus, increased numbers of researchers need to experiment with hybrid forms and art for scholarship's sake, in order to continually refine our critical sensibilities. Increased numbers of scholARTists working with an established criteria for excellence will help others in the field of education research discover aesthetic forms that are valuable to educational inquiry as well as to diverse audiences of scholars and lay people outside the academy including teachers, administrators, politicians, and others involved in pedagogical practices and high-stakes decision-making in educational contexts.

FUTURE DIRECTIONS AND POSSIBILITIES

Among the value arts-based inquiry can afford a researcher's own imaginative thinking is that of sharing the process and products of arts-based educational research with a much larger readership than that of a typical education study, with more immediate and lasting impact. For example, sharing a poem may be a much more effective way to bring a discussion of research findings back to a group of students or teachers, than sharing a lengthy research article or book-length manuscript. Sharing a series of photographic images in the hallways of a college of education may disperse research findings to pre- and in-service teachers in more penetrating and immediate ways than any traditional text. Finally, hybrid forms and art for scholarship's sake may be more likely to find venues outside the immediate academy. For example, Jonathan Kozol's (2005) hybrid piece of journalistic ethnography found a large, influential home in *Harper's Magazine*, potentially reaching tens of thousands of readers about the conditions of under-resourced schooling in low-income areas of the urban United States.

Education researchers cannot lose by acquiring and applying techniques employed by artists as well as scientists. We must assume an audience for our work; one that longs for fresh language and imagery to describe the indescribable emotional and intellectual experiences in and beyond language-education contexts. We may not all be poets, dancers, or painters, but we can all draw on the arts to craft poetic discourse analysis or artful case studies – renderings that realize the heights of artistic as well as scholarly potential, challenging the academic marginality of our work.

We might decide to read more poetry, take a dance class, and thus find ourselves taking more risks in the ways we approach our research methodology – whether this means incorporating sketches of a field site in our notebooks, writing "data-poems" from interview transcripts, or creating a scripted dialogue between the "characters" of influential theorists such as Bakhtin and Vygotsky wrestling with theory and data. Our hope is for education researchers to explore the arts-based research methodologies mentioned here as well as others as a means to add more joy, meaning, and impact to our work. The arts have much to offer researchers as a means to make our thinking clearer, fresher, and more public in rendering the richness and complexity of the observed world.

QUESTIONS

1 Chapter 1 opens with a discussion of assumptions and expectations. What are your assumptions and expectations concerning arts-based research?

2 Trace your research history. If you are new to research, explain your attraction to arts-based research. If you are an experienced researcher, trace your research lineage to this point in your life – in what ways have the arts been explicitly or implicitly present?

3 Cahnmann-Taylor distinguishes between *hybrid forms* and *art for scholarship's sake*. Many others in this volume will make similar distinctions. In what ways are these distinctions helpful? Are there any dangers to making these types of distinctions? Are there types of scholARTistry that defy these binary categories?

4 Have you had an aesthetic experience (e.g. reading a novel, watching a play, etc.) as a viewer, reader, or participant that has led to insight into a social or empirical problem or issue? How did that experience differ from a more traditional educational experience?

5 Interview several other researchers in your field of inquiry. In what ways, if at all, are the arts a part of their professional or personal life? Do they think there is anything artistic or creative about their approach to the research process? In what ways do they identify as "scientists" or "artists"? Is creativity valuable to a researcher? Why or why not?

6 Create a piece of art that introduces where you place yourself on the continuum between "artist" and "scientist" and share the creation with others as a way to initiate dialogue.

REFERENCES

Barone, T. (2001). *Touching eternity: The enduring outcomes of teaching.* New York: Teachers College Press.

Barone, T. & Eisner, E. W. (1997). Arts-based educational research. In R. M. Jaeger & T. Barone (Eds), *Complementary methods for research in education*, Washington, DC: American Educational Research Association.

Behar, R. (1993). *Translated woman: Crossing the border with Esperanza's story.* Boston, MA: Beacon Press.

Benedict, R. (1934). *Patterns of culture.* Boston, MA: Houghton Mifflin.

Brady, I. (2000). Anthropological poetics. In N. K. Denzin & Y. S. Lincoln (Eds), *Handbook of qualitative research*, second edition. London: Sage Publications.

Carroll, J. B. (Ed.). (1956). *Language, thought, and reality: Selected writings of Benjamin Lee Whorf.* Cambridge, MA: MIT Press.

Clifford, J. & Marcus, G. E. (1986). *Writing culture: The poetics and politics of ethnography.* Berkeley: University of California Press.

Dewey, J. (1934). *Art as experience.* New York: Minton Balch.

Edelsky, C. (1981). Who's got the floor? *Language in Society,* 10(3), 383–421.

Eisner, E. W. (1991). *The enlightened eye: Qualitative inquiry and the enhancement of educational practice.* New York; Toronto, ON: Macmillan

Eisner, E. W. (1997). The promise and perils of alternative forms of data representation. *Educational Researcher, 26*(6), 4–10.

Eisner, E. W. (2002). *The arts and the creation of mind.* New Haven, CT: Yale University Press.

Ellis, C. (1997). What counts as scholarship in communication? An autoethnographic response. Access ERIC: FullText. U.S.: Florida.

Ellis, C. (1999). Heartful Autoethnography. *Qualitative Health Research, 9*(5), 669–683.

Erickson, F. & Shultz, J. (1982). *The counselor as gatekeeper: Social interaction in interview.* New York: Academic Press.

Foster, M. (1989). It's cookin' now: A performance analysis of the speech events of a Black teacher in an urban community college. *Language in Society, 18,* 1–29.

Hankins, K. H. (2003). *Teaching through the storm: A journal of hope.* In M. Cochran-Smith & S. L. Lytle (Eds), *Practitioner inquiry series.* New York: Teachers College Press.

Heath, S. B. (1983). *Ways with words: Language, life, and work in communities and classrooms.* New York: Cambridge University Press.

Hymes, D. H. (1964). Introduction: Toward ethnographies of communication. *American Anthropologist, 66*(6), 1–34.

Irwin, R., & de Cosson, A. (2004). *A/r/tography: Rendering self through arts-based living inquiry.* Vancouver, BC: Pacific Educational Press.

Kozol, J. (2005). Still separate, still unequal: America's educational apartheid. *Harper's Magazine, 311*(1864), 41–54.

Kusserow, A. (2002). *Hunting down the monk.* Rochester, NY: Boa Editions.

Lawrence-Lightfoot, S. (1983). *The good high school: Portraits of character and culture.* New York: Basic Books.

Lyons, K. (2005). Then silence. *Anthropology and Humanism, 20*(2), 232–233.

Lyons, K. (2006). The first visit. *Anthropology and Humanism, 31*(1), 87–88.

Maynard, K. (2001). *Sunk like god behind the house, Wick Chapbook Series.* London: Kent State University Press.

Nielsen, L. (2005). *Homepage.* Retrieved March 6, 2005 from www.iirc.mcgill.ca/collaborators/collabln.html.

Perry, D. (2005). Unchartered territory: An autoethnographic perspective on starting a dual language immersion charter school in Georgia. Paper presented at American Anthropological Association, Washington, DC.

Piirto, J. (2002). The question of quality and qualifications: Writing inferior poems as qualitative research. *Qualitative Inquiry 15*(4), 431–446.

Saldaña, J. (2002). Finding my place: The Brad trilogy. In H. F. Wolcott (Ed.), *Sneaky Kid and its aftermath: Ethnics and intimacy in fieldwork.* Walnut Creek, CA: Altamira Press.

Shavelson, R. J. & Towne, L. (2002). *Scientific research in education.* Washington, DC: National Academy Press.

Tyack, D. B. & Cuban, L. (1995). *Tinkering toward utopia: A century of public school reform.* Cambridge, MA: Harvard University Press.

Chapter 2

Persistent tensions in arts-based research

Elliot Eisner
Stanford University, Stanford, California

Elliot W. Eisner is the Lee Jacks Professor of Education and Professor of Art at Stanford University. Professor Eisner was trained as a painter at the School of the Art Institute of Chicago and studied design and art education at the Institute of Design at the Illinois Institute of Technology. He received his Ph.D. from the University of Chicago.

Professor Eisner's contributions to education are many. He works in three fields: arts education, curriculum studies, and qualitative research methods. He has been especially interested in advancing the role of the arts in American education and in using the arts as models for improving educational practice in other fields. He is the author or editor of sixteen books addressing these topics, among them *Educating Artistic Vision*, *The Educational Imagination*, *The Enlightened Eye*, *Cognition and Curriculum*, and

The Kind of Schools We Need, and most recently *The Arts and the Creation of Mind*. He has lectured on education throughout the world.

Professor Eisner has received many prestigious awards for his work, among them a John Simon Guggenheim Fellowship, a Senior Fulbright Fellowship, the Jose Vasconcelos Award from the World Cultural Council, the Harold McGraw Prize in Education, the Brock International Prize in Education, and the Grawemeyer Award in Education from the University of Louisville. In addition, he has received six honorary doctorates from institutions around the world.

He is a fellow of the Royal Society of Art in the United Kingdom, the Royal Norwegian Society of Arts and Sciences, and in the United States, the National Academy of Education.

Professor Eisner was President of the National Art Education Association, the International Society for Education Through Art, the American Educational Research Association, and the John Dewey Society.

I write today about persistent tensions in arts-based research. In many ways, it should be expected that an approach to research that employs new assumptions and methods and has a short history should generate tensions. We would lack vitality if we were cocksure of everything we do. Tensions can be motivating. But before describing them, let me address what I mean by tensions. By tension I mean a psychological state that creates a feeling of mild discomfort, a feeling that can be temporarily relieved through inquiry. A tension is close to what Dewey (1934) means by "disequilibrium." It can be produced by a sense of uncertainty about one's work. It can be stirred by the vague feeling that in one's work something is just not right. It can be the result of being attracted to two incompatible values. But, it can also be motivating, and it can evoke a sense of vitality.

Yet the presence of tension in doing one's work, though it may engender vitality, does not, by itself, guarantee that as a result one's work will be either theoretically cogent or practically useful. There are tensions that virtually all of us experience in doing arts-based research and my aim in this paper is to explore a few of the tensions that I believe to be among the most persistent.

But first, a little history.

It was in 1993 that the first Arts-Based Research Institute was offered to members of the American Educational Research Association (AERA). The Institute was held at Stanford and has been offered at Stanford and at Arizona State virtually every other year since then. In initiating the Institute, I was driven by a tension that I felt personally as a scholar and as someone immersed in the arts. That tension pertained

to the idea that we might apply the arts in some productive way to help us understand more imaginatively and more emotionally problems and practices that warrant attention in our schools. At the same time, the idea that the arts could be at the core of research seemed a bit oxymoronic.

In another life I was a painter, so it is not surprising that I was interested in the ways in which the arts generate awareness – wideawakeness as Maxine Greene (2001) might say. At the same time, I did not expect arts-based research to culminate in the creation of paintings, poems, or pirouettes. I thought that the crafting of evocative forms might enable us to address aspects of educational life that normally get neglected. I also hoped our social-science colleagues would find such work credible.

The initial iteration of this conjecture of mine about the relationship between the arts and educational research had been expressed earlier in the concepts of educational connoisseurship and educational criticism (Eisner, 1991), two notions rooted in the arts. Could there be, I asked myself, an approach to educational research that would rely upon the imaginative and expressive crafting of a form in ways that enlarge our understanding of what was going on, say, in teaching, or in the school cafeteria, or in the high-school mathematics classroom? Educational connoisseurship and educational criticism were in most ways marginal rather than central to the production of an art form. To be sure, criticism and connoisseurship acknowledged, and indeed, employed aesthetic criteria in making judgments about how something was to be rendered, but it was a tool for seeing and for describing far more than an effort to craft a work of art as such.

In many ways, this ambition of mine, to develop an approach to the conduct of educational research that was rooted in the arts and that used art forms to reveal the features that mattered educationally, was a central ambition. This ambition had ramifications. For example, it led to considerations regarding the role of fiction in educational research. The AERA debate that Howard Gardner and I had about whether a novel could function or serve as a dissertation is an example of the position that I embraced (Donmoyer et al., 1996). Gardner argued that doctoral training was essentially that, a training program designed to prepare skilled journeymen in the use of conventional research methods. My argument was that universities ought to be places in which doctoral students could explore imaginatively new methods and concepts and if universities could not provide such a setting, there were few places that could. You might say I was interested in pushing the boundaries of possibility. It is not necessary to get into the details of the debate, but I will say that it was spirited and that it represented two perspectives on how research might be undertaken. In neither case, I believe, was either of us

looking for a single hegemonic orientation to research methods. I have always embraced pluralism in method, and I think Gardner does as well, even if he didn't argue that position when we shared a session in AERA in New York.

To make the case for arts-based research, especially in a research climate of the kind we have today, is as daunting as it is important. The federal government, as almost everybody reading this knows, has embraced field-based experimental trials as the "gold-standard" for supporting educational research (Shavelson & Towne, 2002). What this means is that arts-based research, as a "soft-form" of qualitative research, will have an uphill battle to fight to maintain its place as a legitimate form of inquiry in the educational research community. At the same time, the very position articulated by the federal government concerning what it calls "evidence-based research" (Shavelson & Towne, 2002, p. 1) (implying that other kinds of research do not provide evidence) may ironically strengthen the acceptance of approaches to research that are closer to arts-based research than we have ever had. When your own ox is being gored, you tend to become somewhat more tolerant, maybe even more sympathetic to approaches that you once found problematic. I am saying that the very pressure upon traditional researchers to do experiments may warm them towards non-experimental approaches to research.

In any case, it is still necessary to have arguments that offer support for arts-based research. This is not a new requirement, but it may be, at present, particularly important.

At the same time, the greatest source of security concerning arts-based research is not in tight rationales articulated by academics who have a vested interest in its use, but exemplary arts-based work which is difficult to dislike. In other words, deeds, not words, may be in the end the most persuasive source of support and the source that yields the highest levels of credibility.

So much for establishing a grounding of where I and the field have been. Let's turn to tensions. Earlier I discussed the existence of tensions. I want to identify them now. One of these tensions pertains to a deep dilemma. This dilemma relates, on the one hand, to the desire to work imaginatively and, on the other hand, as a result of doing so producing material that does not communicate.

How shall we arbitrate differences in our interpretive response to materials that have no clear referents? Surely one of the functions of educational research in general, and arts-based research in particular, is to make vivid certain qualities encountered by the researcher normally, but not necessarily in the context of schools. Will the images made through arts-based research possess a sufficient degree of referential clarity to engender a common understanding of the situation being

addressed, or is a common understanding of the situation through arts-based research an inappropriate expectation? If so, what are we to make of the well-crafted but ambiguous poem or painting, for example, the expressive painting that we want to connect to the situation we intend to render but which works more like a Rorschach test? Put another way, how do we deal with referentiality when we do not have a means that enables us to make the needed connections? Should we worry about this?

Just what are the other tensions in arts-based research?

A second tension is located between the particular and the general. By this I mean that there is a tension between focusing on the particular conditions of an educational situation in order to illuminate its distinctive features and, at the same time, developing observations and insights that extend well beyond the particular that was addressed in the first place. As you well know, in conventional forms of generalization in the social sciences, generalizations can be made *if* the sample drawn from a population is random and, if it is, one is able to draw conclusions from the sample to the larger population of which it once was a part. The procedures are straightforward and almost universally applied in studies that attempt to generalize using statistics.

In arts-based research, we have no comparable set of conditions. The very conditions that make a study arts-based are conditions that personalize the study or the situation by allowing an investigator's thumbprint to work its magic in illuminating the scene. Furthermore, the samples in arts-based research are typically convenience samples, i.e. idiosyncratic sites that are most often intuitively selected rather than randomly identified or otherwise rule-governed. How, then, given these conditions, is generalization possible? One answer, which doesn't satisfy everybody, is to argue that the general resides in the particular and that making general observations from particular circumstances is precisely what we do in life. We formulate generalizations on the basis of particular instances, none of which have been randomly selected. But as I said, that explanation, which I find congenial, does not satisfy all investigators. At the same time, it should be remembered that conclusions drawn in statistically based research that purport to generalize are often generalized to populations that were not a part of the population from which the sample was drawn. In other words, generalizations in the social sciences are often over-generalized given the rules of the game that statistically oriented researchers play. Nevertheless, the fact that statistically oriented studies are often generalized beyond their appropriate limits does not grant permission to arts-based researchers to generalize from particulars, *unless* one's conception of generalization adheres to a different model.

The different model about which I speak is a model that is much

closer to literature than to statistical analysis. It culminates in an icon that, let us say, edifies or illuminates. Great works of literature teach their lessons in ways that go well beyond the particular circumstances they address. Their lessons are general. In fact, intelligence itself might be regarded as a process that enables one to see connections between the instance and aspects of the world that were not initially a part of that instance.

As I write these lines in this paper I feel comfortable with a literary conception of generalizability, and yet I well know that for many in the field of educational research this conception is not persuasive. Hence the tension.

It may be the case that the tension is inevitable and will be enduring. "You can't generalize from an N of 1" is an unquestioned mantra in the educational research community. Do we really know that other situations will be illuminated by what we find in the one that we select to study? But perhaps that's all we can get. Perhaps the function of educational research is not to draw near-certain conclusions about states of affairs that generalize, but rather to secure technologies of mind that will enable us to peer more deeply into situations that might not be the same as the one that we study. In short we might say that useful research enlarges our intelligence. In any case, a tension is there and it is one that we need to acknowledge and address with the aid of the best conceptual work we are able to muster.

A third tension in arts-based research is the tension between the desire to achieve a work product that has aesthetic properties and the desire to achieve at least some degree of verisimilitude in our work. It is so attractive and satisfying to shape a line or a paragraph so that it sings even if it portrays in questionable ways the situation we are attempting to address. In other words, there is a tendency to allow aesthetic considerations to trump the need for an epistemic orientation to disclosure or, if not epistemic, at least one that is phronetic. True and certain knowledge – the aspiration to achieve episteme – is, according to Stephen Toulmin (1982), too demanding and unrealistic an aspiration for inquiry into human affairs. It is simply too much to ask for. Nevertheless, aesthetic achievement places its demands upon us; statements about states of affairs can be attractive and wrong. Indeed, the more attractive they become, the more they might mislead. Consider advertising.

But perhaps this, too, is something we should not worry about. After all, in the theater the individuals portrayed by actors are often larger than life. It is their overwhelming character that awakens us to qualities in the human condition that we often neglect in daily life. In other words, the drama on stage can be more vivid than what one might normally find. Is this a problem? One could argue that it is in the very exaggeration of the features of a situation through which we come to

grasp its significance. Put another way, exaggeration can promote understanding.

Perhaps the problem or tension that we experience between the aesthetic and the world it portrays is our belief, often unexpressed, that a correspondence theory of truth is the model that should guide our work. And yet, if it is not the model that should guide our work, just what is? And if it is something other than a correspondence theory of truth, is it likely to be accepted by our colleagues who have grown up on such a model?

But what if we neglected aesthetic considerations in doing arts-based research? If we did, could we still call it arts-based research? I have my reservations. For me, the distinguishing feature of arts-based research is that it uses aesthetic qualities to shed light on the educational situations we care about. Arts-based research is not simply the application of a variety of loose methods; it is the result of artistically crafting the description of the situation so that it can be seen from another angle. To talk about the desirability of seeing a situation from more than one angle is to tacitly acknowledge what I will make explicit.

In promoting the practice of arts-based educational research, I seek no new hegemony in matters methodological. What I believe we need in educational research are multiple perspectives. Each template or lens one engages to see can make vivid what other lenses obscure. Unlike our brethren at the national level who believe that randomized experimental field trials are the only way to go, I believe there are many roads to multiple Romes. Put another way, I don't think there is one destination that several roads will lead you to, but that there are, rather, multiple destinations which require multiple roads.

A fourth tension in arts-based research is related to the features of its "product." For some arts-based researchers, the results of arts-based research pertain to the formulation of new, more interesting questions than the ones one started with. You might say that arts-based researchers are interested in generating puzzlements. Now the generation of puzzlements is an intellectually attractive thing to do. Many claim that questions are the most significant form of intellectual achievement, not answers. What arts-based research should do is to raise fresh questions.

For many of us who love to participate in the life of the mind, this conception of the products of arts-based research has an attractive ring. It suggests an emphasis on inquiry, a tolerance of ambiguity, a preference for what is open-ended, a desire for what is fluid rather than what is rigid. These are all values that most of us here could subscribe to. At the same time, we must not forget that policy-makers, teachers, and parents are not primarily interested in better questions; they would like to have some answers to questions about the ways in which teaching

affects learning, about what their children have learned, or about the discovery of better ways to teach reading. The point is that, while questions are just fine for those of us in the academy, they are not necessarily fine to people who have a problem and who wish to solve it and who believe that research may be one way to provide better answers than the ones they had before. Can arts-based research furnish answers to complex educational questions? Will those answers stand up in court? Is arts-based educational research essentially a reconnaissance effort to generate questions that "real research" can secure answers to? Just what is our stand concerning our ability to present reasonably confident answers to educational questions through arts-based research, or is our mission to provide interesting new leads for other educational researchers to pursue?

I know that in making a distinction between answers and questions I am walking on thin ice. One could clearly argue that conventional research is also interested in better questions; that aspiration is not owned by arts-based researchers. And yet the kinds of answers that arts-based research yields, if any at all, seem much more ethereal, global, impressionistic, than those secured through conventional forms of research. Now it could be argued that what I have called the ethereal character of arts-based research products is a much more congenial fit between situations and ideas about them than the misleading implications that come out of much traditional research that answers are known and that schools should simply implement "what works."

Although I am in favor of implementing what works if what works, works, I do believe that there is a difference and a tension between ideas that culminate in propositional assertions about empirical starts of affairs and those that culminate in qualitative metaphors that may not have the same kind of precision that traditional research offers. Thus, I think there is a tension between the more literally oriented conclusions of conventional research and the more metaphorical conclusions, if they can be called that, of arts-based research.

Now many of us here have an affinity to metaphor. I certainly do. Yet research is more, or at least should be more than a Rorschach test. If arts-based research culminates in little more than a delightful poetic passage or a vivid narrative that does little educational work, it is not serving its function. In other words, I am trying to remind us here that in the end research is an instrument, whether arts-based or not, that is supposed to contribute to the quality of education students receive and that arts-based research must ultimately be appraised on the extent to which that aim is realized.

That this can be accomplished, I have no doubt. When Arthur Powell, Eleanor Farrar, and David Cohen (1985) write of shopping-mall high schools and of students and teachers making *treaties* to enable

them to get through the school year peacefully, they employ metaphors. These metaphors have a purpose. They do call our attention to relationships and to infrastructures that we might not otherwise notice. Metaphors can do educational work. We must try to resolve this tension by trying to make sure that they do.

I mention this consideration because in arts-based research there is at times a tendency, I believe, to mistake the novel for the useful. Since research is related to art, I get a sense that there is a tendency to want to make sure that the form and method employed is novel. Put another way, there is a tendency to want to make the work creative. Now novelty is a part of creativity and creativity is important to have, but when it trumps the instrumental utility I just described, namely that it contribute to the enrichment of the student's educational experience, it loses its utility as a form of educational research. Put in still another way, arts-based research needs to pursue novelty without sacrificing utility. It needs to be more than a projective test. And this creates a tension between achieving the shock of the new and, at the same time, genuinely communicating. When novelty out-distances a reader, the reader's delight may reside in the aesthetic rather than in the usefulness of the work.

Now it must seem strange to you to hear someone like me talk about the potentially distracting effects of the aesthetic and my belief that the practical utilities of arts-based research need to remain salient. I do so because I do not think the future of arts-based research will be well served unless its utilities are achieved. Novelty, or should I say "near novelty," is simply not going to be enough to sustain interest and engender high regard among our colleagues.

Another, fifth tension relates to the recognition that objectivity is always beyond reach and at the same time the desire that most of us have for our work not to be a projection of whatever we want it to be. Put another way, I am seeking a constructivist orientation to knowledge but a constructivist orientation within constraints. How do we resolve the tension between our correct belief that meanings are made and that they are made in part with our life histories while at the same time recognizing that, if in arts-based research anything goes, nothing will.

The "solution" that I have wrought in my own work pertains to the relationship between what Stephen Pepper (1942) calls "structural corroboration" that is a kind of circumstantial evidence, a form of triangulation, and referential adequacy, which is the empirical test of one's observations with respect to the situation that has been described and interpreted. For me, these concepts are helpful, although I must confess that structural corroboration is seldom adequately provided for in the arts-based research that I have seen. I think the field of law, which in

part deals with matters of evidence, can furnish some useful leads on how to think about matters of objectivity and matters of verification; circumstantial evidence comes close.

We know that we cannot ever get a comprehensive view that is objective in any definitive sense, and we also recognize that verification – if that's the right word in the first place – will never be complete. At the same time, we don't want to be pushovers for procedures that will not bear what our colleagues call rigorous scrutiny. Can arts-based research be rigorous? If so, what would it look like if it was?

These five tensions, and I remind you of them now, penetrate our work – first the tension between using open forms that yield diverse interpretations and forms that yield common understandings is one such tension. A second is that between the particular and the general. We want our single case research to extend beyond the single subject studied. A third tension is between the desire to aesthetically craft form and the desire to tell it like it is; aesthetic considerations can trump epistemological ones. A fourth tension is between the desire to pursue new questions and puzzlements and the need in the practical world for answers. Finally, there is the tension for arts-based research to seek what is novel or creative and the need to create work that has verisimilitude to the furniture of the world.

What are we to make of this analysis and can we learn anything from it? I would make three concluding observations about the tensions that I have identified and their significance in education. First, it strikes me that the tensions experienced in the conduct of arts-based educational research are not like the tensions that traditional researchers encounter in doing their own work. The tensions we experience, in some sense, are the tensions of an underdog working in a universe in which we are "the smallest kid on the block." As a result, it has taken considerable courage on the part of arts-based researchers to stick their necks out in order to do work that fits their way of thinking about education.

A second observation pertains to the tensions about beliefs regarding the nature of knowing and the processes of the mind. Convictions about verification, generalization, reliability, and replicability participate in a hard nosed universe of beliefs that we probably know all too well. The concepts and processes that we have employed in arts-based research are much more likely to work at the edge of possibility and address questions of meaning and experience that are not likely to be as salient in traditional research. Put another way, our basic concepts and methods participate in a new universe. Knowing, for example, takes on the attributes of a verb, that is, a process rather than an object or product that is fixed and definitively knowable. Mind, for us, is much more likely to be a fluid stream rather than a fixed rock. Our minds are always a work in process.

Finally, the tensions and procedures that I identify I believe can produce a general model that, if applied in our classrooms, could reshape and advance the practice of education and reform our conception of its proper aims. Regarding mind as a cultural achievement, knowing as a process that yields tentative resolutions, objectivity as an aspiration rather than a realization, the impact of forms of representation beyond the literal use of text, recognizing the power of form to inform, yet realizing that every form of representation both reveals and conceals, such ideas might broaden our perspective regarding what is worth teaching and learning and through a broadened perspective change the scope of the curriculum and enrich the practices that teachers employ to promote student growth.

Let me conclude by saying that, if only a portion of such aspirations were realized, our efforts would certainly be more than worthwhile. After all, the aim of research is not to advance the careers of researchers but to make a difference in the lives of students. That aspiration is not only realized by sharing conclusions about matters of fact, but by changing perspectives on how we see and interpret the world. Arts-based educational research can contribute significantly to a re-visioning of education. That contribution could be, in the long run, its most important.

QUESTIONS

1 Throughout the essay Eisner refers to "traditional" researchers. Whom is he referring to? What constitutes traditional vs. non-traditional research?
2 Discuss Eisner's five tensions and their implications:

 i the imaginative vs. the referentially clear
 ii the particular vs. the general
 iii aesthetics of beauty vs. verisimilitude of truth
 iv better questions vs. definitive answers
 v metaphoric novelty vs. literal utility

3 Eisner says that ABER needs to be "theoretically cogent" and "practically useful." How then does one determine "exemplary" work in ABER? What criteria can be used? Will the criteria differ if a work is based in the literary, visual, or performing arts?
4 How does ABER challenge and recast the aims of education and the expectations of research ?
5 Why does Eisner believe arts-based research takes courage? In pairs or small groups, discuss your own feeling of risk-taking in arts-based research.

REFERENCES

Dewey, J. (1934/1958). *Art as experience*. New York: Minton Balch.

Donmoyer, R., Eisner, E., Gardner, H., *et al.* (1996). *Can a novel be a dissertation?* Panel presented at the American Educational Research Association Annual Meeting, New York.

Eisner, E. W. (1991). *The enlightened eye: Qualitative inquiry and the enhancement of educational practice*. New York: Macmillan.

Greene, M. (2001). *Variations on a blue guitar: The Lincoln Center Institute lectures on aesthetic education*. New York: Teachers College Press.

Pepper, S. C. (1942). *World hypotheses, a study in evidence*. Berkeley and Los Angeles: University of California Press.

Powell, A. G., Farrar, E., & Cohen, D. K. (1985). *The shopping mall high school: Winners and losers in the educational marketplace*. Boston, MA: Houghton Mifflin.

Shavelson, R. J. & Towne, L. (2002). *Scientific research in education*. Washington, DC: National Academy Press.

Toulmin, S. (1982). The construal of reality: Criticism in modern and post modern science. In W. J. T. Mitchell (Ed.), *The politics of interpretation*. Chicago, IL: University of Chicago Press.

How arts-based research can change minds

Tom Barone
Arizona State University, Tempe, Arizona

As Professor of Education at Arizona State University, Barone currently teaches courses in curriculum studies and in arts-based/narrative/qualitative forms of research. His interests in arts-based research date back to the dawn of time – or at least the late 1970s, when, under the mentorship of Elliot Eisner at Stanford University, he investigated in his dissertation the possibilities of literary non-fiction for inquiring into and disclosing educational phenomena. Since then, Barone's writing has continued to explore, conceptually and through examples, a variety of literary-based approaches to contextualizing and theorizing about significant educational issues.

 Aesthetics, Politics, and Educational Inquiry; Essays and Examples (Peter Lang, 2000) traces Barone's intellectual debt to five prominent scholars who,

during the last two decades of the twentieth century, helped guide him toward a greater understanding of how both schools and educational research might better serve educational ends. *Touching Eternity: The Enduring Outcomes of Teaching* (Teachers College Press, 2001), an ironically titled book, is a postmodern arts-based case study that aims to raise uncomfortable questions about the usefulness of a settled definition of "good teaching."

And, as readers of Barone's essay in this book may come to understand, he has become more attentive to the increasingly debilitating political milieu within which schooling takes place. More positively, Barone envisions a future in which audacious arts-based researchers explore novel means for transforming the prevailing cultural and political landscape, as they entice a wide array of people — audiences of educators, layfolks, and policy-makers — into deeper and richer conversations that release our collective imaginations about what schools can be like and school people can become.

INTRODUCTION

Most of us for whom educational studies is our chosen field see ourselves as engaged in an ongoing quest to make the world of schooling a better place. Our efforts, simultaneously personal and professional, are fueled by hopes for an educational enterprise guided by our moral compasses, a felt need to realign its policy and practice, and therefore its outcomes, with our own sense of educational virtue.

I cannot more aptly describe the nature of my own quest than did Maxine Greene (1988, p. xi) in articulating hers. Greene characterized her own lifelong struggle as one of "connect[ing] the undertaking of education ... to the making and remaking of a public space."

But in recent times those with opposing interests, most from outside the field of education, have made the pursuit of that quest more problematic. Working diligently toward the downsizing of that public space, they have, from my point of view, moved to denigrate the public schools and to castigate those who live and work within them, in favor of a less expansive vision, one guided by a narrow, private, corporatist ideology.

As academic professionals, one of the most important outlets for pursuing our quest is our scholarship. And for some educational researchers, quantitative and qualitative alike, it is there more than anywhere, that frustration and even futility reign, with a sense that the realm of schooling has been largely untouched by our painstaking efforts to study that world and to reveal what we have found. Indeed, since the November 2004 elections, a few colleagues, in personal

conversations, have expressed to me their doubts that progressive educational researchers, even in collaboration with like-minded academic colleagues and public-school educators, can ever effect the realignment of schooling in America with their aspirations for it.

Despite the ongoing trials and recent disappointments, my quest, and hopefully yours, is not easily retired. But, as we witness the educational landscapes of the public school and the academy devolving around us, I feel the need to support our longings, to revive our yearnings, for making a positive difference through our scholarly research. And to that end I quote the following words of Jean-Paul Sartre (1988): "The world and man reveal themselves," he wrote, "by undertakings. And all the undertakings we might speak of reduce themselves to a single one, *making history*" (p. 104).

Sartre was not, of course directly addressing the world of educational research, but from those pithy words I extrapolate the following: As educational inquirers, parts of our professional selves are indeed defined by our notions of the educationally true, good, and beautiful. We do indeed reveal these parts of ourselves within, among other locations, our research projects. And it is through those undertakings that we must continue to strive to make educational history.

To that end, this essay represents a tentative foray into a realm of possibilities. In it I explore merely one avenue for redressing the dire state of education though our work as educational scholars and researchers. It is divided into two parts. In the first I attempt to more fully articulate the nature of the obstacles that we face as educational researchers in our efforts at making educational history. In the second I suggest some features of qualitative research, especially arts-based research, that might serve us in our quest.

THE PROBLEM

At the beginning of the twenty-first century we have witnessed the greatest intervention of the federal government into the field of education in the history of the United States, a deep intrusion into the once public space of the classroom for the purpose of managing the transactions between those who live and work there. The consequences of this intervention, intended and otherwise – but largely, I believe, pernicious – are too varied and widespread to catalogue here. But among them has been the reinforcement of frame factors that have served to diminish the professional autonomy of teachers and administrators, deskilling them, as Apple and Teitelbaum (1986) would say, and severely hampering them from engaging in history-making practice, which is to say, praxis.

Among the available forms of resistance to this institutional oppression of educators is a quiet subversion of these externally generated policy mandates from behind the closed classroom door. But while some degrees of professional freedom surely remain for educational practitioners, the omnipresent standardized exam, like Foucault's (1995) panopticon, renders subterfuge more problematical. Subterfuge, moreover, does little to alert non-educators to the extent of the damage currently being inflicted on the educational process. While signs of discontent with practices such as high-stakes testing have emerged among scattered clusters of laypeople, conventional suppositions upon which harmful policy mandates are based go largely unchallenged; within the general public the confusion remains widespread.

Writing in the 1920s John Dewey (1927/1954) observed that a "public that is organized in and through those officers who act in behalf of its interests," including policy-makers, is critical to the health of a democracy. He further noticed that the public of the time "is in eclipse, unsure and uncertain ... The public seems to be lost; it certainly is bewildered" (pp. 15–16). With other social and educational progressives, I detect nowadays a similar "eclipse of the public." The populace seems lost, distracted, largely unconcerned as one of the last bastions of hope for what Dewey called the Great Community – the public school – is betrayed by policy-makers who are failing to act in the public's interests in ways that most do not fully comprehend.

Schneider and Ingram (1997) have identified the kind of politics that operates when the public is bewildered, lost, befuddled, betrayed. They call it *degenerative* politics (pp. 2–3; quoted in Smith, 2004). Degenerative politics depends and feeds on an organized, usually public, display of entertainment. This theatrical display, designed to manipulate social reality toward a desired end, constitutes what Edelman (1988) calls *the political spectacle*. Of the several elements identifiable within that spectacle, I will mention three here.

The first significant element in this public pageant is that of skewed imagery, a series of distorting pictures lodged in the public consciousness. The second is a symbolic language, a set of abstract words, devoid of concrete referents, to which meanings are nevertheless assigned. Third, the words and images live in a mutually supportive relationship within an overarching storyline, similar to what the postmodern social critic Jean-Francois Lyotard (1979) would call a master narrative.

Master narratives are meta-stories that aim to bring final meaning to cultural phenomena. These are stories that we cling to for a comfort and familiarity otherwise denied us in an increasingly jarring and bewildering world. A narrative provides a kind of coherence to the symbolic language and images, just as the words and images drive and illuminate

the story, free to operate within the political spectacle, to pervade public awareness.

The words, images, and meta-story that are serving to confuse the public about educational matters are, of course, part of a more inclusive cultural narrative about issues of childhood, race, gender, social class, intellectualism, and private initiative versus public good. In teasing out the ways in which this vocabulary, imagery, and narrative pertain to education, I blend my own ideas with those of Mary Lee Smith (2004), who has transported some of Edelman's (1985, 1988) notions about the political spectacle into the educational arena.

The public has been bombarded with images of indolent and insolent schoolchildren, especially children of color; of disinterested, incompetent, mostly female teachers who are responsible for those children's purported deficiencies; or of the rare, isolated hero-teacher who, on behalf of their students, combats, without a posse of colleagues, a corrupt and stifling school bureaucracy; and finally there are the manufactured images of the aloof, impractical, theory-obsessed teacher-educator, portrayed as the ultimate apologist for the self-serving educational establishment.

Meanwhile, conversations about education are riddled with words such as "accountability," "high standards," and "freedom of choice." Who, asks Smith (2004, pp. 12–13), could disagree with these words? And yet, she notes, the meaning of each term can vary within alternative contexts. For example, "accountability" suggests something quite different to accountants, to educators, and to testing experts. But those who use the term within the political spectacle "gloss over real differences in definitions and values" in favor of a privileged meaning that serves the narrow interests who seek to maintain the political spectacle.

Within the meta-story that flows from and through these words and images, children, public-school teachers, administrators, and professors of education are stereotyped and scapegoated. Members of the educational establishment are portrayed as not responsible to the motivational forces of the free market. Because they have placed our nation's social, cultural, and economic well-being in jeopardy, they themselves are in constant need of surveillance, or "accountability." Most importantly the public (a.k.a. "government") schools in which they work require a dose of private-sector competition to cure what ails them.

Because this master narrative is an artifact crafted within a degenerative politics it is not, ultimately, a useful one. This is because it draws its breath from within an air of unreality. Edelman (1985, p. 5) suggests that the pictures within the political spectacle "create a moving panorama taking place in a world the public never quite touches," its members never actually experiencing it for themselves. The images associated with words such as "accountability," and the meta-story they

support, lack concrete referents and so "float free of specific meaning" (Smith, 2004, p. 13). "No tether ties these words [and images] ... to the world of experience and intractable concrete details." Nor are the meanings of the words, images, and story within the meta-narrative tied to debilitating cultural forces, details of which might reveal teachers and students as the victims rather than the perpetrators of social crimes. Instead, unwarranted meaning is arrogated to these words and images by those in a position to do so. The result is a public that is "held in a kind of thrall" (Smith, 2004, p. 13).

My favorite evidence of the extent of this psychological bondage continues to be the annual Phi Delta Kappa/Gallup Poll of the Public's Attitudes toward the Public Schools (Rose & Gallup, 2004). Year after year, the poll has demonstrated a sizable gap between the views held about the quality of schools with which respondents are directly familiar, and their views of those with which they are not. In the 2004 poll, 70 percent of parents from across the nation awarded an A or a B to the school attended by their oldest child. Asked to grade all public schools nationally, only 26 percent of the same parents chose an A or B (p. 44).

How to account for this paradox? Between the parents' direct experiences of the nearby schoolhouse and their impressions of the distant classrooms inhabited by other people's children, there toils the political spectacle churning out distorted language and clichéd imagery. These words and images are rife within the products of the commodified and banalized mass media, especially the electronic visual media (Males, 1999) such as film, TV sitcoms, and news magazines, the commercial aims of which are, paraphrasing Abbs (2003, p. 19), "as far removed from actual experience as an amusement arcade is from teaching philosophy."

Those aims are indeed to bewilder and befuddle, to mystify and indoctrinate. The evidence from that Gallup poll (and elsewhere) suggests that, while the flow from the popular media may be limited in its capacity to affect profoundly the meanings we derive from "actual" experiences, it remains sufficiently powerful to transform the benignly distant and unfamiliar into the fearfully strange and exotic. Unfortunately, however, it is within this anxiety manufactured within the political spectacle that much of today's educational policy is being fashioned.

The difficulties of removing the blindfolds should not be minimized. The political spectacle has allowed the seeds of misperception to be planted deep within the collective subconscious. Indeed, discussions in the media about educational matters almost inevitably betray assumptions built on the imagery within the master narrative. When even the National Federation of Teachers condescends to the language of

educational standards and teacher accountability, the extent of the problem is more clearly registered.

The seeds are certainly buried below the cultural topsoil of political partisanship. While the 2004 campaign platforms of the two major parties in the United States surely reflected, to some degree, the interests of different constituencies, the rhetoric on both sides floated above the meaning of terms such as accountability, educational standards, and even the ways in which a child may be left behind.

Of course, in a political campaign the spectacle reaches its height; indeed, dueling pageants vie for center stage. A campaign hardly represents an opportune moment for educating an electorate. It may be in the cooler years, with the spectacle malingering but its fever diminished, that we find the most appropriate moments for our arduous efforts at intervening in history through our scholarship, all the while refusing to create a spectacle of our own.

WHAT TO DO?

What are the various research approaches available to us for the kind of intervention of which I speak? The list of qualitative inquiry strategies has grown more extensive in recent decades, to include the various forms of case studies, participatory action research, phenomenological research, hermeneutical research, cultural studies, critical ethnography, postmodern, post-structural, and post-colonial approaches, autoethnography, narrative research, life history, performative ethnography, and so on.

Only to be recast, as we know, as a kind of *blacklist* of research methodologies (indeed, one that disparages all non-experimental forms of educational research). But recast by whom? Are the proponents of a new, aggressively retrogressive research orthodoxy, the same policy-makers and politicians who benefit from a degenerative politics? If so, does their disdain for these research approaches reflect a concern that the methodologies might facilitate a remaking of the history that they feel they own? The presence of such a fear would support my own beliefs about the potential of these alternative research genres, and so offer hope.

In addressing the possibilities of making educational history through alternative genres of educational research, I focus primarily on the kind known as *arts-based*. I am wondering about the potential of a research approach that, boldly but not rudely, humbly and not arrogantly, intervenes in the current state of educational affairs, one that expands the reach of our scholarship because of (*and not despite*) the fact that it is profoundly aesthetic, one that *both* finds its inspiration in the arts *and* leads to progressive forms of social awareness. I am thinking of an approach to research on educational phenomena that alters the world

by raising questions, one that makes history by providing a catalyst for the changing of minds. And among the candidates whose minds might be changed are the members of the general public currently under the sway of the political spectacle.

This is, as we know, not the usual audience for educational researchers of any stripe. Instead, career success for members of the professoriate has largely depended on the degree to which our texts inform and persuade professional colleagues within our circumscribed discursive sub-communities. But some cultural observers have reinforced our discomforts with this narrow audience, expressing concerns about the tendency of academic writing to alienate readers unprepared to penetrate the opaque prose of disciplinary specialization. Russell Jacoby (1987), in particular, has insisted that even writings by academics with emancipatory intentions have not served to resist, but rather contribute to, a general decline in public discourse.

In the last few decades, some educational researchers have abandoned the traditional premises, procedures, protocols, and modes of representation of the quantitative and qualitative social sciences for those of the arts. But arts-based researchers have thus far only rarely abandoned the traditional conception of research audience. For those who have, the alternative audiences have included, among others, educational practitioners and policy-makers, the informants whose experiences have been represented in the research text, those who commission evaluations of educational programs, and the researcher herself.

I am – emphatically – not suggesting that arts-based researchers cease addressing any audience we desire to address. But I am imagining research projects that reach out to an audience that transcends one consisting only of colleagues and those alternative readers and viewers. Such an audience might include laypeople of all social categories, privileged and otherwise, those who may be identified as members of an intelligentsia or literati, and those who do not know the meaning of those words, all of us who are, or should be, active participants in the larger civic culture, and all of us who have been, in varying degrees, captivated by the spectacle.

I am envisioning educational inquirers who undertake the reclaiming and redirecting of history by communicating directly with the general public through research that is based in the arts. But which characteristics of art and arts-based research hold promise in this regard? Two will be highlighted here. First, I am recommending research that is *socially engaged*, and second, research that is *epistemologically humble*. I begin with the notion of social or political commitment in art and arts-based research.

SOCIALLY ENGAGED ARTS-BASED RESEARCH

We have learned from various postmodern theorists that power relation-ships inevitably inhabit every human activity and cultural artifact. All science is, therefore, inherently political, as is all art. But like some science, art can be emancipatory, and in more than one sense. For Nelson Goodman (1968), art can free us from entrenched, commonsensical ways of viewing the world. By calling for and yet resisting "a usual kind of picture," writes Goodman, "it may bring out neglected likenesses and dif-ferences ... and in some measure, remake our world" (p. 33).

Goodman sees the emancipatory potential of art in its capacity to obviate and undercut facets of a prevailing worldview. Other definitions of art seem to emerge out of a more specific concern for inequities within the sociopolitical relationships in a culture. Art of this sort, more directly focused on the effects of social practices and institutions on human beings, operates out of what bell hooks calls (1994) an *outlaw culture*, one that promotes "engagements with ... practices and ... icons that are defined as on the edge, as pushing the limits, disturbing the conventional, acceptable politics of representation" (pp. 4–5).

Outlaw art represents a kind of assertively political project similar to what Sartre called socially engaged literature. Sartre (1988) also viewed the primary aim of art as a challenge to the established interests within society, seeing the artist as "in a state of perpetual antagonism toward the conservative forces which are maintaining the balance he needs to upset" (p. 81).

Both hooks and Sartre are recommending artistic projects that move to shape and influence the public consciousness by critiquing the politic-ally conventional and the socially orthodox. And artists throughout the ages have succeeded in doing so. From Sophocles to Bertoldt Brecht, from Victor Hugo to Richard Wright, from Pablo Picasso to Judy Chicago, from Spike Lee to Gregory Nava, from photographer Lewis W. Hine to Dorothea Lange, to name but a few is to omit untold numbers of others.

Their work reflects the spirit of more recent activist art, which, as Nina Felshin (1995) put it, has attempted to "change the conversation" by "exposing issues to a public view as a means of sparking *public* debate" (p. 37), and ultimately to stimulate social change. That is the sort of artistic stimulus that stands tall against the *Zeitgeist* maintained through the political spectacle, one that offers hope that history can indeed be made through the personal quest of the artist.

I am obliged to report that I have, up to this point in the relatively short history of the genre, not been privy to a completely unblemished work of arts-based research, one sufficiently powerful, by itself, to redi-rect the educational conversation in the manner suggested by Felshin.

But some, in their closely observed, imaginatively crafted renderings of the struggles of teachers and young people, have confirmed my beliefs about the potential of alternative research genres to upset the balance maintained within the spectacle.

Take, for example, the ethnodrama *Street Rat* (Saldaña *et al.*, 2005), a piece of arts-based research that focuses on the lives of some homeless youths in New Orleans. The play was adapted by Johnny Saldaña, Susan Finley, and her son Macklin from a research story composed by the Finleys (Finley & Finley, 1999) and from poetry written by Macklin (Finley, 2000). In April 2004, I attended a production of this ethnodrama directed by Saldaña.

The script, based on participant-observer Macklin's experiences with his informants, moved briskly from an introduction of the two main characters, Roach and Tigger, to complications arising partly from their relationships with each other and their homeless friends, to a dramatic climax as violence nearly erupts, and finally a touching denouement, a scene in which Tigger and Roach, obviously filling a void in each other's lives left there by others, declared in their garbage-strewn living quarters, that they were, at least for the time being, home. The narrative drive of the story was punctuated by the recitation of poems of various lengths, composed by Macklin, who thereby became, himself, a character in the play.

Other touches added to the production's effective *mise en scène*. Absent a proscenium arch, audience members were seated in a black-draped, rectangular room, its floor shared with the actors. The minimal props, authentic costuming, and background music were all carefully designed and selected to advance the vision of the director and his collaborators.

The formal attributes of *Street Rat* were matched by its content. The telling details in the lives of Roach, Tigger, and their comrades enabled me to dwell within an otherwise, largely unavailable world of homeless young people. Through an array of concrete images, particular forms of intelligence were revealed to me, the structure of moral codes laid bare. Through a cascade of specific utterances and gestures I was granted access to their personal hopes, dreams, and motivations.

As an example of socially engaged research this play addressed sociopolitical phenomena that remain hazy within the spectacle. Indeed, it was willing to refocus on – that is *re*-search – a part of what the postmodern theorist Nelson (1987) lists as

> the neglected ... the forgotten, the irrational, the insignificant, the repressed, the borderline, the eccentric, the sublimated, the rejected, the nonessential, the marginal, the peripheral, the excluded, the tenuous, the silenced, the accidental, the dispersed, the disqualified,

the deferred, the disjointed ... [all that which] the modern age has never cared to understand in any particular detail, with any sort of specificity.

(p. 217)

But the glimpse that this play affords us of a hidden or unfamiliar world is not an act of mere voyeurism. It is, rather, a work of what Stone (1988, p. 160) calls *moral fiction*, one that aims to "establish the connections between [debilitating] social forces and individual lives." The socially committed play accomplishes what good outlaw art can: it "open[s] up institutions and their practices for critical inspection and evaluation" (Lincoln & Denzin, 2003, p. 377). The play's carefully embodied observations, the results of the researcher's scrutiny and artistry, challenge the arrogation of meanings within the political spectacle. It is indeed potentially emancipating in the strong sense advocated by hooks (1994) and Sartre (1988).

EPISTEMOLOGICALLY HUMBLE ARTS-BASED RESEARCH

Still, an arts-based research project geared to subvert the master narrative and confound the political spectacle must be more than socially committed. It must also be epistemologically humble.

Of course, the master narrative that serves the political spectacle, operating within a modernist epistemology that gravitates toward final knowledge, lacks all humility. Master narratives possess a totalizing character as they aim to impose order on the world from a distinct, if often hidden, ideological point of view, one that appears to be authoritative, final, exclusionary of alternative viewpoints, all-knowing.

A disposition of this sort in the social researcher represents the attitude of an epistemological bully. (Note that I have dampened down Lyotard's (1979) overheated epithet of *epistemological terrorist*). "Arrogant bully" is, I think, an appropriate term for an epistemological stance that attempts to impose its own singular view of the world on its audience. But adopting a stance of epistemological modesty in projects of social inquiry entails more than the exchange of a social-science methodology for an arts-based approach. Artists, and arts-based researchers, however high-minded their emancipatory intentions, may produce works as exclusionary, monologic, and hegemonic as other sorts of projects. This happens whenever, to paraphrase Sartre, the would-be artist, eager to change minds, zealous to make history, forgets to make art.

Image, language, and story are indeed the tools and the products of

artists. But socially committed research that evidences an interrogatory rather than an authoritative attitude must not resemble, on the one hand, the self-abnegation of political eunuchs, nor, on the other, the ersatz artistry of dogmatists, propagandists, ideologues, and rigid partisans. My hope is for a politically vital arts-based research, the kind that challenges the comfortable, familiar, dominant master narrative, not by proferring a new totalizing counter-narrative, but by luring an audience into an appreciation of an array of diverse, complex, nuanced images and partial, local portraits of human growth and possibility.

This implies arts-based research with the power to involve members of the public in history-making dialogue, or in what I have called *conspiratorial conversations* (Barone, 2000, p. 150). A conspiracy suggests a communion of agents engaged in exploratory discussions about possible and desirable worlds. When an arts-based work engenders an aesthetic experience in its readers or viewers, empathy may be established, connections made, perceptions altered, emotions touched, equilibria disturbed, the status quo rendered questionable. Individual voices of audience members may be raised in common concern – either within the artistic textual engagement itself (between reader and text), and/or afterwards, among members of an audience of readers or viewers. In these conversations, ideas and ideals may be shared for the purposes of an improved reality. Plots may be hatched against inadequate present conditions in favor of more emancipatory social arrangements in the future.

How can a piece of arts-based research effectively engender conspiratorial moments? To create the possibility of conspiracy the artist must first imagine what Wolfgang Iser (1974) calls an *implied readership*. Implied readers are those who actively participate in the composition of textual meaning" (p. xii). But this term "incorporates both the pre-structuring of the potential meaning by the text, and the reader's actualization of this potential by the reading process" (p. xii).

Street Rat was pre-structured by the Finleys and Saldaña in a manner that pulled me, implied *viewer*, member of the public, into the world of the play, enticing me to reconstruct the illusion first imagined by the playwrights. In such a textual re-creation, wrote Dewey (1934/1958), "there is an ordering of the elements of the whole that is in form, although not in details, the same as the process of organization the creator of the work consciously experienced ... Without an act of recreation the object is not perceived as a work of art" (p. 307).

In this process of formal reconstruction, the viewer lives momentarily in a virtual world, bracketed off from the world of experience external to the work. Phenomenologist aestheticians would argue that the viewer thereby experiences a piece of subjective life, partakes of the vision of the artist as embodied in the pre-structured work. But some works may not allow for an easy return from that vision into the world outside.

Indeed, a work that is only technically accomplished can have an effect opposite to that of promoting conspiracy. While beguiling formal qualities can lure an audience into imagining another world, this hypothetical space is a realm of fantasy, an aesthetic remove. Like the educational spectacle, a formal masterwork may create its own detachment as it bedazzles its viewers into acquiescence with its vision, offering a sublime illusion, never really, as Edelman would say, "touching the world."

Some works of propaganda are like this – technically marvelous, formally beautiful. But they do not emancipate. Lacking nuance, closed to disconfirming evidence, they seek only to indoctrinate, to lull into quietude. This kind of propaganda is, in fact, akin to kitsch, a debased kind of art that sentimentalizes everyday experiences.

Works of kitsch can evoke emotions that are based on nostalgia, or they may construct imaginary enemies. These elements of kitsch are found in the popular media's characterizations of teachers as either singularly heroic or collectively incompetent, their tales in which the intelligence and moral fiber of today's youth compare poorly to those of yesteryear, their images of public schools as out of control (Edelman, 1995, p. 31). In kitsch, as in propaganda, a clear, controlled, unsentimental rethinking of mainstream truths and realities is sacrificed on the altar of the meta-narrative. But in their privileging of form over substance, their refusal to attend to the blemishes on the face of the prevailing master narrative, both propaganda and kitsch are disqualified as art, as re-search, and as catalysts for conspiracy.

Conspiracy is more likely to result from engagements in which aesthetic content grounds a work of art in the closely observed particulars of experience. The merely beautiful, or otherwise kitschy, work is thereby conditioned, planted in virtual space and time. A work that is closed in on itself is opened up to previously unimagined meanings.

The particulars that constituted the aesthetic content of *Street Rat* are what a traditional social scientist would call *data*. But here those data were carefully selected, edited, shaped, fashioned, dramatized, with an artistic end in mind. The aesthetic content of the play, in close relationship to its theatrical qualities, advanced in a credible fashion an understanding of these troubled youngsters, kids who, throughout their lives at home and in school, and later on the streets, were rarely either seen or heard. And now, along with the previously transparent forces that served to deform their lives, they were.

But just as form can become an imperial presence in the arts-based text, so can substance. Indeed, in many of the pieces of socially committed educational research to which I have been privy, aesthetic substance has hardly been the victim of an aesthetic sin. It has been the sinner. In that sort of work a regard for bombast over seductiveness can mean

that formal qualities are casualties of the unrestrained political outrage of the socially committed researcher.

Now, minor imbalances of substance over form can be found in even the best socially committed arts-based research, including *Street Rat*. In that work, the sources of the street kids' alienation from their families, schools, and society in general, suggested within the more prosaic dialogue of the script, were successfully reinforced and amplified by the vivid imagery and driving rhythms of the poems interspersed throughout the text. Occasionally, however, anger overtook artistry, and stridency and shrillness prevailed. The poetry, hovering above the dramatized display of particular, contextualized injustices, seemed too obviously designed for the speedy delivery of a facile social message.

Considering the other attributes of this ethnodrama, those unfortunate lapses are easily forgiven. But in encounters with other emancipatory-minded arts-based projects, I have sometimes found myself cringing at a heavy-handedness in pursuit of noble goals. And even those who enjoy being preached to in a choir should remember that sermonizing the likeminded does not a conspiracy make. At their best socially engaged arts-based research projects aim to entice into meaningful dialogue not merely, on the one hand, the progressivist faithful, nor, on the other, politically entrenched neo-conservative ideologues. They aim to conspire, rather, with all potential allies who have been temporarily mesmerized by the spectacle.

A successful enticement of these co-conspirators requires more than mere emotional discharge, which as Dewey (1934/1958, p. 61) reminds us, "is a necessary but not a sufficient condition of expression." Emotion that is effectively expressed through art is the result of a thoughtful composition of significant subject matter into an aesthetic form in which that emotion is embodied. Absent the artistic expression to which Dewey has alluded, there looms a reduced capacity to persuade profoundly, to move viewers affectively and cognitively into a skepticism regarding social pieties and platitudes.

Instead there is the kind of alienation that Carol Becker (1994) suggests is the product of some activist art:

> Art may be focused directly on the issues of daily life, but, because it seeks to reveal contradictions and not obfuscate them, art works which should spark a shock of recognition and effect catharsis actually appear alien and deliberately difficult. Art easily becomes the object of rage and confrontation. [And artists], frustrated by the illusion of order and well-being posited by society,... [may] choose rebellion as a method of retaliation ... [I]n so doing, they separate themselves from those with whom they may actually long to interact.
>
> (1994, xiii)

This alienation may in fact be seen as the mirror image of that produced by either the beautiful-but-clueless, or the kitschy. Again there are totalitarian tendencies, a disinterest in or failure to facilitate democratic engagement. While *Street Rat* is a largely effective, socially engaged work that managed not to alienate, but to compel the attention of a limited, localized public audience, a second politically committed work has managed to secure a wider audience, although not as a full-fledged work of art. Indeed, it may offer hope regarding the degree of artistry necessary for a piece of qualitative research to promote conspiracy.

The book is *Doing School* by Denise Clark Pope (2001). Its subtitle reveals its political interests: *How We Are Creating a Generation of Stressed Out, Materialistic, and Miseducated Students*. The book explores the culture of competition in a comprehensive California high school as it traces the tensions between the felt needs of students and the materialistic brand of success expected of them. And, at least at its narrative center, it avoids an authoritative stance, striking an effective balance between aesthetic form and substance. The author maintains an eye for telling detail, even as she wisely avoids the off-putting stridency of which Becker speaks. She transforms her informants into quasi-literary characters, transmuting her own concerns into the form of biographical portraits of five ethnically diverse students, fashioning for inspection the idiosyncratic life worlds of these students and the common social forces that operate to diminish them.

Still, in its student portraits, *Doing School* never really achieves the formal power of great literature. In reading the student stories, there is little danger of entrapment in sublime illusion. *Doing School* is therefore, unlike *Street Rat*, hardly activist art. In fact, its author makes no artistic claims for it at all. Instead, the book defies labels, serving, I suggest, as an example of the kind of genre blurring that, so prevalent nowadays, first emerged in social research in the 1970s, during Denzin and Lincoln's (2000) so-called "third moment" in the history of qualitative research. Still, if its quasi-literary center is seen as a core out of which the analytical content is extrapolated, then the project might indeed be identified, if not as artistic, then as arts-based.

The limited formal attributes of *Doing School*, like those of many qualitative research texts, certainly seem sufficient for facilitating readers' reconstruction of the text. Without feeling bullied by either textual form or content, this reader accepted the invitation to dwell vicariously in the lives of these young people. So it was that, through these portraits, I came to regard these students, not as "other people's children" who populate a vague and distant campus, but as specific human beings who harbor recognizable dreams in the face of debilitating circumstances.

Indeed, Denise Clark Pope (personal conversation) has suggested that, more than any other aspect of the book, the student stories account for its surprisingly positive reception among the lay public. A significantly better "seller" than most books about educational issues, *Doing School* has received much publicity, from interviews with the author on CNN, public television stations, national radio shows, and local news media, to the creation of a conference at Stanford investigating the possibilities of school change. During that time, Pope has addressed approximately 12,000 people who are primarily attracted, she says, to both the substantive topic and the readable style of the book. When it comes to hatching conspiracies, *Doing School* seems good enough.

Pope, and in a different way, Saldaña, have been able to entice members of the public into dialogues about meaning, about the nature of educational virtue, connecting that philosophical concern to features of the debilitating sociopolitical matrix in which young people live their lives. Appealing to a wide audience that apparently includes sympathetic "outsiders," they seem to have generated the kind of public discussion that cuts through the miasma of the political spectacle.

They have accomplished this, I believe, by effectively calling into form the particulars of human life, thereby opening up their readers and viewers to the multiplicities of experience in the lives of young people. But, to return to Iser's (1974) notion of the implied reader, there is always the corresponding responsibility of the percipient of the work to assert herself in the actualization of its potential. Conspiracy is – to repeat – a dialogue, not a monologue.

Again, when particulars are called into form by an artist, they can come to mean more than they originally meant in the so-called "real world" outside the work of art. But after reconstructing the meaning contained in the personal vision of the artist, the vigilant percipient may assert her own influence over the work. Sensing a pull toward a closed, formal meaning may produce a healthy skepticism of the work, and a desire to dismantle it. Finding her own voice as interpreter and critic, the percipient may, I mean, interrupt the illusion of the work. Becoming what Belsey (1980) would call a *revolutionary reader*, she moves beyond the role of textual consumer to speak back to the work, to assign her own meanings to it. No longer is it just "reality" that means more than it originally meant. By dismantling the work, and transporting it into her own experiential landscape, the percipient makes it mean something different than it meant to the artist.

This means, of course, that the artist has lost a degree of control over the work. Sometimes the loss is complete, the artist's original vision vandalized. Indeed, Marcuse (1964), Said (1993), and others remind us that, throughout history, once-radical artworks have been co-opted and

tamed by conservative cultural forces for their own purposes. All texts are, of course, vulnerable to an audience free to engage in that which Stuart Hall (1980) characterizes as an *oppositional reading*, one that rejects what a *preferred* reading accepts. In this kind of reading from an oppositional ideological ground, hopes for a spectacle-confounding, conspiratorial engagement are dashed.

Because an artistic engagement depends on the *twin* responsibilities of the artist and the viewer, no matter how potent the pre-structuring of the artwork, the artist's reach is limited. Or as Herbert Read (1966) wrote:

> The eye is thoroughly corrupted by our knowledge of traditional modes of representation, and all the artist can do is to struggle against the schema and bring it a little nearer to the eye's experience.
>
> (1996, p. 71)

I hope that arts-based researchers will never abandon that struggle. Nor, having produced our broadly accessible work, should we fear relinquishing control of it to the public. For this is, I believe, a profound and necessary gesture of epistemological generosity wherein a deeply committed arts-based educational researcher, abandoning the monovocal text out of faith in the social imagination, invites others to engage in a truly dialogical conversation about educational possibilities.

This invitation represents a refusal to reach toward indoctrination, and is born of an understanding that as artists and arts-based researchers we can never, strictly speaking, change minds. We must believe that people, within genuine dialogue, change their own minds. So instead we move to *artfully* coax them into collaborative interrogations of stale, tired, taken-for granted facets of the educational scene.

It is, I believe, precisely our humble stance, our speaking in tentative tones, our refusing to parade around in the uniform of a master narrator, that justifies our projects of arts-based research. Wayne Booth (1961) made the point in writing about the rhetoric of fiction. "I am not," he wrote, "primarily interested in didactic fiction, fiction used for propaganda or instruction. My subject is the technique of non-didactic fiction, viewed as the art of communicating with readers" (p. 1). And we too refuse to advance our small, inviting, carefully observed portraits of school people from a stance of omniscience. Nor do we, in self-defeat, attempt to erase ourselves from our works, refuse to inscribe in them our educational visions, abandon our quests.

In our efforts to create history-making works of arts-based research, we continue to work toward a public expression of a personal *point of*

view, even as we remain observers who, while committed, are open to the world. Convinced that a conspiracy must play itself out in its own dialogical space, may we arts-based researchers ask the trenchant questions rather than provide the easy answers, with no desire to replace a master narrative with a totalizing alternative, let alone one that is preconceived.

CHALLENGES AND POSSIBILITIES

Of course, there are considerable challenges to what may seem like a grandiose, even quixotic, vision of an arts-based educational research community that has succeeded in cutting through the educational spectacle on behalf of genuine educational reform. Engaged in research that is not only (a) arts-based or (b) emancipatory-minded, but (a) *plus* (b), we are swimming against the current of traditional methodological orthodoxy now reinforced, in a fit of political nostalgia, by federal policy-makers. We are also working under the increasing weight of the corporate university, wherein those members of the professoriate who secure extramural grant monies to replace dwindling public revenues for higher education are rewarded with enhanced professional status. We are pushing against our own perceived lack of talent for crafting meaningful works of arts-based research, and against an academic culture that refuses to support the fostering of those talents in the next generation of educational researchers. We are choosing to ignore those, often otherwise enlightened, members of our own educational community who would suggest that we leave the generation of conspiracies to professional artists who are not educationists. And, perhaps most difficult, we are attempting to cut through a seemingly impenetrable, commodified popular culture that is antagonistic toward the thoughtful, challenging, non-kitschy, inexpensively produced artifacts, whether as films, novels, short stories, poems, television programs, or theater.

How can we keep hope alive in the midst of these challenges?

In his book, *Changing Minds*, Howard Gardner (2004) posits a spectrum of mind-altering creativity with two poles. Located at one end, Capital C change is the result of the capital C creativity of capital C change agents. Gardner's examples from the arts and sciences, and fields of public policy, include historical figures such as Einstein, Picasso, de Gaulle, Freud, and the like. At the other pole are the "teachers, parents, and storekeepers who are satisfied with 'lowercase mind change,' changing the mental representations of those for whom they have [direct] responsibility" (Gardner, 2004, p. 132). But Gardner credits his colleague Csikszentmihaly with suggesting (in Feldman, Csikszentmihaly, & Gardner, 1994) that while "most of us cannot hope to

effect big C creativity, we might at least expect to be 'middle C' creators" (Gardner, 2004, p. 132). Understanding that we need not necessarily match the high art of the masters in order to make history might reduce the levels of performance anxiety of some arts-based researchers.

We might also eschew the "Great Man" model of capital C change in order to avoid the isolation of those geniuses who single-handedly turn history on its head, in favor of mutual support afforded within a collectivity of artists. Recall, for example, the politically committed American artists of the 1930s, the novelists, playwrights, cartoonists, photographers, and painters whose work, as Edelman (1995, p. 108) points out, "made poverty vivid for Americans and made them feel its miseries, so that public welfare came to be categorized by most of the public as a justifiable aid to the needy rather than a drain on the treasury."

The work of these artists served to question the prevailing cultural narrative and helped make possible the policy initiatives of the New Deal. Might individual arts-based researchers, each pursuing her own personal desires for the expansion of the public space through her own chosen art form, coalesce to interrogate the entrenched master narrative of our own era? And might we be joined by qualitative researchers of other genres, even social scientists, whose work, now similarly disparaged, has included, ever since its inception, elements of artistry?

Collaborative and group efforts have also been, since the 1980s, the modus operandi of many activist artists. And for those of us without sizable grant funds, the history of activist art may offer clues for feasibly penetrating the popular culture. While sometimes prone to sensationalistic excesses, these artists have nevertheless moved their work, including applied theater, exhibitions, installations, and media events, onto public sites (Felshin, 1995, p. 10). Some activist artists have focused on the creating of visual images designed for consumption by the mass media. More successful, in my estimation, have been those who have targeted specific constituencies within the public, often collaborating with members of marginalized communities. Most recently, activist artists have exploited the possibilities within the electronic media.

Finally, most encouraging is surely the knowledge that our work has, indeed, already begun. Let those apologists for the master narrative feel the need to clutch their tightly sealed version of educational history closer to their bosoms. For there are now, in the once politically subdued and artistically disinclined academic research community, those who would challenge their history. They include Pope, Saldaña, and a growing number of other socially engaged and epistemologically humble qualitative researchers, some of whom are found in this collection. The aim of their – of our – continuing quest is to politely but powerfully, that

is to say, *artfully*, change the conversation, to persuade those to whom history and public policy rightfully belong to resist the "usual kind of picture" in favor of one that, in touching the world of education as it is, makes one wonder about what it should and can become.

QUESTIONS

1 How can arts-based research contribute to our understanding and analysis of political spectacle?

2 If research follows postmodern artistic movements, as Barone suggests, is it enough to raise questions? Should not all forms of research also provide answers?

3 What does Barone mean by "epistemologically humble"? Why does he feel this is important? Can one simultaneously claim to be "humble" and "make educational history"?

4 Referring to *Doing School*, Barone writes "Still, if its quasi-literary center is seen as a core out of which the analytical content is extrapolated, then the project might indeed be identified, if not as artistic, then as arts-based." Why does Barone want to distinguish between "arts-based" and "artistic" research? Are these the same distinctions Cahnmann-Taylor makes in Chapter 1 between *Hybrid Genres* and *Art for Scholarship's Sake*? Are these kinds of distinctions helpful? Why or why not?

5 Barone argues that arts-based research may be more likely to reach out "to an audience that transcends one consisting only of colleagues." What makes it possible for arts-based research to reach out beyond other academics in a manner that is different from other forms of research?

6 Barone advocates the kinds of arts-based research that critique the politically conventional. Might some forms of arts-based research support the orthodox and conventional?

7 As a scholARTist, what kinds of "conspiratorial conversations" would you like to address in your own work? How can a scholARTist be both socially engaged and open to humility, contradiction, and conversation?

REFERENCES

Abbs, P. (2003). *Against the flow: Education, the arts, and postmodern culture.* London: RoutledgeFalmer.

Apple, M. & Teitelbaum, K. (1986). Are teachers losing control of their skills and curriculum? *Journal of Curriculum Studies, 18* (2), 177–184.

Barone, T. (2000). *Aesthetics, politics, and educational inquiry: Essays and examples*. New York: Peter Lang.

Becker, C. (1994). Introduction: Presenting the problem. In C. Becker (Ed.), *The subversive imagination: Artists, society, and social responsibility*. New York: Routledge.

Belsey, C. (1980). *Critical practice*. London: Methuen.

Booth, W. (1961). *The rhetoric of fiction*. Chicago, IL: University of Chicago Press.

Denzin, N. & Lincoln, Y. (2000). Introduction: The discipline and practice of qualitative research. In N. Denzin & Y. Lincoln (Eds), *Handbook of qualitative research*, second edition. Thousand Oaks, CA: Sage.

Dewey, J. (1927/1954). *The public and its problems*. Athens, OH: Swallow Press/Ohio University Press.

Dewey, J. (1934/1958). *Art as experience*. New York: Capricorn Books.

Edelman, M. (1985). *The symbolic uses of politics*. Urbana, IL: University of Illinois Press.

Edelman, M. (1988). *Constructing the political spectacle*. Chicago, IL: University of Chicago Press.

Edelman, M. (1995). *From art to politics: How artistic creations shape political conceptions*. Chicago, IL: University of Chicago Press.

Feldman, D., Csikszentmihaly, M., & Gardner, H. (1994). *Changing the world*. Greenwood, CT: Praeger.

Felshin, N. (1995). *But is it art? The spirit of art as activism*. Seattle, WA: Bay Press.

Finley, M. (2000). *Street rat*. Detroit, MI: Greenroom Press, University of Detroit Mercy.

Finley, S. & Finley, M. (1999). Sp'ange: A research story. *Qualitative Inquiry, 9* (2), 254–267.

Foucault, M. (1995). *Discipline and punish: The birth of the prison*. New York: Vintage Books.

Gardner, H. (2004). *Changing minds*. Boston, MA: Harvard Business School Press.

Goodman, N. (1968). *Languages of art*. Indianapolis, IN and New York: Bobbs-Merrill.

Greene, M. (1988). *The dialectic of freedom*. New York: Teachers College Press.

Hall, S. (1980. Encoding/decoding. In S. Hall, D. Hobson. A. Lowe, & P. Willis (Eds) *Culture, media, language: Working papers in cultural studies, 1972–1979* (pp. 128–138). London: Hutchinson.

hooks, b. (1994). *Outlaw culture: Resisting representations*. New York: Routledge.

Iser, W. (1974). *The implied reader*. Baltimore, MD: Johns Hopkins University Press.

Jacoby, R. (1987). *The last intellectuals: American culture in the age of academe*. New York: Basic Books.

Lincoln, Y. S. & Denzin, N. K. (2003). The revolution in presentation. In Y. S. Lincoln & N. Denzin (Eds), *Turning points in qualitative research*. Walnut Creek, CA: AltaMira Press.

Lyotard, J.-F. (1979). *The postmodern condition.* Trans. G. Bennington and B. Massumi. Manchester: Manchester University Press.

Males, M. (1999). *Framing youth.* Monroe, ME: Common Courage Press.

Marcuse, H. (1964/1991). *One dimensional man.* New York: Beacon Press.

Nelson, J. (1987). Postmodern meaning of politics. Paper presented at American Political Science Association, annual meeting. Chicago, IL, September 3–6.

Pope, D. C. (2001). *Doing school: How we are creating a generation of stressed out, materialistic, and miseducated students.* New Haven, CT: Yale University Press.

Read, H. (1966). *Art and alienation.* New York: Schocken Books.

Rose, L. C. & Gallup, A. M. (2004). The 36th annual Phi delta Kappa/Gallup Poll of the public's attitudes toward the public schools. *Phi Delta Kappan, 86* (1), 41–58.

Said, E. (1993). *Culture and imperialism.* New York: Knopf.

Saldaña, J., Finley, S., & Finley, M. (2005). Street rat. In J. Saldaña *Ethnodrama.* Walnut Creek, CA: AltaMira Press.

Sartre, J.-P. (1988). *What is literature? and other essays.* Cambridge: Harvard University Press.

Schneider, A. & Ingram, H. (1997). *Policy design for democracy.* Lawrence, KS: University of Kansas Press.

Smith, M. L. (2004). *Political spectacle and the fate of American schools.* New York: RoutledgeFalmer.

Stone, R. (1988). The reason for stories: toward a moral fiction. *Harper's 276* (1657), 71–78.

Section II

To dwell in possibility

Poetry and educational inquiry

Writing is a vital element to any research inquiry. Traditionally, the forms used for writing up research in education follow consistent patterns that vary little from the following sequence: *introduction, problem statement, research questions, literature review, research methods, findings, conclusions, implications.* This sequence is helpful in many ways, guiding readers to the contents of each section in a prescriptive, linear manner helpful to access information and assess the quality and validity of each step in the empirical process.

However, during the research process there are many opportunities to vary and practice the art of writing – from how we take field notes to how we make sense of the subject under study to how we share our research process and/or findings with others. Poetry, while at times linear, often makes what Robert Bly (1975) referred to as "leaps" in time and thought. How might the genre of poetry be incorporated into writing for educational inquiry? How much poetic training and skill is required of researchers writing poetry? What are the risks involved in writing poetry as a researcher, and what are the possibilities?

The theme in Section II is inspired by the words of Emily Dickinson:

> I dwell in Possibility –
> A fairer House than Prose –
> More numerous of Windows –
> Superior – for Doors –
>
> Of Chambers as the Cedars –
> Impregnable of Eye –
> And for an Everlasting Roof
> The Gambrels of the Sky –
>
> Of Visitors – the fairest –
> For Occupation – This –
> The spreading wide my narrow Hands
> To gather Paradise

To what extent is poetry a "fairer House than Prose" when trying to capture the complexities of educational experience? This section explores both the risks and possibilities of writing poetry as a poet-researcher. Chapters range from the theoretical to the poetic – including a diversity of perspectives as to poetry's place and structure. There is also representation from scholars from various fields that influence education research – anthropology, literacy studies and qualitative inquiry. Much of what we call "qualitative inquiry" in education – including case studies and ethnographic participant observation – has its origins in anthropology. Showcased here are three anthropologists – Ruth Behar, Kristina Lyons, and Adrie Kusserow – as well as two scholars more firmly located in colleges of education – Kakali Bhattacharyra and Carl Leggo.

Ruth Behar begins the discussion of poetry's place in scholarship by merging her personal history in relationship to poetry's place in the larger field of anthropology. She argues that the history of anthropology is fraught with tensions between art and science. This chapter introduces the notion of a poetic sensibility in scholarship that allows for "charged intellectual insights" to occur. She shares lessons from her own fieldwork and writing experiences as well as that of her students.

The next four chapters share actual poems written by scholARTists on a diverse range of subjects in a variety of forms. Each of these chapters contains the scholARTist's statement, a reflection on their poetic scholarship as well as a sample poem that aims to spread the hands of "scholarly" writing more widely to capture what cannot be said in prose. Kakali Bhattacharya explains how she used the form of the poem to "negotiate voice and silence" in her research among Indian women graduate students and their experiences of transnational education. She shares a poem "The small small things" that incorporates references to both Hindi/Indian and American worlds that are close to both the researcher and participants' experiences.

Adrie Kusserow and Kristina Lyons both share poems from the perspective of anthropologists who are cultural outsiders to the observed experiences but acquiring, through poetry, an emic or insider's perspective of the "other." Kusserow's poem "Lost boy" is written in a third-person omniscient voice that conveys a Sudanese refugee "in all his dimensions." Her scholARTist's statement, like Behar's essay, reflects on the tensions and separations she experienced between "rigid academic writing" and the "moods, feelings, and nuances" she expresses through poetry that she feels does "justice" to anthropological work. Lyons's work reflects on fieldwork experiences in Costa Rica. Rather, than a straight linear narrative, her poem, "Upon traveling to Nosara" employs an unusual "four voices" structure that allows her to capture a multiplicity of readings and renderings of experience.

Finally, Carl Leggo, one of many scholars represented in the volume from Canada, where arts-based research is more widespread, takes the self as a focus for introspective poetry and autobiographical research. Leggo believes that autobiography helps teachers and teacher educators "locate themselves" in "complementary angles." To grow professionally, Leggo argues, is also to grow personally. His poems are reflections of both personal and professional growth he models for teachers: ways to "appreciate the extraordinary in the ordinary."

Together, these chapters illustrate the complexity of writing poetry as a part of the research process and the diversity of structures the poetry might take. One might write a "poetic research study" or an actual poem. One might write about oneself autobiographically, about the self in relationship to the other, or in the voice of the other that is the self. Finally, one might write poetry and/or poetic scholarship that follows traditional or formalist structures, or one might experiment with form – incorporating heightened diction, metaphor, and/or formalist poetic structures to "discover new aspects of our topic and our relationship to it" (Richardson, 2000, p. 923).

Just as the microscope and camera have afforded different ways for us to see what would otherwise be invisible, so too poetry and prose are different mediums that give rise to ways of saying that might not otherwise be expressed (Cahnmann, 2003, p. 31). This chapter is based on the premise that poetic language and structure, in all its diversity, provides exciting possibilities for alternative inquiry.

REFERENCES

Bly, Robert (1975). *Leaping poetry*. Boston, MA: Beacon Press.

Cahnmann, M. (2003). The craft, practice, and possibility of poetry in educational research. *Educational Researcher, 32* (3), 29–36.

Richardson, L. (2000). Writing: A method of inquiry. In N. K. Denzin & Y. S. Lincoln (Eds), *Handbook of Qualitative Research* (2nd edition, pp. 923–948). London: Sage Publications.

Chapter 4

Between poetry and anthropology
Searching for languages of home

Ruth Behar
University of Michigan, Ann Arbor, Michigan

Ruth Behar was born in Havana, Cuba and grew up in New York City. She is the recipient of a MacArthur "genius" Award, a John Simon Guggenheim Fellowship, and a Distinguished Alumna Award from Wesleyan University. Behar has worked as an ethnographer in Spain, Mexico, and Cuba. Her books include *The Presence of the Past in a Spanish Village*, *Translated Woman: Crossing the Border with Esperanza's Story*, and *The Vulnerable Observer: Anthropology That Breaks Your Heart*. Behar is co-editor of *Women Writing Culture*, which has become a central text in debates about the literary turn in anthropology, and editor of *Bridges to Cuba*, a pioneering forum of culture and art by Cubans on the island and in the diaspora. Behar is also known for her essays, poetry, fiction, and work as a filmmaker. Her essay, "Juban América," appeared in *King David's Harp: Autobiographical Essays by Jewish Latin American Writers* and her short story,

"La cortada," was selected by Joyce Carol Oates for inclusion in *Telling Stories: An Anthology for Writers*. Behar's poems have been published in *Burnt Sugar/Caña Quemada: Contemporary Cuban Poetry in English and Spanish*, *Sephardic American Voices: Two Hundred Years of a Literary Legacy*, and *Little Havana Blues: A Cuban-American Literature Anthology*. Behar wrote, directed, and produced *Adio Kerida/Goodbye Dear Love: A Cuban Sephardic Journey*, a feature-length documentary distributed by Women Make Movies. Her book, *An Island Called Home: A Return to Jewish Cuba*, follows up on her interest in visual documentation and creative nonfiction, creating an unusual blend of ethnography and photography to reflect on the meaning of Jewishness on the margins. She is Professor of Anthropology at the University of Michigan. Further information about her work is available on her web site: www.ruthbehar.com.

As a teenage girl growing up in New York, I wrote many poems. I wrote while staring at the moon from the bedroom in Queens that I shared with my younger brother. I had a pretty good view of the moon – our apartment was on the ninth floor of a brick building whose elevator only stopped on odd-numbered floors. We were immigrants from Cuba and my father told us that we ought to feel lucky to live on an odd-numbered floor. If you were a tenant living on an even-numbered floor, you had to get off a floor above or a floor below and take the creepy, hidden stairs either up or down to your apartment.

But I tried not to think too much about the everyday circumstances of our lives. My poems tended to be abstract ruminations on the passage of time and the inevitable decay of things. I spent several weeks writing a poem about the cheap carnations that wilted too soon in the vase on our glass and chrome dining-room table. At the time I also loved drama and fiction, and was very drawn to philosophy, especially the Spanish philosopher Miguel de Unamuno's (1913) notion of the tragic sense of life. I had an absolutely huge admiration for Simone de Beauvoir, who it seemed to me could do everything – be a philosopher as well as a writer, and a smart, beautiful, and well-traveled woman. I didn't know in those years that this brilliant person I put on a pedestal suffered from truly wretched spells of depression, occasioned by an incessant lack of self-confidence that was aggravated in her adult life by her beloved Jean-Paul Sartre's various infidelities.

At home, I didn't receive much encouragement for my poetic and intellectual daydreams. My mother and father worried that I was too studious, that I spent too much time alone with my books. They were both fun-loving people and on weekends they liked to splash a lot of cologne and perfume on themselves and go out to dinner with their

Cuban friends and catch a movie or go dance salsa. Both had gotten as far as high school in Cuba and they thought that was more than sufficient education for me, especially given the fact that I was a girl. My father had dreamed of becoming an architect, but his father forced him to work with him peddling blankets in Havana, so he went to night school and studied the only thing he could, which was accounting. The accounting degree served him well, because he was able to find a job in New York City in a belt and handbag company, but he despised the work and always came home in a bitter mood. I know that he held a lifelong grudge against his father for having broken the wings of his ambition. But when I announced that I'd been accepted at various universities and intended to leave home to further my education, my father became furious and refused to let me go. He felt that I was betraying him and my mother by wanting to leave home. Even though it was the 1970s and the heyday of the feminist movement, he still thought like a man who'd come of age in Cuba in the 1950s and he declared that it wasn't proper for a girl to live anywhere but in her parents' house until it was time for her to be married. Somehow, after shedding many tears at the glass and chrome dinner table, I got my way. I might have surrendered my will to my father had it not been for my high-school Spanish teacher, Mercedes Rodríguez, who was also from Cuba, and vigorously defended my desire to advance my education. I think she was living, vicariously through me, what she wished for her daughter, because her daughter, who was my age, had chosen to stay home and not study any further.

So I went off to college hoping to become a poet, or a philosopher-writer of some sort. But I continued to worry about having abandoned my family in New York, though I'd only gone as far as Connecticut. I missed home, missed it more than I dared admit, and was distressed about the economic burden that my education was placing on my parents, even with the scholarship I'd received. Before my first year of college was up, I'd arranged to graduate a year early through a combination of Advanced Placement tests and summer courses and independent study. Being in a rush to get through school, the poems and stories I wrote were produced all too hurriedly. I was impatient, I wanted, as I say about myself in one of my recent prose poems, to rush my poems out into the street like peddlers who are anxious to be rid of their wares. "How quickly I want the poems to be written! How quickly I want to close the door in their faces! I write with a gun at my temple, I write like a prisoner" (Behar, 2001a, p. 23). Not surprisingly, the teachers I came into contact with in college failed to offer praise, or even just a dab of encouragement for my hasty poems and stories, and I took that to mean that I didn't have talent, didn't have the gift for writing.

There was one teacher, in particular, a philosopher by training who'd imbibed wisdom directly from one of the greatest minds of the twentieth century. And she also wrote poetry. Initially, she advocated for me, but I disappointed her when I did poorly on an important test graded by outside examiners. I hadn't studied for the test because I was too busy directing a production of García Lorca's play, *The House of Bernarda Alba* (1936/1945). I had expected to gain her admiration for putting Art above humdrum academic work. Instead, my favorite professor shunned me, just at the moment when I most needed her support. How I longed for even the most feeble words of recognition from her, a few whispered words of faith in my promise. But those words never came. And that was how I ended up seeking refuge in anthropology – the discipline which attracts all those who are either homesick or homeless, which these days often amounts to much the same thing.

When I began to write poetry again, I was an adult woman with a career, a child, a car, a mortgage, a frequent flyer account. The second floor of my house sagged from the weight of all the books I'd read and the numerous ones I'd meant to read over the years. I'd published my own books, I'd won fellowships. My name appeared in footnotes in other people's writing. Surely I was over the sadness of having left poetry behind for anthropology. But the sadness was still there, and it emerged unexpectedly in a poem I consider to be a kind of underside to my curriculum vitae. I called it "Obedient student":

> I was such an obedient student that when my teachers told me I wouldn't make a good poet, I stopped writing. I adored words more than anything else in the world and preferred to cut out my tongue than to insult the Muses with my sickly and impoverished language. That is why these poems are so timid: like the invalid who rises from her bed after a long convalescence and walks embracing the walls.
>
> (Behar, 1997/2001b, p. 4)

I did try hard to conform to the norms of academic writing in anthropology and my dedication brought results. I got all the rewards that most people seek in an academic career. I was, after all, an obedient student. But the dreams of our youth never leave us. As the years passed, my writing in anthropology became haunted by my longing for poetry. Finally, I came back to poetry, to that intimate voice that had gone into exile, but the poems I wrote *were* timid. They revealed the uncertainty, the humility, the shame I'd come to feel about my abilities as a poet. Still, I wrote poetry anyway, because I needed poetry; it was the only way I could speak while I was restoring my ties

with Cuba as a returning child-immigrant and as an anthropologist who couldn't think about her lost homeland as a fieldsite. Overcome with emotions that were so powerful that they produced panic attacks, I discovered a voice etched with longing and regret in poems I wrote in English and translated into Spanish and published in Cuba. Many of these poems found a home in the handmade books of Ediciones Vigía, an artisanal publishing house in the city of Matanzas where my family has roots.

I consider myself fortunate to have been able to acquire another life, a parallel life in Cuba. I've been reborn there as a poet. I can be a poet in Cuba because I left too young to be wounded by teachers who did not love me.

If this statement sounds rather too pained, I can't help wondering just how much pain lies buried unspeakably within the profession that takes as its subject matter the search for languages of home. Naturally, I don't want to over-generalize from my experience but, as I reflect on the fraught relationship between poetry and anthropology in my own life, I've come to see that I am not the only anthropologist who has had frustrated, or at least hampered, poetry ambitions.

A special issue on "Poetry and anthropology," published in the journal *Dialectical Anthropology* in 1986 and edited by Stanley Diamond, anthropologist and poet, was framed by two telling epigraphs, both written in 1926. The first, by Franz Boas, the German-Jewish father of American anthropology, states: "I'd rather have written a good poem than all the books I'd ever written – to say nothing of a movement in a symphony." The second, by the American-Jewish poet and cultural linguist Edward Sapir, is part of a letter addressed to his friend, Ruth Benedict, a cultural anthropologist whose lyrical books, *Patterns of Culture* and *Chrysanthemum and the Sword*, are classical texts in anthropology. Sapir writes to Benedict, "It is no secret between us that I look upon your poems as infinitely more important than anything, no matter how brilliant, you are fated to contribute to anthropology" (as cited in Diamond, 1986).

The volume includes the poems of Ruth Benedict, the lone woman represented, as well as poems by various male anthropologists. Much as I hate to say it, the poems don't shine; they range from acceptable to dismal. For example, Benedict's three-stanza poem about her grandmother, entitled "Of graves," with its all-too-basic rhymes, describes her elder's carefree relationship to death in this way: "The rabbit nibbled at the grass/Will someday cover me." The closing stanza reads: "And days I shiver swift and strange/This still is what I see:/Sunlight and rabbit in the grass/And peace possesses me" (Benedict, 1986, p. 169). After reading this poem and others equally cloying, I, for one, have to disagree with Edward Sapir. I think we have to be very glad

that Ruth Benedict wrote her anthropology books. Their importance, and certainly their influence, have been far greater than her poems, which have mercifully fallen into oblivion.

Of course, I feel terrible saying this, because I'm denying to Ruth Benedict, now in *her* grave, the words of praise and recognition for her poetry that I so wanted for my own poetry when I was a student, words that, even now, as I hesitantly return to poetry, I hunger for. But the truth is that Ruth Benedict's poems are a less significant achievement, not because she lacked talent, but because her poems, largely written in the 1920s and early 1930s, were simply not given the same chance to grow and flourish as her anthropological writings. The more she focused her energies on anthropology, the more her poetry writing became a secondary and secret pursuit. At her death in 1948, Benedict left many unpublished poems, and those which she published, in prestigious journals like *Poetry* and *The Nation*, didn't carry her real name. They were published under the pseudonyms of Ruth Stanhope and Anne Singleton, in an effort to keep them hidden from the eyes of her academic colleagues, and especially from the eyes of her revered mentor, Papa Franz, who she feared would scoff at her flings with the Muse. But as it turns out, while Papa Franz was busy building anthropology into an intellectual edifice that could speak to the ruins of the past and the racisms of the present, he himself secretly wished he could say what it all meant in a good poem, or, alas, being soulfully German, in the movement of a symphony, rather than in so many hundreds of tedious anthropology papers.

What more is there to say, if even Boas, the Big Daddy of modern American anthropology, longed to be able to write *the* poem that could metonymically stand in for all the bottles of ink he spilled to craft persuasive academic prose that might legitimize an always questionable discipline? It's no accident that I, and other ethnographers like me who are drawn to poetry and the literary and visual arts more generally, continue to struggle with the same conundrum. We didn't invent the fraught relationship between poetry and anthropology. We inherited it as part of the family romance of our discipline.

Poetry – not just the literal writing of poems, but the larger desire to speak from a deeper part of the self, which is the goal of all artistic expression – is the thing that we, that is, those of us who are still living out the family romance, thirst for but feel we can't, or rather shouldn't, admit we desire. To long for poetry is to cast doubt on our commitment to maintaining the sobriety and respectability of anthropology within the bureaucracy of the university system. To long for poetry is to want to throw caution to the winds. To long for poetry is irresponsible. To long for poetry is to be immature, self-centered. To long for poetry is to risk losing it all – losing the academic departments that teach us how

to travel to other places and not be ugly Americans, or lately, that teach us how to go home and see something strange there; it is to risk losing the grants that actually pay for us to go to those places and learn about others and ourselves by becoming temporary nomads; it is to risk losing the jobs that allow us eventually to settle down surrounded by native rugs, clay pots, inlaid wood tables, and bark paintings that we are certain are of much better quality than the second-rate stuff sold to the tourists; it is to risk losing the conferences that try to awaken us from our poetry daydreaming and remind us of all the real intellectual work remaining to be done. To long for poetry, under these circumstances, with all these adult responsibilities and obligations and commitments weighing on us, is to turn our backs on the long-suffering discipline that has stood by us through thick and thin descriptions and given a higher purpose to our wanderings. Dare I say it? To long for poetry is to want to commit adultery.

Now, if we consider representations in Western literature and film, adultery isn't necessarily a bad thing. It's often seen as a necessary evil to bring a burst of oxygen to a suffocating marriage, or to break away toward a necessary freedom from a marriage that has been outgrown, or never been grown into. Yet there isn't a Western representation of adultery that lets an adulterer off the hook without paying some penance. As my *comadre* Esperanza in Mexico always says, "Todo se paga en esta vida." You pay for everything in this life. Take for example Jane Campion's movie, *The piano* (1993). Her willfully silent protagonist, Ada, communicates her poetic longings through her elusive piano playing. The piano has come with her from Scotland across the deep sea, and it symbolizes the vestige of home she has carried to colonial New Zealand. Her father has sold her – as girls around the world are sold into prostitution today – into a miserable arranged marriage. But Ada finds understanding and passion in the arms of a lover, Baines, a European gone native, complete with facial tattoos. However, in the process of creating a new life with Baines, she calls forth the jealous rage of her husband, who chops off the index finger of her right hand in a scene whose violence is excruciating to watch. After their escape, Baines fashions a metal finger for Ada, and he patiently supports her efforts to speak normally again. But Ada's body is forever marked by the price of her liberation, and her piano playing ceases to be haunting and becomes drab and ordinary.

The first time I saw this movie, the tears poured out of me in buckets. I've since seen it many times and taught it many times, and it still makes me cry. I'll be watching the movie, analyzing it carefully and critically taking apart the stereotyped representations of the Maori, so I'll be ready to talk to my anthropology students about it the next day, and then it happens, the scene I know is coming ... Now, now ... Oh,

God, it is so terrible.... The scene is too perfect: the relentlessness of the piano music, the rage of the husband, his picking up the ax, the way he rushes to the house and shoves the delicate, birdlike, mute Ada, the way he drags her out to the chopping block and lays her pretty hand down flat and the way he yells at her to declare whom she loves and the way he lets the ax fall and the blood starts to flow and the way Ada crumples to the ground in the Victorian full skirt, the way she crumples, as if the air, the breath of life had gone out of her. I can't help myself: I cry, I cry as if my own finger had been chopped off, I believe that it is I who am Ada. I too will be punished if I dare surrender to such an immense passion....

Now, obviously, the consequences are not going to be so dire for those of us who stray from anthropology to have a love affair with poetry. At least I hope not! And there are many ways to carry on an affair. I think Ruth Benedict provided a model that many of us, and I include myself, have followed. The poetic legacy she left us, I believe, is not in the words she wrote in verse and called poems and published under an alias, but in the poetry that she spun through her anthropology, the poetic sensibility that she brought to her scholarship and made inseparable from it. There is a certain pathos about this, to be sure. She didn't let the affair get out of hand. She kept it under wraps. She brought Poetry home and dressed it as something else, so that she could stay loyal to Anthropology. This was good for anthropology, very good for anthropology. But what was good for anthropology was not so good for Ruth Benedict's ambitions as a poet.

We could sit around allowing ourselves to become depressed about Benedict's unrealized potential, but I think there's a positive lesson to take from this history. The lesson is simple and obvious: poetry is bigger than the poem. Poetry is much bigger than the poem. There is poetry to be found in every aspect of our lives. There is poetry to be found in all human endeavors to understand the world. The thing is to know how to see the poetry, how to hear the poetry, how to feel the poetry. More often, the thing is just to remember that it's there. In springtime in Michigan, which is always late and always too brief, I'm grateful for that sign a neighbor I don't know always puts up on Seventh Street, which is one of the main arteries through the town. "Slow down and smell the flowers," it says, and I do. I open my windows and bring my driving to a crawl and let the lilacs inside and dare the drivers behind me to honk – which they don't because they're way too polite in Michigan.

So I write my poems while doing my anthropology, just as Benedict did, and fortunately I can do so openly. We now have a Society for Humanistic Anthropology that encourages the writing of poetry, fiction, and creative nonfiction by anthropologists. The Society has a magazine

that publishes works in these genres and awards yearly prizes for the best works. All this is very positive, and no doubt in the future we'll have a larger group of anthropologists who are equally strong poets and writers. But I know that the more important work I'm doing right now is the effort I'm making to craft a poetic anthropology. After all, we have a lot of poetic poets out there, but tell me, how many poetic anthropologists do you know? Anthropology needs its poetic anthropologists. And the funny thing is that most anthropologists don't know that. Or don't want to know that.

What does it mean to be a poetic anthropologist? I can tell you what it has meant for me. It has meant allowing myself to experience the emotionally wrenching ways in which we attain knowledge of others and ourselves. In my ethnographic writing, I've made the case that the most charged intellectual insights occur precisely when one's ethnographic work and one's life crash into each other in a head-on collision, even though every effort has been made to keep them running smoothly in their own lanes.

One of the first such collisions I experienced was when I found myself doing research on attitudes toward death in rural Spain with people I'd known for years and come to love, while at the very same moment my dearly beloved grandfather was dying of cancer in Miami Beach. The conflict between these two loves – the love for a soft-spoken grandfather whose hand I remembered holding in Cuba and despaired of losing forever, and the love for the strangers who'd let me become part of their lives – proved excruciating. I wanted to be in two places at once and I couldn't be. I chose to be in Spain because my family thought it best for things to go on as normally as possible, so that my grandfather wouldn't fear his death. But then, when my grandfather died before I could return, I hated myself. It was the loving kindness of strangers in Spain which gave me the hope of attaining some self-forgiveness. Eventually I was able to honor them and my grandfather in a piece of writing that brought them both together, though in real life they inhabited worlds that were completely separate. That writing, a long essay called "Death and memory" (Behar, 1991), was a doubled ethnography. It was an ethnography of the way death was being commodified in a small, fiercely Catholic village in northern Spain and the pain this was causing people, and it was an ethnography of how the anthropologist who was making the observation had become so detached from her own Jewish roots that she didn't know how to mourn the loss of her grandfather.

After Spain, I spent a considerable amount of time in Mexico in the mid-1980s and early 1990s. It was there that I took the principle of head-on collision between ethnography and life in a different direction,

by engaging in an extensive dialogue with Esperanza Hernández, a woman who couldn't be more unlike me, a street peddler, a woman of Indian heritage, an aggressive, self-assured single mother who'd survived both child abuse and domestic abuse and found strength in the veneration of the spirit of Pancho Villa. Esperanza's story became the foundation for my book *Translated Woman*, a feminist ethnography, in which I explored the conjuncture between her life and mine. What kind of observer was I? What was I willing to see and not see in her life? Why was she telling me her story? How would her story travel across the border and what would it mean in the US academy? All these questions formed the framework for the account of our relationship, which produced new knowledge about the struggles and yearnings of a working-class Mexican woman. While very rooted in the particular life of one woman, this ethnography traveled well beyond its origins; it has been read by Latino and Latina students trying to understand the lives of their Latin American mothers, as well as by women in prison interrogating the violence in their lives, as Esperanza interrogated it in hers, so they, too, can move forward through empowered forms of storylistening and storytelling.

Most recently, I've turned to documentary filmmaking to try to make sense of my own unusual heritage as a Cuban Jew and to learn from others of the same background how they think about their identity. In my film, *Adio Kerida/Goodbye Dear Love* (Behar, 2002), I create a forum for Cuban Jews on and off the island to speak about what their heritage means to them. Although political and economic differences separate these Cuban Jews, and are made evident in the film, a common search for history and memory unites them. The film becomes an imaginary homeland, a space to envision the reconciliation that has yet to happen fully in reality. It is fascinating to me that the character that Jewish Cubans on the island like the best is my father, who openly declares in the film that he has no wish to return to Cuba and doesn't care what Fidel Castro thinks about anything because he lives in the US. Precisely because he's so genuine and so funny in a typically Cuban manner in the way he says what he feels, he appeals to Cubans on the island because they feel he's so much like them. In turn, my father, in watching the film, has been impressed by the struggles of the Cuban Jews on the island to maintain their faith and traditions in the midst of considerable hardship and isolation. Ethnographically speaking, the film allows both sides to recognize each other's humanity, which is always the first step toward the making of community.

These, in brief, are some of the ways I've tried to enact and embody poetry within anthropology during the last twenty years. If I had to say what is the thread that ties together these disparate ethnographic pursuits, it's the search, the unceasing search for connection across borders

of nationality, ethnicity, class, religion, and ideology. And the search, the unceasing search, for languages of description and analysis that have not grown wooden, languages where the sap still flows. There are words I won't use in my writing, even though the concepts they were meant to express are still of great value. Words, for example, like hegemony and habitus, have been sucked dry by thoughtless overuse. But the bigger issue is that I often feel ill at ease in the presence of academic code languages, otherwise known as jargon. Believe me, I know the jargon, I could use it if I wanted to, but I choose not to, try not to.

For me, this is a moral and political decision. It comes from being a minority scholar, a Latina scholar, from coming to the academy as an outsider, without a sense of entitlement. Not that I had the words to articulate this position when I was a graduate student. I think my real education took place after I was done with my Ph.D. in anthropology. It was at this point, as I began teaching, that I connected what I'd learned in the academy with the world of Latina letters and philosophy, which initially developed beyond the academy because it was viewed as so radical. Gloria Anzaldúa, the Chicana theorist, poet, writer, and philosopher, was a key leader in the Latina movement for self-recognition. I know that she had a major impact on my rethinking. How I wish I didn't have to speak of her in the past tense. Gloria passed away recently, too young, and too soon. Gloria more than anyone understood the vitality and creativity of mixtures, of conjunctures, of crossroads. Her book, *Borderlands/La Frontera* (1999), brought into being a genre that blended poetry and prose, theory and family stories, manifesto and analysis, myth and history, English and Spanish that was left deliberately untranslated because she felt it was time for non-Spanish speakers to meet us Latinas and Latinos at least halfway. Gloria always worked on the edge of the academy; she was constantly on the verge of finishing her Ph.D. at U.C.-Santa Cruz. But she struggled with language. She didn't want to use fancy language that would create a new borderland between herself and the Latino community. She advocated for other Latinas to find methods of analysis and research that would not alienate them from their histories and families. I was one of the Latinas who took up her call. Thanks to her example, as well as her gentle encouragement, I found the courage to write poetically, as I'd wanted to in college, but hadn't been able to. She gave me back not only poetry, but philosophy. She gave me back the identity I wanted to claim and wasn't sure I could, telling me that there was no contradiction in being Latina and Jewish. She was the loving teacher I'd been looking for, and I only wish I'd thanked her properly while she was alive.

No doubt, you might want to ask me, as students often have, whether I get a lot of flak for doing what I do, writing the way I write. Well,

gratefully, I have my fans, and somehow I've managed to find a niche in anthropology and in the academy. It's amazing the range of things I get asked to speak to as a broken-hearted anthropologist. Lately, I've been writing a lot of forewords to other people's books – about auto-biographical writing across the disciplines, about women on the verge of home, about wounded ethnographers. I think some sea changes are taking place. It's been shocking to me lately to have two male colleagues of mine at Michigan, who are known respectively for their rigorous work in demographic and linguistic anthropology, pass along manuscripts for me to read that are intensely personal and poetic accounts of the fieldwork stories they never told.

All this is immensely reassuring and does give me some confidence that what I'm doing isn't totally idiosyncratic, but I'd be lying if I didn't tell you that I also get plenty of flak. Serious flak. Flak that really hurts. Because flak hurts more when you've put yourself on the line. Let me share one story that I'm not even sure how to tell. After reading the special issue of *Dialectical Anthropology* on "Poetry and Anthropology" from two decades ago, I thought I'd look to see what they've published lately and, to my surprise, I came across a critical article that included a harsh reading of one of the essays in my book *The Vulnerable Observer* (Behar, 1996). The article (Ryang, 2000) was published in 2000 and no one had ever told me about it. What stunned me, and shouldn't have, was the castigating voice of our profession's gatekeepers, who aren't necessarily the old fogeys, but the young untenured professors made uncomfortable by the artistic flirtations of some of their elders. The writer expressed her wariness about work that is autobiographic and poetic and written in pretty language, because she feels it takes us away from our true mission – to raise up and to make known the voice of the Other. The voice of the People. I could see where she was coming from, because I've heard a million versions of this debate – that auto-ethnography is all about navel-gazing and fails to lift up the People. For me, this rhetoric always smacks of paternal notions of saving the Other because the Other cannot save himself or herself, and personally, very personally, I think it's an insult to the intelligence and independence and creativity of the people who are kind enough to let us into their lives. Anthropologists, though they detached themselves long ago from the well-meaning salvation enterprises of colonial missionaries, have still kept a strong righteous streak. Criticism coming from that angle I could handle. From my perspective anyway, I was still in the ring.

But the punch I wasn't prepared for was when she compared my efforts to write personally with those of Anne Frank and concluded that my texts didn't have the same urgency, and that my life wasn't as interesting as Frank's life. Of course, I had to agree with her on both fronts,

but if every text we write has to measure up to Anne Frank's diary of a death foretold, I don't think most of us are going to be in the running for very long. This comparison, I have to say, struck me as absurd, as cruel to history. I tried to get angry, but I felt overwhelmed by sadness. I wanted to reply, but all that came was silence, a deathly silence. The writer, it was clear, meant to be earnest. She seems to be someone at the start of her career. It is well known that young scholars often try to make their mark by stabbing their predecessors in the heart and drawing blood. And I'll tell you, she succeeded. She succeeded.

You might want to know, because people always ask, is it necessary to have tenure to write the way you do? Some flak is to be expected, after all, but basically, what you're thinking is, she gets away with it. But to do what I do without tenure? Surely it isn't possible. Could a lowly student embark on a similar path?

The answer is no, you don't have to have tenure, and yes, you can do what I do, and you will do it, if you need to. You will reach a point, as I did, where there is no choice but to work from your poetic self. For me to work in any other way would be like pulling teeth. I can't do it. A day may come when I will be formally dismissed from the profession – excommunicated, you might say, or perhaps *desterrada*, deterritorialized, cast into exile. But until then, I will do what I do in the name of anthropology, and create the conditions for others who want and need to do the same.

After many, many years spent in the field, as we like to say in anthropology, I now spend much more of my time in the classroom. Those of us who come to teaching with any degree except for an education degree get absolutely no training in pedagogy, but we are magically expected to know what to do in the classroom. I've had to confront a good deal of ambivalence about being a teacher, as well as a good deal of fear. I am always afraid that I will break the transparent butterfly wings of my students, who grow younger and more delicate, it seems, with every passing year. The kind of teacher I am: too nice, because I'm absolutely terrified of causing harm. I know all too well, from my own life, that we are susceptible as students to the words of our teachers. So as teachers we need to be careful about our words. Nothing we say can be taken for granted.

I've developed a range of methods that I believe help to validate the role of the imagination in intellectual work. Every year I teach an undergraduate course about Cuba since the 1959 Revolution and examine both Cuban culture on the island and Cuban culture brought to the United States by Cuban immigrants. We read across the disciplines and consider a range of themes including Cuban history, politics, race relations, the role of women, art, music, and Afro-Cuban religions.

The course meets requirements at Michigan for courses focusing on race and ethnicity and it also meets a writing requirement. The course is accompanied by a weekly film series and students are required to keep journals about the films. They write three papers that they're encouraged to draft and redraft. For their final project they are given the option of writing a research paper or doing a creative project in any format they wish. The students almost always choose to do the creative project.

All the creative projects are presented in the final class during a four- to five-hour performance party complete with fresh tamales made by a local Salvadoran caterer. The last class is always a lively culmination to an intense semester of immersion in all things Cuban. The students love working on their final projects and this love shows in their presentations. Last year I had two women students who were very moved by the stories of the *balseros*, the rafters who make the plunge into the sea and risk their lives to get to the United States. Their presentation consisted of building a life-size raft, before our eyes, using junked pieces of wood found at Home Depot, on which they painted an image of the Virgen de la Caridad, the patron saint of Cuba. This year I had a gay student from Peru who had fallen behind on schoolwork because of personal troubles and whom I feared wouldn't come to the last class. But he came and delighted us all, arriving cross-dressed in a tight gown and high-heeled platform shoes, beautifully impersonating the great Cuban diva Celia Cruz, who had just recently passed away. There were students who performed the work of Cuban poets, there were students who composed music inspired by Cuban rhythms, there were students who conducted interviews on what their peers think of Che Guevara; and there was a cigar-loving student who researched every aspect of cigar production in Cuba and made the rest of the students try their hand at rolling cigars. Students of Cuban origin in the class who'd never talked to their families about their heritage went home and discovered stories they needed to form their own identities.

On the graduate level, I teach a course each year on ethnographic writing. What began as a course for anthropology students interested in learning about creative ways to write their ethnographies has grown into an inter-disciplinary class that also attracts students in education, literature, history, creative writing, ethnic studies, nursing, and psychology, all of whom come to the seminar with concerns about the possibilities and limits of representing lived experience. All of them want to write more poetically and vividly, but they're not sure how far they can go. In the class we read poetry, fiction, everything from urban to feminist ethnographies, personal essays from the *New Yorker*. I give students writing assignments in the first few weeks to get them thinking about voice, place, and what kinds of observers they want to be. And

then they do their own writing and we discuss it in workshop format in class. Ultimately, I hope the class gives students the courage to know what they know and speak what they think.

Two graduates of the class have recently defended their dissertations (Fosada, 2004: Lehrer, 2005), and they have both completed projects that were immensely brave and imaginative. Erica, whose Jewish family is of Polish origin, went to Poland, learned Polish, and studied the way the legacy of the Holocaust is being taken up by contemporary Polish people in Cracow, many of whom learn Hebrew and otherwise immerse themselves in things Jewish to seek reconciliation with their history. Her family thinks she's crazy for doing this, rather than doing something more Jewish herself, like learning Hebrew and going to Israel. Her dissertation is written as a series of moving vignettes that move between Jewish and Polish voices. In turn, Gisela, who is from Mexico and suffered sexual abuse as a young girl, chose to seek out a deeper understanding of masculinity by working in Cuba with gay men who sell sex to North American and European tourists. In addition to writing life stories of the men, placing side by side the contradictory views of the Cuban men and the sex tourists, she used video, often giving the men the camera to film themselves and each other. The result is an ethnograpically rich portrait of the ways in which intersecting and conflicting desires come together in our globalized and highly unequal world. What impresses me about the work of both Erica and Gisela is how they released the poetry in their personal lives to move ethnography in new, more powerful directions, where what's at stake in the work is never just an intellectual exercise but knowledge that is essential, knowledge that you couldn't live without.

I am now at that stage in a teacher's life where I can learn as much from my students as they can learn from me. It's that stage where the students take your ideas and run with them a whole extra mile, a mile you're not sure you can run any more. And maybe, though I wouldn't have expected it back when I was a student in search of a teacher who could love me, maybe that is the ultimate homecoming.

QUESTIONS

1 In what ways was Ruth Behar discouraged as an artist? How, when and by whom was she encouraged? Think about your own experiences of encouragement and discouragement as an artist or as a scholar. How do those experiences impact the way you wish to define yourself as a scholARTist today? How much and in what ways should teachers be expected to show love, compassion, and/or care for their students?

2 Poetry was a secondary pursuit to Ruth Benedict's anthropology. Can or should a scholARTist develop multiple genres to equal levels of excellence and attention?

3 Behar writes: "To long for poetry is to want to commit adultery." What does this metaphor mean? What does it reveal about Behar's understandings of herself and her work?

4 What does it mean to bring a "poetic sensibility" to scholarship? What is to be gained? What are the possible losses? In what ways does Behar describe poetic sensibility in her own ethnographic work and that of her students?

5 What do you think of Behar's decision not to use academic language such as "hegemony" and "habitus"? How do we make choices about the language we use in academic prose? Can these and other terms in the academy be poetic? Why or why not?

6 Do you agree with Behar's answer, that students and young scholars can write poetic scholarship at the early stages of their career?

7 What are "languages of description?" Are there languages that describe (i.e. languages that obfuscate rather than clarify)? How can the arts both reveal and conceal? How do traditional forms of statistical research reveal and conceal (e.g. what are the functions of outliers or the meaning of N-1 in formulas?) How are the arts the same? How are they different?

8 Consider how Erica and Gisela have imaginatively reconceptualized their research. In each case, what would a "traditional" research question have looked like? Consider other research questions. Brainstorm how these could be imaginatively reconceptualized.

9 In pairs or small groups discuss what is at stake in your own scholarship and scholARTistry. What are the themes that haunt you? What are the questions that don't let you sleep at night? What knowledge can't you live without?

REFERENCES

Anzaldúa, G. (1999). *Borderlands/La Frontera*. (2nd edition). San Francisco, CA: Aunt Lute Books.

Behar, R. (1991). Death and memory: From Santa María del Monte to Miami Beach. *Cultural Anthropology*, 6(3), 346–384.

Behar, R. (1996) *The vulnerable observer: Anthropology that breaks your heart*. Boston, MA: Beacon Press.

Behar, R. (2001a). Prisoner. In *Todo lo que guardé/Everything I kept: Poems by Ruth Behar* (p. 23). Matanzas, Cuba: Ediciones Vigía.

Behar, R. (2001b). Obedient Student. In *Todo lo que guardé/Everything I kept:*

Poems by Ruth Behar (p. 4). Matanzas, Cuba: Ediciones Vigía. (Original work published 1997.)

Behar, R. (Writer/Director) (2002). *Adio kerida/Goodbye dear love* [Motion picture]. United States: Women Make Movies.

Benedict, R. (1986). Of graves. *Dialectical Anthropology, 11*(2–4), 169.

Campion, J. (Writer/Director) (1993). *The piano* [Motion picture]. United States: Miramax Films.

Diamond, S. (1986). Preface. *Dialectical Anthropology, 11*(2–4), 130.

Fosada, G. (2004). The exchange of sex for money in contemporary Cuba: Masculinity, ambiguity and love. Unpublished doctoral dissertation, University of Michigan.

García Lorca, F. (1945). *La casa de Bernarda Alba, drama de mujeres en los pueblos de España*. Buenos Aires: Editorial Losada. (Original work produced 1936.)

Lehrer, E. (2005). "Shoah-business," "Holocaust culture," and the repair of the world in "post-Jewish" Poland: A quest for ethnography, empathy, and the ethnic self after genocide. Unpublished doctoral Ph.D. dissertation, University of Michigan.

Ryang, S. (2000). Ethnography or self-cultural anthropology? Reflections on writing about ourselves. *Dialectical Anthropology, 25*(3–4), 297–320.

Unamuno, M. de (1913). *Del sentimiento trágico de la vida*. Madrid: Renacimiento.

Ethnographic poetry

Adrie Kusserow
St Michael's College, Colchester, Vermont

Adrie Kusserow is Chair of the Department of Sociology and Anthropology at St. Michael's College in Colchester, Vermont. She has published books in both the fields of poetry (*Hunting Down the Monk*, Boa Editions, 2002) and cultural anthropology (*American Individualisms*, Palgrave Macmillan, 2004). In 2002 she won the Case Carnegie Professor of the Year/Vermont Professor of the Year Competition. She received her M.T.S. from Harvard Divinity School and her Ph.D. in cultural anthropology at Harvard Graduate School of Arts and Sciences. Most of her graduate study in poetry was done at Bread Loaf School of English at

Middlebury College, in Middlebury, Vermont and through poetry courses taken in New York City while she did fieldwork on child-rearing and social class in Manhattan. At St. Michael's College she teaches courses on Refugees; Modern Day Slavery; Culture, Illness and Healing; Social Inequalities and Anthropology of Religion. She continues to use film, fiction and poetry in all of her anthropology courses and hopes to teach a course on ethnographic poetry some day with undergraduates who have recently studied abroad. Many of her courses require a service learning component in which students also tutor refugees, work at family centers or homeless shelters. She has done fieldwork in India, Nepal, Uganda, and New York City. She and her husband, Robert Lair, founded the New Sudan Education Initiative (www.nesei.org), a non-profit organization devoted to uniting the Sudanese diaspora in an effort to build secondary schools in south Sudan. She lives in Underhill Center, Vermont, where she was born and raised, with her husband and two children. She always welcomes questions from students: akusserow@smcvt.edu.

I came to poetry as a refugee. After years of forcing myself to perfect rigid academic writing while getting my graduate degrees in anthropology and religion at Harvard, I came to a point where I was miserable enough to consider dropping out. Although I did end up finishing my Ph.D. and now teach cultural anthropology to undergraduates, I did end up actually writing my dissertation away from Harvard (in Northampton, Massachusetts), and it was at that time that I really embraced poetry and admitted that, if I were to stay engaged and committed to anthropology, I had to practice, read and write a kind of poetic anthropology, an anthropology that moves beyond a mere intellectual exercise and becomes an anthropology of the hips and soul. After Divinity School, I was two years into my Ph.D. in social anthropology when I started having trouble with my eyes. Whether this blurred vision was psychosomatic or not I'll never know. I'd been reading so much for my general exams, every time I tried to sit down and read, words became blurry. I was worried I wouldn't be able to see well enough to work on the computer during my general exam dates. After I confessed this to one of my senior anthropology professors, she looked at me with indifference and said, "Well, maybe you're just not fit for this profession. It does require a lot of reading." I left her office feeling ashamed, but also slightly liberated. In trying to impersonate a stiff, male, British scientific approach to the field, I knew more than ever that I had to leave. After years of milking dry academic readings for the soul and poetry of anthropology, I'd had enough. I had to get out. I was tired of feeling imprisoned, stifled,

sick, scientific, stale. Tired of presenting and reading the juiciest parts of anthropology in cachectic, formal, half-dead language.

When I first started to write poetry it felt like a bloodletting. All of the color, moods, feelings and nuances I'd wanted to gush for some time, came out easily. Ironically, despite the miles of bad confessional poetry I initially produced, when I tried to write about cultural concepts, I felt poetry, rather than being some overly subjective fiction, finally accurately represented what I wanted to explore anthropologically. Humans, in all their stickiness, chaos and confusion, their fluidity and subtlety, their unpredictability and color, were suddenly three-dimensional again, through images, smells, looks and metaphors I never dared use before. In this way, poetry not only followed data collection, as a way to focus on my notes and digest what I had observed after hanging out with Sudanese refugees, but it also influenced the kinds of data I chose to gather. Poetry and data collection became mutually informative. The act of writing a poem was a deep meditation on my field notes where I tried to focus on all of the subtleties of what I had observed. And yet a poem sometimes took me to new places, not necessarily places of "fiction," but places of new anthropological insight about Sudanese culture. In allowing a rich, full spectrum of language and metaphor to describe and understand the Lost Boys of Sudan, I came to know them in a more subtle way than had I written them up academically for publication in a journal article. From here I would go back to my participant observation with the Lost Boys, and focus or ask questions about some aspect of Sudanese culture or their adaptation to American culture that I had not fully appreciated before. For the first time, I felt I was doing justice to the anthropology I'd encountered and practiced over the years. The whole human, reality in all its wildness, once out of the procrustean bed of academic writing, never wanted to obediently march back in.

And yet I did make it march back in, briefly, until I got tenure and had my flat, stiff dissertation, replete with tiny footnotes, turned into a book. Until then, I kept my poetry hidden. I didn't attempt to cross any lines or blur any boundaries. I never let my professors know I was writing poetry, or initially even my other colleagues when I got my first academic position. Thankfully, I am now at a college where it is safe for me to come out as a poet. And the two now, poetry and anthropology, exist in a dialectic, like they always should have. I write about what moves me, what fascinates me, what confuses me, what I haven't yet even named. I write about what can't be statistically counted or scientifically verified except through simile and metaphor.

Poetry, in all its subtlety and fluidity, has had a profound impact on where I choose to place my anthropological gaze. Because of poetry, I not only write about obvious formal rituals, but what is underneath and beside them. I now sit with them longer, and lift them up, feel the warmth

of the soil underneath, smell the matted leaves around them – I write about the light on them, the shadows that cross them. Poetry, insofar as it is a fierce meditation, has taught me to uncover layers of reality and subtlety that any good thick description should include, in the same way we get to know the main character in a great novel. I now "study" a Sudanese refugee in all his dimensions, his confusions, his embarrassments, his jokes, favorite videos, longings and failures. Nonverbal behaviors, the spirit or energy of a moment, are all legitimate fodder for my fieldwork.

Recently, I was in Dharamsala, India, the home of the Dalai Lama and Tibetan Government in Exile. Since most of my academic interests now involve working with refugees, I was there to explore setting up a student program to help Tibetan refugee children. While I was there I gave a lecture on postmodern ethnography to some American Tibetan Studies students on a semester abroad with the School for International Training. I read my poems, poems about the most wretched and elating parts of field work, about the 10,000 shades of meaning and emotion that occur between myself and the "Other," about my own encounter with Buddhism, about other Westerners seeking meaning in the East, about Nepali child prostitutes, Sudanese refugees, about taking my daughter to India, watching my son in a refugee camp in Uganda, ladyslippers, Catholicism, the mountain I live underneath.

Through my own poetry, where science and confession, art and social science all feed off each other, I tried to call into question the objective science they were supposedly practicing with the native Tibetans. Every time they tried to pin me down in some category, some four-walled room, some strict definition, I found myself wriggling out, noting how my own emotions influenced my interviews, how my love of colliding cultures influenced my poetry, how my poetic gaze influenced what I chose to study. As much as they were frustrated, I could tell they felt liberated because the range of what they thought could be included in anthropology had just widened and deepened considerably. Art and emotions, thick wild description, the whole messy terrain of the unsaid, the subjectivity they had already learned to wall off from their undergraduate papers, were allowed back in.

LOST BOY

The Lost Boys refers to the 17,000 children in southern Sudan who fled their homes in 1987 seeking refuge from the civil war. They walked 1,000 miles before they finally found protection in a Kenyan refugee camp, Kaukuma. By the time they reached there, half of the boys had died from starvation, thirst, soldiers, lions and bandits. About 3,700 have recently been resettled in America.

Deng Majok sits inside his apartment,
heat cranked up to 80, curtains closed,
a pile of chicken boiling on the stove.
He slides another Kung Fu movie
into the VCR, settles back into the smelly,
swaybacked couch, a Budweiser between his legs.
He giggles.
In half an hour he'll ride his bike
to Walmart, round stray shopping carts
from the cracked grey lot,
crashing them back into their steel corrals.

He remembers joining
a black river of boys,
their edges swelling and thinning
as they wound their way
over tight lipped soil, sun stuck to their backs.
He remembers dust mushrooming
around a sack of cornmeal as it thudded,
slumped over, like a fat woman crying in sand.

In America
they took him to a store,
bought him fresh sneakers
soft and white
as wedding cake.
The next day he walked through whole aisles
of dog food.

At first they dropped by all the time,
church ladies, anthropologists,
students, the local reporter.
They all left elated, having found something real
like yoga and organic food.

The first Thanksgiving, three families booked him.
Leaning hungrily across
the long white table,
they nibbled at his stories,
his lean noble life.
Over and over he told them about lions,
crocodiles, eating mud and urine.

The Americans came alive, with a sad,
compassionate glow, a kind of sunset inside them.

After dinner, he heard them berate their children,
twitching over a second straight hour of Game Boy.

Two years later, November again,
he's dropped out of high school –
he can't take
the kids staring, the tiny numbers and letters
he can't keep straight,
the basketball team he didn't make
despite his famous height.
All night he'll clean the toilets at the hospital
as silent tvs splash their images
over the bodies, into their open mouths.

Now he looks like a too tall gangster,
all gold-chained and baggy-trousered.
He's channel surfing,
listening to Bob Marley on his walkman,
his long legs awkwardly pushed out
to each side, the way giraffes
split their stilts
to drink of water.

Africa's moved inside him,
all cramped and bored, sleeping a lot.

He cracks another beer,
starts to float, the reggae
flooding the vast blue-black continent
of his body now limp and warm,
draped like a panther
over sides of the sofa.

His cousin calls, she needs more money,
her son has malaria. She can't afford school fees anymore.
His uncle gets on the phone to remind him to study hard,
come back and build a new Sudan.

Later he stumbles into the bathroom
to brush his teeth. Groggy Africa
flinches at the neon light, paces
then settles in the corner
of its den, paws pushing into the walls
of his chest with a dull pain.

The next morning he wakes,
stubborn Africa still shoved up against his ribs,
refusing to roll over, back into the middle
of himself where he can't feel it anymore,
back into some open place
where he ends
and America finally begins.

QUESTIONS

1 What makes this poem a poem and not a short story or an ethno-
 graphic vignette? In what ways does the language employ image,
 metaphor, simile and music among other poetic techniques to craft
 the structure of the poem?
2 Can you imagine different ways the data in this poem could be
 reported – e.g. in the form of an essay or a piece of fiction?
3 How is metaphor used in this poem? For example, "like yoga and
 organic food," "they nibbled at his stories," and "Africa flinches at
 the neon light."
4 Which research methods do you think Kusserow used to gather the
 data for her poem?
5 In what ways does this poem vivify what Barone (p. 41) calls
 "political outrage" in research?
6 Try writing a narrative poem in response to an experience with a
 community that is different from your own.

Chapter 6

Understanding and writing the world

Kristina Lyons
University of California-Davis, Davis, California

Kristina Lyons is a doctoral candidate in sociocultural anthropology at the University of California-Davis. Her research examines politics of collaboration and storytelling on the part of local communities, scientists, and humanitarian organizations in Colombia and Ecuador as they advocate against aerial fumigation operations. She obtained her BA in creative writing and Spanish from Middlebury College in 2001 and her MA in Latin American Studies and anthropology from the University of Texas-Austin in 2004. Kristina has spent the last eight years working, researching, and studying in Latin America, and much of her work is bilingual. Her main areas of inquiry are US foreign policy interventions in the Americas, especially the "war on narcoterror," forced displacement of communities, states of emergency, and life politics. Kristina was a poetry scholar at the

University of Galway, Ireland International Writers Course in 1999, the Breadloaf Writers' Conference in 2000 and 2001, and the Writers of the Americas Conference in Havana, Cuba in 2001. During this time she had the opportunity to collaborate with a group of Cuban artists, OMNI ZONA FRANCA. Kristina was awarded first place in the 2005 Society for Humanistic Anthropology Ethnographic Poetry Competition, and her poetry has been published in volumes of *Anthropology and Humanism* and *Esquife*. She considers poetry to be a distinct lens through which to observe and interpret the world, and that this lens has the ability to expand notions of what constitutes ethnographic writing and practice.

Upon Traveling to Nosara emerged from an incident I observed on a highway while leaving the Greater Metropolitan Area of San José, Costa Rica. At the time I was teaching in the Nicoya Peninsula and working on my undergraduate thesis – a compilation of poems reflecting on experiences of everyday violence in Costa Rica, Cuba, and Chile. While I was not studying anthropology then, this poem, and poetry in general, has continued to help me think about and write against the social production of death in Colombia, the site of my doctoral work.

This poem is meant to be performed by a group of four people. Read horizontally it is one single poem. However, each of the three vertical columns is also meant to stand alone. I chose this form after listening to a poetry reading by G. E. Patterson at the 2001 Breadloaf Writers' Conference.[1] The performative nature of the poem is meant to convey the overlapping voices and the variety of sensory components at work in the public bus. It is also meant to imitate the ordering of disorder that people engage in as they make sense of the crash. The notion of space is also important in this piece; for example, the space between living bodies and the corpse, between the passengers and what lays outside, as well as the connections or disconnections between people's disparate reactions to the everyday presence of death.

I believe that poetry's use of images, slices of conversation, repetition, and affect allow it to present both a literal and metaphorical way of seeing the world. By taking up sensory and material components, it creates a visual language in which the written text visualizes philosophical ideas as well as material objects, people, and events. In my opinion, this is the goal of good ethnography as well. The textual integration of poetry in ethnographic writing can mobilize affect, reason, and imagination to help the reader or researcher see a theoretical or philosophical point through a different set of lenses. It allows us to grapple with distinct modes of storytelling, silence, and material conditions that cannot be conveyed through the measured realism of much traditional

ethnographic writing and research methodology. This is not to say that poetry as a form of analysis or methodology is more "real" than documentary realism, but that it may provide a window into multiple perceptions and distinct experiences of reality that can mutually inform theoretical analysis. For me, poetry emerges from material objects, events, and conversations that I encounter in my research and these things anchor me as I filter them through my subjective interpretation. Precisely because of this link, I believe that poetry can help us pay attention to local narrative modes and the quiet work of stitching together everyday life that occurs in contexts of violence, but is often overlooked in metanarratives of suffering and redemption.

The process of writing has been important to me for as long as I can remember. In my mind, there is no separation between the work of scholars and scientists and the poet or storyteller. All are telling stories; although these stories may assemble different audiences and obtain differential power and ability to travel and exert influence in the world. I see anthropology as a space from which to understand how others, as well as how we ourselves, tell stories to remember and use the past, to witness, to resist, and to mute experience. From my perspective, poetry provides an alternative form of analysis from which to address these stories as they continue to circulate among us.

UPON TRAVELING TO NOSARA

– Thanks to G. E. Patterson
for four voices

I am sitting	on a bus	seven hours
with a dead man	Savanna trees	in the dry season
strung together	outside	a haze of mid-day heat
paper cut figures	scraping against the window	The blown out tire's prayer
arriba abajo	*adentro*	A man is dead
leaning	*(chin chin...)*	beneath a stained curtain
against a vinyl seat back	Still more	people climbing in
No one knows	voices colliding	their shoulders almost touching
A man is dead	then silence	stepping on his head

QUESTIONS

1 What research question is Lyons exploring through this poem? Is her intent clear through the poem, or is it necessary to read her introduction to understand what she is seeking to communicate?

2 Who is the speaker in this poem? What is her position in relation to the other characters in the poem? What is the attitude and tone? What do emotional and imagistic details add to our understanding of the observed experience?

3 How does the structure or visual appearance of the poem impact the meaning it expresses? Discuss the interplay of form and content in the arts. Can form and content have meaningful connections in academic disciplines as well? How does form contribute to content in Lyons's poem?

4 Why does Lyons connect the study of anthropology to storytelling and creative writing? If Lyons were a visual artist, could she make a connection between anthropology and painting or sculpture? Why?

5 Poets are often informed by the forms of other poets, as Lyons acknowledges in her dedication to G. E. Patterson. Some poets write directly in form while others write less formal narratives they transform via formal devices after the initial thoughts are written. Try this exercise: 1) Write a narrative of a field experience you've had, paying attention to strong, evocative images and sensory details (e.g. paper cut figures/scraping against the window/the blown out tire's prayer). 2) Now, concentrate on the form the poem takes. You might take the "Four voices" structure as a model or turn to more traditional forms such as the sonnet or the villanelle.

NOTE

1 Patterson was reading from his first book, *Tug* (Graywolf Press, 1999) at the 2001 Breadloaf Writers' Conference in Middlebury, Vermont.

Chapter 7

Voices lost and found
Using found poetry in qualitative research

Kakali Bhattacharya
University of Memphis, Memphis, Tennessee

Formerly a student of Biochemistry and solidly situated in quantitative research, **Kakali Bhattacharya** has found her home in qualitative inquiry and Social Sciences. Bhattacharya, a recent graduate from the Research, Evaluation, Measurement, and Statistics program at the University of Georgia, specialized in qualitative methods and transnationalism in her dissertation. Specifically, her dissertation examined how two female Indian graduate students who have been in the US for no more than eighteen months negotiate their initial experiences while pursuing their education. Methodologically, she explored how qualitative research can be informed utilizing the decolonizing theoretical and methodological frameworks of postcolonialism, transnationalism, and feminism. Currently she is an Assistant Professor in Educational Research in the Department of

Counseling, Educational Psychology and Research at the University of Memphis.

Bhattacharya is the recipient of several large internal university grants which she is using to explore how qualitative methods can be intersected with technology and pedagogy within the current discourse of scientific inquiry. Currently she is working on a book, *Where Do I Claim and Name Home? Un/packing De/colonizing Epistemologies and Methodologies*, where de/colonizing frameworks are applied methodologically in research and teaching practices. Her work is scheduled to appear in an upcoming issue of *Qualitative Inquiry* where she raises questions about ethics in qualitative research and the role of the Institutional Review Board.

When she is not doing research, Kakali can be found publishing non-fictions online, salsa dancing, coffee-shopping, and playing in second life. Lately, she has become interested in creating altered books online within a collaborative environment.

During my dissertation study, I became increasingly vigilant of the multiple deconstructive arguments about voice and re-presentation from feminist, postcolonial, and postmodern perspectives. I acknowledged that the participants' voices are always mitigated through various academic filters, thus questioning our ability to really hear the participants. On one hand, I identified with one of the purposes of qualitative research: to capture the experiences of the participants as told through their voices. On the other hand, how can those voices be really heard through/with/against the researcher's subjectivities and various processes of academic gatekeeping in peer-reviewed published spaces? I struggled with the purpose of data collection and re-presentation especially after I accepted that the participants' voices are always already partially or completely silenced in academic research. But the silencing of voices does not erase the everyday experiences and their effects on participants. Therefore, how should I negotiate voice and silence through the academic gaze that is on me, through the gaze that I put on my participants, and through the gaze that the participants put on me?

I looked towards re-presentations that blurred multiple genres of writing where the messiness of qualitative research was represented in the "findings" of research. I came across multiple poetic representations, one-act plays, and photo-elicitations. I attended some poetry readings and became familiar with a local political activist group in Athens, Georgia, who used found poetry to discuss issues of abortion, race relations, sexuality, and war. Drawn to the organic nature of juxtaposing participants' and researcher's dialogues especially in an insider–outsider researcher–researched relationship, thereby overtly acknowledging the researcher's

subjectivities, I wanted the data re-presentation to be evocative. It cannot be assessed on merits of truth, accuracy, or holistic understanding of the participants' lives. It can only be re-presented as fragmented, contradictory testimonials of participants merging with my own, without any clear indication where the researcher's perspective begins and the perspective of the researched ends.

"*Small Small* Things" became a way for me to speak in multiple mitigated voices of which two can be credited to graduate students from India who had been in the US for less than six months during the timeframe of the study. Taking material from various parts of formal and informal conversations I had with the participants, I used the participants' words, our conversations, filtered through my subjectivities and combined with the aesthetics of poetic re-presentation. Of course, such re-presentation is driven by my cognitive selection of issues of transnationalism, which at a rudimentary level, refers to the practices of migrants who live their lives across multiple nation-states if not in at least two nation-states. Consequently, I identified experiences that spoke of shuttling between familiar and unfamiliar spaces where transnationals negotiate between multiple cultural values and expectations as they accommodate, resist, and re/author themselves. In writing about transnational experiences, I knew I was going to write about myself, my understanding of being in the middle, in constant motion, blurring lines between cultures and familiarity.

As I constructed the poem, I became aware of my complicated positioning as a transnational academic in a higher institution in the US trying to depict experiences of other transnationals. How do I negotiate my multiple contested loyalties between academic expectations, personal experiences of being a transnational, using de/colonizing frameworks that directly contest western academic ways of knowing, and participants' ways of knowing and understanding their experiences? Thus, the poem became a space for me to demonstrate these loyalties in their fractured forms while realizing that these loyalties will always be divided, and pull me in multiple directions.

Strategically, while going through the text data, I selected phrases and ideas that appeared organic in their content and style. For example, the use of the term "*small small*" is indigenous to Indian transnationals and their ways of using the English language, as was the term "after some time." I kept many Hindi words in the poem, some without any explanation or translation, to depict to the reader(s) that the transnational voices and experiences are grounded in these organic emotions and identification that might not be universally understandable or transferable. So the reader(s) would have to be comfortable with the ambiguity, the unfamiliar, and draw on their familiar experiences to interact with the poem, much like the transnationals, shuttling between the familiar and unfamiliar. This poem also represents the contradictions of

being a transnational. On one hand, being away from a "home" culture, the participants crave something familiar in their "host" culture. On the other hand, the hybridized representation of cultural practices and symbols in the US implores the participants to glorify various practices of their "home" culture including religion.

I read the poem at a poetry reading where the participants were present to hear their fragmented voices in spoken words. At the end of the reading, both participants were in tears and stated that they were able to identify, remember, mourn, and personalize the poem to their experiences. Was I successful in capturing their voices? I don't really know. It was evocative and spoke to the participants in a way that was meaningful and real to them. Should that be the purpose of data collection and re-presentation? Who are the intended audiences for research? Is it the researcher, academic circles, the participants, or all of the above? How do we come to negotiate which voices get heard and which silenced when considering a specific group or multiple groups of intended audience? When I imagined my primary audience to be the participants, my writing reflected the care and obligation I had towards them. While imagining an academic audience as a secondary audience, I struggled against being a "Third-World" broker for the US academia who is tempted to exoticize the participants' experiences to consumable dishes of Indian curry. Thus, the only voice I can really "claim" is mine, re-presented through/with/against the contested voices of the participants, which inevitably leads to messy spaces of knowing and being known.

THE *SMALL SMALL* THINGS

Weekend fall breezes
remind me of autumn in India
even without wafting jasmines.
I match my *bindi* to my *salwar kameez;*
sindur red bangles bring out
the reddish pink *jhumkas*
dangling by my ears, eager to hear
puja drums, voices of Indian chatter
in a rented high school auditorium –
Desoto County Spring Valley Tigers.

Even when they are weekend festivals,
not on their actual auspicious dates,
even when they sing Bollywood songs,
not *bhajans*, but *antaksharis* during *pujas*,
holding on to these *small small* things

even when they are amplified, modified
not authentic as I remember,
they are still familiar.

Sometimes I don't like masked
Indian-ness with clothes, jewelry, cuisine,
all-you-can get buffet, for everything Indian.
Main course culture: side orders of religion
and socialization, generous helpings
of comparisons, gossips, and envy –
all in one weekend.

I'd rather pray like Papa, in Mumbai.
How to find God in a high school auditorium?
Unabashed walls roaring
with American football murals
draped with *saree* curtains.
Players, mascot, audience
cheerleaders in short skirts
peeking through silky folds.

In processions, like *Ganpati Visarjans*,
decorated brown bodies
in *sarees, kurtas, salwars*
in *Tikas, tilaks, and bindis*
in *Henna, alta, and mehndis.*
Slums and highrises, side by side,
hearts dancing on the streets.

I miss how I used to be one of them
at the crowded Churchgate station.
Daily passengers, languages blended yet distinct
Punjabi, Gujarati, Bengali, Hindi, Marathi.
Their colors, alta red, turmeric yellow, peacock blue
chiming like the silver bells
on an *adivasi* woman's anklet.

Memories glow like pearls
on the Queen's necklace.
Focusing, blurring
what used to be, what it is.
It's the *small small* things really;
after some time it feels natural.
Natural to forget them.

QUESTIONS

1 How can insider/outsider researchers negotiate voices and silences when working within academia? What should be some guiding strategies?

2 What decisions drive the selection of certain text data over others in constructing a found poem? Should vigilance be placed on the researcher's subjectivities when selecting and juxtaposing texts for found poetry?

3 In what ways do you think voices represented in the poem agree and disagree with each other?

4 Conduct an interview with a research participant (or more than one) in an area of interest to your study. Select the images, syntactical structure, and lexical choice that best convey the character of the participant and transform the transcript into a dramatic monologue poem. Alfred Hitchcock claimed that art is, "life with the boring parts taken out." How can you transform a transcript through selectivity so that it conveys a life through the most heightened language? Are there moments where composite characters might be helpful, rather than data from one person only? Is there a place for fictive invention?

The ecology of personal and professional experience

A poet's view

Carl Leggo
University of British Columbia, Vancouver, British Columbia

Dr. Carl Leggo is a poet and professor in the Department of Language and Literacy Education at the University of British Columbia in Vancouver where he teaches courses in English language arts education, creative writing, narrative research, and postmodern critical theory. In addition to degrees in English literature, education, and theology, he has a master's degree in creative writing. His poetry and fiction and scholarly essays have been published in many journals in North America and around the world. He is the author of three collections of poems, titled *Growing Up Perpendicular on the Side of a Hill*, *View from My Mother's House*, and *Come-By-Chance*, as well as a book about reading and teaching poetry, titled *Teaching to Wonder: Responding to Poetry in the Secondary Classroom*.

During the past 16 years at UBC, Carl has been actively involved in promoting creative, interdisciplinary, cross-faculty approaches to teaching, graduate supervision, and research. With regard to current research projects, he is collaborating with Rita Irwin, Kit Grauer, and Peter Gouzouasis on two research projects titled "Arts-based research in education: Contentious compromise or creative collaboration," and "Investigating curriculum integration: The arts and diverse learning environments." In addition to these projects, he is involved in theorizing and explaining "autobiography" as a research methodology, and in researching the possibilities of poetry for fostering "poetic living." He is committed to exploring the lively intersections between critical discourse and creative discourse. His goal is to open up spaces for the creative arts to inform education research.

Because so much of my teaching, writing, and researching emerge from the intersections of the personal and the professional, I contend that autobiographical writing is always both personal and professional, and that we need to write autobiographically in order to connect with others (see Irwin & Springgay, Chapter 9). I live in the world as a poet. The word poetry is derived from *poiein*, "to make." As a researcher I am a poet or maker. I do not stand outside experience and observe experience like a video camera recording an objective reality. Instead I seek to enter lived experiences with an imaginative openness to the people and activities and dynamics at work and play. I seek to make a story in collaborative dialogue with others, always aware that the story is one of many stories, one of many versions of the story.

My understanding of so much scholarly writing has been shaped by teachers and academics intent on filling the world with five-paragraph theme papers that prattle with predictable and pedantic persuasiveness, teachers who fear poetry with its subversive search for the strange. Still I contend that my poetry and my poetic ruminations on teacher education, teacher well-being, pedagogic imagination, and creative living are scholarly writing, even though it might not always look or sound like the scholarly writing that fills academic journals beyond counting. In fact this kind of poetic research might be closer to the meaning of *scholar* than much writing that claims the label "scholarly writing." *Scholar* is derived from the Greek *schole* which signifies "leisure employed in learning." In much scholarly writing, "learning" is defined as research, explication, logic, reason, argument, and persuasion. The emphasis is on conclusions, implications, and recommendations. There is frequently a tone of world-weary urgency, akin to a military operation or corporate venture or political strategy convention. In most scholarly writing,

learning is not born out of leisure. My research is the fruit of leisure, and it bears the sun-washed, moon-drawn, shadow-written lines of light where it has lingered. Like the familiar traditions of scholarly writing, my writing includes research, explication, logic, reason, argument, and persuasion, but the ingredients are mixed in unfamiliar ways, in a ruminant, poetic brew of learning sought and gained in the employment of leisure, of lingering in the world and in words.

So, in my autobiographic and poetic research, I proceed with a convicted understanding that the personal and the professional always work together, in tandem, in union, in the way of complementary angles. Only when they are together can two complementary angles compose the right angle. All my autobiographical research is devoted to my own professional development and the professional development of other educators (Leggo 2006a; 2006b; 2005a; 2005b; 2005c; 2005d; 2005e; 2005f; 2004a; 2004b; 2004c; 2004d; 2004e; 2004f; 2004g). But for me to grow professionally, I also need to grow personally. Autobiographical writing is both transcendent and immanent, both inside and outside, both internal and external, both personal and professional.

It is not easy to write autobiographically, especially in the academy, especially with honesty about many issues, including experiences of failure, fear, and frustration. We need a different culture, a culture that supports autobiographical writing that is marked by an understanding that writing about personal experiences is not merely egoism, solipsism, unseemly confession, boring prattle, and salacious revelation. We need to write personally because we live personally, and our personal living is always braided with our other ways of living – professional, academic, administrative, social, and political.

I constantly ask, why is it important that I write and tell my stories as a poet, teacher, and teacher educator? Why is it important that others write and tell their stories? Writing autobiographically is like echolocation. By means of echolocation, bats can navigate their nocturnal flights. They send out sound waves which then bounce off distant objects and reflect back to the sender. In a similar way, autobiographers are seeking to locate themselves in a rapidly growing network of contexts, including family, neighborhood, community, profession, and school, by sending out resonances from one embodied and personal location to other embodied and personal locations. There is no separating the personal from the professional. As a teacher, I do not leave my home and family experiences behind me when I drive to campus or when I enter the classroom. And I do not leave my past either. I am the person I am because of the experiences and people and places that comprise my life and living.

All my autobiographical research is about the construction of

identity, especially in the spaces between self and subjectivity. As Griffin (1995) observes, "the self does not exist in isolation" (p. 50). Instead, "to know the self is to enter a social process. One does not know oneself except by being mirrored" (p. 51). I find this a very powerful notion for understanding issues of self-identity, especially the ways that we are often mirrored and represented, and hence shaped, in the discursive practices of the dominant culture. I agree with Griffin's comment about "a desire that is at the core of human imaginings, the desire to locate ourselves in community" (p. 146). The challenge that we constantly face is the challenge to fit into the community but not be swallowed up by the community; to live communally while also developing our individual talents and personalities. All of this is accomplished in telling stories, as Griffin understands, "for each of us, as for every community, village, tribe, nation, the story we tell ourselves is crucial to who we are, who we are becoming" (p. 152).

I often write about family, always seeking to know who I am, to gain a clear sense of identity and positionality in the midst of memory, desire, heart, and imagination, especially in relation to others. For many years, I have been writing autobiographical poetry about growing up on Lynch's Lane in Corner Brook, Newfoundland. So far, I have published three books of poems, and I acknowledge that I will never research, remember, and recreate all the stories of my backyard. I write about people and experiences that I never wrote about in school where I tried to imitate the writing I read in thick textbooks. For many years I heard a persistent voice of warning that it is not sufficient to write about ordinary people, places, emotions, and experiences. It took me a long time to appreciate the extraordinary in the ordinary. If we do not learn to appreciate the significance of our own lived experiences, then we will always live in the frustrating illusions of fictive creations shaped in the images of popular and dominant cultures. In order to know the possibilities for our unique presence in the world, we need to be connected to words that represent as well as challenge our daily understandings of who we are and who we are becoming. We need to know our stories before we can attend to the stories of others with respect and care. Education is a process of becoming in the world, a process of becoming in language and discourse. In *Pedagogy of the Heart*, published posthumously, Freire (1997) acknowledges from the perspective of a long life drawing to a close that the space of his childhood backyard was connected to many spaces:

> My childhood backyard has been unveiling itself to many other spaces – spaces that are not necessarily other yards. Spaces where this man of today sees the child of yesterday in himself and learns to see better what he had seen before. To see again what had already been seen before always implies seeing angles that were not

perceived before. Thus, a posterior view of the world can be done in a more critical, less naïve, and more rigorous way.

(p. 38)

In my poetry I seek to know the spaces of my childhood backyard, and how this specific geographical space represents a location for locution in the bigger world because Freire (1997) encourages me that "the more rooted I am in my location, the more I extend myself to other places so as to become a citizen of the world. No one becomes local from a universal location" (p. 39). Educators and learners need to attend to the specific local locations, the places that they know intimately, in order to see those places with creative and critical imagination, and in order to see how those places are connected to intricate and complex interrelationships with many other places located at lines of latitude and longitude throughout the earth.

I agree with Griffin (1995) who contends that "poetry does not describe. It *is* the thing. It is an experience, not the secondhand record of an experience, but the experience itself" (p. 191). Therefore, I offer the following few poems as exemplars of my autobiographic research, poems that represent part of my ongoing efforts to learn to live well in the world, to learn to live well in relationships with others, with the past, with the earth, with all creatures, seeking always the lines of connection that transcend the personal and the professional, and generate in all the creation a dynamic energy.

SCRATCH IN MY THROAT

Four black birds sit in snow on the fence
inscribing my backyard.
Snow is rare in Steveston.

For a breath I linger in distant
Newfoundland where I lived
long winters in a sacred often scary land.
Wallace Stevens might ask
where are the other nine black birds.

I feel so close to a poem, its breath
a scratch in my throat in the tangled
midst of memories. I live with the past

trailing like a train of U-Hauls stuffed
with stories I no longer need, always hard

to clean the closet, especially in winter
when the stories might still be missed

like homespun sweaters, though this morning
while running on the dike I heard thousands
of snow geese write their way into the dawn
with a raucous eagerness for light.

RHIZOME

Newfoundland is far away.
Lynch's Lane lingers
in imagination and poetry,
bulldozed daisies of memory.

Last night my mother called.

 Cindy Mercer, my third or fourth cousin perhaps,
 but definitely a Mercer like my grandmother and mother,

 met a man through the Internet,
 moved to Australia and married him

 while Cindy Mercer's father said,
 Nice as you could meet anywhere,

like there was doubt, some
need to defend Australian niceness,

and in an April morning with a muffled breath
of spring, my mother's aunt Sal Mercer
who liked shopping but never spent a cent

hiked the Heights to the new Wal-Mart
but collapsed as the automatic doors opened,

dead before the ambulance arrived,
the end to nine decades of Mercer stories,
few Mercers left, except

there are Mercers everywhere

 married in Australia
 on their way to Wal-Mart
 seeking poems in British Columbia

rhizome connections in the earth,
the sheer certitude of lives spelled in
fields of wild plump strawberries
and sturdy crabgrass beyond counting.

ECOLOGY

In the solitude of sabbatical retreat
in York Harbour on the Atlantic cusp,
I learn to hear the heart's light
borne on titanium filaments,
strong and resilient, beyond breaking.

I live without a clock, in the heart's time,
no longer a crone's gigolo beating
the incessant whine of chronos
measured precisely like cement blocks.

Instead of rushing from task to task,
without end or satisfaction, compelling
my body to catch up when it can,
I now move slowly, feel my feet,
grounded, taste the heart's rhythm.

In my old life, I had little time for grief
or prayer, God lost in the frantic crowd,
but now I hold others in the heart's space,
in the quiet time of imagination's bounty.

In the still silence of York Harbour
like a monastery in moonlight on the edge
of the snowlight sea, I hold friends
on lines of latitude throughout the earth,
friends with hearts, both swollen and splintered.

In the half dozen months I have dwelled
here, one friend has died with cancer,
another has received the dread news,
two more are regaining health after cancer.

I hold each one like wind in trembling aspens
including my pastor who no longer knows God,
claims God no longer knows him, lost in middle age
like a tangled forest where he can't be found,

and Clive, scholarly and cantankerous,
who taught me Wittgenstein while I taught him
the basics of teaching grade 9's the novel,
whose heart stopped in Japan, my age, now gone.

In today's e-mail I learned Bill died
in his sleep. Could Bill have stayed up all night
and beat death like a Stephen King novel?
He sat daily on the rock outside our office building
with a tender smile for everyone hurrying by.

If I can believe in an invisible net of worldwide
interconnections in cyberspace, surely I can
believe in the ecology of words and lines of care
borne lightly in the heart, even the unbearable.

I will hold my friends through the blustery
winds of winter into the promises of spring
as I know they will hold me, in blood-beating
heart and imagination and memory beyond
all counting of tense time, in tenderness only.

QUESTIONS

1 Leggo suggests that poetry is not a reporting of an experience but the experience itself. How can this apply to research?
2 Leggo asserts that these are poems of personal processing. Why and how can such "personal" poems matter to the reader, particularly to the reader interested in educational scholarship? What is the purpose of both writing and reading this type of poem?
3 Eisner argues that ABER needs to focus on educational issues. How is Leggo's concern with autobiography an educational issue? If we accept Eisner's criteria, does Leggo's work affect the lives of students?
4 Leggo's poetry extrapolates metaphors from everyday experience. As a classroom exercise, ask students to write down a memory of their home life. This memory need not have any narrative structure, (i.e. beginning, middle, or end), or a crisis and denouement. Working in small groups, ask students to find themes in their writing. These themes can be as simple as descriptive verbs or adjectives. Still working in groups, have students think of metaphors or similes that extend, amplify, or enrich the memory. Finally, as a class, discuss whether these metaphors deepen our insight into the original memory that each student recounted. How do these metaphors invite what Barone (p. 39) calls "conspiracies?"

REFERENCES

Freire, P. (1997). *Pedagogy of the heart*. Trans. D. Macedo & A. Oliveira. New York: Continuum.

Griffin, S. (1995). *The eros of everyday life: Essays on ecology, gender and society*. New York: Doubleday.

Leggo, C. (2006a). Attending to winter: A poetics of research. In W. Ashton & D. Denton (Eds), *Spirituality, ethnography, and teaching: Stories from within* (pp. 140–155). New York: Peter Lang.

Leggo, C. (2006b). End of the line: A poet's postmodern musings on writing. *English Teaching: Practice and Critique*, 5(2), 69–92. Available at: http://education.waikato.ac.nz/research/journal/view.php?article=true&id=424&p=1.

Leggo, C. (2005a). Autobiography and identity: Six speculations. *Vitae Scholasticae: Journal of Educational Biography*, 22(1), 115–133.

Leggo, C. (2005b). Alphabet blocks: Expanding conceptions of language with/in poetry. *TESL Canada Journal*, 23(1), 91–110.

Leggo, C. (2005c). Pedagogy of the heart: Ruminations on living poetically. *Journal of Educational Thought*, 39(2), 175–195.

Leggo, C. (2005d). An archipelago of fragments: Writing other gendered lines of connection. *Men and Masculinities*, 8, 195–207.

Leggo, C. (2005e). The letter of the law/the silence of letters. In P. Trifonas (Ed.), *Communities of difference* (pp. 110–125). New York: Palgrave Macmillan.

Leggo, C. (2005f). The heart of pedagogy: On poetic knowing and living. *Teachers and Teaching: Theory and Practice*, 11(5), 439–455.

Leggo, C. (2004a). Listening to the silence: Honouring the complexity of the narratives we live. *Brock Education*, 14(1), 97–111.

Leggo, C. (2004b). Living poetry: Five ruminations. *Language & Literacy*, 6(2), 14. Available at: www.langandlit.ualberta.ca/current.html.

Leggo, C. (2004c). The curriculum of joy: Six poetic ruminations. *Journal of the Canadian Association of Curriculum Studies*, 2(2), 27–42. Available at: www.csse.ca/CACS/JCACS/V2N2.html.

Leggo, C. (2004d). Light and shadow: Four reasons for writing (and not writing) autobiographically. *Vitae Scholasticae: Journal of Educational Biography*, 21(1), 5–22.

Leggo, C. (2004e). The poet's corpus: Nine speculations. *Journal of Curriculum Theorizing*, 20(2), 65–85.

Leggo, C. (2004f). The curriculum of becoming human: A rumination. *International Journal of Whole Schooling*, 1(1), 28–36.

Leggo, C. (2004g). Tangled lines: On autobiography and poetic knowing. In A. L. Cole, L. Neilsen, J. G. Knowles, & T. C. Luciani (Eds), *Provoked by art: Theorizing arts-informed research* (pp. 18–35). Halifax, Nova Scotia: Backalong Books.

More than words can say

Researching the visual

Qualitative research most readily focuses on spoken and written words. This preoccupation with the complexity of language is evoked by Alan Peshkin who describes the task of the qualitative researcher as "making words fly" (Glesne & Peshkin, 1992). As demonstrated by the poets and dramatists who have presented their works of scholARTistry in Sections II and IV of this text, arts-based researchers share a concern with the crafting and evocative power of words. However, arts-based research extends beyond the aesthetic application of language. It also includes visual research that focuses on the non-linguistic communicative power of images featured in Section III.

In arts-based research, the creation of images may produce data. Creating images may also be a method of data analysis as well as a means of data representation. In these ways, arts-based research moves beyond reading semiotic meaning from photographic representations (Pink, 2001).

Opening research to the *making* – not simply the photographic *recording* – of visual images challenges over 2,000 years of Western philosophy. Plato argued that all visual images are essentially lies – pale imitations of a reality they seek to reference. Images were not trustworthy, and the individuals who trafficked in them were dangerous frauds (Hamilton & Cairns, 1961). In the mid-eighteenth century, the field of aesthetics challenged this age-old prejudice by suggesting that the visual was a realm of negotiated meaning (Siegesmund, 1999). Nevertheless, a prejudice against the visual continued in mainstream science. Quantitative analysis and analytic logic remain the dominant forms of discourse (Eisner, 1994).

The visual – photography, and particularly filmmaking – emerged relatively simultaneously with the formal academic fields of anthropology and sociology. In these academic disciplines, the camera was regarded as a neutral and disinterested tool that recorded facts. Photographic evidence was assumed to benchmark a "fixed" reality. Later photographic evidence showing how a culture might have changed over

time was interpreted as a deterioration of an "authentic" culture (Banks, 2001).

Analysis of these images, through language, reveals layers of semiotic meanings. This could be called an *objective* view of the visual. Contemporary objective approaches also investigate how an image was constructed. We now ask, in what ways might researchers actively, or passively, manipulate and stage a scene before the photograph was taken – with or without the collusion of the participants? To fully understand a visual representation requires both an analysis of the visual evidence as well as the underlying contexts and conditions through which the image was conceived, created, and marketed (Pink, 2006).

Arts-based research adds to these methods of analysis. As he discusses in this text, Eisner, through his arts-based methodology of educational criticism (Eisner, 1991), initially sought to apply the methods and procedures for the analysis of aesthetic works of art to the study of human interactions within the context of schools. In his approach, the researcher took on the role of the critic – and the role of the critic is to educate perception (Dewey, 1934/1989). With the guidance of the critic, we learn to see what we otherwise would have failed to notice. This is accomplished through attention to subtle qualitative relationships and the felt reactions they generate – in addition to semiotic significance. Through the lens the critic provides, our felt reaction to a work of art – the aesthetic meaning we can extract – is enhanced. This view could be called a *formative* approach to the visual. This role of arts-based research as a task of learning to see, and thereby learning to feel, is an important aspect of the methodology of a/r/tography and all of the scholARTists represented in this section.

In this regard, Stephanie Springgay's ScholARTistry focuses on what we do not wish to see. Springgay has analyzed (through both words and sculpture she has created) the mediated understandings that emerge to the sight of her breast-feeding her child at academic conferences, family restaurants, or in airplanes. Giving sight to the unseen is also an important aspect of Barbara Bickel and Joanne Elvy's work.

However, the arts-based researchers who are presented in this section have pushed the visual to a new level. They do more than help us see an external reality that heretofore has gone unnoticed by *reading* images. They actively form a new visual reality by *creating* images. The visual is not just a tool for recording, analyzing, or interpreting data, it has becomes a tool for the production of data. The visual has reached a new dimension. It has become *generative*.

Thus, visual research can be seen as falling across a spectrum anchored at one end by the objective rendering of images and at the other by the generative creation of images, with the formative falling in

the middle. Arts-based research is located between the formative and the generative points of this continuum.

Arts-based visual research reminds us that data is not found; it is constructed. It emphasizes the authority of both researcher and reader to create personal meaning from a work of research – rather than relay or receive an external meaning. As images exponentially increase in our lives – from the visual display of information on cell phones, to the visual presentation of data through the internet, and the ubiquitous presence of digital cameras, scanners – as well as the continuing influence of film and television – the power of the visual has implications for all qualitative researchers.

In addition, as the scholARTists in this section demonstrate, the continuing self-creation of images in traditional visual arts media remains a powerful tool for investigation, analysis, and presentation of data. Therefore, the inclusion of structured training in the visual – the objective, the formative, and the generative – is a challenge to the preparation of future qualitative researchers in mediated understanding.

REFERENCES

Banks, M. (2001). *Visual methods in social research*. London and Thousand Oaks, CA: Sage.

Dewey, J. (1989). Art as experience. In J. Boydston (Ed.), *John Dewey: The later works, 1925–1953* (pp. 1–400). Carbondale: Southern Illinois University Press. (Original work published 1934.)

Eisner, E. W. (1991). *The enlightened eye: Qualitative inquiry and the enhancement of educational practice*. New York: Macmillan.

Eisner, E. W. (1994). *Cognition and curriculum reconsidered*. (2nd edition). New York: Teachers College Press.

Glesne, C. & Peshkin, A. (1992). *Becoming qualitative researchers: An introduction*. New York: Longman.

Hamilton, E., & Cairns, H. (Eds). (1961). *The collected dialogues of Plato including the letters*. Princeton, NJ: Princeton University Press.

Pink, S. (2001). *Doing visual ethnography: Images, media, and representation in research*. London: Sage.

Pink, S. (2006). *The future of visual anthropology: Engaging the senses*. London and New York: Routledge.

Siegesmund, R. (1999). Reasoned perception: Aesthetic knowing in pedagogy and learning. *Arts and Learning Research, 15*(1), 35–51.

Chapter 9

A/r/tography as
practice-based research

Rita L. Irwin
University of British Columbia, Vancouver, British Columbia
and
Stephanie Springgay
Pennsylvania State University, University Park, Pennsylvania

Photography by A. Reid, Fedcan.

Rita L. Irwin is a Professor of Art Education and Curriculum Studies, and
Associate Dean of Teacher Education, at the University of British
Columbia, Vancouver. She has been an educational leader for a number of
organizations including being President of the Canadian Society for
Education through Art, the Canadian Association of Curriculum Studies,
and most recently the President of the Canadian Society for the Study of
Education, an organization that represents educational researchers from
across Canada. Her research interests have primarily focused on teacher
education, sociocultural issues, arts education, and the development of
artistic forms of educational inquiry. She is best known for her work in
a/r/tography. Her artistic pursuits are often autobiographical in nature and

have recently been concerned with liminal identities. Rita publishes widely, exhibits her artwork, and has secured many research grants, including Social Science and Humanities Research Council of Canada grants to support her research in Canada, Australia, China, and Taiwan. Two of her most recent co-edited books include *Curriculum in a New Key: The collected works of Ted T. Aoki* (co-edited with William F. Pinar) and *A/r/tography: Rendering self through arts-based living inquiry* (co-edited with Alex de Cosson).

Stephanie Springgay is an Assistant Professor of Art Education and Women's Studies at Penn State University, University Park, Pennsylvania. Her research and artistic explorations focus on issues of relationality and an ethics of embodiment. In addition, as a multidisciplinary artist working with installation and video-based art, she investigates the relationship between artistic practices and methodologies of educational research through a/r/tography. She is the m/other of Maurya age two, who has just moved into a "big girl bed" and is expecting her second child this spring. Stephanie is a breastfeeding advocate and activist. Recent publications include: Thinking through bodies: Bodied encounters and the process of

meaning making in an email generated art project, *Studies in Art Education*; An intimate distance: Youth interrogations of intercorporeal cartography as visual narrative text, *Journal of the Canadian Association of Curriculum Studies*; Body as fragment: Art making, researching, and teaching as a boundary shift, *A/r/tography: Rendering self through arts-based living inquiry*; and A/r/tography as living inquiry through art and text, *Qualitative Inquiry* with Rita Irwin and Sylvia Kind. She is also co-editor with Debra Freedman of *Curriculum and the Cultural Body* published by Peter Lang.

We're waiting for the bus that travels south on Granville Street in Vancouver, British Columbia. For weeks we've been staring down the street from the bus stop at a storefront window that appears to function as a type of shelter for the public – sometimes seemingly random people stop and step inside only to emerge again and continue on their journey. It dawns on us one morning, when the coffee is extra strong and frothy, that what we've been witnessing is in fact a recent exhibition by the Canadian artist Germaine Koh at the Katriona Jeffries Gallery. *Shell* is one of Koh's recent explorations into the behaviours and situations that define and construct public and private space. Fashioned from aluminum, plexiglass, and plywood, Koh has modified the glass-fronted private space of the gallery. An enclosure is built on the inside of the space, attached to the existing glass front of the gallery, but with a pane of glass removed in order to create free access to the structure from the street. In contrast to the gallery, the public has access to this space 24 hours a day. Resembling a bus shelter, and conjuring up metaphors of crustacean shells (Szewczyk, 2005) this in-between space which is both and neither private or public, exposes the vulnerability of private space, the fragility of safety, seclusion, and property (Koh, 2005). As Monica Szewczyk (2005) writes in the exhibition text, Koh's space accentuates both the contemplation of time, and the wasting or killing of time. Koh's architectural intervention is a transitory space, waiting to be filled and acted upon, inviting participation in the in-between. It is this openness, uncertainty, and exposure of meaning that situates this work and others like it, as potential acts that allow us to inquire into and create new models for thinking and conducting research. Just as Koh's art presents a vulnerable space between private and public, how might we begin to think of research methodologies as relational situations that provoke meaning through contemplation, complication, and as alternative models of space and time?

In this essay, we introduce the features of a/r/tography. We draw on scholarship from philosophy, phenomenology, educational action

research, feminist theories, and contemporary art criticism to theorize the methodology of a/r/tography, with an attention to the *in-between* where meanings reside in the simultaneous use of language, images, materials, situations, space, and time.

A/r/tography is a research methodology that entangles and performs what Gilles Deleuze and Felix Guattari (1987) refer to as a rhizome. A rhizome is an assemblage that moves and flows in dynamic momentum. The rhizome operates by variation, perverse mutation, and flows of intensities that penetrate meaning, opening it to what Jacques Derrida (1978) calls the "as yet unnamable which begins to proclaim itself" (p. 293). It is an interstitial space, open and vulnerable where meanings and understandings are interrogated and ruptured. Building on the concept of the rhizome, a/r/tography radically transforms the idea of theory as an abstract system distinct and separate from practice. In its place, theory is understood as a critical exchange that is reflective, responsive, and relational, which is continuously in a state of reconstruction and becoming something else altogether. As such, theory *as* practice becomes an embodied, living space of inquiry (Meskimmon, 2003).

In turn, rhizomes activate the *in-between;* an invitation to explore the interstitial spaces of art making, researching, and teaching. According to Elizabeth Grosz (2001):

> The space of the in-between is the locus for social, cultural and natural transformations: it is not simply a convenient space for movements and realignments but in fact is the only place – the place around identities, between identities – where becoming, openness to futurity, outstrips the conservational impetus to retain cohesion and unity.
>
> (pp. 91–105)

Like Koh's *Shell*, the in-between disrupts dualisms (private and public or neither). Similarly, it is not merely a physical location or object but a *process*, a movement and displacement of meaning (Grosz, 2001). Contemporary art criticism argues that the relationship between artist and place is a complex discourse where place is re-imagined as "situation." Site moves from a fixed geographical category to a relational constitution of social, economic, cultural and political processes (Doherty, 2004; Kwon, 2002). Process becomes intertextually and multiply located in the context of discursive operations. It is a process of invention rather than interpretation, where concepts are marked by social engagements and encounters. Again we turn to Deleuze and Guattari (1994) and their arguments: "[c]oncepts are centres of vibrations, each in itself and every one in relation to all the others. This is

why they all resonate rather than cohere or correspond with each other" (p. 23). Meaning and understanding are no longer revealed or thought to emanate from a point of origin rather they are *complicated* as relational, rhizomatic, and singular.[1]

A/r/tography as practice-based research is situated in the in-between, where theory-as-practice-as-process-as-complication intentionally unsettles perception and knowing through living inquiry. Our chapter will examine the constructs and conditions of a/r/tographical research: as practice-based research, as communities of practice, as relational aesthetics, and through six renderings of engagement. The chapter further complicates the space of doing a/r/tographical research, unfolding a series of questions about the possibilities and challenges of practicing this form of qualitative research.

PRACTICE-BASED THEORETICAL UNDERPINNINGS

Our understandings of practice-based research are informed by feminist, post-structuralist, hermeneutic and other postmodern theories that understand the production of knowledge as difference thereby producing different ways of living in the world (St. Pierre, 2000). One way of understanding this is through theories of touch and intercorporeality (Springgay, 2003, 2004a, 2004b, 2005a, 2005b, 2006; Springgay & Freedman, 2007). Western thought has been primarily influenced by Cartesian rationalism which isolates the distinct and autonomous subject, whose "vision" of the world is separate and distanced from the object perceived. "I see" is commonly understood to mean "I know." Thus, distant, objective vision is a means by which to judge or examine phenomena. However, a phenomenological, feminist, and/or a/r/tographical approach to understanding through touch reconfigures the ways in which we perceive objects, providing access to depth and surface, inside and outside (Grosz, 1994; Merleau-Ponty, 1968). Touch expresses active involvement with the subject matter. Touch becomes a mode of knowing through proximity and relationality and poses different ways of making sense of the world, challenging the mechanisms of visual perception. Similarly, it draws attention to sensory experiences and knowledge that is interconnected with our bodies and with others.

In contrast to rationalist thought which imposes system and order, classifying and categorizing the world in dualistic terms, where individual consciousness is viewed as private, self-contained, and invisible, theories of touch propose that subjects are interconnected. According to Maurice Merleau-Ponty (1968) "to comprehend is to apprehend by coexistence" (p. 188) and Jean Luc Nancy (2000) reiterates this

concept, maintaining that meaning is constituted between beings. A/r/tography resides in this intercorporeal space, and attends to the forms and folds of living bodies. It is a thinking that reflects on inter-embodiment, on being(s)-in-relation, and communities of practice. Research becomes a process of exchange that is not separated from the body but emerges through an intertwining of mind and body, self and other, and through our interactions with the world.

What emerges from such considerations is an understanding of embodiment as "being in motion" (Ellsworth, 2005). Yet this "being in motion" is not the act of a hand moving a paintbrush, or a dancer's limbs being catapulted across the stage. Such understandings of the arts and embodiment are limiting and superficial, akin to Gardner's theories of multiple intelligences. While "movement" can be embodied, it isn't always. Likewise, a painter can sweep their arms across a canvas and it can be a disembodied action. Rather, embodiment is constituted through the self/body's movement, force, action, and transformation "in the making" (Ellsworth, 2005). Accordingly, Elizabeth Ellsworth (2005) contends: "embodiment puts us into a moving relation with forces, processes, and connections to other in ways that are unforeseen by consciousness and unconnected to identity" (p. 121). This imme-diate, living, and unfolding body is enmeshed with an understanding of the cultural location and the specificity of the body (Garoian & Gaudelius, 2007).

> Embodiment is not about identity per se, a topic of earlier perfor-mative representations, but about subjectivity. As such, embodi-ment is not an immutable signifier of identity, but is a signifier of multiplicity existing within a complex web of cultural understand-ings and significations.
>
> (Garoian & Gaudelius, 2007, p. 9)

Likewise it is dangerous to suggest that the arts are more suited to embodied forms of learning and research. This continues to perpetuate a cognitive/bodied divide between the arts and other (the "serious" or "hard") disciplines. Rather, as Ellsworth (2005) argues, "some know-ings cannot be conveyed through language" (p. 156) and as such invite us to "acknowledge the existence of forms of knowing that escape the efforts of language to reference a 'consensual', 'literal', 'real' world" (p. 156). This knowing, Ellsworth purports, moves us beyond "explanation" that can be commodified, captured, and in essence "taught," towards a way(s) of knowing that is rooted in embodiment as being in motion, relational, and singular. The arts, or a/r/tographical research, we argue, provide potential time-space inter-vals for the "coming of a knowing" (Ellsworth, 2005, p. 158).

For instance, recent bodies of literature in the arts and education are exploring how practices inherent in the work of artists and educators are indeed forms of research. The intellectual, imaginative, and insightful work created by artists and educators as practitioners is grounded in ongoing forms of recursive and reflexive inquiry engaged in theorizing for understanding. This perspective is in contrast to longstanding traditions – that have enveloped both the arts and education – in which research is perceived as a means of gathering and interpreting data using traditions steeped in social-science disciplines such as sociology, history, and anthropology, or in natural-science disciplines such as biology. Though these traditions and their research paradigms address questions of great interest to society, they have a particular orientation to knowledge that is quite different from inquiry steeped in the practices of many artists and educators. Whereas the disciplinary-based science traditions perceive research and theory as a means of explaining phenomenon or revealing meaning, practitioner-based research perceives research as a disposition for knowledge creation and understanding through acts of theorizing as complication. In the earlier instance, theory and research serves to find answers to questions. In practitioner-based research, theorizing through inquiry seeks understanding by way of an evolution of questions within the living-inquiry processes of the practitioner. In other words, practitioners are interested in an ongoing quest for understanding, a questing if you will. This active stance to knowledge creation through questioning informs their practices making their inquiries timely, emergent, generative, and responsive to all those involved.

Many people see artists as practitioners (see Bird, 2000; Brown, 2000) and educators as practitioners (see Britzman, 2003). Graeme Sullivan, an advocate of art practice as research, argues for practice-based research and states that theorizing for understanding through practice is "grounded in the praxis of human engagement and yield[s] outcomes that can be seen to be individually liberating and culturally enlightening" (2004, p. 74). He goes on to state: "If a measure of the utility of research is seen to be the capacity to create new knowledge that is individually and culturally transformative, then criteria need to move beyond probability and plausibility to *possibility*" (italics in original, p. 72). These ideas resonate with the work of Terrance Carson and Dennis Sumara (1997) who talk about action research as a living practice. In educational circles, teacher research is a practitioner-based form of action research. Carson and Sumara talk about educators who, as action researchers, are deeply committed to meditative and contemplative practices: "lived experiences that permit an openness to the complexity of the relations among things and people" (1997, p. xv). Although they suggest that a commitment to writing is required in

living a life of awareness, they also acknowledge the potential of an artistic commitment to changing habits of expression. In this way, practices are not comfortable taken-for-granted ways of being but are rather the challenging practices of learning to perceive differently within our everyday practices. Carson and Sumara state:

> As all artists know, the greatest challenge to producing works that interrupt normalized ways of perceiving and understanding is to learn to perceive freshly.... Learning to perceive differently, then, requires that one engage in *practices* that, in some way, remove one from the comfortable habits of the familiar.
>
> (1997, italics in original, p. xvii)

When asked how one conducts a life committed to educational action research, they suggest:

> Who one *is* becomes completely caught up in what one knows and does. This effectively eliminates the tiresome *theory/practice* problem that continues to surface in discussions of educational action research, for it suggests that what is thought, what is represented, what is acted upon, are all intertwined aspects of lived experience and, as such, cannot be discussed or interpreted separately.
>
> (1997, italics in original, p. xvii)

We would go a step further by saying that knowing (theoria), doing (praxis), and making (poesis) are three forms of thought important to a/r/tography (see Leggo, 2001; Sullivan, 2000). Relationships between and among these ways of understanding experience are integral to an intertextuality and intratextuality of ideas and form a foundation for a/r/tography (see Irwin, 2004). All three ways of understanding experience, theoria, praxis, and poesis, are folded together and form rhizomatic ways of experiencing the world. This is important as we come to appreciate how a/r/tography is conceived as research. Thus,

> action research [and a/r/tography] practices are deeply hermeneutic and postmodern practices, for not only do they acknowledge the importance of self and collective interpretation, but they deeply understand that these interpretations are always in a state of becoming and can never be fixed into predetermined and static categories.
>
> (Carson & Sumara, 1997, p. xviii)

Whereas many forms of research are concerned with reporting knowledge that already exists or finding knowledge that needs to be uncov-

ered, action research and a/r/tography are concerned with *creating the circumstances* to produce knowledge and understanding through inquiry-laden processes (see Irwin *et al.*, 2006).

COMMUNITIES OF PRACTICE

Practitioner-based research is necessarily about self but it is also about communities of practice. Individuals committed to inquiry are situated in communities of practice. Deborah Britzman suggests that for teachers:

> To theorize about one's experience means to engage one's reflective capacities in order to be an author of that experience.... The sources of theory, then, are in practice; in the lived lives of teachers, in the values, beliefs, and deep conviction enacted in practice, in the social context that encloses such practice, and in the social relationships that enliven the teaching and learning encounter
>
> (2003, pp. 64–65)

Through a dialogical perspective teachers are able to engage in independent and socially transformative activities by theorizing practice.

Relations between and among teachers, students, and society are important to this dialogical perspective. Yet, this is also true for artists, audiences, and institutions. Relations in artistic communities of practice are equally important. Artists do not create in a void. Their work is necessarily related to the work of others, and their theorizing happens within communities of affiliation. Whether as an artist, educator or researcher, a/r/tographers acknowledge the work of others in the documentation of their own work. For many this would mean attending exhibitions or performances or reading about artists and sharing this knowledge in one's a/r/tographic work. It would also mean reading about research in education and sharing the work of educational researchers. Citational practices are important for a community of practice-based researchers wanting to understand a body of literature and work in their fields while positioning their own work within those and potentially other fields. Furthermore, as a/r/tographers work with others, the potential exists for many individuals and groups to become a/r/tographers in a way that is appropriate for them. Thus, primary teachers can be a/r/tographers working with young children who may engage in age-appropriate forms of a/r/tographic practice. Alternatively, community-based artists could be a/r/tographers working with community members who in turn become a/r/tographers as they rethink

taken-for-granted ways of being in their communities. In essence, it is the intertextual situations that provoke a/r/tographical research, not necessarily academic intentions.

A/r/tography is steeped in the practices of artist-educators committed to ongoing living inquiry and it is this inquiry that draws forth the identity of a researcher. Artist/researcher/teacher identities contiguously exist in relationship to one another (see Springgay *et al.*, 2005). In communities of a/r/tographers, it may be that separate communities of artists, educators, and researchers exist yet it is more likely that hybrid communities of artists, educators, and researchers locate themselves in the space of the in-between to create self-sustaining interrelating identities that inform, enhance, evoke, and/or provoke one another. It is here that a definition of artist and educator should be considered.

A/r/tography as living inquiry necessarily opens the way to describing and interpreting the complexity of experience among researchers, artists, and educators, as well as the lives of the individuals within the communities they interact with. As a result, it also opens the topics, contexts, and conditions of inquiry. Although a/r/tography privileges the identities of artist, researcher, and teacher within its name one needs to be thoughtful about how these identities might be conceptualized. For instance, educator may be a more inclusive title for the identity of the individual we are imagining. Many artists and educators have questioned the boundaries placed upon their identities and as such have interrupted the hegemony of schooling as a primary location for education (see Barone, 2001) as well as the hegemony of art-world establishments as primary gatekeepers to art and art institutions. With this said, it is important to point out that education in the context of a/r/tography is broadly conceived to mean any contexts concerned with learning, understanding, and interpretation. Therefore, educators who consider themselves a/r/tographers are those individuals who are committed to acts of learning, teaching, understanding, and interpreting within communities of learners. Similarly, within a/r/tography, art is broadly conceived to mean sensory-oriented products understood, interpreted, or questioned through ongoing engagements and encounters with the world. Artists are therefore committed to acts of creation, transformation, and resistance. Artists engaged in a/r/tography need not be earning a living through their art, but they need to be committed to artistic engagement through ongoing living inquiry. Educators engaged in a/r/tography need not be K-12 educators, nor educators within higher education, but they need to be committed to educational engagement that is rooted in learning and learning communities, through ongoing living inquiry. In this way, both artists and educators can be found in many contexts employing a range of ideas and materials. Perhaps more importantly, the relationship between artists and educators becomes

somewhat blurred using our definitions. Both artists and educators are concerned with learning, change, understanding, and interpretation. It is in this complex space of the in-between that the disposition of inquiry brings us to a researcher identity through an implicit and explicit commitment to ongoing living inquiry across the domains of art and education. Earlier, we stated that action research is concerned with creating the circumstances to produce and complicate knowledge and understanding through inquiry-laden processes. In effect, a/r/tographers are concerned with creating the circumstances that produce knowledge and understanding through *artistic and educational* inquiry-laden processes.

THE RELATIONAL IN-BETWEEN OF SPACE AND TIME

A/r/tography is a process of unfolding image and text together (image in this sense could mean poetry, music, or other forms of artistic inquiry). As a research methodology that intentionally unsettles perception and complicates understandings, how we come to know and live within space and time is subsequently altered. Since the 1960s artists have engaged in what has commonly come to be understood as site-specific work. Miwon Kwon (2002) identifies various permutations of this form including site-determined, site-oriented, site-referenced, site-responsive, and site-related. All of these various terms are concerned with the relationship between the art work and its site; how the production, presentation, and reception of the work incorporated the physical conditions of a particular location (Kwon, 2002). However, as Kwon argues, the term "site" itself needs to be redefined not through physical or local terms, but as a complex figure in the unstable relationship between location and identity. In other words "sites" are not geographically bound, but informed by context, where "context [is] an impetus, hindrance, inspiration and research subject for the process of making art" (Doherty, 2004, p. 8). Site is not a fixed category but constituted through social, economic, cultural, and political processes, which Nicholas Bourriaud (2001, 2002, 2004) calls *relational aesthetics*. Like Kwon, Bourriaud contends that in "site-specific" art or "situations" (see Doherty, 2004) both process and outcome is marked by social engagements. These encounters breakdown the conventional relationships between artist, art work, and audience. The artists and art works that are the subjects of Kwon and Bourriaud's investigations create art as a socially useful activity:

> The forms that [the artist] presents to the public [does] not constitute an artwork until they are actually used and occupied by people.
>
> (Bourriaud, 2004, p. 46)

In this instance the audience moves from beholder of art (interpretation) to interlocutor (analyzer). In many instances audiences are actually called to a specific time and place where they become active participants in the art work, and thus argues Bourriaud (2004) alternative modes of sociality are created. *Shell* exemplifies this slippage between time and space, a condition of relational aesthetics. Meaning making within relational aesthetics is embodied in the intercorporeal negotiations between things.

Another theoretical way of understanding relationality of space and time is through complexity theory. According to Sumara and Carson (1997) complexity theory "suggests that the world is organized and patterned in ways that can be mathematically modeled but not in a predictive, linear, or deterministic manner" (p. xviii). Understandings emerge "from the associative relations among complex interactions" (p. xix). Therefore how we make meaning of images and texts is contingent upon the relations between artist (or in this case let us say a/r/tographer), art work, text, and audience and social, cultural, economic, and political contexts, and the ways these relations are altered by what Derrida (1978) calls the "as yet unnamable which begins to proclaim itself" (p. 293) – that which is not readily apparent. Thus, relationality is more than just the contexts that are brought to bear on particular "sites" but the potentialities and the "other thans" (Springgay, 2004a, 2004b) that continuously evolve and provoke meaning. Merleau-Ponty (1968) writes of this intertwining between self and other, inside and outside, as a way of becoming folded together in a porous encounter that leads to openings between subjects. Each subject is created through encounters *with* others and it is this *with* that creates the contiguity and distinctiveness of aesthetic forms (see Nancy, 2000).

In western cultures, time is typically perceived as uniformly flowing without regard for individuals, events, or contexts. Space is typically perceived as a container or even a vast emptiness (outer space). Yet artists, poets, performance artists, novelists, and musicians perceive time and space differently. They often speak of time as pausing, enduring, changing, interrupting, and pacing, and speak of space as openness, fragmented, endless, confined, and connected. Artists see time and space as conditions for living, conditions for engaging with the world through inquiry. After all, how we perceive time and space in the world affects how we engage with the world.

Educators also see time and space in particular ways. Complexity theories of learning (Davis *et al.*, 2000) describe learning as participatory and evolutionary. Learning therefore is never predictable and is understood to be a participation in the world, a kind of co-evolution of those learning together. Thus, learners would be interested in keeping pace with their changing yet evolving circumstances. One might call this

relational learning in that contiguous entities such as mind/body, theory/practice, or artist/researcher/teacher are not separate or dichotomous but are "enfolded in and unfold[ed] from one another" (p. 73) as learning becomes more sophisticated, flexible, and creative within acts of relationality. The notion of a fold (see Springgay, 2003, 2004a, 2004b) is important to a/r/tography as it suggests an infinite number of undulating entities unable to be separated into parts: in fact, through un/folding more folding may result. Understanding a/r/tography as un/folding the phenomena and/or identities being studied "can be simultaneously seen as a whole, a part of a whole, or as a complex compilation of smaller wholes" (Davis *et al.*, 2000, p. 73). Therefore learning becomes concerned with critical concepts rather than isolated facts, and the interconnections between concepts – learning as rhizomatic.

CONCEPTUAL PRACTICES: RENDERINGS

The research conditions of a/r/tography reside in several notions of relationality: relational inquiry, relational aesthetics, and relational learning. Mieke Bal (2002) and Irit Rogoff (2001) have informed our work through their discussions of interdisciplinarity. Rogoff suggests that an emphasis upon process rather than method allows an active space for participation that lies between existing disciplines and their methodologies while resisting the formation of new methodological criteria. It is this pr ˜s space that alludes to the conditions for research. Furthermore, we look to Bal for an understanding of how to engage with these relational aspects. She suggests that interdisciplinarity "must seek its heuristic and methodological basis in *concepts* rather than *methods*" (italics in original, 2002, p. 5).

We interpret concepts to be flexible, intersubjective locations through which close analysis renders new understandings and meanings. These concepts or renderings, as we prefer to call them, guide our active participation in making meaning through artful, educational, and creative inquiry. Renderings offer possibilities for engagement and do not exist alone but in relation to one another. Though it is tempting to suggest these renderings are criteria for a/r/tography, they are better perceived as rendered possibilities.

Renderings are embedded in the processes of artful inquiry (in any art form such as music, dance, drama, poetry, and visual arts) and writing. To be engaged in a/r/tography means to inquire in the world through both processes, noting that they are not separate or illustrative processes but interconnected processes. Relational inquiring through relational aesthetics and relational learning is constitutive rather than descriptive and may represent the work of a single a/r/tographer, a

community of a/r/tographers and/or an audience member's process of meaning making. Each individual and group informs and shapes the living inquiry. Therefore, renderings are concepts that help a/r/tographers portray the conditions of their work for others. Elsewhere, we have interpreted each rendering in great detail (Springgay *et al.*, 2005). For the purpose of this chapter we would like to briefly describe each of the six renderings: contiguity, living inquiry, metaphor/metonymy, openings, reverberations, and excess.

Contiguity

Contiguity is a rendering that helps us understand those ideas within a/r/tography that lie adjacent to one another, touch one another, or exist in the presence of one another. This happens in several ways. First of all, contiguity is found with the artist, researcher and teacher identities existing simultaneously and alongside one another. The forward slash or fold portrays this act of contiguity. Secondly, contiguity is found in the relationship between art and graphy, that is, between the art form and writing with, in, or about the phenomenon. And thirdly, contiguity is found in the act of double imaging between art as an activity or product and a/r/t as a symbolic representation of the three constituent identities. To live the life of an a/r/tographer is to live a contiguous life sensitive to each of these relationships and particularly to the spaces in-between. Being attentive to the in-between spaces opens opportunities for dynamic living inquiry. A/r/tographers may visualize these in-between spaces as parts of an endless fold, or folds within folds, or as concepts linked together. A/r/tographers may or may not choose to include text as part of their art forms but they will always include textual materials and writing in their ongoing inquiry processes (Richardson, 1994). This includes citing and engaging with the work of other artists, researchers, and educators as a/r/tographers pursue their inquiries. These acts of contiguity ensure relational inquiry and learning amidst an attention toward relational aesthetics.

Living inquiry

Living inquiry, another rendering, refers to the ongoing living practices of being an artist, researcher, and educator. Elsewhere we have defined living inquiry as "an embodied encounter constituted through visual and textual understandings and experiences rather than mere visual and textual representations" (Springgay *et al.*, 2005, p. 902). Though this definition privileges the visual, any sensory form can be applied. Living inquiry is a life commitment to the arts and education through acts of inquiry. These acts are theoretical, practical, and artful ways of creating

meaning through recursive, reflective, responsive yet resistant forms of engagement. A/r/tography is a methodology of embodiment, of continuous engagement with the world: one that interrogates yet celebrates meaning. A/r/tography is a living practice, a life-creating experience examining our personal, political, and/or professional lives. It uses a fluid orientation within the contiguous relationships described earlier. Its rigor comes from its continuous reflective and reflexive stance to engagement, analysis, and learning. This can include any qualitative form of data collection such as interviews, journal writing, field diaries, artifact collections, and photo documentation, yet it can also encompass any form of artistic inquiry such as painting, composing music, and writing poetry, and educational inquiry such as student journal writing, teacher diaries, narratives, and parent surveys. The reflexive and reflective stance to analysis will be ongoing and may include aspects from traditional ethnographic forms of inquiry such as constantly comparing themes that emerge from the data. What is important is the attention given to ongoing inquiry through an evolution of research questions and understandings. It is here that the difference between thesis and exegesis is important. Most research is designed to answer, address, or create a proposition that is advanced through an argument. This is called a thesis. In a/r/tography and other arts-based or arts-informed types of research, an exegesis is more suitable. An exegesis is a critical explanation of the meaning within a work. In the arts, an exegesis is often extended to include any documentation that contextualizes the work (see Sullivan, 2004) and helps to critique or give direction to theoretical ideas. Some theorists suggest that this documentation should not be considered research but rather the method by which ideas are conceived (see de Freitas, 2002). We prefer to see the process of living inquiry, as well as the understanding created through the inquiry, as comprising the full research enterprise. An exegesis provides opportunities to do just that.

From time to time, a/r/tographers may choose to share their inquiries with others and it is here that products are refined and shared. These living-inquiry moments are not end results but rather understandings of experiences along the way. Thus, a/r/tography needs to be pursued continuously over time while searching for ways to disseminate aspects of the work at particular moments in time. Artists may wish to display or perform their artistic works in particular venues while educators may wish to share their scholarly engagements in other venues. Though these endeavours are not separate, there are times when particular aspects may be highlighted for unique audiences.

Metaphor and metonymy

A/r/tographers will naturally favor the third rendering: metaphor and metonymy. Through metaphors and metonyms, we make sense of the world and we make relationships accessible to our senses (see Richardson, 2002). Both tropes open possibilities for meaning making: metaphor through its substitution of signifiers and metonym through its displacement of subject/object relations (see Aoki *et al.*, 2001). Metaphors and metonyms exist as intertwined relationships in which meaning un/creates itself. There is at once a loss of meaning, a realization of meaning, or neither. Just as there is contiguous movement between other concepts so too is there between metaphor and metonymy. This movement reverberates in and through each rendering as struggles in understanding emerge and shifts in awareness take place. It is in these struggles that openings are created.

Openings

One purpose of a/r/tography is to open up conversations and relationships instead of informing others about what has been learned. Another purpose of a/r/tography is to open up possibilities for a/r/tographers as they give their attention to what is seen and known and what is not seen and not known. Openings are not necessarily passive holes through which one can see easily. Openings are often like cuts, tears, ruptures, or cracks that resist predictability, comfort, and safety. It is here that knowledge is often created as contradictions and resistances are faced, even interfaced with other knowledge. Meanings are negotiated by, with, and among a/r/tographers as well as with their audiences. It is in these conversations that multiple exchanges co-exist and reverberate together.

Reverberations

Reverberations refer to a dynamic movement, dramatic or subtle, that forces a/r/tographers to shift their understandings of a phenomenon. Reverberations often take us deeper into meanings or they shift us toward a slippage of meaning. Pollock talks about nervous performative writing in a similar fashion, suggesting that it "anxiously crosses various stories, theories, texts, intertexts, and spheres of practice, unable to settle into a clear, linear course, neither willing nor able to stop moving, restless, transient and transitive" (1998, pp. 91–99).

Excess

Research then becomes an evocation, a provocation, calling us to transformation. This transformation often happens with some attention to the final rendering of excess (see Bataille, 1985). Excess is that which is created when control and regulation disappear and we grapple with what lies outside the acceptable. Excess may deal with the monstrous, the wasteful, the leftover, and the unseen, as well as the magnificent and the sublime. It is also the "as yet unnamable" the "other than" – those aspects of our lives and experiences that are potentials and filled with possibility. Excess opens up opportunities for complexifying the simple and simplifying the complex by questioning how things come into being and the nature of their being.

Renderings, as the conceptual practices of a/r/tography move into the boundaries between theory, practice, and creative activity and allow each to impact one another. A rigorous attending to the renderings will result in deep interactions within the relational conditions of relational inquiry, relational aesthetics, and relational learning. An assessment of any a/r/tographic work will depend upon its compelling ability to yield access to, and new insights about, a particular phenomenon.

PRACTICING A/R/TOGRAPHY: CONTRIBUTIONS AND CHALLENGES

If encounters like the work of *Shell* embody an a/r/tographical position, how does one engage in a/r/tographical educational research? Without appearing pedantic in responding to this question, we firmly believe that a/r/tographical work entails living and inquiring in the in-between, of constantly questing, and complicating that which has yet to be named. The transformative power of theory as practice changes our understandings of research methodologies beyond the bounds of specificity and objectivity, towards an articulation of research as intercorporeality, relationality, and process. Residing at the in-between, a/r/tographers dwell in the space and time of contemplation insisting on the openness of everyday phenomena (see Irwin, 2006). Like *Shell*, a/r/tography is an interstitial process, where encounters between subjects, thoughts, and actions propose new assemblages and situations. Furthermore, a/r/tographical research calls for an interrelation between image (or any artistic and creative form) and text, not that one is descriptive of the other. Visual encounters exist simultaneously with textual understandings. Thus, the construction of a/r/tographical research goes beyond the insertion of images into a research paper or dissertation. It is a way of living, inquiring, and being that is relational.

This last point however, enters us into another struggle, namely that of assessment and measurement. How do we evaluate and judge an a/r/tographical work? Once again we turn to philosopher Jean Luc Nancy (see 2000) to assist us with this task. In his essay *Human Excess*, Nancy contends that the engagement with measurement is a matter of bringing a certain responsibility to light. Rather than an understanding of excess as a numerical equivalent (ten, 400 or two million) we need to think of excess as elements of discourse in its totality. Measurement is not a degree of magnitude, but rather magnitude itself is the infinite totality of Being – the measurement of no other. Excess becomes an unheard of measure. In other words measurement is not qualifying something against something else – the setting of criteria or an established norm. Rather the conditions for measurement (assessment) are contingent upon and exist within the structure itself – an absolute measure.

In this sense an a/r/tographical act is its own possible measure. Instead of thinking of our actions, encounters, and thoughts – our living inquiry as substance that can be arranged in discrete moments, counted, and subjected to normative evaluations, we need to understand living inquiry as responsibility. However, "To be responsible is not, primarily, being indebted to or accountable before some normative authority. It is to be engaged by its Being to the very end of this Being, in such a way that this engagement or *conatus* is the very essence of Being" (Nancy, 2000, p. 183). We are not responsible *for* our own actions or the actions of others (a passive approach that separates and distances) but our very Being, our subjectivities, identities, and ways of living in the world are gestures and situations that struggle with, contest, challenge, provoke, and embody an ethics of understanding and a responsibility. Responsibility itself resides in the in-between. Stepping outside the glass front of the gallery – our personal shell – turning a corner onto the city street, we may be hailed by other situations; unexpected gestures and invitations to all responsible persons.

QUESTIONS

1 Irwin and Springgay claim that "a/r/tography radically transforms the idea of theory as an abstract system distinct and separate from practice, toward an understanding of theory as a critical exchange that is reflective, responsive, and relational, which is continuously in a state of reconstruction and becoming something else altogether." What does this mean? What are the implications for the form of a thesis, dissertation, a work of art, or a pedagogical site of pedagogy?

2 How does the work of Kusserow (Chapter 5) and Elvy (Chapter

12) differ from the purposes of a/r/tography? In what ways do these works share methodological aspects of a/r/tography?

3 When is it necessary for research to be a process of invention rather than interpretation? Can a single research project be both?

4 Irwin and Springgay state that "within a/r/tography, art is broadly conceived to mean sensory-oriented products understood, inter- preted, or questioned through ongoing engagements and encounters with the world. Artists are therefore committed to acts of creation, transformation, resistance." What kind of research questions would generate such art?

5 In a/r/tography, the conception of art and education is not as an object that is viewed and interpreted, but as a site where multiple meanings unfold. How might you imagine interpreting and analyz- ing the conditions of art or a site of learning as they are informed by relational inquiry and the renderings of a/r/tography? How might this form of inquiry impact your sense of responsibility to yourself and to others?

6 Irwin and Springgay assert that "in western cultures, time is typ- ically perceived as uniformly flowing without regard for indi- viduals, events, or contexts." List situations where this statement is true. Can you find examples from western science that challenge this conception of time? How do you account for these conflicting conceptions? Do you think one is more accepted than the other?

7 Define the six renderings of a/r/tography: contiguity, living inquiry, metaphor/metonymy, openings, reverberations, and excess.

NOTE

1 Singularity in this usage is derived from Jean Luc Nancy's (2000) theories of "being-singular-plural." For Nancy (2000) to be a body is to be "with" other bodies, to touch, to encounter, and to be exposed. In other words, each individual body is brought into being through encounters with other bodies. It is the relationality between bodies that creates a particular understanding of shared existence. Relationality depends on singularity. A singular body, argues Nancy (2000) "is not individuality; it is, each time, the punctuality of a 'with' that establishes a certain origin of meaning and connects it to an infinity of other possible origins" (p. 85). Peter Hallward (2001) substantiates this with: "The singular proceeds internally and is constituted in its own creation. The singular, in each case, is constituent of itself, expressive of itself, immediate to itself" (p. 3). Criteria are not exter- nal but are determined through its actions. Nikki Sullivan (2003) provides us with a further explanation: "Each 'one' is singular (which isn't the same as saying each 'one' is individual) while simultaneously being in-relation" (p. 55). Singularity, as a theoretical construct demands that self and other no longer hold opposing positions. Bodies/selves cannot exist without other bodies/selves, nor are the two reducible to one another.

REFERENCES

Aoki, T. T., Low, M., & Palulis, P. (2001). *Re-reading metonymic moments with/in living pedagogy*. Paper presented at the American Educational Research Association Annual Meeting. Seattle, Washington.

Bal, M. (2002). *Traveling concepts in the humanities*. Toronto, ON: University of Toronto Press.

Barone, T. (2001). *Touching eternity: The enduring outcomes of teaching*. New York: Teachers College Press.

Bataille, G. (1985). *Visions of excess: Selected writings 1927–1939*. Trans. A. Stockl. Minneapolis: University of Minnesota Press.

Bird, E. (2000). Research in art and design: The first decade. *Working Papers in Art and Design* (vol. 1). Retrieved 24 July 2005 at www.herts.ac.uk/artdes1/research/papers/wpades/vol1/bird1.html.

Bourriaud, N. (2001). *Post production*. Paris: Les presses du réel.

Bourriaud, N. (2002). *Relational aesthetics*. Paris: Les presses du réel.

Bourriaud, N. (2004). Berlin letter about relational aesthetics. In C. Doherty (Ed.), *From studio to situation* (pp. 43–49). London: Black Dog Publishing.

Britzman, D. P. (2003). *Practice makes practice: A critical study of learning to teach*. New York: SUNY Press.

Brown, N. (2000). The representation of practice. *Working Papers in Art and Design*, (vol. 1). Retrieved 24 July 2005 at: www.herts.ac.uk/artdes1/research/papers/wpades/vol1/brown2full.html.

Carson, T. R. & Sumara, D. J. (Eds), (1997). *Action research as a living practice*. New York: Peter Lang.

Davis, B., Sumara, D., & Luce-Kapler, R. (2000). *Engaging minds: Learning and teaching in a complex world*. Mahwah, NJ: Lawrence Erlbaum.

De Freitas, N. (2002). Towards a definition of studio documentation: Working tool and transparent method. *Selected working papers in art & design* (vol. 2). Retrieved 26 July 2005 at www.herts.ac.uk/artdes1/research/papers/wpades/vol2/freitas.html.

Deleuze, G. & Guattari, F. (1987). *A Thousand plateaus: Capitalism and schizophrenia*. Minneapolis: University of Minnesota Press.

Deleuze, G. & Guattari, F. (1994). *What is philosophy?* New York: Columbia University Press.

Derrida, J. (1978). *Writing and difference*. Chicago, IL: University of Chicago Press.

Doherty, C. (2004). *From studio to situation*. London: Black Dog Publishing.

Ellsworth, E. (2005). *Places of learning: Media, architecture, pedagogy*. New York: Routledge.

Garoian, C. & Gaudelius, Y. (2007). Performing embodiment: Pedagogical intersections of art, technology, and the body. In S. Springgay & D. Freedman (Eds), *Curriculum and the cultural body* (pp. 3–20). New York: Peter Lang.

Grosz, E. (1994). *Volatile bodies*. Bloomington: Indiana University Press.

Grosz, E. (2001). *Architecture from the outside: Essays on virtual and real space*. Cambridge, MA: MIT Press.

Hallward, P. (2001). *Absolutely postcolonial: Writing between the singular and the specific*. Manchester: Manchester University Press.

Irwin, R. L. (2003). Towards an aesthetic of unfolding in/sights through curriculum.

Irwin, R. L. (2004). A/r/tography: A metonymic métissage. In R. L. Irwin & A. de Cosson (Eds), *A/r/tography: Rendering self through arts-based living inquiry* (pp. 27–38). Vancouver, BC: Pacific Educational Press.

Journal of the Canadian Association for Curriculum Studies, 1(2), 63–78. Available at: www.csse.ca/CACS/JCACS/PDF%20Content/07._Irwin.pdf.

Irwin, R. L. (2006). Walking to create an aesthetic and spiritual currere. *Visual Arts Research, 32*(1), 75–82.

Irwin, R. L., Springgay, S., & Kind, S. (in press). Communities of a/r/tographers engaged in living inquiry. In G. J. Knowles & A. L. Cole (Eds), *International Handbook of the Arts in Qualitative Social Science Research*. Thousand Oaks, CA: Sage.

Irwin, R. L., Beer, R., Springgay, S., Grauer, K., Gu, X., & Bickel, B. (2006). The rhizomatic relations of a/r/tography. *Studies in Art Education, 48*(1), 70–88.

Koh, G. (retrieved September 2005). www.germainekoh.com/shell.html.

Kwon, M. (2002). *One place after another: Site-specific art and locational identity*. Cambridge, MA: MIT Press.

Leggo, C. (2001). Research as poetic rumination: Twenty-six ways of listening to light. In L. Neilsen, A. L. Cole, & G. J. Knowles (Eds), *The art of writing inquiry* (pp. 173–195). Halifax, Nova Scotia: Backalong Books.

Merleau-Ponty, M. (1964). *Signs*. Evanston, IL: Northwestern University Press.

Merleau-Ponty, M. (1968). *The visible and the invisible*. (A. Lingis, Trans.). Evanston, IL: Northwestern University Press.

Meskimmon, M. (2003). Corporeal theory with/in practice: Christine Borland's *Winter Garden. Art History, 26*(3), 442–455.

Nancy, J. L. (2000). *Of being singular plural*. Stanford, CA: Stanford University Press.

Pollock, D. (1998). Performative writing. In P. Phelan (Ed.), *The ends of performance*, (pp. 73–103). New York: New York University Press.

Richardson, L. (1994). Writing. A method of inquiry. In N. Denzin & Y. Lincoln (Eds), *Handbook of qualitative research* (pp. 516–529). Thousand Oaks, CA: Sage.

Richardson, L. (2002). The metaphor is the message. In A. P. Bochner & C. Ellis (Eds), *Ethnographically speaking: Autoethnography, literature, and aesthetics* (pp. 372–376). Walnut Creek, NY: AltaMira Press.

Rogoff, I. (2000). *Terra infirma: Geography's visual culture*. New York: Routledge.

St. Pierre, E. (2000). Working the ruins: Feminist poststructural theory and methods in education. New York: Routledge.

Springgay, S. (2003). Cloth as intercorporeality: Touch, fantasy, and performance and the construction of body knowledge. *International Journal of Education and the Arts, 4* (5). http://ijea.asu.edu/v4n5/.

Springgay, S. (2004a). Inside the visible: Arts-based educational research as excess. *Journal of Curriculum and Pedagogy, 1*(1). 8–18.

Springgay, S. (2004b). Inside the visible: Youth understandings of body

knowledge through touch. Unpublished doctoral dissertation, University of British Columbia.

Springgay, S. (2005a). Thinking through bodies: Bodied encounters and the process of meaning making in an email generated art project. *Studies in Art Education*, 47(1), 34–50.

Springgay, S. (2005b). An intimate distance: Youth interrogations of intercorporeal cartography as visual narrative text. *Journal of the Canadian Association of Curriculum Studies*. www.csse.ca/CACS/JCACS/index.html.

Springgay, S. (2006). Small gestures of the un/expected and the "thingness" of things. *Arts and Learning Research Journal*, 22(1), 163–183.

Springgay, S. & Freedman, D. (Eds), (2007). *Curriculum and the cultural body*. New York: Peter Lang.

Springgay, S. & Irwin, R. L. (2004). Women making art: Aesthetic inquiry as a political performance. In G. J. Knowles, L. Neilsen, A. L. Cole, & T. Luciani (Eds), *Provoked by art: Theorizing arts-informed inquiry* (pp. 71–83). Halifax, Nova Scotia: Backalong Books.

Springgay, S., Irwin, R. L., & Wilson Kind, S. (2005). A/r/tography as living inquiry through art and text. *Qualitative Inquiry, 11*(6), 897–912.

Sullivan, G. (2000). *Aesthetic education at the Lincoln Center Institute: An historical and philosophical overview*. New York: Lincoln Center Institute (www.lcinstitute.org).

Sullivan, G. (2004). *Art practice as research: Inquiry in the visual arts*. Thousand Oaks, CA: Sage.

Sullivan, N. (2003). Being, thinking, writing "with." *Cultural Studies Review, 9*(1), 51–59.

Szewczyk, M. (2005). Chronocidal citizens. Retrieved September 2005 from www.germainekoh.com/pdf/szewczyk2005.html.

Who will read this body?
An a/r/tographic statement

Barbara Bickel
University of British Columbia, Vancouver, British Columbia

Photography by Eva Tihanyi.

Barbara Bickel is an artist, researcher, educator and independent curator. She is a Ph.D. candidate in Art Education (Curriculum Studies) at the University of British Columbia where her a/r/tographic research is focused on women, spiritual leadership, collaborative art making and education. Her writing on arts-based inquiry, a/r/tography, women, spirituality, ritual, collaboration, curriculum and the body, has been published in numerous journal articles including the online journal *Visual Culture and Gender*, the *Journal of Curriculum and Pedagogy*, *Journal of Social Theory in Art Education*, *Studies in Art Education*, *Journal of the Association for Research on Mothering*, and in book chapters *Curriculum and the Cultural Body* (Peter Lang), and *Being with A/r/tography* (Sense Publishers,

forthcoming). Her art has appeared on the covers of numerous Canadian poetry books and music CDs.

She holds a BFA in Painting from the University of Calgary, a BA in Sociology and Art History from the University of Alberta and an MA in Education (Curriculum and Instruction) from the University of British Columbia. Her art and performance rituals have been exhibited and performed in Canada since 1991. She is currently represented by the Fran Willis Gallery in Victoria, British Columbia, Kensington Fine Art Gallery in Calgary, Alberta and School of Ideas Gallery in Welland, Ontario. She co-founded the Centre Gallery (1995–2001), a non-profit women's focused gallery in Calgary, Alberta. Her art and thesis can be viewed online at www.barbarabickel.ca and www.barbarabickel.com.

An Artist Statement is a historical document written by an artist as accompanying text for an art exhibit. Each Artist Statement that I have written over the years has challenged me to create text that will assist the viewers'/readers' understanding of my art. Most artists prefer to allow curators, art historians, and art writers/critics to take on the textual expanding of the art. I have to admit that I have been one of these artists. As a spiritual feminist artist now situated within the academy, committed to add researching, teaching, and writing to my practice of art making, I am challenged to reach beyond my familiar artist practices. The practice of a/r/tography (Irwin & de Cosson, 2004; Springgay *et al.*, 2004) has given me a framework to address this challenge. *A/r/t*ography calls for an inner collaborative relationship between my *a*rtist self, *r*esearcher self, and *t*eacher self. Each role engages a critical hermeneutic, self-reflexive practice of art making and writing. The a/r/tographic work is offered to the public as an interwoven tapestry of art/research/education/writing.

The Statement (Exhibit 1) that accompanied my thesis art exhibition was my first A/r/tographic Statement. It was originally offered to gallery viewers within a gallery setting, similar to an Artist Statement. It was written just prior to the exhibition and before I began the written component of the thesis (Bickel, 2004). Within this essay, I offer the A/r/tographic Statement with selected images of the art and performance rituals. I consider the Statement a time-specific historical archival document and because of this footnotes are added as hypertext to share my expanded thinking and writing beyond that moment in time.

EXHIBIT 1: A/R/TOGRAPHIC STATEMENT

The more I delve into fleshing inquiry through the body, I am more deeply aware of the paradoxes resonant within me.

Celeste Snowber (2002)

I am an instrument in the shape of a woman trying to translate pulsations into images for the relief of the body and the reconstruction of the mind.

Adrienne Rich (1997)

This body of work exposes a creative research process that began with a one and a half hour private performance ritual,[1] witnessed by two friends, in which I literally wrote on my body. The documented private performance ritual launched the a/r/tographical inquiry that makes up part of my Masters thesis in the Faculty of Education at the University of British Columbia. The performance ritual was an intuitive[2] effort, undertaken in part, to embody and understand the numerous feminists who compellingly summon women to write from their own bodies and write with the body as a form of resistance (Cixous, 1997; Dallery, 1992; Irigaray, 1997: Lorde, 1984; Minh-Ha, 1999; Rich, 2001; Snowber, 1997). My personal intention and desire in this performance ritual was to begin to externalize and embody writing as art. What has become apparent with the unfolding of the art and exhibition preparation is that it transgresses the boundaries between shame and freedom through the intimate and personal exposure of both the subconscious female mind and the naked female body, through the ritual process of a/r/tography. While I have felt at home with the method of a/r/tography, I have also struggled with the challenge of being conscious of and activating the often conflicting roles of artist, researcher, and educator this method demands.[3] Through this struggle I have come to recognize art making as research and curriculum making, seen art as curriculum, experienced performance ritual as pedagogy and worked with the body as text. This statement is an attempt to articulate a complex, exciting, and emergent research journey.

Who will read this body? was preceded by a thirteen-year individual and collaborative (co-creative) art practice of (re)presenting the human body, predominantly the female body, in two-dimensional drawings and collages, and in the multi-dimensional medium of performance rituals. The process and experience of art making is extremely important for my art and practice. I have attempted to bring the art-making process into the gallery setting through performance rituals co-created by myself and the co-creators/models of the projects. The solo multimedia installation of *Who will read this body?*, which included video

installation, sculpture, and two-dimensional collage, along with an artist talk and public performance ritual, reveals the raw, organic, ritual process of a/r/tographic research and documentation, that has in the past been hidden from the viewer/reader/learner in my art exhibitions. I have come to learn through a/r/tography that my art has a complex agenda.[4] Not only does it encompass honoring and freeing the human body, but it also serves to challenge and bring to the surface a wounded patriarchal culture of shame and fear. I live within and embody this oppressive and hurtful culture on a daily basis and believe that it is rooted in and perpetuated by the philosophical rupture between the mind and body[5] that has existed within western society for more than 500 years (Eisler, 1987). In this split, the mind is valued over the body, associated with the masculine and aligned with societal power, while the body is associated with the feminine and the natural world and is considered something to be controlled and brought into submission (Grosz, 1994). In admitting my own struggle within this philosophical split I come to acknowledge my self as a microscopic part of a whole system.

I begin this journey with my self; with my own body and my own writing. I welcome the viewer/reader/learner into the exhibition space as witness to my a/r/tographic testimony; a testimony that has the potential to disrupt body/mind dualisms and illicit feelings of shame and discomfort.[6] Drawing upon the feminist phrase "the personal is the political," I invite the reader/viewer/learner to witness the personal with or without shame and to move with the personal to the larger, more complex challenge of re-forging the often dissociated and hurting elements of mind, individual, and language, with those of body, communal, and image.

In this work I ask the viewer/reader/learner to ponder with me the questions[7] that have troubled my own a/r/tographic journey:

Am I not making art?
Am I not researching?
Am I not educating?
Am I not writing?
Am I not performing?
Am I not ritualizing?
Am I not learning?
Am I not my self?

The multimedia art exhibit and performance ritual, entitled *Who will read this body?* took place at the University of British Columbia in April 2004, at the AMS Gallery (Figure 10.1).

Upon entering the gallery the visitor was shielded from the exhibition

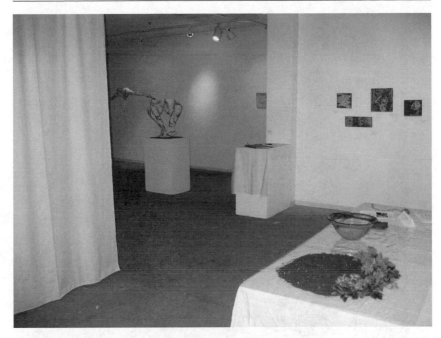

Figure 10.1 Bickel, B. (2004). *Who will read this body?*, gallery entrance view. Vancouver, BC: The University of British Columbia, AMS Gallery. Photography by B. Bickel.

by a white veil. Before entering the gallery they encountered a ritual table and were invited to take part in a ritual of putting their hands into earth (soil) and water. Consciously choosing or not choosing to take part in the ritual prepared viewers to enter the gallery as "sacred space." Viewers not comfortable or interested in the ritual turned away and left the gallery at the point of encountering the ritual invitation. On the other side of the veil, two TV monitors angled at opposite corners in the gallery, played looping videos of the ocean and its horizon at close range. The hypnotic sound of waves was accompanied by a woman's recorded voice sharing multiple trance journeys. Intimate and small art pieces appeared intermittently on the gallery walls, while body cast sculptures drew the viewer into the central gallery space. As the viewer approached the far end of the gallery another veil was encountered. Behind this veil the video of the outdoor forest performance ritual entitled *Who will read this body?* was projected onto a large piece of plywood.

Continuing the walk through the gallery, a floor installation piece brought the viewers' gaze to the floor. Within this installation, black-and-white photos documenting the ritual in the forest (see Figure 10.2) were displayed within two long rectangular containers filled with water and lit by four glass-encased candles.

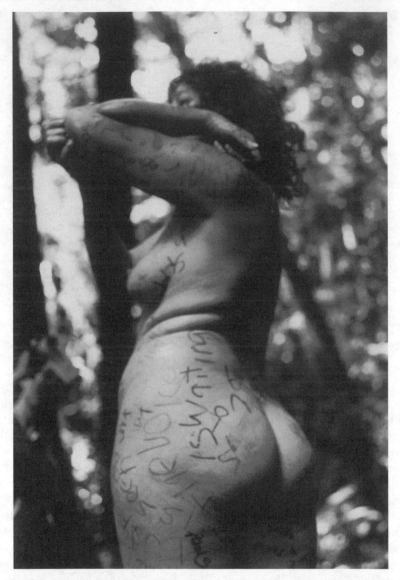

Figure 10.2 Bickel, B. (2003). *Private performance ritual.* Vancouver, BC: The University of British Columbia Endowment Lands. Photography by C. Pulkinghorn.

The submerged photos were veiled thinly under the surface of water. A hand-bound book of poetry, written throughout the inquiry process, was part of the installation and was read by some viewers before fully engaging the gallery space or was looked at before they left the space.

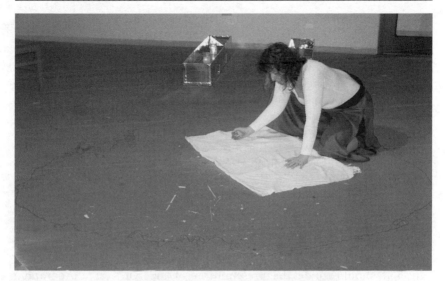

Figure 10.3 Bickel, B. (2004). *Who will read this body? Public performance ritual.* Vancouver, BC: Canada: The University of British Columbia, AMS Gallery. Photography by D. Reicken.

I was present throughout the week-long exhibition, witnessing those that viewed the art. At times this was difficult as I was the exposed subject being "researched" in this exhibition, witnessing strangers witnessing me. Months of internal debate as to the vulnerability and risk of exhibiting this art as research, led to the creation of sacred space in the gallery installation and prompted me to have a pre-gallery opening ritual, where I invited close friends and family to witness the exhibition and offer their responses and supportive intentions just prior to opening the gallery doors to the public.

The path of the artist as researcher and educator is demanding on many levels. Not all artists have the support or guidance available to take on the multiply complex practice of a/r/tography. I have found it requires external support from others willing to be critical allies, as well as an internal personal practice that assists in working through the emotional, ethical, and spiritual issues that arise when engaged in this practice. Following my months of preparation, which included dialogues with my thesis committee and colleagues and the pre-gallery ritual within the sanctuary of the gallery, I was able to step beyond my personal discomfort. Being present as a witness and being witnessed in the exhibition allowed me to understand more deeply the embedded societal struggle of reuniting the body and mind.

As the final list of questions in my A/r/tographic Statement suggests, I was left with many questions at the completion of this exhibition. In the

three months following the exhibition, I wrote the thesis and entered into these questions more deeply. The opportunity to stop and reflect critically on my art practice was a gift that many artists do not have the luxury of, as economics often require they immediately prepare for the next exhibition. The responses I received from those that saw the exhibition and the discussion and engagement that ensued at the end of the performance ritual in the gallery, offered further self-understanding of my work as a cultural worker (Giroux, 2000). Through this, I have come to fully acknowledge that my preferred teaching site for "transformative learning" (O'Sullivan, 1999) is within public spaces such as art galleries. The space of the gallery is transformed with each individual exhibition. Within the contemporary gallery setting there is an expectation of innovation and stepping beyond familiar understandings and representations, allowing the beholding of new information and interpretations that can change patterned ways of knowing, seeing, and being in the world. Aesthetics as well as public interaction and learning can and should guide the presentation of art with an a/r/tographic intention of expanding understanding and knowledge.

Through multiple methods of inquiry, I engaged and collected data

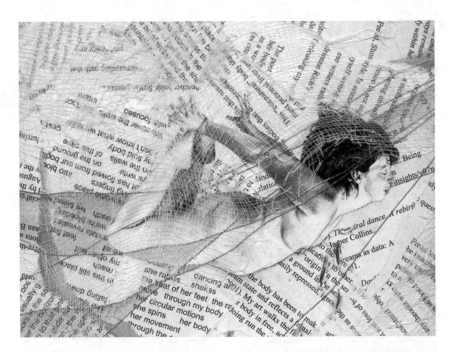

Figure 10.4 Bickel, B. (2004). *Spinning red words on paper*, detail. Vancouver, BC: The University of British Columbia, AMS Gallery (mixed media collage on wood, 12 × 24 inches). Photography by B. Bickel.

from processes that included art making, ritual, the female menstrual cycle, trance, journal writing, and poetry. Drawing from these arational sources for the research allowed me to access material that my rational mind would have kept hidden or deemed inappropriate. Surfacing the hidden and unspoken caused me to rationally rethink and reassess the limiting assumptions that I was operating within. Critically reflecting through writing, and researching the work of other artists and writers, carried the inquiry to another level. My discoveries were not unique, yet my expression of the struggle between the body/mind dichotomy re-revealed the struggle and allowed an individual embodied understanding of it to unfold. This in turn offered an embodied location for others to reassess their own struggles and assumptions within the body/mind split.

The practice of a/r/tography led me, oftentimes reluctantly, into an expansive research process where I was making art, researching, educating, writing, performing, ritualizing, and learning while simultaneously expanding my notions of a self. This multi-modal and multi-perspectival research has made my commitment to arts-based research within the humanities and social sciences that much stronger and clear.

Offering arts-based research as a valid research method within the academy challenges a limited modernist lens that privileges rational ways of knowing over arational ways of knowing. As an artist interested in art as transformative learning, a/r/tography offers a location to engage an integral spiritual feminist practice that utilizes rational knowing alongside arational knowing. A/r/tography is not a path that everyone can travel easily. It is a disorienting practice that "shifts the relationship[s]" (Springgay, 2004) between, around, and within the mind and body, writing and art, ritual and education, and the rational and arational. In sharing my experience of the a/r/tographic inquiry, my desire is to intrigue as well as invite artists that are educators, artists interested in their art as research and education, arts educators, educators and scholars, to support and engage further explorations of the practice of arts-based research.

QUESTIONS

1 Bickel's work invites viewers to impose their own meanings and interpretations on the rituals that she performs. Is this an example of research as "Rorschach Test" that Eisner (Chapter 2) fears?
2 Describe Bickel's methods to engage Barone's "social imagination" (Chapter 3) within a public sphere. Is Bickel's work an example of Behar's autoethnography of the homeless (Chapter 4)?
3 How does Bickel incorporate the concept of beauty as an educational idea within her work?
4 What does Bickel mean when she says "I have come to learn

through a/r/tography that my art has a complex agenda"? What distinction is she making between a/r/tography and art?

5 Bickel's a/r/tography illuminates her own struggles "as a microscopic part of a whole system." Use of the self in qualitative research has been critiqued by detractors as "navel gazing," i.e. more about self than other. What are your views about schol-ARTists examining themselves and their place within society as a point of departure or end point in their research?

6 After viewing Bickel's work, what feelings and/or emotional resonance do you come away with? What do you think would be the added effect of viewing Bickel's performance rituals?

7 What space is there for Bickel's a/r/tography in teacher education? What conversations might be generated from this work among educators? Students? Others?

NOTES

1 *Ritual* creates the sacred space/context/container for entering the often disorienting and challenging work of a/r/tography. Ritual essentially includes an arational sacred practice of trans-egoic respect/awareness/openness to the creative interaction of physical, emotional, intellectual, and spiritual realities, within nature, culture, and self, for the purpose of transformation (for further reading on women's ritual see Northrup, 1997).

2 I have come to articulate the intuitive component of art making as an arational process. To further explore the concept of the arational, I draw from the late philosopher Jean Gebser's theory (1984) of the arational. The arational as a form of knowing includes the body, emotions, senses, intuition, imagination, creation making, the mystical, spiritual, and the relational, alongside the rational. The concept of the arational viewed from the rational (mental) perspective, has most often been confused with the irrational, thus repressing it, pathologizing and disqualifying it from being seen as a valid and significant site of learning (Tarbensen, 1997). Contemporary philosopher, Ken Wilber (2002) draws from and expands Gebser's arational/aperspectival-integral view and offers a model of consciousness that embraces and integrates the arational with the rational. Wilber defines integral "Not in the sense of a uniformity, and not in the sense of ironing out all the wonderful differences,... but in the sense of unity in diversity, shared commonalities along with ... wonderful differences" (p. 15).

3 At its best, a/r/tography encourages the combined creative freedom and risk-taking of the artist with the theory, rigor, and responsibility of the academic researcher, along with the ethics and compassion of the educator. Combining these three roles with the integrity and awareness of what is called for from each area, is a demanding undertaking. During my thesis art making and research process, I tended to privilege the role of the artist. It was often with resistance and struggle that I had to cede my familiar artist's lens to activate and give equitable authority to the roles of the researcher and teacher.

4 As an artist I have been content to trust an intuitive-like process. I have

held onto an anti-intellectual stance in my research as an artist that has limited my ability to fully take in the complexity of the cultural politics embedded within my art practice and art.

5 I refer here to the Cartesian mind/body split that came with the age of the rational Enlightenment (Wilber, 1996). Philosophers (i.e., Derrida, Foucault) and feminists (i.e. Grosz, Irigaray) have and continue to deconstruct this dichotomy and its impact on the world.

6 Figure 10.1 is pulled from a larger installation piece in the exhibit entitled *To Find Traces of Her Estrangement*. Documentary photographs of the performance ritual in the forest, where I wrote on my body with menstrual blood and make-up pencils, were part of the installation. I chose to install them submerged in water within an aluminum container set on the floor. Glass-encased candles burned ritually, illuminating the photos. The water, along with floating red threads, embodied the metaphor of life's blood acting as a protective veil over the photos. Placing the photos under water required the viewer to leave the comfortable element of air and pass visually through to an alternate realm of water in order to gain access to the images. It was a risk to pull this individual image out of the installation and place it onto a page within my thesis text. I risk separating the image from its context again, offering the image within this essay as an exposed and integrated body as text.

7 In asking these questions I spun off the questioning lyrics of Canadian singer-songwriter Jane Siberry within her song, "Sail Across the Water" from her 1993 CD, *When I Was a Boy*.

REFERENCES

Bickel, B. (2004). *From artist to a/r/tographer: An autoethnographic ritual inquiry into writing on the body*. Unpublished Masters thesis. Vancouver, BC: University of British Columbia.

Cixous, H. (1997). The laugh of the Medusa. In R. R. Warhol & D. P. Herndl (Eds), *Feminisms: An anthology of literary theory and criticism* (pp. 347–362). New Brunswick, NJ: Rutgers University Press.

Dallery, A. (1992). The politics of writing (the) body. In A. Jaggar & S. Bordo (Eds), *Gender/body/knowledge: Feminist reconstructions of being and knowing*. (pp. 52–67). New Brunswick, NJ: Rutgers University Press.

Eisler, R. (1987). *The chalice and the blade: Our history, our future*. San Francisco, CA: Harper & Row.

Gebser, J. (1984). *The ever-present origin* (Trans. N. Barstad & A. Mickunas). Athens: Ohio University Press.

Giroux, H. (2000). *Impure act: The practical politics of cultural studies*. New York: Routledge.

Grosz, E. (1994). *Volatile bodies: Toward a corporeal feminism*. Bloomington: Indiana University Press.

Irwin, R. L. & de Cosson, A. (2004). *A/r/t/ography: Rendering self through arts-based living inquiry*. Vancouver, BC: Pacific Educational Press.

Irigaray, L. (1994). *Thinking the difference: For a peaceful revolution* (Trans. K. Montin). New York: Routledge.

Irigaray, L. (1997). This sex which is not one. In K. Conboy, N. Medina & S. Stanbury (Eds), *Writing on the body: Female embodiment and feminist theory* (pp. 248–256). New York: Columbia University Press.

Lorde, A. (1984). *Sister outsider: Essays and speeches*. Freedom, CA: Crossing Press.

Minh-ha, T. T. (1999). Write your body and the body in theory. In J. Price & M. Shildrick (Eds), *Feminist theory and the body* (pp. 258–266). New York: Routledge.

Northrup, L. A. (1997). *Ritualizing women: Patterns of spirituality*. Cleveland, OH: Pilgrim Press.

O'Sullivan, E. (1999). *Transformative learning: Educational vision for the 21st century*. Toronto, ON: OISE/UT and University of Toronto Press.

Rich, A. (2001). *Arts of the possible*. New York: W.W. Norton.

Siberry, J. (1993). Sail across the water. *When I was a boy*, [Compact Disc]. Canada: Reprise Records.

Snowber, C. N. (1997). Writing and the body. *Educational Insights, 4*(1). Retrieved from www.csci.educ.ubc.ca/publication/insights/v07n02/contextual explorations/wilson_oberg/.

Snowber, C. N. (2002). Bodydance: Enfleshing soulful inquiry through improvisation. In C. Bagley & M. B. Cancienne (Eds), *Dancing the data*. New York: Peter Lang.

Springgay, S. (2004). *Inside the visible: Youth understandings of body knowledge through touch*. Unpublished doctoral dissertation, University of British Columbia.

Springgay, S., Irwin, R., & Wilson Kind, S. (2004). A/r/tography as living inquiry through art and text. *Qualitative Inquiry, 11*(4), 897–912.

Tarbensen, J. N. (1997). Arational epistemology: A Gebserian critique of rationalism and causalism in the Western culture. Retrieved October 24, 2004 from www.tarbensen.dk/uk/arational_epist_abstract.shtml.

Wilber, K. (1996). *A brief history of everything*. Boston, MA: Shambhala.

Wilber, K. (2002). *Boomeritis: A novel that will set you free*. Boston, MA: Shambhala.

Yorke, L. (1997). *Adrienne Rich: Passion, politics and the body*. London: Sage.

Nurse-in

Breastfeeding and a/r/tographical research

Stephanie Springgay
Pennsylvania State University, University Park, Pennsylvania

I'm sitting on an airplane *en route* to an academic conference. My laptop, diaper bag, breast pump, nursing pillow, stroller and carseat have been stowed and I've managed to do up my seatbelt using my left hand, my right being otherwise occupied, holding my 11-week-old daughter to my breast. She nurses hungrily – looking up at my face occasionally to make sure that amidst the chaos of traveling I'm still here. Other passengers are still boarding the plane. Some smile as they pass me, others avert their eyes, and a few try and steal a good peek at my breast. I personally couldn't care less as I settle into my seat and sigh. Boarding a plane is a lot of work these days. I don't travel light. But I'm sitting down now, everything in its proper place and my daughter is content, making noises of deep satisfaction. She'll drift off to sleep soon, waking up in yet another city. This is her third conference and long-haul flight. We're pros at making it work.

Two months later a *New York Times* article catches my attention. Outside the ABC studios in New York City 200 women have taken to the streets to nurse their babies protesting celebrity Barbara Walters, who on the talk show *The View*, remarked that the sight of a woman breastfeeding next to her on an airplane was "disgusting" and made her feel uncomfortable (Harmon, 2005). She applauded her co-host who was feeding her baby formula from a bottle.

At another conference, hosted in a large American city on the east coast, the conference facilities lack places to sit in the corridors, hallways, and common areas. I'm forced to hover on a cement floor in-between sessions.

The local and popular *Waffle Shop* asks my family to leave one Sunday morning over brunch. Another patron has complained about my nursing in public. It's a family restaurant after all.

On campus, while I'm surrounded by academic women, many of whom have had children during the course of their careers, it feels as if I'm the first woman to give birth and lactate. My office is not private, I share it with two grad students and the door has a large window. I'm offered an

empty office space, cluttered with dusty books and empty boxes, where the only outlet for my *Medla pump 'n' style* is behind a bookshelf. For the remainder of term I chose to invite grad students to my home or the local coffee shop; my daughter always joins us. What's more natural than coffee and milk? I'm asked by a colleague if I plan on holding office hours?

Completing my first year review I find appropriate spaces on the standardized form to list two international art shows, more than a dozen published papers – many invited and a few peer reviewed, four successful conferences, and a busy service record. Mentoring undergrad and graduate students and committee work has its rightful place; as do the three research grants that I have been awarded. In the space between I write in "flesh and blood" (Dunlop, 1999) that I have also successfully managed to breastfeed my daughter exclusively. It was a difficult beginning after a C-section, mastitis (twice), and the usual early stages of public discomfort. Maurya is growing steadily, she's ready to crawl, enjoys swimming classes and her favourite food is sweet potatoes. I found a great part-time babysitter affording me time to make use of my *Medela pump 'n' style* more often.

As I realized that mothering and my family life would not be recognized as relevant to my work, I felt that it was imperative to make art about my experiences in order to make my/breastfeeding/ academic/ working mother's reality known. While much of Western thought has celebrated the splitting of women's identity into "mother" or "other" – the perception that women cannot be both – re-thinking mothering from the perspective of "performativity" recognizes the relationality between mother and other (Springgay, 2007). As Emily Jeremiah (2006) writes, "To understand mothering as performative is to conceive of it as an active practice – a notion that is already progressive, given the traditional Western understanding of the mother as passive" (p. 21). In doing so, we shift our attention from motherhood as biological, selfless, and existing prior to culture, to a practice that is always incomplete, indeterminable, and vulnerable. A relational understanding of m/othering opens up the possibility of an ethical form of exchange between self and other and "allows us to understand the maternal subject as engaged in a relational process which is never complete and which demands re-iteration" (p. 28). Mothering as performance "contain[s] the potential for a disruption of dominant discourses on maternity" (p. 25) and thereby makes room for maternal agency. Thus, it is not simply a matter of making oneself visible as a mother in the academe but about changing the way that mothering has been understood, conceived of, and practiced. This re-conceptualization of m/othering refuses to be split, while also remaining ambivalent.

In becoming a m/other I write/image/teach/research my lines between my daughter's, or as Renee Norman (2001) suggests, "I write on top of

small scrawls and drawings, not to erase them, but so our writing is fused" (p. 1). This living in-between the lines reminds us that personal experiences are narratives that run alongside the dominant discourse in such a way as not to mirror it, but to disrupt it, and to render it malleable and in motion (Ellsworth, 2005).

Exposing aspects of life after birth I created a series of works titled *Nurse-in* and *Spillage* as a way to inquire into the visceral experience of m/othering; repulsion coupled with the necessity of nurture. Materialized out of felted human hair and glycerin soap, the breast pump and its parts – breast shield, milk storage containers, pads, and hoses – elicit dis/comfort and animate the uncertainty of meaning. Their functionality has been disrupted and made ambivalent, rupturing the commonality of domestic warmth with metaphors of the abject – the leaky, fleshy, and weighty body (Kristeva, 1982). Although the American Academy of Pediatrics recommends that mothers breastfeed exclusively for six

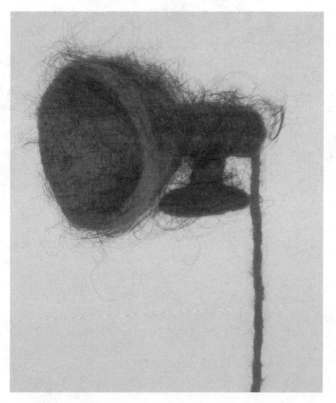

Figure 11.1 Springgay, S. (2006). *Spillage*, detail of installation. Felted dyed wool and human hair. Approx. 6 inches × 4 inches.

months and if possible up to one year, citing that breastfed infants require less medical care in the long run, fewer than one-third of all new mothers in the United States continue breastfeeding beyond the first few weeks (Harmon, 2005; Sears & Sears, 2000). Self-consciousness about exposing themselves and the difficulties of finding spaces where nursing seems acceptable (and possible) are cited as primary reasons. The visual culture of the breast in Western society is one of sexuality, not maternity (Bartlett, 2006). The visual symbols we associate with breasts are of the Pamela Anderson variety, plump with silicone, not milk, smooth, hard, and perky. The abject leaky breast, blue-veined, with dark areola and a large protruding nipple is absent from our visual culture. Moreover breastfeeding in public exposes one's mothering skills to public scrutiny in a culture that celebrates the disciplining of the body.

The installations, *Nurse-in* and *Spillage*, negotiate breastfeeding and mothering as personal experiences, disrupting their social and cultural constructions. The artworks represent the tensions between nurturing and productivity, discipline and intimacy, and family and work. Human hair and soap attest to the vulnerability and uncertainty of the maternal body and the fragility of the terms that define and shape mothering. Similarly, a/r/tography as a practice of living inquiry engages in the interstitial spaces between knowing and being. As a methodology of embodiment, never isolated in its activity but always engaged with the world, a/r/tography requires that one live a life open to inquiry that is redolent – engorged, leaking, spilling forth and becoming something else altogether. It is a way of living, knowing, and being in the world through touch, where encounters with others are not defined by distance and objectivity, but through intimacy, proximity, and intercorporeality (Springgay, 2005). Like breastfeeding, a/r/tography is about intimacy and relationality, where passions govern knowing and understanding rather than discipline and reason.

QUESTIONS

1 Springgay's artworks "represent the tensions between nurturing and productivity, discipline and intimacy, and family and work." Every core value that we hold (such as nurturing, discipline, or family) can be recast in opposition to another valid value. What values underlie your own research? What dualism can you create that would question these values?
2 Springgay's essay incorporates intimate personal narrative. What does she gain (and lose) by bringing in these details?
3 How is Springgay's work an example of "epistemological humility?" (Barone, Chapter 3). Do you find it troubling that her essay,

like so many others in this book, ends in questions and does not suggest "conclusions" or "recommendations for practice?"

4 This essay moves from personal narrative, through breastfeed statistics, and an argument for a/r/tography. Springgay does this to create a narrative that runs "alongside the dominant discourse." Are there narratives in your life that you feel run against dominant academic discourse?

REFERENCES

Bartlett, A. (2006). *Breastwork: Rethinking breastfeeding*. Sydney: New South Wales University Press.

Dunlop, R. (1999) Boundary Bay: A novel as educational research. Doctoral dissertation. Vancouver: University of British Columbia.

Ellsworth, E. (2005). *Places of learning: Media, architecture, pedagogy*. New York: Routledge.

Harmon, A. (2005). Lactivists taking their cause, and their babies, to the streets. *New York Times, June 7*, pg. B. 3.

Jeremiah, E. (2006). Motherhood to mothering and beyond: Maternity in recent feminist thought. *Journal of the Association for Research on Mothering*, 8(1/2), 21–33.

Kristeva, J. (1982). *Powers of horror: Essays on abjection*. New York: Columbia University Press.

Norman, R. (2001). *House of mirrors: Performing autobiograph(icall)y in language/education*. New York: Peter Lang.

Sears, M. & Sears, W. (2000). *The breastfeeding book: Everything you need to know about nursing your child from birth through weaning*. New York: Little, Brown and Company.

Springgay, S. (2005). Thinking through bodies: Bodied encounters and the process of meaning making in an email generated art project. *Studies in Art Education*, 47(1), 34–50.

Springgay, S. (2007). Intimacy in the curriculum of Janine Antoni. In S. Springgay & D. Freedman (Eds), *Curriculum and the cultural body*. New York: Peter Lang.

Notes from a Cuban diary: We believe in Our History

An inquiry into the 1961 Literacy Campaign using photographic representation

Joanne C. Elvy
University of Toronto, Toronto, Ontario

As a wide-eyed teenager in pre-1989 Europe, **Joanne Elvy** was riveted by sociopolitical events that led her to photograph as a process of memory work. She then studied photography at Ryerson Polytechnic University in Toronto (B.A.A., 1985), challenging traditional boundaries of photographic practice in her desire to interpret the lives of others in a poetic manner.

As a photographic witness to the sociocultural disruption in a post-1989 world, she observed how the lived everyday of a people was interpreted by those outside the original experience. This inspired her thesis "Behind the Seen" (M.Ed, Queen's, 2000), where she argued how perception, caught in the logic of history, is framed by an ideological lens to exclude stories that do not fit.

As an artist-researcher at OISE/University of Toronto, she emphasized the extent to which the photograph functions for her as a language – not a

"kind" of language, rather, as a language – a very real means by which she engages with and responds to that around her. This knowing continuously impacts the way in which she relates to subjects in her doctoral research.

As a professor in the areas of photography and film at Algoma University College, Sault Ste. Marie, Canada, Elvy points out how viewers unwittingly take in the photograph as absolute – an object of truth – as media often trivializes "ordinary" events as banal and sensationalizes incidental moments as "news." Likewise, she believes that the photograph can transcend linear thought as a poetic, intimate document, when words alone fall short.

In 1961, the Revolutionary government in Cuba initiated a Literacy Campaign of great magnitude that became the vehicle for social change in the country; a vision that affirmed to Cuban citizens the value of education, health care, citizenship, professional development and the conception of family and community. With educational reform a high priority in the early years of the Cuban Revolution, more than 100,000 middle-class urban youth between the ages of ten and 19 traveled to remote areas of the country as literacy *brigadistas* as part of this Campaign, facing challenges that were not "easy, safe or immediately rewarding" (Kozol, 1978, pp. 348–349). They lived with peasant families for months at a time, sharing in the manual labor by day, and teaching reading and writing at night. More than half of those who volunteered as *brigadistas* were young women.

As artist-researcher, I explore the transformation that occurred in Cuban women who reflect upon their role as *brigadistas*; in how the self-actualization that happened at that time spurred them to contemplate broader ways of viewing their own lives. My practice of photography has been a valid way for me to engage in and present my findings.

The cultural and social values of pre-Revolutionary Cuba provided little opportunity for women beyond the expected familial role of wife/ mother, and traditionally parents made decisions on behalf of unmarried daughters to ensure their futures as "good" wives. For the young woman away from the family home for the first time, how she would perceive and envision possibility in her own life would no longer be the same:

It was the first significant Revolutionary event for those of my age. Myself, I was only 13 years old.

Figure 12.1 Carmen, Santiago de Cuba.

Being in this massive undertaking
was a point of departure for me,
in respect to my personal independence & identity,
and the responsibilities I took on as a young woman...
Rosa, Havana

As a photographer outside the fixed event from times past, I am now invited into their homes, and inside a poetic moment. As each woman names the limited opportunities they once had, I am "filled with fear and with joy," observing and responding "as faithfully as I can" to their memories (Cixous, 1991a, pp. 52, 91). As women, we know how our stories – and those of our mothers, and those before – have been historically undervalued or overlooked by patriarchal constructs of one form or another; ones "written on the body ... the accumulations of a lifetime" (Winterson, 1995, p. 89).

With my own body, "a human instrument" and an integral part of the research process, my perceptions of and interactions with these women are tools I use to record and interpret our exchange (ibid). Together our voices claim space, as we take steps not to forget.

This Literacy Campaign was one grand life lesson.
As a brigadista, this was the moment I took charge of my life.

Figure 12.2 *Eneida*, Santiago de Cuba.

I became outgoing … I became conscientious.
I wasn't going to be tied down again!
Dora, Santiago de Cuba

How can one measure a "knowing" that does not fit within a prescribed format? The broader success of this Campaign cannot be merely fixed as "data," as it reverberates in the lived presence of these women in how its fundamental principles and ideals carry from their past into the present. If I contain myself within the margins of traditional knowledge production, I struggle with conventional forms of representation: "I would have liked to hear a sentence with room for me in it" (Cixous, 1985, p. 83). As human experience is dynamic and meanings shift over time, I relocate the photograph within poetic space, beyond the limitations of its own history and its "decisive" moment.

With the language of photography evoking an ideological lens that captures, frames, contains and regulates subjective experience within the mere click of the shutter, I thus redefine this patriarchal hold on the construction and interpretation of photographic images. As a woman I turn inside, "further into the birth-voice" (Cixous, 1991b, p. 52); the darkroom, a familiar space, alchemic and visceral, where technique and intuitive knowing embrace as visual text. "Led beyond codes," history unravels and "meanings flow ... no longer enclosed in the maps of social constructions" (ibid). The academy similarly dictates an institutional standard for information gathering and thesis presentation that collides with the spirit of the lived everyday; in how research is defined and implemented, in which knowledge holds value ... and in what can be tolerated.

An illiterate woman is chained to her responsibilities at home.
She takes care of her husband & attends to the children.
But an illiterate woman can't participate in society,
as a person & as a human being.
It's clear to me, she can be taken advantage of,
if she can't defend herself. Someone who is illiterate just
doesn't know.
And THAT's exploitation.
Humbelina, Pinar del Rio

Further, with the Cuban everyday reinventing itself in relation to exterior forces, what outsiders to these events see as problematic may well be assumptions held hostage; ideological renderings framed, fixed and analyzed through a particular lens by those who hold the power and privilege to do so. The blur of technical boundaries of and with digital media also requires that I acknowledge my own moral and ethical responsibilities as a photographer on image production, and on no uncertain terms. Winterson argues that "if we admit that language has power over us, not only through what it says but also through what it *is*, we come closer to understanding the importance of poetry" as a tool for transformation, one that can take us further than we could have ever imagined; "the poet will not be satisfied with [simply] recording" data (1995, p. 76).

As a Revolutionary event, the Literacy Campaign sparked the
consciousness in the Cuban people to then help others.
Certainly, as we became educated as a people,
we came to realize
what we had achieved as a people.
Alida, Ciego de Avila

In reconciling with the visual, Barthes describes how seeing, feeling and noticing are part of a collective memory woven into the broader script of our being human, "a carnal medium, a skin I share with everyone" (1980, p. 42). With reflective quotes written by the women I interview reaffirming the Campaign's significance, onlookers draw from their own embodied memory to become active participants in the research "findings."

Purveyors of a knowing we are able to *feel*; a visceral mediation as we are "moved by what we see in images," as we are touched (Robins, 1995, p. 39). As a visual gesture that can appeal to diverse audiences and reflect experiences above and beyond the walls of the academy, I argue that the photograph as a language holds the potential to transcend linear thought as an intimate, poetic document. As humanity continues to face fragile and uncertain times, I propose that this knowing, a *felt* knowledge, will carry through past the immediate, when words alone fall short.

This Literacy Campaign was such a gesture of humanity.
I believe it could not have happened
without the participation of women.

Figure 12.3 Nuria, Santiago de Cuba.

Those of us who were part of it, we proved that
together we could overcome obstacles,
despite all the challenges we would undoubtedly face,
socially or economically.
Yes, women ARE capable of taking on such tasks.
Zeida, Pinar del Rio

Outside a fixed point in time, I believe that the stories of these women are not yet finished and cannot be finished; and that history can be impermanent to allow for the possibility of a world not yet realized. In this case, history comes alive as a kind of performance, inside the collective memory of a people, shifting the Literacy Campaign from a nostalgic event in the past to a vision for the future, intellectually, emotionally and ethically. Such stories give light to Cuban women; and they who already have it, points out Lizette Vila, noted Cuban television producer and filmmaker, as "the illuminator of her surroundings" (Morris, 2001).

And together our voices claim space, as we take steps not to forget.

QUESTIONS

1 Elvy's interest is in the enduring legacy of the 1961 Literacy Campaign, believing that the women in these photographs embody that legacy. How do these images communicate the legacy of the campaign? What do the images convey that text alone might not?
2 The text in Elvy's essay is not explanatory, but leads the reader back into an investigation of these images. The words guide you into looking closer. How is research a task of guiding a reader to take time to closely examine something rather than explaining it?
3 Elvy has designed the layout of each page, carefully selecting image and words – going so far as to specify distinctive type fonts for the representation. She strives to create a breathing space on the page between the image and word. Working from your own images, design a layout of text and images that are interwoven (note: this intimate relationship between image and word is often a feature of children's literature).

ACKNOWLEDGMENT

Photo of J. Elvy accredited to Joanne Robertson ©2007.

REFERENCES

Barthes, R. (1981). *Camera lucia: Reflections on photography*. Toronto, ON: McGraw-Hill Ryerson.
Cixous, H. (1985). *Angst* (Trans. J. Levy). London: John Calder.
Cixous, H. (1991a). *The book of Promethea*. New York: Routledge.
Cixous, H. (1991b). *Coming to writing and other essays*. New York: Routledge.

Kozol, J. (1978). A new look at the literacy campaign in Cuba. *Harvard Educational Review, (48)*3, 341–377.

Morris, H. (2001). Adventure divas: Lizette Vila, host. Retrieved 15 March 2004 from www.pbs.org/adventuredivas/cuba/divas/vila.html.

Robins, K. (1995). Will images move us still? In M. Lister (Ed.), *The photographic image in digital culture* (pp. 29–50). New York: Routledge.

Winterson, J. (1995). *Art objects: Essays on ecstasy and effrontery.* Toronto, ON: Alfred A. Knop.

Section IV

Performance inquiry, ethnodrama and ethnofiction

Real life with the boring parts taken out

Adapting ethnographic fieldwork, ethnographic texts, and autoethnography for the stage and novel requires the skills of an experienced artist and scholar. The writers in Section IV have used dramatic and fictional prose genres to do with ethnography what Alfred Hitchcock is known to have said of making movies – to present real life with the boring parts taken out. These contributors vary in their backgrounds, home countries, years of experience, subject matter, and form, but they share the desire to adapt fieldwork experiences to textual and performative genres that can be shared with diverse audiences.

The section begins with Terry Jenoure, who reflects on the blurred boundaries between empirical and personal explorations, between fact and fiction, and between the literary, visual, and performing arts. Jenoure uses artistic performance, which includes sight, sound, and the body, to shape a final representation of her research. She wonders if this representation is a "finding" or if it is something else. Do researchers, in particular arts-based researchers, need a new word for "findings?" What Jenoure creates, in the place of findings, is a performance that speaks to her experience of teaching in the US and South Africa. She seeks to convey to others the sensed moments of "wonder and awe" that occur in education, moments that spring from deep and complex emotional ties that intersect in, but are not limited to the classroom. Through the experience of such performances, our conversations on what it means to educate and learn grow richer and deeper. These layerings become, in Jenoure's words, "a force that drives us home."

Similarly, Douglas Gosse's example of scholARTistry in Chapter 14 is a journey home. Gosse provides an excerpt from *Jackytar*, the first educational novel published in Canada, originally written as part of his doctoral dissertation. Gosse imbues the novel with queer theory, both in form and content. As in traditional Hebraic texts where commentary is essential, Gosse uses footnotes to write creatively and share critical, theoretical, and empirical reflections with readers. This hypertext form of writing helps to translate some of the French and Newfoundland

English dialect that appears throughout the novel, *Jackytar*. The hypertext also allows the writer to add empirical and theoretical information such as data on suicide rates among queer youth, in a way that doesn't insist on disrupting the narrative flow.

Joni L. Jones also goes by the African name, Omi Osun Olomo. Jones/Olomo has performed *sista docta* extensively and in emerging formats around the world. In Chapter 15, she reflects on the history of this personal and collective performance piece, invoking the "collective autobiography" of Black women in academia. Her reflections are an inspiration for other arts-based researchers to continue to challenge themselves, learning from their own creative projects in an ongoing, critically reflexive way.

In Chapter 16, Kathy Roulston, Roy Legette, Monica DeLoach, and Celeste Buckhalter share a readers' theater piece constructed for a conference. In this performance, music generates data. The musical performance is not a report to the audience. Instead, the audience participates and creates the performance. In the tension and anxiety – and satisfaction – of the performance are the findings of the research and new reflections on arts-based approaches to professional presentation.

In the concluding chapter to the section, Johnny Saldaña shares how he became a "research geek," engrossed in qualitative methodology after years of training and experience as an actor and director. While engaged by the field of qualitative methodology generally, he was specifically attracted to the evocative prose and dramatic qualities in Harry Wolcott's ethnographic work. Saldaña describes the emerging collaboration, and how he adapted Wolcott's work for the stage, providing excepts from one of his many ethnodramas for review. Readers might use Saldaña's and Roulston *et al.*'s models to think anew about performing ethnographic work as they have done – in the context of an academic presentation at a national or regional conference or in a theater.

These chapters show by example how one might use fiction and performance genres to adapt ethnographic experiences that are both professional and personal to the page and stage. One might adapt an existing ethnography for the theater, interweave empirical data within a fictional plot, or collaborate with other scholars, artists, and family members to create moving portraits of individual cases or collective educational experience. This section assumes ethnographic work can be both stimulating and about real life.

Chapter 13

Hearing Jesusa's laugh

Terry Jenoure
Lesley University, Cambridge, Massachusetts

Terry Jenoure was born and raised in the Bronx in New York City into a Puerto Rican and Jamaican family. She began music training on the violin at the age of eight and is self-taught in the areas of visual art and poetry. She dances constantly in her body and in her head, and makes hand-sewn art dolls, which are carried by commercial galleries. An early student of European classical music, her first venture away from this discipline was when she played guitar and sang Buffy Sainte-Marie's "Universal Soldier" for an audience of 3,000 at Central Park during an anti-Vietnam war moratorium in 1969. This marked a first step outside the world of written notation into what would soon become a life-long passion for musical experimentation. She has performed and taught in various capacities throughout the US, Canada, Colombia, Brazil, France, Germany, Holland, India, Israel, Italy, Mexico, and South Africa. Social change, spirituality,

self-awareness, creative functioning, and improvisation are all themes that comfort and feed her work. Dr. Jenoure's Masters and Doctoral degrees are from the University of Massachusetts Amherst in the area of Multicultural Education, and she has a Bachelors degree in Philosophy from the College of Wooster in Ohio. She is on faculty at Lesley University's Graduate School of Arts and Social Sciences. Her teaching focuses on arts integration and arts-based research. A recipient of three grants from the National Endowment for the Arts, as well as ones from the Money for Women Fund, and the New England Foundation for the Arts, she has also been a consultant for the National Endowment for the Arts, the Lila Wallace Readers Digest Fund, and the Ford Foundation. Her first book, *Navigators: African American Musicians, Dancers, and Visual Artists in Academe* was published by SUNY Press, and she has published articles exploring the connection between jazz improvisation and pedagogy. Terry is currently working on a memoir of essays, poems, drawings, and music.

Jesusa's Laugh is a dramatic musical performance created to report findings from educational research I conducted in South Africa. It combines live and pre-recorded music with dance, poetry written by my students and me, journal entries, taped interviews, and visual imagery. Through my trip, I was looking to understand two things: How might I apply arts-based pedagogy to a cultural context much different from my own? What have been some of the experience of ten teenage boys from a South African township? Then, through the performance that ensued, I was hoping to find ways of sharing what I learned, some of which were related to my original inquiry, but most of which were not. The entire endeavor has propelled me towards ongoing investigations into my professional practice and family history, and has stirred up longings among many parts of myself. Like a ball of yarn with its strands of fibers wrapping and spiraling all around each other, the many facets of this project come together through seemingly unrelated, yet connected people, places, and events configured and reconfigured in New York City, Puerto Rico, and South Africa.

In this essay, I am attempting to reconstruct the route I took in merging educational research and this performance. Although this all may seem quite tidy and straightforward, it is far from that. By my own admission, I did not originally view this as a research project. A newcomer to the field, and an outsider by my own recognizance, I am looking at what occurred from a bird's-eye view. It does not follow a linear route, and may be better appreciated as an amorphous entity with tentacles in odd and unlikely events and conversations. Only as I

continue to watch and question it, as I have here, am I better able to define and find a place for it.

This essay is explored in four parts. The first part is about my trip to South Africa in 2001 – what prompted it and what transpired once I got there. The second describes some of my process as I went about bridging research with art. The third part is a script of the text from my performance. Then following are concluding thoughts about the meaning and purpose of the project as well as implications for its application.

I IKHWEZI

My trip to South Africa has firm, solid roots. I was a little girl, living on the fourteenth floor of a high-rise in New York City's fierce Bronx. Examining braids and scars, lip plates and scooping breasts, I lovingly and carefully turned the pages of my father's large coffee-table books that carried me off to a continent he always regarded with tremendous dignity and reverence. I knew the quickening in this little girl had something to do with a deep, complex "me." Another root: The album cover for singer and South African icon Miriam Makeba that I saw at age twelve, and the inimitable sound of her clicking Xhosa tongue. I looked and listened studiously. Her close-cropped, unstraightened, naturally kinky hair was not yet a common sight in my neighborhood, nor in the America I had come to know in my brief years. But it was 1965 and I had my adolescent ear to the ground. I was getting wind of the "Black and Proud" storm that was sweeping America, in which, just a few short years later, I would be gleefully swept away. And in my home, where aesthetics and politics were inseparable, "Natural" and Pride in Self" were mottoes that reigned supreme. So, I admired the self-assuredness of this Miriam Makeba while I was reminded over and over by my family of a priceless teaching that would last me at least another forty years: confidence in expression is ultimately where all beauty lies.

There were aspects of my current professional work that inspired the trip. I am a musician who often collaborates with artists in other media, including dance, poetry, and visual art. I am also the director of a university art gallery that produces visual and performing arts events. And, for ten years I have been a teacher educator at another university, with many earlier years spent as an educator in secondary schools and private instruction.

Oddly, it was my growing frustration as an educator that initially played the most significant part. I teach through the arts in a Masters degree Education program that has distance sites, with students in many parts of the country. Most of them are in-service public school teachers who are learning to apply the creative use of the arts in their

classrooms. In addition to guiding them in developing curriculum strategies, I talk a lot about the need for creative teachers to think and function more like artists, shaping people, places, things, and ideas in unprecedented ways. We mostly agree that the arts are good medicine for an ailing, flailing system. But *why* make art? Here is where we seemed to part ways all too often.

It was the teaching of my mostly White, mostly middle-class, mostly women – my kindergarten through twelfth-grade teachers from Oregon to Georgia to Wisconsin to New Mexico to Maine to Montana to South Carolina to Idaho that troubled me. More and more frequently, I found myself wondering what had happened to me? What had happened to my sixties' Black Power, working-class, bent on "revolution by any means necessary" self? It had always been a part of me that burned when I taught, and that taught me to keep burning. It had initially been my entry into this work. I was certain and driven about the connectedness of art and cultural identity. But lately, I had begun to feel myself buckling inside when my students quietly snickered at my proclamation that America is a racist nation, or were horrified by my critical condemnation of blind national patriotism. Many of these women resented the readings I assigned about the insidious nature of sexism in education. I had begun to cringe when they snarled into my exclamation that we are slaves to a patriarchy, our mutual resistance and disdain, politely tucked behind our deadpan expressions.

A child of the sixties, I had never quite shaken my first political lesson: question authority. And, a child of parents whose biographies had come together from two different countries, economic class associations, and languages, I was raised to honor cultural distinctions, to value questions and to question values. But now, our worlds, my students' and mine, collided and crashed again and again. I had become hypersensitive, so I saw the smirks before they were formed. I felt their desire for the course to be over before it had begun. They didn't want these topics approached, and definitely not by me. Yes, most of them were terribly frustrated with their schools, and with the politics of standardized testing and the daunting repercussions in their classrooms and other parts of their lives. And yes, their schools had become increasingly more diverse. To some degree, many had a desire to understand more about the nature of change in regard to multiculturalism as an educational mandate and a social reality, and the role that the arts could take in reforming schools. But in one course after another, as I attempted to respond to these needs, I seemed to be meeting fewer of mine. I was beginning to see them through the eyes I had so often cautioned them against. They had become one loud voice. A "them."

When I teach, I want to be heard. I want to breathe into a warm receptacle instead of shouting into what was feeling like such a

cavernous vacuum. Granted, there was a part of me that still loved what I did, and even *needed* to do it. But, there was also a growing part of me that was angry at them, at *us*, really, for being so smug. So complacent. So bored with yet another method for teachers to bandage their classrooms. The Arts in Education. Another antidote. Like a new improved mouthwash or laundry detergent. And I was tired of being the traveling saleswoman. There was nothing left of me to give. Ultimately, it was a good thing because this wall that I hit helped me make my move.

When I went to South Africa, I was looking to find out whether I could apply my experience and skills in arts integration to a very different cultural context: South Africa, a Black-ruled country that had been rebuilding itself for about ten years, following centuries of the enforced racial segregation and minority rule called Apartheid. But I had other questions: What would I learn about my relationship to Africa that would be fresh and personally uplifting? Would I meet people with similar professional and sociopolitical interests? So, at first, when the trip was still just in the realm of "a good idea" and not quite yet "a plan," I received a grant. Without a template or suggestions on how to proceed, I trusted my hunches and my excitement. I began to focus on what I wanted from the trip. And I wanted a lot. I wanted to teach; to find out more about people's lives; to meet and collaborate with other artists; to find educators who use the arts for the purpose of bringing about social awareness and change in their communities; to pursue a very old emotional connection to Africa; to explore whether South Africa might be a place where I could return and establish professional roots and partnerships; to fortify myself in order to continue my teaching at a more developed, profound, and satisfying level.

I had no roadmap for this inquiry. I simply began talking to a wide range of people about the seed that was germinating. Colleagues, students, as well as strangers with indirect connections to me offered helpful contacts through email addresses. They'd say things like, *Get in touch with him. He teaches at this university and knows lots of people.* Or they'd say, *I know someone who received a grant to go to South Africa a few years ago. Maybe you should contact her.* Or a couple said, *Here is the name of an organization in South Africa that is somehow connected to arts and AIDS awareness.* The associations were broad and varied, but almost all of them led me somewhere. So, I launched my emails introducing myself, explaining some of my interests, what I wanted to do, why the trip was important, always offering myself as a volunteer speaker, teacher, or musician. Before I knew it I was receiving responses: *I don't know much about arts education but I know someone at a local university who has a similar curriculum. I'll send your email to a few people.* My letter was being shared among

academics, artists, social workers, people with compatible interests. I felt vulnerable. I felt strong. I had imagined something and had taken steps to make it real, like when God told Noah how to build the ark, dimensions down to the minute details. The hammer and nails were my thoughts, emails, lists, and conversations. Then there was more pondering, more lists, more emails. This boat felt impenetrable, and the flood ended up being more like a cleansing downpour.

In 2001, I spent a frightening, exhilarating, exhausting month in South Africa, resigned to the heat, the newness of everything, the way English sounded so smooth in other people's mouths – so smooth I caught my head nodding to the melodies and often missing the questions and answers. My calendar was packed. I crammed in as much as I could. I met scholars from Johannesburg's prestigious Witwatersrand University, and the founders and coordinators of the renowned Art against Apartheid movement, which had become popular for its radical political stance. I led art and poetry classes with two groups of children. I interviewed Princess Francina the elder artist from Siyabuswa, in the countryside near Pretoria, who has assumed leadership in retaining and teaching an important Ndebele painting style. Her art has restored a nearly lost tradition whereby the exteriors and interiors of homes are painted in bold, geometric patterns. She spoke with me about her views on teaching young people. Dr. Jackie Phahlamohlaka graciously invited me to be a keynote speaker at the graduation of a college preparatory school, the Siyabuswa Educational Improvement and Development Trust, in a rural technology program. At the close of one particularly long, strenuous day, I was honored to have met the Ndebele cultural leader, King Mayisha, at his home. But shortly before I was about to leave, I fell under his harsh inquisition. Without hesitation he cornered me and probed about my trip to this community that continually attracted curious tourists: *What have you brought?* I felt myself shrink. By then, I had been wondering the same thing. What could I possibly have to offer in a country where 20 percent of the population suffers from AIDS, water is precious in rural areas, and drugs ease the nagging, unbearable pain of unemployment, hunger, and disillusionment? Art? I felt like a glutton. For one very long and painful moment my visit felt trite. Even today, I wrestle with this jumbled mix of feelings.

My trip culminated in a five-day workshop that I led in Cape Town. Sias Sabelo Dyani, David Magidigidi, Vuyani Mahalwana, Lindela Sydwell Ndzulu, Zweli Tukayi, Sizwe Mfecone, Phumlani Nkoyi, Richard Mzwamadoda, Nqgongwa, Luwandh Melikhaya Tana. They were a group called Ikhwezi, which means "the morning star" in Xhosa. They were ten kids from Khayelitsha, a nearby township, who would be in my class. My friend Ingrid Askew, a theater artist and community activist, had formed the organization when she left

Massachusetts to live in Cape Town about five years earlier. It was Ingrid's apartment, where I stayed, which overlooked Table Mountain, at the tip of Africa where the Indian Ocean meets the Atlantic intimately and inevitably. During Apartheid apartments and houses with this glorious view in Cape Town had been a privilege reserved for Whites. My new acquaintances, these living witnesses of such profound shifts in their destinies, reminded me and each other of this fact often, and with a mix of disgust and pride.

Ikhwezi already knew I had come to them not only as a teacher, like Ingrid, who vibrated with energy and devotion about art and the building up of their communities. I explained that I had come in two capacities: as an educator and as the director of a university art gallery. I would be teaching them, using collage and poetry as part of our ongoing explorations. I would then take their art back with me to my gallery and display it in one of the upcoming exhibitions as part of our Young Artists Series, which features visual art by a diverse population of young people interested in delving into topics related to cultural identity.

And so, it is time for us to begin. I have some vague idea about what might happen – what could happen. My teaching style tends to be both tight and loose at the same time. I love the precision and choreographed rhythms, but I also need the clutter. On the first morning, as they arrive and we introduce ourselves, we wind our way through the wooded area along the rim of the manicured botanical gardens abutting the National Gallery of Cape Town, just across the street from Ingrid's apartment. We're going to work with "found" materials from the park, so we begin to collect things. Odds and ends. Junk. Leaves and candy wrappers, dirt, sticks, matchbooks, grass, bugs, newspapers. Although I'm not exactly certain what we will do with them, as we hunt it becomes clearer. The group is timid and I'm feeling the same way. Still, we are excited to be together. The weather is hot and dry. The park in the summer is full of visitors. Luckily, none of them are even slightly interested in us. Our group breaks up into twos and threes while some wander off by themselves into other sections of the park. They gather more than I expect they will and far more than I figure they need. I'm enthusiastic because they are. These beautiful young men, old enough to be my children, almost young enough to be my grandchildren. I announce that we will now go inside and look a little closer at these things we've gathered. They're curious, and all of us are amazed, laughing at what we've found, putting our treasures in brown paper bags as we head indoors.

Our classroom is in an annex of the National Gallery of Cape Town. It is a formidable institution in what seems to be a relatively affluent area. Some of the young men already know each other from

Khayelitsha, their home town, but many of them met for the first time when Ingrid formed the organization. They are accustomed to getting together regularly in her drama course and have already grown close. They call her Mama Ingrid. A bus picks them up at a central location in their neighborhood and brings them to Cape Town. Then after class, the bus takes them back home. Some of the members of the group have dropped out of school. Some of them have night jobs that barely help feed families. Some have had drug problems. Some are plagued by circumstances I know nothing about, and can't even imagine. Their spirits are enormous and profound.

I'm suddenly so moved, so overwhelmed by what they are giving me in the form of attention and commitment. I'm impressed and warmed by it. Ingrid did a wonderful job of developing this kind of trust long before I arrived. I announce that I want to share a song with them. We go into a more spacious room and I explain, *I have songs from the African American Freedom Movement of the 1950s and '60s that I want to share. These songs mean a lot to me. This one is called "I Woke Up This Morning With My Mind On Freedom."* They watch me closely and listen. I'm encouraged. When I finish singing, they applaud with excitement and I feel completely centered and certain.

The investigation through the arts that I've planned in this workshop continues, as I wonder: *How can we speak to each other? What is it about ourselves that we feel others may or must know? How can we tell those stories? Who do we want to tell them to? How will they be heard? What will happen to these stories once we tell them? Once we hear them ourselves?*

We settle at desks that are arranged in a square around the room with large white poster boards, one for each person. There is plenty of room behind them to stretch and move around, and room in the center for me to move among them. Materials are spread out on the tables: paint, large sheets of white paper, colored construction paper, glitter, markers, yarn, glue, tape. *Use the materials that you've found in the park as well as the supplies that I've brought. Also, look around and see if anyone else might have things that they've collected that they wouldn't mind sharing – things you may want to use. Create images and marks that represent something important to you – it should tell us something special about you. Maybe it's something you want people to know about you. It can tell us about something you think about often, or that frightens you. It might be someone very special in your life, or an event that is meaningful, or maybe a desire or dream that you have. Maybe it's some experience you've had or some advice you want to share with others.*

The room is completely quiet. The boys stare out in front of them. I wonder: *Will they go along with this direction? Does it even interest*

them? I'm beginning to feel tense and self-conscious. They move very, very tentatively. I wonder if they understand my directions, so I repeat them slowly. Then, I invite them to ask me questions. I explain, *I love questions. I'm not always as clear as I'd like to be, so if you ask me questions, it may be one that someone else is thinking about too. In fact, it probably is.* But I soon realize that they do understand my directions and are just thinking quietly, deeply, carefully. Slowly, they begin talking to each other and working, and I can suddenly feel the room get warmer and brighter. Relieved, I'm feeling light and giddy as I think about the days that lie ahead and realize how fast they're going to go by.

On the second day, we move from handling these materials to examining how we might incorporate words too. I direct them: *Write one sentence that tells us about the image you've created.* When they have done this, I instruct them to take a word from their sentence and free-associate new words for as many of the words in their original sentence as they can. Then, from that huge list we'll use as many of the words as we can in order to create a poem. This encourages the writers to accumulate words that they may not have employed if writing in a more linear fashion. It invites contributions from the mind's subconscious reserve, finding new meanings and applications for common words. I demonstrate this with a sentence of my own. We generate a long list of amusing associations, laughing at their incongruity, all of us wondering where we might be headed. This large list of freely generated words becomes like the artist's pallet of colors. We dip in, arrange, and rearrange them for my sample poem. I say: *As you do this on your own, you will find that you have lots of words that don't seem to make sense for the poem you want to write. Don't worry about that. Use them anyway, and use as many as possible. Use them even if you think that no one will understand its meaning.*

The poems are then integrated with the visual representations in whatever way they choose. Some put the poem on the back of the image, some blend it into the body of the visual art, while others attach it to their painting or collage with tape or staples. Three days have gone by. And in the busy, noisy room, in between the pasting and writing and drawing, they individually, throughout each session, call me over to their tables. They whisper things about their personal lives to me. They understand that we may not meet again. They ask my opinion and even suggest their own wisdom about some of their predicaments. The more I hear, the less I understand. This is an important, unexpected moment for me.

As they work, I encourage them to step back and take time away from what they're doing – make some distance – get another perspective – another approach perhaps. *Go visit other stations – go see other*

people's construction – get inspired. As they do this, their interest in each other's processes grows. Again, I ask them to borrow an object from their neighbor's bag and incorporate it somehow in their own work. I continue to encourage the intentional use of new or unintended materials. It is this element of surprise and the ability of the mind to operate below the surface of consciousness and cognition that often offers the most meaning to us and to each other. They complete their art on that third day. The collages are magnificent, with no two even remotely alike.

There is a lot of detail in Richard's picture. It is arranged like a storyboard into a few different segments, and divided with lines to separate the portions and lead us through the events. It has a surreal quality, with fragments and characters and scenes in odd dimensional relationships to each other. His poem helps us follow the trail:

> *Suddenly the sun shines like a foretold*
> *Mirror on the wall story*
> *The dog is creating a great deal of noise*
> *Under a big shade tree while mumbling and chatting to itself*
> *It growls and enjoys some sweet bones.*
> *Suddenly a hungry wolf is making ugly music*
> *Of its own character not caring who dares*
> *To not enjoy it and suddenly its targets*
> *Human, sheep and beetles murmured with fear*
> *As their ears witness the music of the good*
> *Bad one.*
>
> *Suddenly nature observes the matter*
> *By sending the dawn of the day*
> *Suddenly it's night again, and the day*
> *Is gone and it shades bad image.*
> *Suddenly an elder is telling a story to*
> *The grandchildren, uncles, and aunts, sons, and daughters,*
> *A story of secret long-lost tribes of Africa.*
> *But it was not an end for them*
> *They continued to struggle for their*
> *Tribal voices and not forgetting who*
> *They were and where they come from and*
> *Deep in my heart I am one of them.*

In contrast, Phumlani tells about a life that's been very hard. His message is personal, candid, and introspective. He seems withdrawn and is observant and determined. His image is striking. A boy, his large blue face covers almost the entire surface of the paper about

three-feet square. The face looks straight out at me. There is a huge teardrop falling from his eyes. I wonder why he is crying:

> *This boy was sad*
> *He was yelled*
> *He was shouted*
> *Sent to shops when it was raining outside*
> *People were taking advantage of his kindness*
> *Life was not fair for him*
> *He made one big mistake*
> *He is down on his knees*
> *Begging for forgiveness*
> *Oh Lord won't you see him*
> *Let the road be clear*
> *Of Satanism.*
> *He is pushed*
> *To force to face the ground*
> *Those who know say*
> *"Don't kiss the ground."*
> *Just push them aside.*
> *Your journey is only beginning.*

I see from their responses that many have faced the grip of drugs directly or indirectly. Luwandh has produced two pictures and poems. They have a mixture of materials, but with no representational images. They make references to themes I am unable to connect. He writes punitively, didactically, and urgently about the importance of not using drugs:

> *Many things break hearts*
> *But most broke are unexpected,*
> *Hard or easy*
> *Black or white heart now*
> *Be broken if use drugs.*
>
> *We always have someone to blame.*
> *Who is to be blamed for broken hearts*
> *You hurt us why can't you heal us*
> *What is it that makes a heart?*
> *We have to heal each other.*
> *Stop Drugs*

His second poem is more emotionally revealing and has the desperate feel of someone holding on to a lifesaver:

I've lost my love I lost every thing
But my body is still my body
I've lost my love but my friends
Brothers, relatives and family are not lost.
So I'm still a human
I can't use drugs to heal my wounds.
I can't eat vitamins to heal my wounds.
Yes I can survive without drugs.

Vuyani's poem is a wonderful mix of literal and metaphoric ideas. He talks about travel in physical and emotional terms:

I took a ride on the horseback
To Africa where I belong
I flew by jet flight
I took a ride on the elephant's back
Sometimes on the rhino's back
I passed many rivers by ship

I traveled by train without tickets
I saw places and faces on my way
I learned new cultures and customs
I got caught by police and traveled by police van.

It was confusion without fear
I used a bicycle as my vehicle without feast
I have no clothes, shelter, and direction
I spent many years in foreign countries
By dedication I'm home again

When Sydwell writes about Nelson Mandela, his references remind me of ones we've come to associate with the leader, including Mandela's contributions to cultural and racial reconciliation and progress. The painting is grand, exaggerated, and explodes with pride. There is a noble-looking man in a house with ferocious animals as he rests with ease in his surroundings. From the words, we get a real sense of what is valued, as well as a tribute he's created with reverence and satisfaction. He calls it, "The Home of a King or a Hero":

The king's home is symbolized with its beauty.
The doors are decorated with bars
The house with shiny diamond
Fire pot also shows that it is a hero's house.
The man who had been won the battles.

The man who had been stopped the violence,
Discrimination itself.
People are forgiving each other because of that man.
It is something
As you see his home is very beautiful with
Flowers, trees and the tiger.
The tiger shows his braveness when the time
Of wars
The bones of ancestors helped him to abolish
The violence, bad behavior and discrimination.
The sky and the sun shows that the king
Is the man who had worked hard so he
Deserved to have such beautiful home.
Heavy rains were raining to this man
Trying to eradicate him with his roots
This home itself signifies it is owned by the man
Who had worked hard for people
This home is the reward for his attempts
To freedom.
I'm talking about the home of a hero here you see.

On the fourth day we finally hang the art works up across the length of the room's very long wall in order to view them as a whole. I want them to talk about themselves – the stories they are telling, and anything else they may care to share. I want them to own the presentation – to lecture, to teach, to take full control of the colors, shapes, textures, words, and feelings that cover the walls – to bring these tales to even larger life.

But now there seems to be a glitch in my plan. The National Gallery has a resident photographer who covers special events like ours in order to announce and promote the institution's programs. I'm told that she will be here this morning to photograph. I reluctantly agree. I tell the group that we will simply continue with what we're doing when she comes. We have already mounted the art on the walls for our final viewing. We have lined up these large mixed-media configurations one next to the other to examine them – to see them from a distance and up close. And, mostly to understand each other better and celebrate this special time we've had together. We are so pleased with the results, which we spread out over the walls like a map to our pulses, lifestyles, and moments in our collective stories.

The photographer arrives about halfway into our morning. She is a small, young, White woman, very polite and excited to be taking pictures. She assures me she will not interrupt. After taking a series of shots of the group while we continue our viewing and discussing, the

young woman asks if she can take a picture of the group standing together. It is now beginning to feel like an intrusion. I had hoped that our last day of production would be spent completely focused on the task of critical examination. It is crucial that we summarize and make meaning of our efforts. Nevertheless, I agree to her suggestion. We stop and they huddle for the shot. Then, in an instant that now seems both distorted and strangely lucid, she puts her camera down. She has a good idea. Will those who are wearing baseball caps please turn them around? Will they please turn their hats around and smile really big for the camera? I am frozen. In fact, the memory is a fractured one. It is a collage of arms and breath, eyes, breath, adrenaline and hats, browns, blacks, and heat, more breath, fear, and a raw rage. She has seen the group of young men in this room and now has a picture in her mind that she wants to reproduce. As she directs them on how to pose, I now see the picture too. It's that stereotypical, media-driven, hip-hop image of rappers. Her instructions are an assault on our work – the strenuous task of claiming our voices and choices. Of acknowledging the political implications of what it means to "be yourself," and what it means to rule ourselves as human beings – to be "free" and "new" as is suggested by the common phrase, "The New South Africa." Some of them take their hats off and begin to turn them. *Don't do that. Turn your hats back around.* I shout it. And in that one split instant my mind collapses as I retrieve a forty-year-old memory:

> *It's Saturday. We're on the outer edges of the Bronx River Projects, my mother, my brother, and me. We walk down Sound View Avenue toward Westchester Avenue where all the shops are located. The elderly Jewish storeowners in our neighborhood, a long way from their own families, who live anywhere but here. We go to the hardware store, where my mother wants to purchase something. But now, the old man is talking strangely to her. Like she's worthless. She's a bother. She's a despicable child. I hear his impatience and scorn, his clipped speech and tone. And there's his small, wrinkled wife who stands hunched and gray and sour, smugly and just slightly behind him. How dare they talk to her that way? My beautiful mother, always gracious in private and in public. Slim, dignified, her skin, just a shade darker and warmer than my own. In an instant, she's changed. Only moments ago, she was light as a feather, now everything inside her is condensed, solid. Her eyebrow raised, mouth tight and pursed, she turns and quickly ushers my brother and me out the door.*

And today, I feel like my mother as I call Ikhwezi to attention in that little basement room in the National Gallery of Cape Town

decades later and on the other side of the world. I need to draw the line. I also need to let these young men know what I'm seeing, hearing, and feeling. I have a desperate need to break this down for them and for me. They have been telling their stories all week. And though the opportunity has presented itself in an oddly unexpected and awkwardly painful way, I now have a chance to tell mine. *Keep your hats on the way you're wearing them.* I hear myself say. But I'm disappointed. I have nothing more. The photographer packs up and leaves. We are alone. There's a huge echo in the room. Some look at me gently, respectfully. Others seem to not be thinking at all about what has just happened. While others look hopeful, expecting me to say something. I know I *want* to say something. I know it is part of my teaching – part of our learning. I need to translate the experience – to scream it really loud. I want to say that the stench that lingers is what remains of a dead thing. The stink of cruel and hideous agreements that are made between people. Of assumptions and frustrations – all of ours – the photographer's, theirs, and mine.

It's quiet. They're waiting on me. I'm accosted by the memory of an old man who had set up his shop in my neighborhood, then decided who my mother was and how we must behave. I'm disgusted, appalled, at what just took place in what had been our sanctuary, and probably not much less, at what it evoked, this intense moment that binds us in a common wretched history. But our workshop is nearly ended, and to my surprise, I resist my urge to follow the Race trail. It seems too ominous and will undoubtedly lead us to parts of this dense place with insufficient time or resources with which to find our ways home. *Don't you ever let anyone tell you how you should look or act.* Again, my voice disappoints me. Surely I must have something more to say. But what is burning on my heart is so huge that now it's stuck in my throat. It chokes me. And here in South Africa, like back home, my desire to talk Race with my students is still not quenched. There remains that part of me that wants to be fully revealed to my students, whoever they are. To walk with them down this decrepit place of our shame and rage with its wretched stink and mildew. I want to uncover and release that monster we keep trying to appease with our ignorance, and that keeps me feeling, whether here or back home in Georgia, Montana, and Oregon, like Isaiah, the barefoot prophet who cries deep from his soul: Save yourselves now. The end is near.

The next morning, we sit in our circle for one last time. I ask their permission to record our conversations. We make speeches to each other. To my complete surprise, they read poems to me – poems they've written on their own over the past few days, mostly at home or on the bumpy bus ride from Cape Town to Khayelitsha. The poems are about me. Some are naked and raw. Some are formal and contained. They tell

me the things they've learned. They tell me what they plan to do with what they learned, and about how they care for me. They'll miss me. We sing our Freedom songs. David leads the group with his full tenor voice as they present me with a gift: a traditional Xhosa Initiation Song with accompanying dance that is sung in their communities when boys turn to men. It seals a promise, or at least a hope. We'll meet again.

Ikhwezi disbanded less than a year later due to the many changes in Ingrid's and their lives, as well as problems with funding for the project. They never saw pictures or videos of the exhibit I curated at my gallery, with their magnificent paintings and poetry filling the walls. They never saw their collages again, or even heard about the excerpts from their art that I used in my own performance piece where I attempted to make meaning of our profound journey together.

I returned home to teach my teachers. They were impressed by the story, wondering what it's like to be me, and to be Ikhwezi. They speculated. I insisted that their schools and communities are sites of meaningful culture no greater or lesser than Khayelitsha. Still, I'm conflicted and greatly troubled. To this day, I wrestle with it – how much I gained. I had wanted to know if I could apply my teaching methods in a cultural environment that was this unfamiliar to me. And yes, at least on the surface and to varying degrees, the learning had been valuable to us all. I wanted to know about the experience of these young men, and I had discovered many rich and unexpected things through their art and the relationships that had been formed. Still, I had other things on my mind. I had turned one visit into an invaluable and complex array of lessons and opportunities for myself. But had Ikhwezi been able to do the same? If not, how could I have facilitated that learning? If so, where had it taken them? What had *they* done with the results of our five days? My heart is loaded with these questions. They are burdens to this researcher. I struggle with what sometimes feels like a thwarted enterprise. I can still hear King Mayisha interrogating: *What have you brought*?

Ingrid reminds me that some of the young men, now fully grown, still sing the Freedom Songs I taught them, and occasionally ask about me on their way to the places they travel to day after day. I hold on tight to those bold eyes and compassionate smiles. There's a flutter in my deep self.

II IKHWEZI MEETS JESUSA

It took time to settle myself upon returning home. So much had happened in a month. I had taught children, met artists, activists, teachers, old people, seen the countryside, the cities, conducted interviews and lectures, witnessed suffering and a lot of laughter. The wind and smell of the air had felt so

drastically different from anything I had ever known. The way I seemed uninteresting to people in the streets occurred in high relief to my usual blistering presence in the small New England mill town where I now live. And although the project had been catapulted by my long-held attraction to Africa, my desire to escape the painful, strained race discourse with my students, and my passion for international travel and collaborations, I was far from finding closure or having definitive answers about much of anything.

It was almost a year before the idea of merging that experience with my life as a performer occurred to me. Upon initiating the research, my most prominent question had been whether I could translate skills as a teacher educator in the area of arts in learning to another, vastly different cultural context. However, the full answer was far more complex and unrecognizable than what I could possibly discuss, write about to others, or even make sense of for myself. In fact, I was at a loss about how to express what had happened and was still happening. The notion of performing my findings happened easily, enjoyably, and to my relief in the best way I could imagine, which was without intention or a plan. It happened when I was invited to perform at a venue where I would ordinarily work with my jazz ensemble. However, now, my mind was on this project. Those worlds began to come together as I prepared to share events and thoughts and conversations and insights and observations that had seemed so complicated.

I first began letting my mind wander freely for very long periods of time over the course of many days and weeks. I took notes for a while. And I noticed my mind's patterns, but I didn't try to make sense of what I was feeling or thinking. As I began to see and hear images and sounds, I noticed and marked those that emerged and were most prominent or lasting, and those that seemed to have less energy or made less of an impression on me. I made notes about important experiences in South Africa that I had managed to document, either in my journal, photographs, on audio tape, or through the children's poems and paintings. There were lists and comments and questions and short melodies and visual images and shapes, and then hunches and connections, and eventually, some stories I thought I might want to tell.

In sorting out the many pieces that seemed to be presenting themselves, I didn't try to make meaning of them or coordinate or organize them in any way. I simply let them come. I welcomed everything. The incongruent and unlikely ideas remained in the pages of my notebook. I trusted that I would at some point know what to do with them all. Eventually, things began to come together and make sense.

For me, the most profound part of my process was how I had all of a sudden and seemingly out of nowhere begun to think about my maternal grandmother. This was surprising and emotionally jarring. For reasons unknown to me at that time, I found myself aching as I

reached inside myself for memories of her. In fact, I hadn't thought a great deal about my grandmother in the ten years since her death. I don't think I had even allowed myself to miss her in the way I now seemed to be doing. My grandmother's image and our conversations that immediately preceded her death were becoming more vivid as I retrieved memories of South Africa. She seemed peripheral but somehow related to this work. It was odd, but I completely trusted what was happening and allowed it. I even expected it to lead me, which it did. I began keeping journal notes about my grandmother in order to coax the question that felt lodged inside: *What is the relationship between my experience in South Africa and my grandmother?*

This sudden, unplanned focus on her is very appropriate in retrospect. As I began to explore her role in the performance, she began to take center stage. My grandmother, Jesusa Calcano Lanzo Lopez was born and raised in Loiza, Puerto Rico. This small rural province on the northeast coast of the island was the main port where enslaved Africans were forced to live by the Spanish who had brought them to the island. Loiza has retained its identity as an important cultural site, nurturing many of its memories of West Africa through music, visual arts, religion, and language.

It all came together when I decided to use an interview that I conducted with my grandmother for the performance I was creating. The interview had taken place, about ten years earlier, when my grandmother was eighty-nine, only a few days before she died. At the time, I remember feeling conflicted about interviewing her since she had recently been hospitalized and was deteriorating rapidly from cancer. But it turned out to be a powerful exchange. I selected a brief excerpt from our conversation where she is talking to me about her mother and father. Those few moments eventually become a key segment that opens the performance. Our voices can be heard while the stage is still dark. Also, in the process of listening closely to that interview, studying it in order to decide what I wanted to include, I remembered something so wonderful about her. My grandmother had been a joyful person who always found it within herself to laugh. Joyful, not in the sense of being jovial, but her soft laughter was part of a reserved and shy demeanor. My interview captures this signature laugh in spite of her physical condition at the time. When I went into the recording studio to have the engineer place the segments of our talk that I had selected on a compact disc for use in the performance, I did some experimenting and eventually found a moment in it that reveals her wonderful laugh. I had the engineer lengthen it and create a feeling of timelessness through the use of recording technology. I employed this effect to punctuate sections in the piece, hence, the title, *Jesusa's Laugh*.

As I began feeling clearer about what was coming together, I vacillated between listening to the interview with my grandmother and listening to the interviews and songs I had collected in South Africa. By then, I had fully given over my work habits to my intuition, which serves me very well, and upon which I always depend for this exciting and crucial part of my process. As I did this, I also began writing with more assurance, and that writing became the foundational narrative for the performance. It was also to be the first of many subsequent essays and poems about my family. I wasn't sure what I had on my hands. Was it something I would want to perform? Was it any longer part of my South Africa project? What were the data I was reporting? What had been the research? Where were the facts, and where was the fiction? Where were the boundaries between all my explorations? Who would determine this? And how? And why? Eventually I knew that I would do what I always do, which was to trust myself and the certainty I was experiencing. Then, at a later date, perhaps I would figure out what it was I had.

I began making theatrical decisions. I would integrate Ikhwezi's poems. Some of them are woven through the music, either spoken or sung with instrumental accompaniment. The interview with Francina in South Africa was on cassette tape. She spoke Ndebele and had an interpreter with her on the day we met. By listening to his simultaneous translation as she and I spoke, I was able to choose a segment that was directly related to teaching. Her ideas inferred the sort of spiritual ancestral and cultural teaching I was now also receiving from my grandmother. For me, Francina becomes a type of Jesusa. This three-minute segment was edited in a recording studio, where a huge echo was placed on Francina's melodic voice. As it reverberates and the piano synthesizer plays rich "washes" of sound beneath the recitation, it creates a dreamy, mesmerizing, haunting effect that is at once both ominous and intimate. I put this in a section where the dancer moves slowly and with exaggerated gestures in a central location on stage. There is a clothesline that runs diagonally and is draped with flowing, silky fabric reminiscent of the bright, bold colors Francina employs when she paints. The dancer moves from behind this wall of color with large motions, suggesting that she is communicating an array of tasks, directions, and feelings. The clothesline is a metaphor for women and traditional work. I ignore my usual critical, feminist inclinations, and feel very comfortable and settled with this association as I think about my grandmother, an immigrant who spoke mostly Spanish – a proper and strict, but kind, generous woman who stayed at home to raise her four children.

I chose a few brief sections from my journal notes, although, as the piece came together it became more difficult to decide what to include without it feeling too much like a travelogue. I wanted the audience to

sense my wonder and awe, and finally decided on three short excerpts. The Initiation Song that Ikhwezi sang for me on our last day together in Cape Town, and which I had fortunately recorded, became such a powerful element in the performance. Their adolescent voices are right on the verge of manhood. I placed their singing at the very end and composed live music that plays simultaneously. It is a collage, with the juxtaposition of their slow, steady, rhythmic traditional song against the live musicians with their stark, extremely fast, free-swinging jazz ideas forged by the bass and drums. It is a fevered layering of musical styles, time zones, periods in our histories, traditions, and inventions. It becomes a force that drives us home – the performers, the audience, Ikhwezi, Francina, my grandmother, and me.

III JESUSA'S LAUGH

The following is the narrative for the performance of *Jesusa's Laugh*. It is the core around which the music, poems, dance, and interviews, revolve in this seventy-five minute work. In the quest to report what I found, I create a mythical bond between the South African township of Langa, and Loiza, the town in Puerto Rico where Jesusa was born and raised. This bond, alongside a tribute to her laugh, and my farewell at her bedside constitute the essence of the text.

> (Pre-recorded interview segment)
> Me: *So Grandma, when are you going to let me do my interview with you?*
> Jesusa: *[laughs] ... I don't know. I don't remember [laughs]*
> Me: *What did you tell me your mother's name...*
> Jesusa: *se llama Florentina*
> Me: *[pronounces carefully] Florentina? Is...*
> Jesusa: *... is my mother*
> Me: *Your mother.*
> Jesusa: *Y my father, Balbino Lanzo [pronounced slowly and clearly]*

> [Tape fades]

> #1
> *I heard her laughing as I landed in Cape Town. There she was waiting for me. Jesusa, in the late afternoon wind that whips around the flat-capped mountain. I'd know her laugh anywhere, but this time it was charging through Langa, the township that cannot keep a secret. It's tin roofs and clogged toilets. It's ferocious*

appetite and relentless pulse. Disgrace and ascension, gathered on this one piece of ground.

Africa is a come-and-go, here-but-not-always, there-but-not-really kind of thing for me. Like the trip I took. Like my hair, my nose, my behind and calves and feet that keep on tripping me, tricking me, changing and growing, then shrinking, then spreading. Africa will never be like I knew it before – pictures in my mind, through national geographic or nationalist rants and romance. And it all just keeps me wondering: about me, about you. Like, when I say "Africa," I can't say for sure, but I suspect you may be disturbed by your own not-so-free association shaped like a hammered, chiseled thing that protrudes like fibroids out the middle of this putrid American shame. To my own surprise and relief, but not without a lot of fighting that same hammer, when you say "Africa," I think about my grandmother. Listen. Can you hear her laughing? Because if you're lost, she may lead you through this fog that seductively drapes la montana de la mesa como una cubierta. I'm coming to understand so much of what I saw and heard and felt in South Africa through Jesusa's laugh.

#2
Even when we were young my grandmother's laugh sounded like it had stones in it. Not gravel, but stones the size of marbles. Her laugh was never loud or even bubbly. It started tight, high up in her throat, and ended in short, syncopated lows down in her chest.

Jesusa laughed all the time. It chased all her remarks that tumbled out in her own English that my mother figured only she understood. We understood grandma perfectly, my brothers and me. Her few words ... her huge heart. But whenever she came to visit, mommy would habitually translate anyway. Grandma would say [with heavy accent] "Eh mira, I think-eh I go-eh shop-eh down-town a Sound View Avenue" and Mommy would override the end of grandma's sentence, look at us and say: "Grandma's going shopping down at Sound View Avenue today." Even in her last days, through the cancer, her unmistakable laugh made its way through the pauses in her stories on a bed in a sterile death room on Jackson Avenue.

#3
I spent a lot of time with grandma when I was growing up, but I knew almost nothing about her life as a young woman in Puerto Rico. I did know she was from Loiza. I remember when I found out that she was from the African section of the island – what a gift that was – Imagine! – To discover that when I was so high on being Black and coming into my beauty in 1960 something. It's always

been my lifesaver. Claro que si! Loiza, of course, Loiza. That made perfect sense to me. Loiza is the part of me that ignites like a brush-fire when I hear the [rhythmically] kette tung- ke-pa- paaa/to-dun-to dun,dun kung of my own footsteps. Loiza is the part of me that spins incessantly when I hear the [rhythmically] kette tung- ke-pa-paaa/to-dun-to dun,dun kung of my feet. But I wonder why grandma never danced. We'd grab her hands and pull and pull, trying our best to get her on the floor to dance with us. But she would just make her body real heavy, and she'd laugh and laugh. If by some miracle we managed to pry her loose while she was already up on her feet and sweeping, she shook her hips two or three times, laughed some more and went on about her business cleaning. I knew she loved it, and we did it to hear her laugh. Now, I wonder if she ever waited for us back then, waiting, hoping we'd want to dance with her.

And, why and how did grandma keep Loiza, who never stops dancing, locked up like a criminal? When Loiza's only crime had been to push Jesusa through her womb and down the canal! Even hours just before Jesusa's birth, Loiza had been out dancing all night again. I suspect she might have been with Langa. Langa, who sits at the foot of Table Mountain, king that he is. Langa, who reclines against Table Mountain waiting, so cocky and confident, for his mamacita Loiza. It wasn't Loiza's fault that Jesusa never danced. Who can blame her? No, Loiza tried to teach her Bomba. But anyway, Jesusa slid from her womb and down her canal and through her legs. Maybe grandma got her directions all mixed up. Someone must have whispered Spanish Harlem to Loiza's belly before Jesusa slid from her womb and down her canal and through her legs and she landed on 102nd St. & Lexington Avenue.

#4

Jesusa's story isn't a story in the "once upon a time" sense of having a beginning and an end. It's more like the way I am inside. It's the weaving in and out of my understanding as best I know, so I don't get scorched or drowned. So I don't get overwhelmed or buried under the weight of it all. Her story takes me in and out of myself just enough for me to pull up bits and pieces of recall … tiny bits and pieces of this love, this honor, this obedience to God and self and abuela. Through her soft skin and infectious laugh and strong hands, and heavy breasts and wavy hair and thin wrists and broad hips and slim ankles, and the way she always smelled like talcum powder, I'm deep in the sub-Sahara making sense of us – me and grandma.

#5

She tells me simple things. I can't believe I didn't know them before. And why had I waited until now? I stand and look at her. I want to hold her and bury myself in her. The best I can do is to hurry and catch her words as they fly and flutter and sputter and float and wade. Then, there are the words that have waited, wondered, wrapped themselves with such great care around these delicate breakables. These memories: Her mother Florentina who had one eye. Her father Balbino who was White, "but he was a very, very nice man" she assures me. She carefully unpacks and offers them to me. Her shrunken fingers tremble. Her breathing says she won't be needing these memories anymore. I think there's something about dying ... like childbirth where no one has to tell us to push ... When it comes, no one will need to tell us to travel light.

So, in a cold, metal-sterile hospital room. White sheets, white covers, white walls, white door, huge, cold, windows that look so mournfully sad out onto Jackson Avenue. Blaring TV overhead. My grandmother's sickness shaking hands with Good Morning America, The Price is Right, and Days of Our Lives...

Jesusa laughs. I can hear the little stones rolling around in her chuckle. She tells me names and who wore them. We listen back. She laughs some more.

#6

What do I know? I know that from the Bronx to Cape Town, from Loiza to Langa, I am led and followed by myself. I take all that I am wherever I go!

I know how strange it is that we should meet here like this, under the stars and beneath the street lamp. Us. Yes, it's your story too. There is no seam, no pause, no here and there, no this and that. No line between marriage and death, sickness and health, Loiza and Langa, you and me. We're here, together, in this one moment ... all dressed up and ready for dancing Bomba well into the night.

IV THE LAUGH RESONATES

The way I know that something is successful is by measuring how fruitful it has been. Has it opened doors for me and for others? Has it been inspiring and motivating? Has it been a source of revelation? Does it lead to unexplored frontiers? When I can answer "yes" to these questions, then I know I am headed down the right trail. My trip to South Africa and the resulting exploration of its meaning through this

performance have helped me to define and value many things. These include how arts-based research has made its way into my current teaching, how it has affected other professional ventures as an arts administrator and performing artist, and some of the ways in which it has profoundly influenced my personal life. Perhaps the most abstract but transcendent finding for me lives in the last section of *Jesusa's Laugh*, which tells us that ultimately, everything is connected.

When I first pursued the idea of traveling to South Africa, its purpose seemed so entrenched in personal needs that it was difficult to see how something so self-serving could be useful to anyone but me. I slowly came to realize that in searching for a venue to express my composite voice as an artist and educator there might be some value for others in this project. A novice in the field, there were a few incidents that introduced me to arts-based research. None of which were rooted in my knowing about "a field" or even about others doing such things. There are two incidents that seem particularly responsible for my direction.

Right before I left for South Africa, I had a timely conversation with a graduate student at my university. He knew that I had traveled a great deal, and in particular, knew that I had spent two years, during the 1970s, living in the Middle East. He strongly encouraged me to write about that experience in particular, but my other numerous international travels in general. He insisted that they would benefit my work as an educator. A student of African American literature, he reminded me that there is a scarcity of our voices in the area of travel essays and related literature. There is an even greater lack of African American women in the field. I was excited by the prospect of documenting my experiences, and valued it as a new arena for me with much promise. In fact, I vaguely envisioned possibilities for the merger of my travels with my interest in pedagogy. This encouragement from a graduate student may have marked the clearing of a soil in which yet another seed was planted.

It happened some time just before I left for South Africa, as I found myself performing the results of my dissertation research at conferences. My dissertation, which had been published and had since become a book, had centered on understanding the experience of African American artists who teach in higher education. Upon its completion, I had begun to experiment with ways I might participate more genuinely and with greater authority at conferences in which I was being asked to share my research. Because I had spent so much time with my participants' stories and really missed performing on a more regular basis as I had in past years, I began to entertain the idea of transposing my research to the stage. This transition happened quite organically. I looked for new outlets to share my experiments, and eventually met and collaborated with others who were also examining similar possibilities.

Another benefit of this project is how it has pushed me to look at the personal implications of my professional experiences in greater depth. I don't know if I would have made the connection between my family, and my trip to South Africa had I not decided to create the performance. Hearing Francina's voice alongside the voice of Jesusa, offered me an unusual chance to join them in that unparalleled sensual dimension where art lives. Even today, I am not confident in my ability to verbally articulate what their relationship *is*. Yet, I feel sure in my attempt to discover it through performance, as well as in my ability to unravel it in the messy but fully satisfying way that art allows. Nowhere in this process am I more convinced of Jesusa's connection to Francina, or Loiza's with Langa, or with the sound of Ikhwezi's singing voices with my own than when I perform this. Efforts to understand it through discursive means fall short and reveal huge holes in their knowledge bases. It is through the process of knowing and sharing the research through an artistic medium that new, previously obscured avenues make themselves apparent.

I especially love to introduce this world to my students. Since returning from South Africa, my increased patience and resolve with all of our struggles with "otherness" and the enormous job of creating more caring educators and communities, and addressing sociopolitical inequities has resulted in a new enthusiasm for teaching. I have picked up where I left off, insisting that my students investigate their relations, real and imagined, to people they may view as "other," and that this happen for the sole purpose of creating a more equitable society. Only now I focus on formalizing my performance research methods. I apply my approach to developing *Jesusa's Laugh* in my teaching, and I want to see my students find their own distinctive ways into this limitless inquiry. The journey we take is invigorating. In fact, I find myself going to those places within me that I previously thought were only possible through my own art making. The excitement and freshness of students' discoveries about themselves and others, as well as their willingness to venture into aesthetic languages that may help them articulate more vague or dangerous or locked realms of knowing have proven to be rewarding.

A sample assignment throws light on one way I have applied arts-based research in the classroom. At the beginning of one course, my students are required to explore their own notions, biases, and assumptions about culture. We look at how those ideas may have been formed. Mainly, we begin to understand how we have all, in our own ways, consented to these notions. At the same time, in the early portions of the course, we experiment a great deal with the arts. We investigate ways of "speaking" about ourselves through visual art, sound, movement, stories, and poetry. Here, I am certainly not interested in or expecting to provide training in any art medium. On the contrary,

students get to look at their own stumbling blocks, previously held and often debilitating self-images as art makers, as well as the potential that art wields for penetrating areas of discourse that are uncomfortable, unusual, or simply unexplored, such as notions about culture.

After some inquiry about how we create cultural and aesthetic knowledge, and as we begin imagining how they mingle with and serve each other, I give an assignment: *Identify someone you believe is different from yourself in some markedly clear way.* They must interview that person. I give some very pointed suggestions and encourage them to practice phenomenological interviewing methods. This approach is intended to help their participant to speak fluidly and in detail about their experience. I am asking students to avoid "flat" questions that might simply evoke "yes" or "no" answers. For example, "Tell me about growing up in Mississippi?" is preferable to "So, you grew up in Mississippi, didn't you?" Or "Where did you grow up?" I also do some in-class exercises to develop listening skills. They need to differentiate between "a conversation," where they are having an exchange with the participant, and "an interview," where they are looking to glean as much data that are neither tainted by their own biases and judgments, nor filtered through the shape-shifting of casual discourse.

Students must then use a combination of arts to present their findings. I ask them not only to offer information about their participants, but also to identify new insights into their own growth. I encourage the exploration of tensions and inconsistencies, their own preconceived ideas about this "other" person, and some of the ways in which they are both different and alike. They need to describe those social, economic, and political forces that are in motion in both of their lives. They should consider the implications as educators. The results promote changes in thinking and lead us into discussions about the role arts can play in reporting data.

Then we go even further. The next phase is undertaken in order to refine their presentations. I want them to recognize the many aesthetic forms that are possible and that may be applied in the service of arts-based research. To do this, I ask them to tell a story. It should be one that is surfacing to their awareness as a result of the presentation that they have just done. I have no preconceived notions about what this story should be. Fiction? Non-fiction? Science fiction? A mystery? They write their stories down. This stage helps them travel even further, retrieving data that they may have missed – to unravel the stories that may be hiding, tucked beneath the surface. These findings are often about themselves. My method leads students into a comfort level and a welcoming of this highly distinctive part of the trek. Finally, the last phase is to determine what parts of the writing might lend themselves to movement, or perhaps puppetry, or use of pre-recorded music, or

comedy. Any range of creative modes is possible. They can amalgamate interviews, their writing, and these art forms in any way they like. At this point, they are functioning in "studio" mode, without my direction and at their own pace. I function as a consultant and encourage them to show their ideas and to get feedback from the other "artists."

This is an extraordinary time for me. I get to immerse myself in what I love more than almost any other activity in which I engage: performance. I thoroughly enjoy watching my students awaken to the fear and power that accompany the stage. In those precious moments, there is no other place I want to be. At those times, even the professional stage, where I "entertain," feels slightly dimmed compared to being able to introduce and merge these lives, these worlds.

The trip to South Africa led me to venture into other areas I had not anticipated entering. Upon return to my gallery, I exhibited the paintings and poetry of Ikhwezi as part of our Young Artists Series, as I told those young men I would. The response from my university community was overwhelmingly supportive. My appreciation for international travel in the mutual service of communities was growing. I decided to establish a program called Arts International Residency Project (AIR), which would support artists in doing something similar to what I had done. Through this program, the gallery now sponsors artists to live and teach overseas, exploring the boundaries and limits of their philosophies and methods in these new contexts, and returning to us with their findings. They report these in their respective media in the form of exhibit performances as part of the gallery series. Since my trip to South Af ica, I have also traveled to Mexico, India, Germany, and Colombia to teach young people and community leaders through the arts, sharing what I know about arts integration, and to establish a broader range of partner sites and colleagues for this new initiative.

There are still other areas that have been affected. For one, my explorations have broadened both my performance style and self-identification as an artist. Before entering this arena of arts-based research, my professional performing persona was defined as a musician. A jazz improvising violinist, vocalist, and composer, I performed exclusively with music ensembles, occasionally collaborating with dancers, or taking poems and adapting them into lyrics. The focus has shifted. I am currently integrating my own writing, painting, and movement, all of which was done for my own enjoyment for many years, into my performances. The shift being that although I still identify as a musician, I feel quite comfortable publicly employing a wide range of materials, much as I have encouraged my students to do over the years.

Finally, some of the resounding effects have been more personal in nature, such as this particular story that seems to have pointed me towards a large corridor with even more open doorways. As a result of

creating *Jesusa's Laugh* and having revisited the taped interview with my grandmother, my emotions were exposed and raw. Around that same time, I learned that my grandmother's sister, my great aunt or "titi" as Spanish-speaking people say, had recently entered a nursing home. Titi Yaya is 100 years old and in unusually strong mental health, though blindness in one eye and difficulty walking led the family to agree that she could no longer care for herself in her apartment. She had never married or had children and, since much of our family is spread out, she was pretty much alone, barring occasional visits from her nephews. I began visiting her last year on my trips to New York City. Titi Yaya has talked to me about being a young girl in Loiza, Puerto Rico. She talked about her one remaining sibling, my Great Uncle Amador who still lives there. I knew that I must finally make the trip I had put off for so long. So I went to Puerto Rico in 2004 for the first time, and reconnected with my family. I returned to Loiza again this year, this time taking my mother for *her* first visit to the small, rural town where her parents were born. The following month, Titi Yaya's ninety-year-old brother came from Puerto Rico to visit her in the nursing home. It was the first time they have seen each other in close to fifty years.

Something magical and priceless has taken place simply because I walked through the right doors: unknowingly, my students pushed me to my travels in South Africa. South Africa led me to Jesusa, who guided my performance. The performance prepared me to carve out opportunities for new endeavors with international partners, my art, and teaching. All those paths pointed homeward to Loiza, Puerto Rico where I met uncles and cousins, conducted more interviews, painted pictures, wrote poems, took photographs, and now, have learned that my family has land in Loiza, which we inherited from Jesusa, and which is waiting to be claimed. The lawyers' papers sit on my office desk and I'll be calling him next week. These worlds are the wooly, fragmented threads in that ball of yarn that spiral and coil and twist upon themselves. They even seem to unravel at times, though I always pick up a loose strand or two and begin wrapping again. My sharply honed instincts tell me that I may only be able to make sense of all of this by diving into yet another performance.

QUESTIONS

1 Jenoure says "the entire endeavor has propelled me towards ongoing investigations into my professional practice and family history." What personal/professional investigations are you curious about? How might these questions be brought into a topic of research?

2 Jenoure refers to her project as a "ball of yarn." What other metaphorical comparisons might you suggest for your own research project? How does a metaphor describing research suggest a method for conducting research?

3 Jenoure seeks to merge educational research and performance. What has she gained by doing so? What may be lost?

4 Jenoure says that when she teaches, she wants to "breathe into a warm receptacle." How do you respond to this image? What are other kinds of metaphors for teaching?

5 Jenoure describes her teaching style as "both tight and loose at the same time. I love the precision and choreographed rhythms, but I also need the clutter." How would you characterize your own styles, how do these styles create opportunities for ABER?

6 Do you value intuition in your work? In what ways? Traditional research methods extol objectivity and distancing as integral to the conduct of research. How does arts-based inquiry emphasize the value of the researcher trusting him/herself?

7 At the beginning of section IV of her chapter, Jenoure says, "The way I know that something is successful is by measuring how fruitful it has been." In what ways do researchers measure success? How will you measure your own success as a scholARTist?

8 Following the directions given to the Ikhwezi group, create your own collage/poem. Try using multiple media to express your creation.

Queering identity(ies) and fiction writing in qualitative research

Douglas Gosse
Nipissing University, North Bay, Ontario

Douglas Gosse taught for thirteen years in elementary, intermediate, and secondary schools. His doctoral degree is in Curriculum, Teaching, and Learning, specializing in Social Justice and Cultural Studies, from the Ontario Institute for Studies in Education at the University of Toronto. He now teaches in the pre-service teacher education program of Nipissing University, North Bay, Ontario, specializing in Junior/Intermediate and Intermediate/Senior Curriculum Methods. Douglas's research investigates questions of men's studies, identity construction, hidden curriculum, queer theory, fiction writing, storytelling, and the creative research and writing process of writer-researchers. He is the author of three novels, *The Celtic Cross, A Vampire Journal* (1995), *The Romeo & Juliet Murders* (1997) and *Jackytar* (2005). His dissertation research on identity(ies) and the creative research process won several prestigious awards: The

William Pakenham Award Fellowship in Education, the Ontario Graduate Scholarship, the Social Sciences and Humanities Research Council of Canada Fellowship, and the Arts-based Educational Research Special Interests Group's Dissertation of the Year Award of the American Educational Research Association. Douglas serves on the Junior Advisory Board for the *Handbook of the Arts in Qualitative Research: Perspectives, Methodologies, Examples, and Issues* and is an editorial member of the *Canadian Online Journal of Queer Studies in Education*. He has been involved for over a decade with Canadian Historica Fairs and is currently the North Bay Regional Historica Fair Coordinator. Douglas is director of the Northern Canadian Centre for Research in Education and the Arts (NORCCREA) at Nipissing University: www.nipissingu.ca/NORCCREA/index.htm and may be reached at: douglasg@nipissingu.ca.

While I share common research goals with many qualitative researchers, such as attempting to better understand subjectivities, social conflicts, and cultural contradictions, arts-based educational research using queer theory and fiction writing is highly imaginative, reflective, and singularly provocative. *Jackytar* (Gosse, 2005b), the first educational novel published in Canada originally written as part of a doctoral dissertation (Gosse, 2005a), responds to a desire in education to inquire into diversity in new ways that more effectively provoke empathy and deeper learning (Parsons & Brown, 2001). The imaginative data for this research derives from my own implicit and explicit experiences and knowledge as an educator, researcher, and bilingual, working-class, disabled gay man who grew up in rural Newfoundland, where a steady exodus of Newfoundlanders continues, people leaving the struggling island in droves to explore better opportunities elsewhere.[1] In Newfoundland, "jackytar" refers to a person of mixed *Mi'kmaq* and French origins and carries pejorative connotations, such as laziness and moral decrepitude (Charbonneau & Barrette, 1992, p. 48). In the novel, the protagonist, Alex Murphy, is both gay and a "jackytar." While teaching in Toronto, he receives a phone call informing him that his mother is dying. Upon returning to rural Newfoundland, situations and people from his past incite him to a gradual re-examination of societal beliefs, customs, and practices. Through the lens of sexuality, I creatively investigate the intertwining identity markers of race, class, gender, sexual orientation, geographical location, ablebodiness, geographical location, and language and culture, in the lives of the fictional characters. Since *Jackytar*'s publication by Jesperson Press, and distribution in bookstores and libraries

across Canada, we have contributed to a needed bridge between the academy and the public, a core goal of much arts-based (Barone, 1995) and arts-informed educational research (Cole & Knowles, 2001). Rather than invest in the ubiquitous uncertainty reduction of positivists and limit the sharing of my research to an academic elite, I seek to poststructurally challenge status quo assumptions, provoke further questionings, and shed light on intricacies of the human condition to as expansive a readership as possible.

This queer theoretical perspective is stylistically and figuratively embodied in the fiction writing itself but also evoked through judicious use of footnotes that act as marginalia or a kind of hypertext. To those interested in becoming writer researchers, my temperate use of footnotes may prove stimulating. In the dissertation version of *Jackytar*, footnotes serve five fundamental purposes. First, they serve to reference stories I adapted from others and to heighten awareness of the subjective construction and intertextuality of all knowledge and research. In particular, I footnote several contemporary and poignant parables told by Rev. Dr. Brent Hawkes, social activist, pastor of the Metropolitan Community Church of Toronto,[2] and stirring storyteller. These stories derive from sermons I observed and contain themes of compassion and perseverance in the face of adversity which mirror *Jackytar*'s social justice foundation. Second, footnotes provide additional academic sources on key themes related to race, class, gender, sexual orientation, ablebodiness, geographical location, and language and culture for interlocutors[3] who wish to complement their reading of the fictional text in this way, although it is not a necessity for comprehension or engagement. Third, I sometimes trace the genealogy of certain words as part of my queer resistance (Jagose, 1996) and reference these in footnotes; this occurs most flagrantly towards the end when the character of Rev. Heather Byrne queers[4] Biblical scripture in a sociolinguistic manner. Fourth, I employ footnotes to articulate specific thoughts on the creative research process tied in with parts of the text.[5] Helping interlocutors understand my creative research process so that they might engage in similar writing was one of my primary motives. Fifth, I explain words and expressions indigenous to Newfoundland to highlight linguistic domination (Gosse *et al.*, 2000). *Jackytar* explores how the acceptance or legitimization of knowledge and power in society depends largely upon subordination of certain groups, particularly those from rural, working-class, ethnic and linguistic minority backgrounds, and how individuals and groups may resist marginalization.

The published version of *Jackytar* does not contain footnotes because the publisher initially felt this might compromise the public's appreciation, but the published novel remains identical to the dissertation version in all other respects. However, plans for another edition

containing footnotes are now in progress for both academic audiences and what has been a convivial, enthusiastic public readership. I used the dissertation version of *Jackytar* which includes footnotes with great success in a fourth-year cultural anthropology course I taught at the University of Toronto, entitled "Sexualities and Dissident Narratives." My students read *Jackytar* and journaled their critical interpretations regarding identity(ies) and linguistic and cultural domination in particular; *Jackytar* also proved a powerful platform for critical discussion with reference to other course readings. At Nipissing University where I teach in the Faculty of Education, a number of students continue to read the version published without footnotes, and to share their interpretations with me. One such reading by a straight woman spurred an empathetic dialogue after several years of silence with her gay brother. In several cases, the intertwining nature of identities and power in the published *Jackytar* spawned thoughtful debates among colleagues and students that led us to re-examine our beliefs and practices about what constitutes acceptable research and the intricacies of power in our relationships: Is not all knowledge a subjective construction and sharing of stories? Do we not all drift in and out of sites of privilege and subjugation that studies of intersectional identity (rather than traditional binaries such as male/female or bourgeois/plebs, for instance) may elucidate? Should not heterosexuality, like research historically on homosexuality, be more rigorously studied via intersectional identity analysis, as a constructed social phenomenon with its own rituals, rigid codes of behavior, and shaky hold on what is commonly enforced and viewed as "normal" and "acceptable?" I continue to receive personal emails from interlocutors in the broader public which lead me to believe that, with or without footnotes, the story is a catalyst for critical self- and social reflection. Ultimately, interlocutors seem to identify with the fictional characters and provocative themes in a myriad of ways for I strove to provoke multiple interpretations and reflections throughout the entire reading process, including the ending, unlike in many traditional novels which focus on developing a central conflict and then leading readers towards resolution (Gosse, 2006). I hope that *Jackytar* may continue to function in provocative ways in a wide gamut of settings, not only for its propensity to generate critical debate, but also for its qualities and form as an example of arts-based educational research using queer theory in an accessible way.

So what might *queer* mean in the context of *Jackytar*, and what are some connections to analysis of identity/ies?[6] People tend to grapple uneasily with queer theory but its strength lies in shocking our sensibilities and generating debate. The queer research focus in *Jackytar* challenges the status quo of positivist research by providing more questions than answers, especially via persistent analysis of language (including

tracing the genealogy of words) and sexualized cultural representations. *Jackytar* also inquires into ways in which queer identities seem partially constituted and reconstituted by acts of symbolic violence, particularly silencing. For instance, as queers we may be silenced from contributing our opinions for fear of psychological reprisal, including disapproval, taunting, and ignoring. Likewise, queer symbolic violence may take the form of invisibility in institutional culture, such as an absence of affirmative job action initiatives or equity policies. Indeed, despite official policies from government and school boards against racism and sexism, and sexism has become synonymous with bias against females (O'Beirne, 2006), thereby often obliterating the multiple ways many males are marginalized; furthermore, homophobia remains a virulent epidemic in our schools and is largely ignored. To illustrate, drop-out and suicide rates for queer students are significantly higher than that for their heterosexual peers, as well as incidents of reported physical and psychological violence (Dorais & Lajeunesse, 2004). Initiatives to counteract bullying rarely consider the widespread homophobic components of much male socialization. Schools tend to assume that everyone is heterosexual when in fact there are many educators, administrators, support staff, parents, and students who self-identify as queer, or have members of their families, colleagues, and larger community who do. Furthermore, Francophones like Alex who are also queer, an ethnic and linguistic minority, and from a working-class background, may experience increased violence within social, educational, familial and work spheres and the workplace (Labrie & Gosse, 2003). Still, representations of queers in popular culture would lead us to believe that most queers, if not all, are White (upper) middle-class, stylish, urban, ablebodied, wry gays and lesbians, whereas the so-called homosexual population is every bit as diverse as the heterosexual population. The use of the French language and Newfoundland dialect in *Jackytar* may trouble many interlocutors to reflect upon such linguistic and cultural domination. Significantly, the negotiation and regulation of normalized heterosexual identities are also stringently troubled in *Jackytar* in keeping with queer theoretical analysis (Namaste, 1996). In *Jackytar*, I have attempted to create revisionist telling(s) and reading(s) of stories that provoke, disarm, disrupt, and transform.

JACKYTAR EXCERPT: CHAPTER 3

This dream sequence/flashback occurs while the adult Alex is on board a plane heading to Newfoundland. The use of third-person limited narrative creates a sense of distancing and contributes to a mood/theme of alienation.

"Well, now, looky who we got here!" sang Jeremy.

"Whatcha doin today?" asked Sandra, her voice syrupy.

"Just gettin some stuff at the shop," said Alex.

"What? Tampons?" said Jeremy.

Sandra snickered.

"Ya got a pussy in those jeans, Alex?" said Austin, their cousin, a teenager a few years older, stocky and strong from working in the local lumber mill. Alex commanded his legs to move but they felt like jelly. He tried to remain expressionless.

On répond aux imbéciles par le silence.

A rough hand fastened on his shoulder. "Hey, I was talkin to ya!"

"Ya fancies un, don't ya Austin? Maybe ya wants to date un, eh?" Sandra said. "Take un up in the alders then and have some fun!"

The redness spread from Alex's ears down to his neck.

"No fuckin way!"

"Whatcha holdin on to his shoulder for then?" Sandra sneered. "Luh, he's in heat. All flushed like a bitch. Go fer it, Austin."

Austin let go of his shoulder like he had leprosy. Then he spat on the dusty road and stepped back. "Goddamn gay[7] pussy faggot!"

"Ah, now you'm hurtin his feelins. Leave Alex alone, youse. He's m'friend. Ain't ya Alex?" Jeremy grabbed him by the arm and tried to kiss his face. "Wanna play hoist-yer-sails-and-run[8] wid us?"

Sandra and Austin pretended to gag.

"Watch out! Ya might catch AIDS," Sandra said.

"Let's git the fuck outta here," Austin said. "Leave the little Jackytar pussy alone."

"O' revwraaar!" drawled Sandra.

They sauntered off, giggling.

The boy walked alone. Past saltbox houses. He looked at the landwash. Remembered having spent time there with Sandra two years ago when they were ten years old. They had poked at a gigantic cobweb. The biggest spider they'd ever seen scurried away from their sticks. Sandra had toyed with the spider until she got fed up and squished it with her stick. He'd hidden his squeamishness from her. Voicing it might have risked her friendship.

Not that it mattered anymore.

He thought about Nanny. Every morning, she used to have toast and tea[9] ready for him at the kitchen table, overlooking the bay. Toast cooked over the wood stove and real butter. Delicious hort jam, what some called blueberry, picked on the Bond Cove barrens. He missed her. The Atlantic Ocean used to look so peaceful from the kitchen window. Now it just reminded him that he had to

escape, that somewhere out there he might find happiness. And be safer.

"Why do things have to change?" he muttered aloud.

He spied Ole Man Howell working in his garden, using an old-fashioned sickle to cut the grass like in the olden days. He faked a smile and waved. Someone was always watching. Except when he needed them most. Through parted curtains. From a shed. From a passing car. This was an old people's town. Young people moved to the Mainland to get jobs – Toronto or Fort McMurray.

To escape maybe like he had to. One way or another.

He walked along Brigg's Road. The curving dirt road hugged the ocean side. The houses were pretty colours. Red. Blue. White. Beige. Red was his favourite. Especially the faded red of Johnson General Store. Boarded up now for years. He remembered shopping there as a small boy with his Nanny and Poppy. Mannequins loomed overhead, and more than once, he could have sworn their limbs stirred, or a head slightly cocked in his direction.

"Git some candy popcorn, m'ducky, if ya wants," she used to say.

Once, his Poppy Murphy had called him over for a special gift.

"Look, m'son, let's git ya some t'igh rubbers, awright?"

Poppy did indeed buy him thigh rubbers and he had worn them proudly that whole evening, until bed.

"Ya gotta go to sleep, now," Poppy cooed. "Wear em for just anot'er little while."

But he had never really enjoyed trouting. Poppy would have liked spending more time with him trouting in silence on the ponds and sometimes spinning yarns. He enjoyed the yarns, but trouting was boring. And he hated it when Poppy Murphy killed a trout.

"What's the matter, b'y?" Poppy Murphy had asked him the first time. "That don't hurt em none, luh!"

And he'd bashed the struggling trout on the head against a rock to prove his point and then tossed it in the basket. "Trout don't feel not'in a t'all!"

But he'd always suspected that trout did feel pain. And he couldn't bring isself[10] to do it. Eventually, his grandfather stopped coaxing him along.

And he didn't like the rough softball games on the field either. The older boys swore. They grabbed each other by the bum or balls. They talked dirty about girls. And that always made him feel ashamed.[11] The younger boys strove to copy them. But not him.

"What's wrong? You idden[12] a girl, is ya?"

"You should go play wid the girls' team!"

Or sugar sweet tones. "Leave un alone. He's m'buddy. Alex

prefers the books. Right Alex? You idden into the girls yet, is ya? I can't blame ya. No time for that when ya gotta study, right?"[13]

More often than not, he'd try to laugh it off, or ignore it, hoping it'd go away. His mother had taught him, "On répond aux imbéciles par le silence!"

One by one, most of his local friends started imitating the older boys. This past summer had been agony, even though he had a couple of friends visiting from Ottawa and a few other outsiders who still chose to hang out with him. Alex thought about crossing Jeremy, Sandra, and Austin Smith for the hundredth time.

He wished he had no feelings like the trout.

Being treated like he was a piece of shit hurt deep down, and there was physical pain. He stopped and held his stomach for a moment. There was only so much he could take. Funny how they never went after him when they were by themselves. Never when he was with his few remaining friends. Just when he was outnumbered.

The past two weeks in Bond Cove had been pure torture.

How he loved Shepherd's Bluff, where away from the others, he felt safe. He used to love hearing about the pirate legends from Poppy Murphy, but Poppy told him he was getting too old for that now. He still spent hours wandering the mossy footpaths, conscious of the blue bay and its small boats sailing in and out, day after day. He heard sheep close by, and was mindful not to step in dung. Just last summer, he had spent hours here playing space warriors with friends. Now most of them avoided him like the plague and joined the likes of Sandra, Austin, and Jeremy Smith. Drinking and getting into mischief started early in Bond Cove. He crouched down almost flat, feet first, and slid over the edge of the cliff. Rocks and pebbles rolled to the bottom, but he wasn't afraid. He'd climbed down this same drang[14] tons of times.

At the bottom, he sat on the rock.

"My Rock," he thought. Shaped like a chair with armrests. Facing the Atlantic Ocean. While it was summertime, the wind felt chilly. His bum grew numb on the icy seat.

"I hate being called Jackytar. I hate being made fun of because I speak French! Oi'm[15] not a lazy half breed Indian! I'm not a faggot!" he said aloud, starting to weep. "I hate my life!"

He reached down and gingerly picked up a piece of broken beer bottle. He twisted the amber glass back and forth.[16] The sun was bright but he was seated in shadows. Alone. Miserable. He pressed the pointy tip of the shard to his wrist...

Déclic![17]

"Excuse me sir, would you like a snack?"

I heard metallic sounds: clicking seatbelts and clanging utensils. "Pardon?" I said, waking up and opening my eyes.

"Would you like a snack? Perhaps some bottled water? A soft drink?"

I removed my hand from my wrist where the tiny scar remained and recalled bits and pieces of the dream I'd just had. Memories to be more precise. My mouth felt dry and gritty.

"Yes, some water, please."

"Then please put your laptop away. I'll be back shortly."

The flight attendant, an athletic man with a narrow waist and broad shoulders, worked his way down the aisle, serving right and left. I pressed a button and my seat righted itself. The interior of the plane was bathed in gentle grey shadows. I put my laptop in its case and stored it underneath my seat. The flight attendant arrived and handed me bottled water, a glass, and a napkin.

"Are you from here?" he asked.

"Huh?"

"You just visiting?"

"I'm originally from Newfoundland but I moved to Toronto. How long until we land?"

"Oh won't be too long now. We left Montreal a few minutes ago and you fell asleep like a baby. Maybe another hour and a bit? We have the winds behind our sails as the Capt'n says. Excited?"

"Yeah, it's been a few years."

"Well, nothing ever changes on the Rock!"

I smiled but the knot in my stomach worsened.

QUESTIONS

1. Gosse says that, "*Jackytar* explores how the acceptance or legitimization of knowledge and power in society depends largely upon subordination of certain groups, particularly those from rural, working-class, ethnic and linguistic minority backgrounds, and how individuals and groups may resist marginalization." How might research that embraces fiction and other creative arts be helped in addressing subjects of marginality and resistance?

2. Discuss how Gosse uses endnotes in his selection from *Jackytar* as a form of meta-commentary and analysis. What else might an arts-based researcher place alongside a piece of fiction to support analysis of the text?

3. What can a narrative reveal about character that more conventional case-study prose might not?

4. *Jackytar* addresses issues of intersectional identity (e.g. race, class,

gender, sexual orientation, geographical location, ablebodiness, geographical location, and language and culture). How does Gosse demonstrate intersectional identity through dialect? What are the risks and possibilities of using dialect in writing?

5 Choose a "character" from your research site. Begin a short story with spoken language that reflects the person's identity. Think about place, character, plot structure, and a story's pacing.

NOTES

1 Higgs (1996) suggests that, while various research methods have utility, the subjective experiences of an educator may also be construed as legitimate knowledge. Similarly, he uses tacit knowledge as data for the construction of stories that explore questions relevant to education and psychology.

2 The worldwide Metropolitan Community Church counts predominantly queer congregations and is under-acknowledged in queer studies (Altman, 2002).

3 I use the term *interlocutor,* derived from French, rather than *reader.* I choose this term because it denotes taking part in dialogue or conversation with another (Rey, 1988, p. 551), a more analytical, (inter)active connotation than *reader,* in my mind, which suits the reflexive nature of what I aspire *interlocutors* to do.

4 Queer researchers examine how heterosexuality is made to seem normal, and who and what is excluded when polarized terms such as man-woman or gay-straight are used. In this case, *queer* is used as a verb to designate this type of analysis which may lead to *ruptures,* where troubling of knowledge or knowing occurs.

5 For instance, the Author's Note at the start of the *Jackytar* is inspired by Jean-Paul Sartre's ruse at the beginning of *Nausea* (1964), in which he similarly claims the editors found notebooks and papers belonging to his fictional character, Antoine Roquetin, a historical researcher. My fictional character, Alexandre Murphy, an educator, similarly makes journal notes, but that he later uses to (re)construct his own story in a hybrid journal-novel.

6 The excerpt from Chapter 3 of *Jackytar* contains footnotes which detail several more interpretations of "queer" to ponder.

7 *Gay* may be used to refer to homosexual males only. For some, *gay* carries a White, middle-class, urban male stigma (Hogan & Hudson, 1998). It may also be used as a problematic umbrella term, like *queer,* for people who do not identify as straight (St.-Hilaire, 1999). *Queer* generally carries a more political, confrontational connotation and may be associated with queer theory (Halperin, 1995). Ultimately, although they must be used, these terms need to be challenged in light of who and what is left out and *Why?*

8 Hoist-yer-sails-and-run: tag or hide-and-seek (Story, 1959), that in this instance may carry a threatening, sexual overtone.

9 *Tea* may be pronounced *tay.*

10 *Himself* may be pronounced *isself* or *hisself* (Lowell, 1974, p. 124).

11 Shame is a leitmotif throughout this educational novel and closely linked

to invisibility and silencing (Armstrong, 2002). Males and females may dissociate or repress memories of abuse.

12 *Idden* may be used instead of *isn't* or *aren't*, and *tidden* for *it isn't*, parallel to Western England usage (Story, 1977).

13 Heterosexuality is often defined in relation to dissonant sexualities (Ghaill, 2000); hyper-masculine and misogynist qualities imbue homophobia, so that even being studious may be viewed as *gay* or *unmasculine*. This is a troubling reality for educators to confront.

14 Drang: a long, narrow path (Story, Kirwin, & Widdowson, 1990).

15 The Newfoundland pronunciation of *I'm* as *Oi'm* has British parallels (Story, 1977).

16 Queer youth are at a greater risk for suicide because they often lack familial, peer, school, and community support compared to straight youth (Dorais & Lajeunesse, 2004).

17 *Déclic*, French for *snap* or *click*, signals some ruptures in this educational novel (interlocutors are free to interpret others), as well as flashbacks.

REFERENCES

Altman, D. (2002). *30 Years of gay liberation in Australia*. Paper presented at the Queer Studies Conference, Out from the Centre, University of Newcastle, Australia, 29–30 October.

Armstrong, M. (2002). *The price we pay for shaming little boys*. Paper presented at the Canadian Boys, Untold Stories, Colony Hotel, Toronto, Ontario, 4 March.

Barone, T. (1995). The Purposes of Arts-based Educational Research. *International Journal of Educational Research, 23*(2), 169–180.

Charbonneau, P. & Barrette, L. (1992). *Contre vents et marées, l'histoire des francophones de Terre-Neuve et du Labrador*. Moncton, New Brunswick: Les Éditions d'Acadie.

Cole, A. & Knowles, J. G. (2001). Qualities of inquiry: process, form, and "goodness." In L. Neilsen, A. L. Cole, & G. K. J. (Eds), *The art of writing inquiry* (p. 321). Halifax, Nova Scotia: Backalong Books.

Dorais, M. & Lajeunesse, S. (2004). *Dead boys can't dance: Sexual orientation, masculinity, and suicide* (Trans. P. Tremblay). Montreal, Kingston, London, Ithaca, NY: McGill-Queen's University Press.

Ghaill, M. M. a. (2000). The cultural production of English masculinities in late modernity. *Revue canadienne de l'éducation/Canadian Journal of Education, 25*(2), 88–101.

Gosse, D. (2005a). *Breaking silences, an inquiry into identity and the creative research process*. Unpublished doctoral dissertation, Ontario Institute for Studies in Education at the University of Toronto.

Gosse, D. (2005b). *Jackytar*. St. John's, Newfoundland: Jesperson Publishing Ltd.

Gosse, D. (2006). *Deconstructing queer theory and literary devices in Jackytar, the Canadian Bildungsroman*. Paper presented at the Arts-based Educational Research (ABER) Special Interest Group of the American Educational Research Association (AERA), San Francisco, 7 April.

Gosse, D., Labrie, N., Grimard, M., & Roberge, B. (2000). *Violence in discourse of gay and lesbian Francophones.* Paper presented at the Lavender Conference, Washington, DC, September.

Halperin, D. (1995). *Saint Foucault: Towards a gay hagiography.* New York: Oxford University Press.

Higgs, G. E. (1996). *Jordan, an allegorical novel exploring meaning and educational counseling psychology.* Unpublished Ph.D. thesis, University of Tennessee, Knoxville.

Hogan, S. & Hudson, L. (1998). *Completely queer: the gay and lesbian encyclopedia.* Markham, ON: Fitzhenry & Whiteside Ltd.

Jagose, A. (1996). *Queer theory.* Melbourne: Melbourne University Press.

Labrie, N. & Gosse, D. (2003). *Multiple identities and resistance to marginalisation: Bilingual French-speaking gays, lesbians, and bisexuals in Ontario.* Paper presented at the Department of Sociology and Equity Studies in Education Speakers Series, Ontario Institute for Studies in Education of the University of Toronto, 24 March.

Lowell, R. (1974). *The new priest in Conception Bay.* Toronto, ON: McClelland and Stewart.

Namaste, K. (1996). The politics of inside out: queer theory, post-structuralism, and a sociological approach to sexuality. In S. Seidman (Ed.), *Queer theory/sociology* (pp. 194–212). Cambridge and Oxford: Blackwell Publishers.

O'Beirne, K. (2006). *Women who make the world worse and how their radical feminist assault is ruining our schools, families, military, and sports.* New York: Penguin Group.

Parsons, C. & Brown, P. (2001). Educating for diversity: An invitation to empathy and action. *Action in Teacher Education, 23*(3), 1–4.

Rey, A. (Ed.) (1988). *Le Micro-Robert, langue française.* Paris: Dictionnaires le Robert.

Sartre, J.-P. (1964). *Nausea.* (Trans. L. Alexander). New York: New Directions Publishing Corporation.

St.-Hilaire, C. (1999). Le paradoxe de l'identité et le devenir-queer du sujet: de nouveaux enjeux pour la sociologie des rapports sociaux de sexe. *Recherches Sociologiques – Rapports sociaux de sexe, 3*, 23–37.

Story, G. M. (1959). *A Newfoundland dialect questionnaire, Avalon peninsula.* St. John's, Newfoundland: Memorial University of Newfoundland.

Story, G. M. (1977). The dialects of Newfoundland English. In H. J. Paddock (Ed.), *Languages in Newfoundland and Labrador* (preliminary edition, pp. 74–80). St. John's, Newfoundland: Memorial University, Department of Linguistics.

Story, G. M., Kirwin, W. J., & Widdowson, J. D. A. (1990). *Dictionary of Newfoundland English* (2nd edition). Toronto, ON: University of Toronto Press.

sista docta, REDUX

Joni L. Jones/Omi Osun Olomo
University of Texas at Austin, Austin, Texas

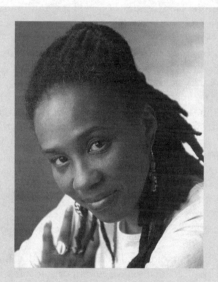

Omi Osun Olomo/Joni L. Jones, Ph.D. is an Associate Professor of Performance Studies in the Department of Theatre and Dance, and Associate Director of the Center for African and African American Studies at the University of Texas at Austin. She is an artist/scholar who is currently engaged in performance ethnography around the Yoruba divinity Osun, and is writing a collaborative ethnography on the use of a jazz aesthetic and Yoruba sensibilities in theater featuring the work of Laurie Carlos, Daniel Alexander Jones, and Sharon Bridgforth. While on a Fulbright Fellowship in Nigeria (1997–98), Dr. Jones taught in the Department of Dramatic Arts at Obafemi Awolowo University and contributed Theater for Social Change workshops for the Forum on Governance and Democracy in Ile-Ife. Her articles on performance and identity have appeared in *Text and Performance Quarterly*, *Drama Review*,

Theater Topics, Theater Journal, and *Black Theater News*. She is the founder of The Austin Project – a collaboration of women of color artists, scholars, and activists, and their allies who use art to re-imagine society. The work of The Austin Project is being compiled in a forthcoming book tentatively entitled *The Austin Project Archive: Experiments in a Jazz Aesthetic*. Her performance ethnography includes *Searching for Osun, sista docta*, and *Broken Circles: A Journey Through Africa and the Self. sista docta* served as the plenary performance at the Second Annual Performance Studies Conference at Northwestern University, and has also been presented at the National Communication Association Conference, Pedagogy/Theater of the Oppressed Conference, and the Black Women in the Academy II Conference as well as at several universities throughout the US.

Since I first performed *sista docta* in 1993 at the National Communication Association conference in New Orleans, I have added several new moments to this seriate collage of my experiences as an African American woman at predominantly White universities. These new moments reflect my evolving understanding of academic life and my developing clarity about my role within that world. As a sista docta – a Black woman with a Ph.D. – my experiences are my own, and they also exist as "collective autobiography," that particular brand of storytelling that is at once specific and individual as well as representative of group realities (Cudjoe, 1990). I believe these experiences also constitute a kind of collective scholarship that joins the many conversations around race, gender, and politics. This work is not collective in the sense of collaboration, but rather in the sense of comradeship. While I did not create *sista docta* with E. Patrick Johnson, D. Soyini Madison, Oloye Ajidakin Aina Olomo, Daniel Alexander Jones, Sharon Bridgforth, or Edmund T. Gordon, the performance is intimately linked with conversations, print scholarship, workshops, dinners, meetings, and celebrations I have shared with them. We work together every time we work individually.

The possibility of collective scholarship that occurs across time and place is one lesson I have learned in the intervening years between that first terrifying public exposure of my frustrations and fears presented at an academic conference and this current private moment as I write this commentary and attempt to live up to the complexity and richness that my intellectual/spiritual/artistic comrades have given me.

In the world of Black art, much time has been given to discussing the burden that Black artists bear as we respond to a muse who some feel makes us accountable to our diverse array of often competing forces – our ancestors, the NAACP, the Black Panthers, the Black Muslims,

Lucumi traditions, the White academy, and all manner of Black Christian church groups. Regardless of our backgrounds, this is the swirl of political/ spiritual realities that envelope our creativity. In Langston Hughes's (1926) often quoted essay "The Negro Artist and the Racial Mountain," Hughes admonishes a young artist for wanting to be "just an artist, not a Negro artist." While I understand and concur with Hughes's insistence that the young man is suffering from the rejection of his racial identity and a subsequent self-hatred, it is also true that Black artists walk onto the stage as interlocutors conversing with a host of invisible end men and women. Our freedom is not an unfettered creativity but instead resides in the courage and audacity to raise our voices at all.

Collective scholarship works as a buoy rather than a weight. Even as I write this commentary, I am envisioning another addition to *sista docta*, a praise song/dance in which I identify those who have shaped my art, scholarship, and activism. And as I review the above list – Johnson, Madison, Olomo, Jones, Bridgforth, Gordon – I realize that only one of those collective scholars is indeed a sista docta.

Another important lesson learned between 1993 and now is the necessity for returning to the same terrain again and again. Rather than embarking on a new solo project, I have revised, adapted, edited, and massaged *sista docta* from a 30-minute companion piece with E. Patrick Johnson's *Strange fruit* to a 90-minute performance complete with audience collaboration and self-defense demonstrations. Initially, I presented *sista docta* as a kind of museum piece – repeating it rather than inhabiting it anew. Soon, it became clear that the work was becoming more for the audience than for me. I'd be invited by an institution to present *sista docta*, often with the hopes of stimulating dialogue in their communities about education and representation. Rather than continuing to research the subject of academic identity through my own embodied experiences, I settled for presenting the same research over and over, denying performance the very spontaneity and immediacy that is its strength.

I would do this work for them with little attention to my own experience inside of the work. This choice was born more from an underdeveloped activist impulse than from an artistic one. Revolutionary poet Raul Salinas reminds us that when engaging in social change work, we should ask "How does this help me, not how will it help *them*" (personal communication, 12 February 2006) Salinas's wisdom is also apt for performance. After that dramatic and transformative first performance, I went on to perform *sista docta* as a challenge to racism and sexism, and slowly the power of the original truth telling began to dim. The work moved from being an urgent declaration of my role as an academic misfit to a commodity that was used to demonstrate an institution's forward thinking and progressive posture.

As a performer, my job is to be present with my own experience through the work being shared. I found myself consumed by the fight – the ongoing struggle to bring equity to academic institutions – at the expense of the very spark that makes art vital. bell hooks (1995) warns of the danger of mass duplication of Black art; conceived as a product for general consumption, Black art loses its insurgency and its transgressive power. In order to reinvigorate the work, I had to continue to ask terrifying questions – What am I most afraid of saying right now and why? What do I gain from this performance critique? How am I rein-scribing the very images I hope to challenge? The most critical questions were the ones I had to pose to myself, not the ones I rather arrogantly presumed the audience needed to ask. I had to commit once again to truth telling because truth telling changes with time and circumstance. In 1993 it was courageous to have audience members read aloud the racially obtuse comments that had been made to me, but by 2000, especially after the work had been published and widely available to the performance studies community, *sista docta* became an act of pre-dictability devoid of much of its potential power. Post-performance discussions suggested that audiences were still challenged and provoked by the piece. However, by not fully investing my current questions and discoveries into the work, I limited the understanding available both to the audience and to myself.

Being a scholar artist in the academy had already created constraints on my ability to access my art heart; the cramping of my artistic impulses was compounded by envisioning the work as the audience's instead of as mine. I reclaimed the urgency and danger that fueled *sista docta* by creating new segments about life in the academy.

After many of the performances, audience members would offer comments that pushed me to add to or amend the work. After a student challenged me about why I remained in the academy if it was so frus-trating, I created a series of improvised moments in which I talk to myself and the audience, entitled "what I like about my job." This segment of the performance remains one of the most difficult as I attempt to articulate what joy I find in academic life. Would my honest answers to this question root me too deeply in a satisfied/satiated middle-class position that would undermine the very critique I was hoping to make? I am still grappling with this one.

When a former colleague from Howard University asked me why I had not mentioned my experience at an HBCU (Historically Black College or University), I wondered what I was avoiding by omitting these experiences from the performance. Was I reluctant to offer as stiff a critique of an HBCU as I was of White institutions? What lens might it uncomfortably shine on me to expose my feelings of sexism and homophobia at an HBCU? Had *sista docta* become that familiar space

of assumed Black kinship that really masks a host of unspoken wounds? In answer to these questions, I created a chant done to movements reminiscent of a Black sorority step show routine.

We are the sista doctas from the HBCUS
But when we talk about our differences Blacks give us the blues
At Black colleges they preach unity
But forget feminism and sexuality

When a sista docta says what about women's rights
They tell her she's been hanging out with too many whites
When her analysis includes sexuality
They say, "Hey, that sista docta sho nuff must be gay!"

And when a White woman asked me why I hadn't included a segment on being a woman and being a mother, I initially dismissed her comments – after all, I thought, my very physical presence makes my womanness a given. My Black femaleness was a spectacle that could not be missed. As K. Sue Jewell, Deborah Gray White, and Sander Gilman have illustrated, my Black female body is the very essence of the grotesqueries and excesses ascribed to the construct called Woman. Was this yet another White person unable to see inside of an experience that did not overtly include her? Could she only connect with me and my work if I specifically mentioned sexism? What else could I do to invite her into my world, and was that my job anyway? Didn't my very body serve as a critique of the academy's sexism? It was not until after completing a Fulbright Fellowship at Obafemi Awolowo University in Ile-Ife, Nigeria that I was moved to comment on what being a woman in the academy felt like to me. Perhaps in a location where Black was more subtly set in bas-relief against Whiteness, the issue of gender was foregrounded.

NEVER TELL A WOMAN TO WEAR LIPSTICK

and she sprang forth
fully formed
limbs lean
torso taut
feet sturdy nimble
a mind like quick silver
darting at the speed of light
a heart open yielding
a soul (her best feature)

large like the Sahara
dense like the Amazon
ancient like the Nok terracottas in all the Western museums
a natural work of art
her self package was not Kmart
but kente and asoke
courageous conscious marketing
counter hegemonic moves at every turn
crafted by the master carver
whose medium is always spirit, not flesh
if paint adorned her face
it would chart the course of the moon and the stars
in copper kohl across her brow
trace the lotus of her cheek and the yoni of her lips
in indigo cream
map the shadow of the goddess lurking on her lids
her face a canvas on which to play
but her mirror conjures Alice, not Diana
no ruby mouth and apple cheeks
no synthetic locks or press on nails
no magazine poses and visionless visions
for a righteous sista
would Beloved move you more if Toni's lips were red?
would the slaves have been more free if Harriet had pinched her
cheeks?
would the revolution have been stronger if Angela wore mascara?
so when you tell her
out of
friendship
that she could really use a little lipstick
know what vast beauty
you seek to erase

My response to the question of motherhood in the academy was to invite my daughter Leigh Gaymon-Jones, then in high school, to write about her experiences of being my daughter. This may have been skirting the issue of speaking my own truth about motherhood, but at least my reality as a mother would be firmly positioned within the performance.

Although "Leigh's Version" was published in 2003 in *Voices Made Flesh* (Miller *et al.*), I had not yet performed the piece. It was Leigh's story, not mine, and it seemed to lose power and authority when I attempted to perform it as her. Then, in 2005, I was invited to perform *sista docta* at Spelman College while Leigh was living in Atlanta. It was

the perfect opportunity to give life to those words through Leigh's voice, body, and spirit. Before an auditorium full of Black women in Spelman's elite "Women of Excellence Leadership Series," Leigh and I shared her experience of being my child. The drummer that evening was Omelika Kuumba, founder and director of the women's drum and dance company, Giwayen Mata. Her mother was in the audience. Through the performance, the women of Spelman could see a legacy of achievement and struggle and possibility, of individuality and solidarity as two generations of Black women made an offering of sweat and art.

LEIGH'S VERSION

"Concentration
ishi-oshi-ation
thinking of (clap, clap)
starting with..."
Moma
she *is* superwoman
and there is no kryptonite
soaring over private schools to save me
diving into fires, says prayers for me
knocking out ignorant boys who act crazy
and this is how my moma raised me
all praise to thee

class/rehearsal/out of town/meeting/
rehearsal/*ile* work/office/performance/
out of town
wait, what day is it?
right:
meeting/dinner/performance/class/
meeting
is it Thursday?
oh yah, out of town ... "Don't forget to take out the trash"
rehearsal/class/performance/office
me ... me ... me
but you're late...
let's eat out ... rent a movie

never neglected
opinion always respected
forever protected

moms
never alone
always felt at home
even when I thought I was grown
moma
stressed, always
busy, maybe
careless, never
mommy

rock, rock
non-stop
in her arms wrapped up
always big hugs
kisses on eye lids
like Eskimo love

you think I'm pretty?...
i know, my mother shines through well
my spirit's beautiful?...
it's an inherent gene passed through her cells

"am I doing this right?"
"is this what a mom is supposed to be?"
yes, you lift me to infinite heights
and teach my light how to flow free

class/rehearsal/meeting/class/performance
out of town...
superwoman
soaring
forever protected
infinite heights
eskimo love
rock, rock
even when I thought I was grown
and this is how my moma raised me.

Fourteen years later, I am very aware of my mortality as I perform *sista docta*. Ann DuCille (1994) has been conducting research on health issues related to Black women academics. We seem to be dying at an alarming rate. Cancer and heart disease have become common – more for us than for our sista doctas of other racial backgrounds. I recently completed an essay about the work of Laurie Carlos and Robbie McCauley in which I

addressed the stresses of being an artist in academic institutions (Olomo, 2007). After I had submitted the essay for publication, I was shocked when I realized that I had forgotten to mention that Robbie suffered a heart attack a few years ago, which she attributed to contingencies such as diabetes along with the internal unspoken tensions that come from being a Black woman artist in White institutions. She believes her life is threatened by the very experience that pays her bills and buys her food. At the beginning of this academic year, I was hospitalized with an unexplained cramp in my heart that pushed the pain down my left arm. In fact, I had been suffering from shortness of breath, this aching heart, and other symptoms of overwork and stress for at least five years – but doctors found nothing and sent me home without medicine or advice or answers. What I know is that my rounded shoulders, bulbous waist, and thickly calloused feet are evidence of living, and my being alive – a Black woman academic – is something worth celebrating. Even in 2006, Black women comprise less than 5 percent of tenured faculty in the United States. I created "imperfection" as an unconscious response to the White woman's question about my gendered presence in the academy as I have come to understand sexism all the more as my body ages.

"Imperfection" premiered at the University of Georgia in 2004. As my taped voice read the text, the audience watched a series of random slides that created a loose genealogy of the interpretation of Black women's bodies/images – Hattie McDaniel with Vivien Leigh in *Gone with the Wind*, Saartje Bartmann, Florence Mills, Freddie Washington, Hilda Simms, Louise Beavers in *Imitation of Life*, Josephine Baker, Ethel Waters with Julie Harris in *Member of the Wedding*, and the deeper abstractions of Romare Beardens's nudes, Betye Saar's *The Liberation of Aunt Jemima*, and Lyle Ashton Harris and Renee Valerie Cox's *Hottentot Venus 2000*, along with family photos – me accepting the National Merit Scholarship, my parents Dorothy Mae Brown and William Edward Jones on their wedding day, me with fellow high-school speech-team winners, me in the marching band, my mother pregnant with my oldest sister and my father laughing his huge laugh at the camera, me as an infant. And as the audience watches this montage and listens to my story of fear regarding the impossibility of perfection, I sit below the photos, my back to the audience, take off my top and wash/cleanse myself with water from a white bowl.

I knew the audience could see the rolls and creases around my waist, the way in which time had marked my body. And this is what I wanted. I wanted the women not to be afraid of the changes that time will inevitably bring; I wanted everyone to come into contact with their notions of beauty and desire, power and fragility. I wanted to free myself of the shame and terror of my own mortality. I hoped my bare torso would say "This is what middle age looks and feels like. Can you see the beauty in it? Do you avert your eyes in shame? Does my exposure

encourage you to fold your arms across your own bellies in protection and defiance?" With "imperfection," my live, exposed body against the Mammies and Hottentots and Jezebels, and my words of fear and longing further tensed the poles of real versus imagined Black femaleness.

IMPERFECTION

When I was little, I used to bring my report card home to my father for approval. He respected education. It was a sign of status, of class – and so I wanted him to be proud of me. He had said how beautiful my oldest sister was, and he seemed to really have a special fondness for my second oldest sister – and I also wanted a place in his heart.

For my mother – I cleaned the kitchen. I went down on my knees with an old rag and Comet cleanser and scrubbed all the wax off of the yellow tile floor. Wiped up all the gritty cleanser, then put down a new thin layer of Johnson's wax. I cleaned the greasy film from the top of the refrigerator, I neatly arranged the salt and pepper shakers, the napkin holder, the toothpick holder and the odd nick-nacks on the yellow formica kitchen table. I made the kitchen really shine. This I did for my mother – I knew she would love it, and gasp at how clean it was, "Ooo Joni you have done such a good job! You are the one I don't have to worry about" – and I knew that the more my knees ached from the scrubbing the more she would be pleased, the more painful it was for me the more love I would get from her. That's the love formula.

But the report cards were for my father. The camera of my memory sees me walking from the kitchen into the living room where my father sat waiting to see my grades. The camera is right over my right shoulder so that the audience – me – can see my hands holding the folded thick paper stretched toward my father seated on the couch like a judge or a king or both. I walk slowly toward him, past the piano that my oldest sister played, and past the carpeted staircase that led to the bedrooms, and past the wooden mural my father had made for the wall.

On one occasion, daddy was sitting in the living room after having been in a car accident. He had broken some ribs and was sitting stiffly in the center of the couch with the glow of the picture window behind him. Or maybe this didn't happen at all and I just want this movie to

be true – daddy there – the man who could bestow upon me my worth, sitting in judgment, doling out approval or condemnation. Smiling that almost menacing smile, and I float toward him, like in a Spike Lee film – the grades were my offering, my veiled dance, my tap dance and coon song, surely this would be enough, surely he would love me unquestioningly then, surely I could rest now.

Then there was high school and hours of overachieving – the band, the speech team, the precision dance team, the honor societies, national merit scholar, valedictorian, the graduation address – the sleepless push for perfection. Surely daddy could see, surely I was as beautiful as Regina and as sensuous as LaVerne. Smarter than Moma, more entertaining than Willetta. Surely I could rest now.

I float toward him with my sacrifice in my hand, a moment of perfect pain, of delicious horror – my worth scribbled in blue ink by teachers who always commended me for being nice – a nice colored girl – and one teacher, Mr. Finnegan, who had gone to Vietnam or was at least drafted and sent a letter to our class with instructions for me to read it – me! – and I stood before the class with the sheets of white paper outstretched before me, confirmation of my worth, of my superiority.

And in the memory movie, I am always walking toward daddy and I never quite get the report card to him – my king, my god to whom I bowed in submission and devotion. Always outstretched but never arriving. Never there.

And I prepared my credentials, the sum of my worth – these essays, these book reviews (of much lesser value), these productions (of almost no value at all). And I bound them neatly, beautifully in folders – clearly marked so my worth would not be missed, beautifully packaged so I would shine above the rest.

And there I sat on a shelf waiting for daddy to review me, to confirm me, to say "it's ok. You will never be as good as me, but I can see that you work hard. Hard work is not as good as intelligence but it is something. Such good work for a Negro." There I sat on the shelf waiting, still, quiet, terrified. The sum of me typed on sheets, gashed with three ring holes and strapped to folders.

And I hated myself as I gave away my power. And I hated the floating walk, my faceless self. I hated the man who smiled almost menacing smiles – "it must be nice to be a performer." "How about

a little sugar." "I just want what's best for you." And Leigh just
said "fuck 'em" and Reggie said "why do you choose pain" and
Laurie said "they don't have to like you." But I stretched my hand
out to my daddy and I never quite arrived.

The most recent addition to *sista docta* came in 2006 during a time
when I was serving as Acting Director of the Center for African and
African American Studies (CAAAS) at the University of Texas. For the
previous five years, I had been Associate Director of CAAAS, but in
2006 the Director, Edmund T. Gordon went on a much deserved leave
of absence. This left me at the helm and fully in charge of aspects of
CAAAS that I had been happy to leave in Ted's command.

This administrative position gave me a new window into academic
life. Hegemony is powerful. The struggle to challenge the status quo, to
turn from the path of least resistance, to speak even the most obvious
truths is depleting and demoralizing. I saw more clearly that the White
elite were not the only impediment to the intellectual and political
advancement of Black people. My one-semester stint as Acting Director
of CAAAS prompted me to write "the off center blues." I first per-
formed this piece at the CALARTS "Impunities" conference in October
2006. I invented a blues rhythm and melody, and proceeded to safely
critique people and circumstances that were unknown to that audience.

> Sometimes you get called to service
> And you think you really want to go
>
> Sometimes you get called to service
> And you think you really want to go
>
> But sometimes that service makes you more Blue than you knew
> you could go
>
> When you working with your people
> You think – this is good – we all playing the same game
>
> I say when you working with your people
> You think – yeah, this is good – we all playing the same game
>
> But the way your own people treat you is a low down dirty shame
>
> Now I'm not talking about them HBCUs
> I done taught at Howard and know those Black on Black Blues
>
> What I'm shouting about now

Is those Negroes at those white Research One Public Schools

Whoa UT – You sho nuff killing me
Whoa UT – You sho nuff killing me

You put them Black crabs in a barrel
And laugh as we bring each other to our knees

Now Negroes can spout Omi and Winant, we know Gilroy chapter
and Verse
We quote from Kobena Mercer, Joy James, Patrick Johnson the
First
But when it comes to supporting each other we couldn't act no
worse

I say, Whoa Black UT – You sho nuff killing me
Whoa Black UT – You sho nuff killing me

You talk about how white people treat you
You say you not getting your due
The critique you aim at others should be aimed at you

Whoa Black UT – You sho nuff killing me
Whoa Black UT – You sho nuff killing me

Research is a life project, not a one-time exploration – no matter
how grand that exploration might be. The artist returns to the work
to push further and deeper into that initial investigation. Each
performance is a step in the development of an idea rather than a
definitive resolution. I have been fortunate enough to have the
opportunity to revisit *sista docta* through performance, like com-
muning with an old feisty friend – and the conversation expands with
each visit. In this way, each performance is truly redux, something
that is restored to its former importance and prominence.

QUESTIONS

1 Jones/Olomo refers to her work as simultaneously individual and
 collective. When we create a piece of fiction, drama, poetry, or other
 form of art that is based on collective experience with other scholars
 and/or participants what are the potential gains and challenges? Who
 receives authorship for a work, who performs, how are the royalties
 from a work shared? Are there other questions that might arise?

2 Jones/Olomo mentions the tension she experienced presenting the same version of *sista docta* to various audiences without changing its text. How might artists present a piece of literary, visual, or performing art that remains the same but performs differently according to context, venue, etc.? What are the advantages of changing the artistic form or keeping it constant?

3 The author charges herself with the task to continually challenge herself with lessons from *sista docta* and other artistic projects. What are some of the taboo lessons that have emerged from this work? Can you think of other truths that have not yet been said about what it means to be a *sista docta*? How do you relate to this piece from a racial, gendered, educational, or classed subject position?

4 What is a truth that you haven't dared say about a community in which you are a part? Read "Poem for Myself," by Etheridge Knight and other models of blues poetry and music such as those of blues singers, Ma Rainey and Bessie Smith. Use the form of the blues refrain [a b a b c b] to make a commentary about what it is like to be a member of your community group and to say what hasn't been said through music and lyrics.

REFERENCES

Cudjoe, S. (1990). Maya Angelou: The autobiographical statement updated. In H. L. Gates, Jr. (Ed.), *Reading Black, reading feminist: A critical anthology.* New York: Meridan.

duCille, A. (1994). The occult of true Black womanhood: Critical demeanor and Black feminist studies. *Signs: Journal of Women in Culture and Society,* 19(3), 591–630.

hooks, b. (1995). Performance practice as a site of opposition. In C. Ugwu (Ed.), *Let's get it on: The politics of Black performance.* Seattle, WA: Bay Press.

Hughes, L. (1926) The Negro artist and the racial mountain. *The Nation,* 122(3181) 692–694.

Jones, J. L. (2003) sista docta. In L. C. Miller, J. Taylor, & M. H. Carver (Eds), *Voices Made Flesh: Performing Women's Autobiography* (pp. 237–257). Madison: University of Wisconsin Press.

Olomo, O. O./Jones, J. L. (2007). "Making language": The jazz aesthetic and feminist foundations. In K. Juhl & A. Armstrong (Eds), *Radical acts: Feminism, theater, and transformation.* San Francisco, CA: Aunt Lute Press.

Chapter 16

Troubling certainty

Readers' theater in music education research

Kathryn Roulston, Roy Legette, Monica DeLoach,
and Celeste Buckhalter
University of Georgia, Athens, Georgia

Kathryn Roulston is an Associate Professor in the Qualitative Research
Program in the Department of Lifelong Education, Administration, and
Policy at the University of Georgia, Athens where she teaches
coursework in qualitative research methodology. Prior to moving to the
United States in 2000, Kathy taught music in elementary schools (K-8) in
Queensland. She has a B.Mus.Ed. degree from the Queensland
Conservatorium of Music, a Masters of Music degree (Kodály emphasis)
from the University of Calgary, Alberta, and a Ph.D. in education from the
University of Queensland. Her research interests combine three of her
passions – examinations of topics in music education, close investigations
of talk-in-interaction, and qualitative research methodology. Her

publications include articles in *Music Education Research, Qualitative Inquiry, Qualitative Research, International Journal of Education and the Arts*, and *Research Studies in Music Education.*

Roy Legette is an Associate Professor of Music Education at the University of Georgia, Athens where he specializes in elementary music for children grades K-6. He received the B.S. degree from Fayetteville State University, Fayetteville, NC; the Masters of Arts from the University of Iowa and the Ph.D. degree from Florida State University. He is a past member of the Editorial Committee for *Update: Applications of Research in Music Education*, and a current member of the editorial board for *Southern Music Education Research*. His research interests include music instruction and student self-concept, student motivation and achievement, and factors that influence teaching effectiveness. Some of his work can be found in the *Journal of Research in Music Education, Update: Applications of Research in Music Education, Bulletin of the Council for Research in Music Education, Journal of Music Teacher Education* and *Music Education Research.*

Monica DeLoach is a music specialist at Gaines Elementary School in Athens, Georgia. She holds a Bachelors of Music in Music Education, Masters of Music Education, and Education Specialist Degree from the University of Georgia. Currently, she is a music education Ph.D. candidate at the University of South Carolina. She is a member of Georgia Music Educators Association, South Carolina Music Educators Association, Music Educators National Conference, Clarke County Association of Educators, Georgia Association of Educators, National Educators Association, and National Association for Multicultural Education.

Celeste Buckhalter received her Bachelors in Music Education from the University of Southern Mississippi and taught K-5 grade general music for

four years in public schools in suburban Atlanta. She has completed graduate coursework in Instructional Technology at the University of Georgia and is currently pursuing an MS in Human–Computer Interaction at the Georgia Institute of Technology in Atlanta, Georgia. Her research interests include gender, music education and educational technology as well as information and communication technologies in countries with weakened economies.

> for artists of all stripes, the unknown, the idea or the form of the tale that has not yet arrived, is what must be found. It is the job of artists to open doors and invite in prophesies, the unknown, the unfamiliar…
>
> (Solnit, 2005, p. 5)

Originating in drama and theater studies, readers' theater involves interpreters reading scripts aloud in order to involve audience members in a "living experience" in which "the readers share the attitudes, viewpoints, and actions of a literary piece with an audience, causing the audience to experience the literature" (Coger & White, 1982, pp. 5, 7). Taking up the notion of having speakers reading aloud from scripts, readers' theater has served in various educational settings to introduce participants – frequently, but not always students – to literature, language arts, history, and issues in medical practice (see for example Coger & White, 1982; Fredericks, 2002; Maher, 2006; Savitt, 2002).

More recently, inquirers employing arts-based research traditions have also used readers' theater as a method of representation to display qualitative data and findings to audiences, often in conference venues (Donmoyer & Yennie-Donmoyer, 1995, 1998). This form of creative analytic practice (Richardson, 1999) calls for audience participants to perform scripts supplied by the researchers and presenters (see for example Adams *et al.*, 1998; Hurren *et al.*, 2001). By inviting audience members to become part of the presentation through reading texts aloud, or performing a musical interlude, researchers and presenters utilize two aspects considered key to readers' theater (Coger & White, 1982, pp. 12–13); *interaction* of audience members with the topic presented; and stimulation of audience members and readers' *imaginations* through vocal and embodied interpretations of texts.

Researchers in music education, however, are generally unfamiliar with the use of artistic modes of representation of research data, or other forms of arts-based inquiry that generate artistic products in the process of research (Vaughan, 2005, p. 3), even as other fields such as education, communication studies, and sociology have moved in these directions. In our reading, we have found only one published readers'

theater related to issues in music education (Lamb, 1991), and Finley (2003) asserts that there is "[m]uch work to be done to fully explore the potential uses of media other than verbal, linear texts for performing and (re)presenting inquiry" (p. 290). By involving audience members in the presentation of a script that drew on findings from our research project, and in the performance of a musical interlude composed for percussion instruments, we wanted to purposefully upset the usual passivity involved in listening to research papers at academic conferences. By inviting audience members to play tuned and untuned percussion instruments in a repeated musical interlude, participants and listeners stepped into the world of music education – albeit briefly – adding embodied musical experience to the spoken texts – which dealt with music teaching, research, and the everyday work of music teachers. Taking up Finley's challenge, in this chapter we examine the following: How can educational researchers use readers' theater to engage audiences' imaginations through interaction and performance of a script that involves nonverbal media such as instrumental performance?

We began by crafting a script using qualitative data we had collected during a one-year project that investigated how a teacher-research community that involved university educators and practicing music teachers might provide mentoring for beginning teachers (Roulston *et al.*, 2005). For our conference presentation, the script was organized into sections that represented the preliminary findings of our analysis of transcripts of meeting talks and interviews. By participating in reading the script aloud, our audience of educators, music teachers, pre-service teacher educators, and researchers were called upon to reflect on the opportunities and challenges of teacher-research collaborations, and the session concluded with a focused discussion led by one member of the group, Celeste.

The excerpt from our original readers' theater that follows is framed by the repeated musical interlude that was composed, orchestrated, and taught to audience participants by Roy Legette (see Figure 16.1). Given that the readers' theater deals with issues in music education, the interlude is integral to the performance of the script, and the audience members were invited to both read text and make music. This excerpt was first performed in its entirety at the annual conference of Interdisciplinary Qualitative Studies (QUIG), in Athens, Georgia in January 2005. Readers – including those who counted themselves as "non"-musicians – were invited into the communal world of music making that was everyday to the music teachers who participated in the teacher-research project. This unsettling of audience members, who were expected to participate in the collaborative music making, in some ways mirrored the disorientation experienced and described by the two elementary music teachers who took part in a collaborative teacher-research project. That is, the audience came to know and experience, if

even somewhat artificially, the challenges and rewards presented to the group members as a result of participating in the research project.

Below, we include "The Challenges of Teacher-research," which was the third section of the original four-part script – conceived as a "rondo"[1] in which the recurring section was that of the musical interlude. The challenges of teacher-research are many – lack of time for research, lack of support for the concept in schools, the difficulties involved in learning how to conduct research and, in Monica's case mentioned below, negotiating county approval procedures to conduct research (see Roulston, Legette, DeLoach, & Pittman, 2005 for further details). In this section, the dialogue is crafted from conversations that occurred during our monthly research group meetings. Here, Monica and Celeste discuss some of the challenges that they faced in formulating research questions, and designing independent studies that could be conducted in their classroom settings. We then reflect on our use of readers' theater, offering points for consideration by other researchers, educators, and music educators.

A READERS' RONDO: THE CHALLENGES OF TEACHER-RESEARCH

The cast:
C: Celeste (an elementary music teacher)
M: Monica (an elementary music teacher)
K: Kathy (a faculty member in the College of Education)
R: Roy (a faculty member in the School of Music)
N: Narrator

Figure 16.1 Musical Interlude.

NARRATOR: In our meetings, we discussed the problems we encountered in conducting research. Sometimes these discussions emerged from a question we used regularly in meetings, "What stood out for you in the readings?" As a group, we listened to one another's difficulties, gave advice where possible, and encouragement when there appeared to be no solutions to offer.

C: How to refine a research question. I spent hours with this page. We had a nice long relationship there for a while. The one thing on the page I have a huge star by was "avoid value laden words or phrases." I guess I knew that. Somewhere in the recesses of my mind I knew to avoid those, but they seem to creep up anyway, especially when you're so close to the situation. That's been a tough thing for me – getting rid of those value laden words and just stepping back from the situation removing myself … a little bit.

R: That's hard

K: I think that's an ongoing struggle for all researchers.

C: Really?

K: Yeah, that's not unique to you.

C: Oh okay.

M: Another question I have is, given the time period that we have to do this research … do you think … I'm just worried about will it really be dramatic results … that I will get?

K: That's what the question is.

ALL: (laughter)

M: Yeah.

R: You may come up with nothing.

M: Right.

R: I mean that's just the nature of the beast. Monica, do you think you could send us a draft of your proposal before our next meeting? We can kind of hammer it out at the next meeting and maybe solidify it?

K: I think that would be really good.

R: Because I'm concerned that we're going to run out of time. Once it goes to the County for approval, you can count on about six weeks before you get it back.

K: And if yours goes in on the next date that they have the meeting … you won't get approval until the beginning of March.

R: You seem troubled by all of this.

M: Yes.

R: What's eating at you?

M: I guess where I wanted to go at the beginning and then with getting approval for the project. I just really didn't even think about having to write the proposal to fit with the school improvement plan and it kind of narrows everything now. Meeting the guidelines for the proposal has been very difficult. I would have rather stuck to a topic related solely to music. I have to now relate the project to literacy within the school improvement plan. It really controls your whole research process, I think, instead of it being a way to improve your teaching.

R: Threw a monkey wrench.

K: Though part of the school improvement plan calls for you to talk to teachers, because that improves your knowledge of the students. I'm wondering whether you could write that in as part of a project. Do you get scheduled time with the special needs teachers?

M: No.

K: So I was wondering … whether you could have a consultation and talk to them about these … particular 3rd grade students. Talk to them about the skills and the activities that they already do with the special needs teacher … and then maybe that'll help direct what you could do in your classroom. Do you see that would work?

M: Um hmm.

R: What about you Celeste, how are you thinking about your study?

C: If I do a survey … that one was really tough. I started to think about it and I teach 600 out of the 1200 students, so at first I was like it'd be great to get all 600 then I started thinking, let's be realistic.

R: If you created your survey, there are other issues. You'd want to pilot that survey, and you'd want to determine reliability, whether or not it measures what it's supposed to measure and does it do it consistently.

M: I was going to say, what would happen if you got all these surveys back and these parents said they want more musicals?

C: I know! I know! That's true.

R: As a teacher … that informs your teaching right there.

C: Right.

R: That fact alone.

C: It also confuses my teaching. I'd like just a straight, clear shot. To know exactly what these parents want over here is going to be what we teachers are pushing for over here; and what the curriculum is pushing for over there is also what the administrators want. It's not all lining up.

K: No. It's really messy.

C: So, I think that's a big problem for me right now.

M: And classroom teachers really have a lot of responsibilities. It's hard, I think, to engage in research outside of those responsibilities. There are so many things that we have to be held accountable for. I think it's just hard right now, especially with all the legislation, to find time to engage in teacher research. It's the time issue. I just really don't see a lot of teachers saying, "I want to research, write this, and submit it, and get it published." I don't see that happening because of the everyday situations that they have to deal with. Especially now, coming up in April we have our state tests – that is a big thing that outweighs other things.

K: I think I've got the same issue that Monica said, finding the time to wrap your head around all of this is just really difficult and I recognize it's even more difficult for you … because you have classes every half hour.

C: One of the frustrating things for me has been that my school is pretty large. You get lost in the shuffle if you don't make your presence known all the time. So the administrators don't remember that I'm there, and that I'm working on a research project. My administration has said, "We would like to read the end result," but it feels like they're not interested. I think for me, whenever I think of a teacher doing research within a school, I think if I were an administrator, I would want to know more about what is going on.

R: So it is don't ask, don't tell around there?

C: Pretty much.

– Musical Interlude –

Reflecting on readers' theater

For members of our teacher-research group, using readers' theater was a new experience. To prepare the script for our QUIG presentation was both interesting and challenging as we revisited the hundreds of transcript pages containing our year-long discussions, and reflected on how our views and roles within the group had changed over time. One challenge involved deciding which excerpts to use from the voluminous data set. This was resolved by group discussion, while recognizing the fragmentary and partial nature of the completed script.

We structured the readers' theater in four parts: (1) our group's developing sense of community; (2) working with our differences; (3) the challenges of doing teacher-research; and (4) group members' perspectives concerning the professional outcomes of involvement in the project. These sections were organized to mirror the journey that we had taken together as members of a collaborative research group. First, we started out by getting to know one another, and developing a sense of community in which we could work together productively. Over the year-long project, we began to recognize and work with the multiple perspectives we each brought to the project that were products of differences in cultural and racial background, teaching experience, theoretical perspectives to music education, and research background and training. The third section of the readers' theater dealt with the challenges faced by a group of educators coming together to work collaboratively on a teacher-research project. The final section dealt with participants' perspectives on the outcomes of the project (see Roulston *et al.*, 2005 for further details). The musical interludes unified the actual performance, and brought a sense of variety to the presentation that was not possible through words. For audience members involved in the playing of musical instruments, "parts" were learned and rehearsed quickly – and performers experienced a sense of pressure to "get things right." This dual sense of pressure – both in terms of being required to learn how to do things quickly, and wanting to "do things the right way" mirrored the anxiety sometimes expressed at our monthly meetings by Monica and Celeste as novice teacher-researchers involved in the study.

Most of our audience members were involved in either reading the script, or playing tuned or untuned percussion instruments – and were highly engaged in the presentation. Through performing, our representations of our research experience were personalized for the audience participants, enabling them to grasp some of our thoughts and feelings in the process of the teacher-research collaboration. This engagement flowed over into the discussion that followed the presentation of the readers' theater, as participants teased apart issues raised in their reading, and reflected on their own experiences concerning theory and

practice, teacher-research groups, and university-K-12 collaborations. For example, one of the audience members discussed his experience as a teacher-researcher in Wisconsin, and shared resources with others.[2]

Performance of this readers' theater demonstrated to us that research does not have to be a collection of dry facts written on a page, but can be interesting, exciting, and speak to multiple audiences in a meaningful way. However, because readers' theater is so different to the usual presentations to which conference participants are more attuned, one challenge for researchers is to keep the audience's attention focused on the *content* of the presentation, rather than on the *process* of delivery. This point was underscored for us after our presentation when one of our audience members asked of our group: "What were the findings of the study?" And we had thought that the final section of the readers' theater had explicitly addressed that question! Contrary to what we had anticipated, this participant had been so engrossed in performing; it seemed that the substance of the text had been missed. Either that – or the text we had chosen needed to be clarified. We have discussed this issue on a number of occasions since – and we as group members have mixed opinions on the value of using readers' theater for the presentation of "findings." We do agree, however, that readers' theater does achieve a level of interaction and audience engagement that does not occur when findings are read, as is common at academic conferences. One method that researchers might employ to prepare participants prior to the performance would be to outline the subject matter of the presentation, and reiterate the main points through focused discussion at the conclusion of the performance.

Both students in university and college classrooms and conference participants are frequently faced with teachers and presenters who do all of the talking. Readers' theater provides an interactive and participatory means for students and listeners to claim ownership of instruction and knowledge through active involvement in its presentation. The ultimate success of this approach, as with any method of presenting or teaching, may well hinge on how interesting and engaging the researcher and teacher can make the subject matter. As we learned, great care must be taken in the construction, selection, and preparation of the text/s for performance. Yet it is only through exploring the unknown, by opening doors, and troubling the certainties of the ways in which we conduct and re-present our research to others that we might learn; perhaps even stumble upon what we still have to learn.

QUESTIONS

1 Think about conference presentations you may have attended at professional meetings. What might be gained from the use of readers' theater?

2 The authors recommend that "researchers ... keep the audience's attention focused on the *content* of the presentation, rather than the *process* of delivery." If audience members are so caught up in the process of performance that they do not retain the content, does the performance still have value? If researchers must downplay the performative aspect of their research delivery method, why bother to present their research using this method at all?

3 In the selection, one of the teacher-researchers is concerned about not getting "dramatic results." Do you share this concern about the products of research? Is there a concern that arts-based research tends to focus more on process than product?

4 Using data from your own inquiry project, compose a piece of readers' theater for a class or conference presentation that includes a place for audience participation. How will you structure the "findings" section of this piece? Will you work collaboratively or alone with the data? What do you learn from working with data in this performative way?

NOTES

1 A rondo is a musical form characterized by different sections, interspersed with a repeated section (A): ABACA.
2 See www.madison.k12.wi.us/sod/car/carhomepage.html.

REFERENCES

Adams, N., Causey, T., Jacobs, M.-E., Munro, P., Quinn, M., & Trousdale, A. (1998). Womentalkin': A reader's theater performance of teachers' stories. *International Journal of Qualitative Studies in Education, 11*(3), 383–395.

Coger, L. I. & White, M. R. (1982). *Readers theater handbook: A dramatic approach to literature.* Glenview, IL: Scott, Foresman and Company.

Donmoyer, R. & Yennie-Donmoyer, J. (1995). Data as drama: Reflections on the use of readers' theater as a mode of qualitative data display. *Qualitative Inquiry, 1*(4), 402–428.

Donmoyer, R. & Yennie-Donmoyer, J. (1998). Reader's theater and educational research – give me a for instance: A commentary on *Womentalkin'*. *International Journal of Qualitative Studies in Education, 11*(3), 397–407.

Finley, S. (2003). Arts-based inquiry in QI: Seven years from crisis to guerrilla warfare. *Qualitative Inquiry, 9*(2), 281–296.

Fredericks, A. D. (2002). *Science fiction readers' theater*. Westport, CT: Teacher Ideas Press.

Hurren, W., Moskal, M., & Wasylowich, N. (2001). They are always watching me: A readers' theater script based on the performative aspect of be(com)ing teachers. *Teaching Education, 12*(3), 335–345.

Lamb, R. (1991). Medusa's aria: Feminist theories and music education, a curriculum theory paper designed as readers' theater. In J. Gaskell & A. McLaren (Eds), *Women and education* (2nd edition, pp. 299–319). Calgary, Alberta: Detselig.

Maher, J. (2006). *Most dangerous women: Bringing history to life through readers' theater*. Portsmouth, NH: Heinemann.

Richardson, L. (1999). Feathers in our CAP. *Journal of Contemporary Ethnography, 28*(6), 660–668.

Roulston, K., Legette, R., DeLoach, M., & Pittman, C. (2005). What is "research" for teacher-researchers? *Educational Action Research, 13*(2), 169–189.

Roulston, K., Legette, R., DeLoach, M., Buckhalter Pittman, C., Cory, L., & Grenier, R. (2005). Developing a teacher-research group in music education: Mentoring and community through research. *Research Studies in Music Education, 25*, 14–35.

Savitt, T. L. (Ed.). (2002). *Medical readers' theater: A guide and scripts*. Iowa City: University of Iowa Press.

Solnit, R. (2005). *A field guide to getting lost*. London: Viking.

Vaughan, K. (2005) Pieced together: Collage as an artists' method for interdisciplining research. *International Journal of Qualitative Methods, 4*(1), Article 3. Retrieved August 25, 2005 from www.ualberta.ca/~iiqm/backissues/4_1/pdf/Vaughan.pdf.

The drama and poetry of qualitative method

Johnny Saldaña

Arizona State University, Tempe, Arizona

Johnny Saldaña received his BFA and MFA degrees in Drama Education from the University of Texas at Austin. He is currently a Professor of Theatre for the School of Theatre and Film in the Katherine K. Herberger College of The Arts at Arizona State University (ASU), Tempe where he has taught since 1981.

Saldaña has been involved in the field of theatre education as a teacher educator, director, and researcher. His books include: *Longitudinal Qualitative Research: Analyzing Change Through Time* (AltaMira Press, 2003), a research methods book and recipient of the 2004 Outstanding Book Award from the National Communication Association's Ethnography Division; and *Ethnodrama: An Anthology of Reality Theatre* (AltaMira Press, 2005), which includes his co-adaptations of *Street Rat*, based on Susan Finley and Macklin Finley's fieldwork with homeless youth in New

Orleans, and *Chalkboard Concerto*, which dramatizes Charles Vanover's career as a teacher in Chicago. Saldaña's ethnodramatic adaptation, *Finding My Place: The Brad Trilogy*, appears in Harry F. Wolcott's *Sneaky Kid and Its Aftermath: Ethics and Intimacy in Fieldwork* (AltaMira Press, 2002).

Saldaña is a recipient of the American Alliance for Theatre & Education's 1996 and 2001 Research Awards; and the ASU Herberger College of The Arts' Distinguished Teacher of the Year Award in 1995, and Research Award in 2005. He conducts workshops nationally in ethnodrama, focusing on the researcher as autoethnographic storyteller. His future ethnodrama projects include a production about the Red Hat Society and adaptations of published contemporary ethnographies.

As a theatre artist, I have been trained to find the drama of everyday life so that it may be faithfully reproduced on stage for realistic plays. As a playwright, I have also been trained to find the poetry in everyday language so that it may inspire the creation of evocative monologue and dialogue. This conditioning preceded my study of qualitative inquiry by almost 25 years and greatly influenced my introduction to the literature.

When I first read selections from the canon of educational research and ethnography, I encountered everything from sterile reports to emotion-laden narratives. Just as there are some storytellers who are more theatrical than others, there are a few writers who are more dramatic than others. Contemporary works in narrative inquiry, qualitative research, auto/ethnography, and investigative journalism have provided riveting and sometimes haunting stories (e.g. Barbara Ehrenreich's (2002) *Nickel and Dimed: On (Not) Getting By in America*; Jennifer Toth's (1993) *The Mole People: Life in the Tunnels Beneath New York City*). Yet for some reason, I found myself initially drawn to and engaged with the methods literature most of all. There was something about the "how to" that kept me enthralled. I was evolving into a "research geek" (my term), and I was literally fascinated with fieldnote protocol, coding schemes, and analytic procedures. Depending on the author, even seemingly mundane research methods books contained inspired writing.

Wolcott (1995), in *The Art of Fieldwork*, reflects on the parallels between art and ethnography:

> My purpose in this book is to examine how fieldwork not only invites but also requires something of an artistic approach.... [A]rt plays a significant role in my life, not merely in terms of what I enjoy and appreciate aesthetically, but as well in what I have been able to create, in spite of the absence of any recognizable talent. I

like to think that there is something of the artist in me, some capacity not only for appreciating but for creating, just as I assume there is something of the artist in you, and in everyone.

(p. 13)

When I read the works of Harry Wolcott during my qualitative research courses with Tom Barone and Mary Lee Smith at Arizona State University, it was in his articles and methods books that I found the drama and poetry of qualitative research. Wolcott's gift with language – even at the technical level – engaged me. And the series of articles dubbed "The Brad Trilogy" – an anthropological case study profiling Wolcott's relationship with a young man who eventually descended into paranoid schizophrenia – kept me in awe. "This is theatre," I thought to myself, and it would eventually influence my ventures into arts-based research (see Saldaña, 2005, *Ethnodrama: An Anthology of Reality Theatre*).

Some writers in the social sciences have a flair for evocative writing, even if their works are academic in reportage. Their prose is vivid or conversational and "feels" like monologue or dialogue that can be directly transferred – even from a methods textbook – onto the stage. Wolcott is one of those writers. Sentences from his texts found their way into our theatrical adaptation of *Finding My Place: The Brad Trilogy* (Saldaña, in Wolcott, 2002). When appropriate, insightful and even humorous passages from *Writing Up Qualitative Research* (1990), *Transforming Qualitative Data: Description, Analysis and Interpretation* (1994), *The Art of Fieldwork* (1995), and *Ethnography: A Way of Seeing* (1999) became part of his monologues.

The Art of Fieldwork was particularly rich with "one-liners." For example, in the Prologue of the play, Wolcott addresses the audience on his love for ethnography: "In fieldwork, you immerse yourself personally – with passion, without apology – for the purposes of research. Fieldwork beckons, even dares you, to become part of what you study" (Wolcott, 1995, pp. 239–240; Saldaña, in Wolcott, 2002, p. 171). Later, Harry notes that Brad can make a valuable contribution to a commissioned report on education if he consents to be interviewed: "Like Blanche DuBois in *A Streetcar Named Desire*, fieldworkers must rely on the kindness of strangers to help get where they want to go" (Wolcott, 1995, p. 148; Saldaña, in Wolcott, 2002, p. 177). And when Brad catches Wolcott covertly writing field notes about his behavior, Harry notes to the audience in a tone reminiscent of Oscar Wilde, "We humans are not above making surreptitious observations, but we most certainly hate to get caught making them" (Wolcott, 1995, p. 152; Saldaña, in Wolcott, 2002, p. 185).

Wolcott's (2002) *Sneaky Kid and Its Aftermath: Ethics and Intimacy*

in Fieldwork includes the original Brad Trilogy articles, additional information and reflections on the case, and the ethnodramatic adaptation of the story, *Finding My Place: The Brad Trilogy*. The title character is a young drifter whom Harry befriends, but whose unforeseen mental illness and destructive behavior wreaks havoc on Wolcott's professional and personal life. I have included excerpts below from the dramatization as a sample of ethnodramatic dialogue and monologue: the beginning of Scene One, and the Epilogue. The former was Harry's choice for inclusion in this article to introduce the work, and the selection demonstrates the dramatization of qualitative data (Saldaña, 2003). The latter was my choice to showcase the poetic cadences of method. As for what happens in between, read Wolcott's *Sneaky Kid* to find out.

A SELECTION FROM *FINDING MY PLACE: THE BRAD TRILOGY*

SCENE ONE: DESCRIPTION
(SLIDE: Serendipity)
HARRY
I first came to know Brad through what ethnographers sometimes refer to as serendipity.
(music up: "Heart of Glass" by Blondie)
(HARRY finds a bow saw on the ground, picks it up, looks at it curiously)
Literally as well as figuratively, I discovered Brad in my own backyard, unannounced and uninvited.
(SLIDE: BRAD's cabin)
(BRAD enters, carrying a sapling, stops when he and HARRY see each other; BRAD sets the sapling down, shuts radio music off; they look at each other warily)
A 19 year-old had managed to construct a crude but sturdy 10- by 12-foot cabin at a remote corner of my densely wooded, 20-acre home-site, which my partner Norman has shared with me since 1968. He didn't know on whose property he had built his cabin, perhaps hoping he had chosen public land next to mine.
(hands BRAD the saw, which he grabs)
BRAD
(defensively, to HARRY)
Can I stay?
(SLIDE: Early Encounters)
HARRY
(beat, as HARRY looks BRAD over; to audience)

I attach great importance to first impressions.

(HARRY stares at BRAD; BRAD starts packing up his tools)

At the moment of our first and unexpected meeting, I felt hesitant about allowing him to remain on my land; yet I felt an even greater reluctance in insisting that he leave.

BRAD

(to HARRY)

I needed some place to get out of the wind and keep dry. The rent ran out. I knew the rains would continue and I'd have to do something.

HARRY

(to audience)

He had no money, no job, and no place to go. I couldn't see how I could claim to be any kind of humanitarian and throw him off my property.

(SLIDE: Courtesy and Common Sense)

(HARRY picks up the sapling and examines it; to BRAD)

I guess if you're going to be here, I need to know something about you: Where you're from? What kind of trouble you're in?

BRAD

(takes sapling, saws into it)

I'm not in any trouble. I'm not that stupid. I used to live at this end of town; my father still lives here but I never see him. And I've lived in a lot of different places, like California, Portland, out in the country; different places in town, like The Mission – you had to sing for Jesus before they'd feed you there – a halfway house,

(slightly mumbling)

reform school.

HARRY

Reform school?

BRAD

(defensively)

Yeah, but it wasn't really my fault.

(SLIDE: Survival)

I picked up my sleeping bag and the stuff I had and headed for the hills. I didn't know exactly what to do. I saw this piece of level ground and I set up a tarp for shelter. There were plenty of trees around. I decided to build a place for myself, because I wasn't doing anything anyway.

(SLIDE: BRAD's cabin)

(HARRY looks at the cabin as BRAD describes it)

I put up four posts and started dragging logs around till the walls were built. As I went along I just figured out what I would need. I got the stuff I needed – tools and nails – from new houses being

built nearby. The roof's made of paneling that I carried up from some kid's tree fort. I knew about plaster because I had worked with it before, so I smeared some on the walls. So now, I've got this cabin. This is better than any apartment I've ever had, that's for sure. It really works good for me. Here I am.

(beat; BRAD shrugs his shoulders)

That's it.

(SLIDE: Getting a Start and Building on Later)

HARRY

It wasn't much of an introduction, but it marked the beginning of a dialogue that lasted almost two full years from that moment.

(returns to his desk; BRAD turns on his radio to a loud volume and returns to fixing his bike; HARRY glares at him, goes to the radio and lowers the volume; HARRY sits on the lawn chair and watches BRAD work)

(music: "Jump" by the Pointer Sisters)

I didn't expect him to stay. Norman has an aversion to people he identifies as "losers," and from the outset had as little to do with Brad as possible. But as time went on and Brad continued to make improvements, he gradually became as much a fixture about the place as was his cabin. We saw rather little of him at first, but I became *fascinated* with him and intrigued with his –

(BRAD removes his shirt; HARRY stares at his muscled torso)

chosen lifestyle. (Saldaña, in Wolcott, 2002, pp. 173–176)

* * *

EPILOGUE

(SLIDE: Epilogue)

(HARRY picks up some of the index cards, sets the stage aright as best he can, puts away things in his desk)

HARRY

In a professional lifetime devoted to teaching, research, and writing, I know little and understand even less about this case, the one that's affected me the most, and the one that continues to haunt me for answers I doubt I'll ever find.

(SLIDE: Getting It Right)

I felt I knew Brad so well, so intimately, that I would get a straight story – and get the story straight. I was reeling then, and continue to do so to this day, from realizing how little we ever know, heightened in this instance by the feeling that this time, in my own cultural milieu, my own language, and even in my own backyard, I had finally *gotten it right*.

(getting angry, he slams the desk drawer shut)

I just wish that it all might have turned out differently.

(SLIDE: Meaning)

What is this *really* a study of? The meaning of the story isn't precisely clear because meanings themselves aren't all that apparent or clear. We don't have neat findings, tidy hypotheses, conclusions that can be summarized or reduced to tables and charts. There are no guarantees, no umbrellas or safety nets, no foolproof scientific method to follow.

(SLIDE: Validity)

Fieldwork consists of more than collecting data, something that catapults it beyond simply being there. And whatever constitutes that elusive "more" makes all the difference. Regardless of outcome, I think the critical test is how deeply you've felt involved and affected personally. *Provocative*, not *persuasive*.

(SLIDE: Understanding)

(HARRY is close to tears)

After years of attending so singularly to the sanctity of methods, I finally realize that only *understanding* matters. We must not only transform our data, we must *transcend* them. *Insight* is our forte! The whole purpose of the enterprise is *revelation*! When you emphasize description, you want your audience to see what you saw. When you emphasize analysis, you want your audience to know what you know. When you emphasize interpretation, you want your audience to ... understand what you think you yourself have understood.

(pause)

(SLIDE: Last Words)

(he walks to the projection screen)

In the end, we only abandon our studies; we never really complete them. The human condition doesn't remain static long enough for the work to be completed, even for an instant. You need to recognize when to keep reaching, when to focus, and when to stop.

(SLIDE: face shot of BRAD)

So. How *do* you "conclude" a qualitative study?

(music up: "Father Figure" by George Michael; HARRY looks at slide of BRAD)

You don't.

(lights fade to black; SLIDE of BRAD fades to black as music rises)

(Saldaña, in Wolcott, 2002, pp. 209–210)

QUESTIONS

1 Saldaña brings over 30 years of training and experience in theater to his research in education. What level of artistic development do you think arts-based researchers should have?

2 What does it mean to find "the drama and poetry of qualitative method"?

3 Saldaña describes Wolcott as having "a flair for evocative writing." Does "flair" come naturally or can it be developed? If it can be developed in a writer, how?

4 Saldaña uses ethnodramatic monologue and dialogue to share Wolcott's research with a wider audience. When might a researcher him- or herself use the techniques of ethnodrama?

5 What feelings are evoked through the selection from Scene One and the Epilogue? What are the effects of suspense in this work? How do stage directions and scene changes help the reader understand what took place?

6 What are the qualities that might make research recognizable as potentially dramatic or theatrical? When might these qualities be advantageous in academic writing?

7 What are the effects of the autoethnographic reflections in the Epilogue? Are you engaged enough to want to read the complete play script? Why or why not?

8 Try your hand at a dramatic rendering of an interview transcript of fieldnote data or the text of an ethnography you have read before (e.g. Penny Eckert's *Jocks and Burnouts*, Laurie Olsen's *Made in America*).

REFERENCES

Ehrenreich, B. (2002). *Nickel and dimed: On (not) getting by in America*. New York: Owl Books.

Saldaña, J. (2002). *Finding my place: The Brad trilogy*. In H. F. Wolcott, *Sneaky kid and its aftermath: Ethics and intimacy in fieldwork* (pp. 167–210). Walnut Creek, CA: AltaMira Press.

Saldaña, J. (2003). Dramatizing data: A primer. *Qualitative Inquiry* 9(2), 218–236.

Saldaña, J. (2005). *Ethnodrama: An anthology of reality theatre*. Walnut Creek, CA: AltaMira Press.

Toth, J. (1993). *The mole people: Life in the tunnels beneath New York City*. Chicago, IL: Chicago Review Press.

Wolcott, H. F. (1990). *Writing up qualitative research*. Newbury Park, CA: Sage Publications.

Wolcott, H. F. (1994). *Transforming qualitative data: Description, analysis and interpretation*. Thousand Oaks, CA: Sage Publications.

Wolcott, H. F. (1995). *The art of fieldwork*. Walnut Creek, CA: AltaMira Press.

Wolcott, H. F. (1999). *Ethnography: A way of seeing*. Walnut Creek, CA: AltaMira Press.

Wolcott, H. F. (2002). *Sneaky kid and its aftermath: Ethics and intimacy in fieldwork*. Walnut Creek, CA: AltaMira Press.

Section V

Conclusion

The tensions of arts-based research in education reconsidered

The promise for practice

Richard Siegesmund and Melisa Cahnmann-Taylor
University of Georgia, Athens, Georgia

A complex array of goals guides inquiry. The product of inquiry – which we may call research – can be used for a diverse range of purposes. Different methods of inquiry, guided by different goals, produce different products, which serve different needs. A hammer is a very efficient tool that, when handled skillfully, produces remarkable results. However, it is a very poor tool – even an inappropriate choice – if the task is removing a countersunk screw. Therefore, the conduct of inquiry requires recognizing the most appropriate tool for the job the researcher seeks to accomplish.

As few real-life situations correspond to a multiple-choice question, choosing a method of inquiry is not as simple as correctly distinguishing between a nail and a screw. Education, for example, is a complex lived exchange involving human beings. Complexity exponentially increases with interactions between individuals. Thus, attempting to grasp the magnitude of complexity – be it a single individual or individuals in relationship to others (i.e. a classroom) – is an initial task in research.

Assessing the magnitude of complexity begins by naming questions. This is no small feat: to bring what has not been said into language. It means staking out the territory to be explored. Recognizing the complexity within these stated questions is the second task. Constructing a method for investigating the identified complexity is the third task. This investigation can take one of two forms: resolving a problem or challenging the imagination.

The first response frames complexity as a solvable problem. From this point of view, inquiry exacts clarity. The second response is deferential and seeks to capture the full dimensions of a given set of research questions. Complexity, in this second response, is a challenge to imagine something new: to cast a wider net of what our mind might hold. From this perspective, inquiry seeks to conceive something that has been heretofore outside of comprehension. Both paths of inquiry produce research. Neither path demands a quantitative or qualitative approach. Either works. Both paths allow for hybrid forms that might

include scientific methods as well as arts-based methods. Our book seeks to demonstrate how arts-based methods expand the researcher's toolkit, adding paintbrushes and line breaks to our box of hammers and nails. In particular, we want to show the relevance of this approach to issues in education.

It is important to think about what is the right tool for the job. Therefore, we return to the five tensions of arts-based research that Eisner outlines in Chapter 2 of the text: 1) The imaginative vs. the referentially clear; 2) The particular vs. the general; 3) Aesthetics of beauty vs. verisimilitude of truth; 4) Better questions vs. definitive answers; and 5) Metaphoric novelty vs. literal utility. We reflect on each of these points, to illuminate how contributors to this volume have addressed them. In turn, this generates greater clarity regarding the construction of effective works of arts-based research.

THE IMAGINATIVE VS. THE REFERENTIALLY CLEAR

Arts-based research offers the layered versus the linear, the cacophonous versus the discursive, and the ambiguous versus the aphoristic. What is the advantage of pursuing the direction of the imagination? First, it is an achievement of mind to recognize the fullness and complexity of the layered, the cacophonous, and the ambiguous. Comprehending complexity is not a given. Our sensory systems are not recording devices that take a full and complete imprint of the world around us. We must learn to see. Perception itself – before analysis – is cognitive (Arnheim, 1969). Semiotic theory refers to the sensory bank of pre-analytic sensory impressions as the *experiential store* (Suhor, 1984). These impressions are coded into meaning through language, numbers, images, music, or any other symbol system. Inquiry is not limited to coding the experiential store into meaning. A goal of inquiry can be building the experiential store itself. This is an explicit goal of a/r/tography as discussed by contributors in Section III. Barbara Bickel and Stephanie Springgay present examples of researchers using arts-based methods to build an experiential store – which they analyze further through both language and image.

In Chapter 8, Carl Leggo refers to the attending to and nurturing of this experiential store as the ecology of personal and professional experience. Just as our natural environments can be denuded and impoverished, so too our experiential store can be desiccated and withered. This is not a problem of aesthetic appreciation; it is a problem of thinking. If the experiential store is shrunken, then there is a limited data bank from which to encode meaning. In education, we so often mistake – particularly in children who come from impoverished back-

grounds – a limited data bank in the experiential store as a problem of cognitive processing. Inquiry needs to attend to both realms.

Consider Kristina Lyons's (Chapter 6) poem *Upon Traveling to Nosara*. This poem records the experiential store of the researcher traveling by public bus in Costa Rica, yet this aspect of experience is normally stripped from our academic methods of reporting. What do we lose in understanding the complexity of field research, in a fuller understanding of another place, or even in our sensitivity for training new researchers for the challenges of inquiry when such evidence is silenced in pursuit of clarity?

Nevertheless, the educational researcher is not deploying arts-based inquiry to portray complexity as a kind of Rorschach test on which the reader can decode meaning from inkblots. Here, John Dewey offers important insights regarding complexity and empiricism. Dewey too acknowledged this bank of experience, which semioticians refer to as the experiential store. He claimed that in this mental realm of conscious – before symbolic thought – we think in terms of the *relationships of qualities* (Dewey, 1934/1989) which possess felt intuitive meaning. Eisner (1994) observes that through numbers, language, images, music, and our body we express the felt meanings found in the relationships of qualities through *forms of representation*. Inscribing relationships of qualities in forms of representation such as poems, paintings, and dramatic performance demonstrates skill in *qualitative reasoning* (Eisner, 2002). Through inscription of forms of representation, qualitative reasoning becomes publicly accessible. We can then discuss these varieties of representations in language. Thus, imagination expands discourse. In turn, discourse holds the promise of improving the referentially clear by helping us to see the structure of qualitative reasoning (Eisner, 2002).

The philosopher Ludwig Wittgenstein (1958) maintained that the poet (and by implication the artist), could build qualities of relationship into complex meanings. Language could not guarantee a concise, analytic, and definitive translation of aesthetic meanings. Different readers would have different words to interpret the intentions of the poet. However, Wittgenstein maintained that close readings, grounded in the work itself, and not the fantastical extrapolations of the reader, would share a *family resemblance* of meaning. Through these family resemblances, meaningful communication that expands understanding can occur. Meaning in an artwork would not be a linear analytic formula, but a constrained circle of communication. Therefore, arts-based research is not open to any interpretation. The researcher perennially plays with the tension between an open and yet inscribed circle.

A distinguishing feature of arts-based inquiry is that the researchers seldom make an "art-for-art's-sake" claim that their work is beyond analysis. More than conventional artists, arts-based researchers often

explain their work and offer cues as to how to read their representations in relationships to social science. For example, consider the Talmudic-like use of endnotes in the work by Douglas Gosse (Chapter 14). In Johnny Saldaña's theatrical work (Chapter 17), slide projections supply important orienting cues to how the creative text is addressing a social-science concern. Adrie Kusserow furnishes an introduction that explains the sociological problem of Sudanese refugee resettlement that she addresses at the beginning of her poem *Lost Boy* (Chapter 5).

Traditionally, because the dramatist, poet, painter, or composer were not employing discursive, referentially clear language to communicate, they were considered incapable of doing so. Therefore, it was the task of the dramaturge to help the audience learn about the context of the playwright, the literary critic to help make the craft in a poem or piece of fiction more clear, or the art critic to interpret the visual to an uncomprehending public. Arts-based inquiry suggests, as Tom Barone (2001) claims, that the trained researcher is capable of playing "two games at once" (p. 171). The external critic is no longer necessary. The trained artist can assume this role. The arts-based researcher can both create and critique, challenge and explain.

Even as the researcher assumes the mantle of both artist and critic, ultimately, a question arises over the concept of clarity itself. In German aesthetics, there is the concept of *freischwebend*, which literally means, to hover above (Bauman, 1992). Knowing requires not knowing: a state of being lost in order to find. It also suggests that not everything is knowable, and that wisdom distinguishes between what we can positively affect and what is beyond our grasp. This is the aesthetic foundation of Barone's call (Chapter 3) for epistemological humility in research. *Freischwebend* suggests that clarity is the recognition of complexity, and not every aspect of complexity is solvable. To see complexity is a challenge for research as is distinguishing between what can and cannot be changed. We cannot change Africa's roar in a young man (Kusserow, Chapter 5). We must struggle to hear and hold Jesusa's laugh (Jenoure, Chapter 13). In this sense, the tension between the imaginative and the referentially clear is inherent and critical to the conduct of arts-based research.

THE PARTICULAR VS. THE GENERAL

The intellectual promise of arts-based methods is that they allow the researcher to not only work with the symbolic tools of words and numbers, but that they expand the researcher's palette to allow attention to the relationships of qualities (Dewey, 1934/1989) in data collection, analysis, and reporting. A quality might be the solidity or

transparency of a mass, the rhythmic intensity of meter and beat, or the shape of gesture made by the body in space and time. Our awareness of qualities comes from attending to the particular. We must pay attention to note a quality. Paying attention is the habit of a disciplined mind.

Mass, rhythm, and shape have no significance in themselves, but relationships of qualities of mass, rhythm, and shape have the power to communicate feeling and emotion (Damasio, 1999; Shusterman, 1999). They communicate nonverbally through the flesh. We feel them. Our capacity to think in relationships of qualities does not replace symbolic processing. It contextualizes it. Damasio (1999) demonstrates how rationality is situated within felt reaction. If we cannot situate rationality within the proper qualitative relationships, then rationality is impaired. This is a problem for education that demands research.

By attending to qualities, such as Kristina Lyons's poem about a breakdown in the road (Chapter 6), the researcher bears witness to the complexity of a moment. Human emotions and feelings are conveyed. Is this poetic rendering merely a reporting or is it illuminating? Answering this question points to a profound difference between how arts-based inquiry or traditional research methods conceptualize their respective audiences.

Traditional social science often conceives of the researcher as the intellectual authority. In this view, research offers prescribed treatments that the readers – the audience – are to explicitly follow in order to obtain the described benefits. The procedures for creating a sample from which to generalize allow the researcher to communicate to the reader the level of confidence the reader can anticipate for receiving the benefits described in the research if procedures are followed. Thus, generalizability views the audience as an essentially passive recipient of the researcher's found wisdom.

Aesthetic theory offers an alternative to generalizability. In his early twentieth-century criticism of cinema, Walter Benjamin (1939/2003) considered the shifting role of the audience from passive appreciator of a fixed knowable meaning in a work of art, to a dynamic interactant in which individuals and groups create their own meaning and response. Echoing Benjamin, Barone (Chapter 3) argues that a virtue of excellent arts-based research is its accessibility to a broad audience. Much like Benjamin's critique of cinema, Barone (Chapter 3) argues that qualitative arts-based research has the capacity to resonate in the public imagination, and thus affect serious social and policy change. This change is not achieved by convincing the audience through a numeric confidence ratio that the research is correct, but by inviting members of the audience to apply the insights of arts-based inquiry to their own lives. Instead of viewing the audience as a blank slate which receives and records the researchers' meaning, Barone envisions an audience that is an active participant in authoring meaning along with the researcher.

Thus, the test for generalizability in arts-based research is its ability to both widen a circle of conversation and to ask better questions. Barone (Chapter 3) calls this the ability to evoke *conspiratorial conversations*. Such an effort is seen in Joni Jones/Olomo's work (Chapter 15) as her collaborative scholarship draws attention to experiences in the academy as an African American woman; in Douglas Gosse's (Chapter 14) narrative attention to layers of marginal identity among gay and lesbian youth in Newfoundland; and in Carl Leggo's (Chapter 8) attention to the self, transforming the personal to the universal through poetry. Communities form through such conversations. From these communities social action may emerge. Thus arts-based research might aspire to engaging social change. However, the methods of change are different from traditional research, which applies change top-down through the intellectual authority of the researcher. Arts-based research seeks change from the bottom-up through grassroots circles of conversation. As Barone (2001) has noted, the person who did most to change the child labor laws in Great Britain in the nineteenth century was Charles Dickens.

Qualitative research has traditionally challenged the terminology of social-science research. Alan Peshkin (1988) questioned objectivity as an undisputed standard in research. His research added subjectivity to the toolkit of inquiry. Similarly, generalizability may be a term that applies only to particular forms of research. In *The Enlightened Eye*, Eisner (1991) proposed the term *consensual validation* to replace mechanistic definitions of generalizability. A work of arts-based research would attain *consensual validation* if informed audiences carefully discuss and validate the work. Did a data-poem or ethnodrama initiate broadening dialogues? Do these dialogues improve upon conversations of the past? Had the arts-based research allowed people to understand complexity more fully, look more closely, and consider aspects of reality that had previously gone unnoticed? Tom Barone (Chapter 3) pushes this concept by asking arts-based research to achieve a standard of *critical persuasiveness* in which the work is compelling enough to begin a conversation. Joni Jones/Olomo (Chapter 15) suggests a standard of *collective autoethnography* where the work engenders a deep empathetic understanding that generates dialogue. Irwin and Springgay (Chapter 9) remind us that a deep sense of *responsibility* must guide these standards.

For example, all of these arts-based standards are present in Douglas Gosse's story of queer youth in Newfoundland. The research opens up the landscape. It brings to our attention a story that needs to be told. It helps us to see a portion of lived experience that previously may have been invisible to us. It is persuasive and vulnerable. It is a story of the particular, yet Gosse's work resonates with stories of queer youth around North America, from Newfoundland, Canada to Columbus,

Georgia in the US and perhaps elsewhere around the world. From this story, we may be able to act with greater understanding. Our perception and sensitivity to the world is increased.

The task of arts-based research is, as the poet William Blake described it, "to see the world in a grain of sand." The particular becomes research when it advances understanding (Barone & Eisner, 1997); an investigation of the particular, whose sole goal is to produce aesthetic pleasure, is not research. Therefore, arts-based research negotiates the tension of finding the resonance that provokes widening and deeper conversations out of the particular. The aesthetic provokes new questions. It does not close down conversation by providing a summative conclusion. Great works will prove the point. Traditional generalizability is not an applicable issue.

AESTHETICS OF BEAUTY VS. VERISIMILITUDE OF TRUTH

In the work of Joanne Elvy (Chapter 12), three women confront us. From a formal aesthetic perspective, these photographs are exceptional. They exploit the full value range of a gray scale, moving from stark white to the deepest black. The contrapposto of the women's bodies subtly connects these women to the traditions of antiquity as much as the framing also situates these individuals in the present. These images are the work of an artist who is skilled with the camera and the medium of black-and-white photography. A museum might exhibit these works without explanatory text. However, aesthetic beauty is not the sole purpose of the work. Aesthetic beauty is a tool that Elvy uses to draw the reader into looking closer. It is a tool for starting a conversation.

In Elvy's case, this is a conversation about dignity and the transformative power of education. These women are giving testimony. Elvy is employing her aesthetic powers to honor the stories of education that these women are telling. She does not intend the text to furnish a full discursive explanation. The text is only enough to orient the viewer and redirect attention back into the photography. To paraphrase Michael Polanyi (1967), the image tells more than words can say. Perhaps, too, in the case of arts-based research, words help say more than what is communicated through the images alone.

Eisner refers to the verisimilitude of truth because science too can only make its best guess as to what truth is. What is true today could change tomorrow (Kuhn, 1970). In statistics, we discard outliers because they muddy the picture. We use $N-1$, where N is the sample size, in our calculations of standard deviation of correlation coefficients, because N, the actual sample size, by itself does not produce an

accurate numeric representation. However, which specific case from N do we discard in order to make the numbers work?

Arts-based researchers often look explicitly *for* outliers. What was the case that did not fit the data pattern? Why did we want all data to belong to the pattern in the first place? Barone (Chapter 3) reminds us that aesthetic rendering of truth often disrupts the master narratives in our midst and produces an alternative to consider. In this way, arts-based researchers, like many qualitative researchers, play with "truth" when they excerpt an interview text – only arts-based researchers might go further: breaking lines, creating composite characters, crafting a data-poem.

In the eighteenth century, Immanuel Kant (1790/1987) proposed that the purpose of the disruption caused by aesthetic beauty created a freefall of the imagination. In this freefall, old categories of thinking would be shattered. The mind would generate new categories that would encompass these new ideas. In this manner, rationality renews itself and does not stagnate or become ossified. For Kant, the aesthetic and imaginative were critical to rational inquiry. Over a century later, Einstein observed that a science that was limited by the scientific method was ultimately impoverished and sterile (Holton, 1996). Arts-based research is a structured response to Kant's aesthetic theory and Einstein's challenge to the imagination. Thus, it is integral to the highest traditions of Western rationality.

BETTER QUESTIONS VS. DEFINITIVE ANSWERS

Ruth Behar (1996) speaks of making herself a vulnerable observer. This requires setting aside privilege and power and assuming a stance that Barone calls epistemological humility. As discussed earlier, this assumes a different kind of relationship with one's research participants and with readers of research. It is no longer a process of telling; it is a process of sharing and listening. The researcher is inviting questions and new voices into her "poetic anthropology" (Behar, Chapter 4).

How we listen can be complex. Kathy Roulston, Roy Legette, Monica DeLoach, and Celeste Buckhalter (Chapter 16) challenge our conventional ways of listening by juxtaposing how we listen while creating a piece of music in a performance, to how we listen in the conduct of qualitative research. By drawing us into the challenging experience of performing music, the authors seek to develop a greater empathetic understanding of the difficulty of conducting research and the challenge of preparing teachers who are critical, reflective practitioners. By asking the audience to become performers – something they have not been trained to do – they duplicate the experience of how we ask teachers to

conduct research into their own practice – which, similarly, up until this point in their education, they have not been trained to do. The anxiety that the audience shares in suddenly being asked to become musical performers replicates the anxiety that teachers have when suddenly asked to become researchers. Thus, the work seeks to engage the audience in a shared process of questioning and answering. This differs from traditional research where the researcher is the all-knowing vehicle of analysis.

METAPHORIC NOVELTY VS. LITERAL UTILITY

Good research tells a story. Stories differ in their emphases on the prosaic and poetic. Stories may be dry and technical, or they may be lively and imaginative. However, all stories have a narrative thread, and metaphors frequently furnish the framework that sustains the theme. Metaphors provide ways of understanding an issue by comparing it to a parallel image/expression from a different, already familiar reality. Metaphors help us conceptualize the conduct of research. New metaphors allow our thoughts to shift and fold. New associations emerge (Lakoff & Johnson, 1980).

The concept that research has utility is based on metaphor that associates education with industrial manufacturing (Tyack & Hansot, 1982). Through this view, research affords precisely calibrated equipment and tools that facilitate the highest level of production (i.e. learning) for the lowest cost. In the utilitarian concept of research, human beings are a random collection of gemstones: each properly categorized and efficiently tooled through the proper sequential treatment that produces the greatest value (i.e. societal worth) with the most efficient use of resources.

Breaking with the technocratic metaphor, Eisner (1997) describes research as publicly accessible transformations of consciousness. In his view, the task of preparing educational researchers is one of creating opportunities to engage in heightened states of awareness. Through deliberate, sequential activities that translate primary experience into communicable form, researchers can share their work with a wider constituency concerned with issues of learning. In this view, researchers are storytellers. We are metaphor makers. The value of our metaphors is in the degree they help us see the world in new and meaningful ways. Do these new metaphors help us integrate aspects of our lives that were previously minimized, denied, or left unseen? How do these new metaphors "make sense" of experience? Is the goal for a researcher's metaphors to transform consciousness feasible, or perhaps, egotistical?

Eisner shifts the metaphor for research from demonstrating

cost-efficient practice to expanding a circle of communication. This metaphor allows us to value educational curricula that help students demonstrate processes through which they come to know – not merely demonstrate prowess of memorization – even if these practices are time-consuming and costly. The primary aim of research is not to produce knowledge with the least resources, but "to advance human under-standing" (Eisner, 1997, p. 5).

However, metaphoric novelty in itself does not necessarily advance human understanding. Novelty may be aesthetically pleasing. It may even prompt lively conversation. However, conversation itself is not a measure of the aesthetic or practical worth of arts-based research. The conversation has to help us see more deeply. The conversation has to lead to better questions. A conversation that is an entertaining diverti-mento, which helps to pass the time, is not inquiry-driven.

Terry Jenoure (Chapter 13) describes deepening conversations in her encounter with South African youth. Her arts-based experience becomes authentically collaborative with her learning as much from the young men in her workshop as they from her. The research and work takes on a shared responsibility. Joni Jones/Olomo (Chapter 15) does not simply tell us what it means to be a female African American acade-mic, but she brings us to a point where we can viscerally feel her struggle. She brings us to a point of collective scholarship. Kakali Bhat-tacharya (Chapter 7), Barbara Bickel (Chapter 10), and Stephanie Springgay (Chapter 11) also dare to address aspects of female identity that the academy suggests would be best unseen, or irrelevant to how we choose to pursue the advancement of understanding. These schol-ARTists explore the boundaries of the restrictions imposed by a pre-emptive disembodied parsing of the definition of intelligence.

Hannah Arendt (1968) observed that aesthetics is a means of creating communities of caring by speaking to what is emotionally most dear to us. By confronting tensions in how we make meaning and synthesize the experiences of our lives in a visceral, embodied way, communication can lead to empathetic understanding that is the basis of community. Such communities are not rule-governed – where politically correct dictates control behavior – but are self-regulated through felt concern for others. Arts-based research can contribute to building such communities.

We acknowledge that this view of aesthetics – as a philosophy of building deeply caring communities – is far from a conventional defini-tion of a philosophy of beauty. Once again, we emphasize that, while art may pursue beauty as a goal, our interest in art is as a vehicle that propels research. If one is concerned about art for art's sake, reinter-preting a poem or painting in language that addresses praxis is not necessary for its appreciation. However, we argue that the poem, musical interlude, theatrical gesture, or visual representation of semiotic

meaning or repetitive ritual may enable both researcher and reader to *see into* languages of theory and practice. Similarly, language also facilitates our understanding of qualitative relationships. In Chapter 13, Terry Jenoure allows us to hear Jesusa's laugh, which illuminates a pathway of education that is both personally relevant and relevant to others. The points of connection and communication swell. The promise of inquiry to affect change improves. Metaphors should generate new dimensions of understanding. They should augment – or trouble – our capacity for explanation.

ASSESSING VALIDITY

The five tensions inherent in arts-based research create criteria for judging its soundness and worth. From the tension of the imaginative vs. the referentially clear, we ask how effectively the work expands perception. Is the scholARTist building a pre-symbolic, qualitative database from which to encode and inscribe meaning? Do these works of scholARTistry exhibit qualitative reasoning? We can determine a work's value through close, critical examination. When we discuss the outcomes of our examinations, do our findings exhibit what Wittgenstein called family resemblances – close similarities of interpretation that allow for comparative discussion? Does the work inspire dialogue? If our meanings are diffuse, scattered, and monologic, the claim of the artwork as a work of research is more problematic. Finally, do the conversations that emerge from arts-based educational study and analysis help us understand issues of teaching and learning in new ways? The hope is for the arts-based study in question to hold discussion open and resist closure.

The second tension is the particular vs. the general. Again, does the work help us to attend to qualities of a question or problem that heretofore might have gone unnoticed? How is the audience brought into this process of discovery? Does the audience become an active participant in the construction of meaning, or is the meaning imposed on the reader by the researcher? Does the experience of the particular bring the reader and the researcher together in a sense of shared conversation and responsibility?

The third tension is the aesthetics of beauty vs. verisimilitude of truth. Is beauty evoked to open or close a conversation? A successful work of arts-based research initiates, extends, and develops a conversation rather than a summative conclusion. As Immanuel Kant asked, does beauty help us to reconstruct reality – or does it only offer pabulum that lulls us into complacency?

The fourth tension is better questions vs. definitive answers. Lively and rich discussion is not an indicator of a successful work of

arts-based inquiry. The discussion must be purposeful. It must be directed and lead to greater understanding. Not all discussion leads to positive growth. If a work of arts-based research generates misunderstanding, which closes discussion with audiences the work seeks to address, then there is a serious flaw. After reading a successful work of arts-based research, we should be able to frame better questions towards making our communities more caring, embracing, and inclusive. How has the inquiry advanced understanding?

The fifth tension is metaphoric novelty vs. literal utility. Do the metaphors employed in the work of scholARTistry expand our understanding? Alternatively, are they simply novel, witty, or ingenious? Does the metaphor make felt qualitative meaning more accessible?

Together, these criteria can establish the validity of a work of arts-based research. These criteria also provide a basis for guiding the development and refinement of such a work. As Dewey (1934/1989) observed, criteria helps the artist know what to do next. Criteria help the artist-researcher know how to make a work of scholARTistry better.

ARTS-BASED RESEARCH AS A HYBRID FORM

In this text, we have argued against art as a separate, isolated form of human experience that stands apart from how we understand and make sense of the world. We believe art to be a part of rationality. It has a role in structured inquiry. In this view, we are arguing for *art for scholarship's sake*. We support the use of the term scholARTistry (Nielsen, 2005) because it captures this integration of purpose. We see the arts as woven into existing methods and methodologies for researching education. We seek to expand the palette of options available to researchers, not to restrict it.

Such an expansion raises questions regarding the training of educational researchers. There are a limited number of class hours in a program of study. What is the most effective use of those hours? What skills should we expect from those who wish to conduct arts-based research?

Most, but not all, of the scholARTists represented in this text have had formal aesthetic training in their art form at either the undergraduate or the graduate level. From this background, they have purposively blended their training as artists and/or their engagement in the arts into their empiricism and theory building. They do this in an attempt to push the boundaries of what we can see within education. They manipulate perception in purposeful, hybrid ways that interweave the symbolic and non-symbolic in order to create personal meanings, interpretations, and hypotheses.

In short, scholARTists apply hybrid methods of research because of their own hybrid backgrounds and training in combining the arts and the social sciences. However, by demonstrating the structured intelligence in the hybrid methods of arts-based inquiry, scholARTists not only broaden the field of research but also broaden our discussions of what needs to be considered in educational opportunities in K-12 schools, our pre-service teaching programs, and the graduate training of researchers. In this sense, the cognitive flexibility, adaptability, repurposing, and invention that characterize ABER is a skill set that we may reasonably set as a goal for general education. Thus, the kind of hybrid training that up to now has been restricted to a relatively small number of arts-based educational researchers, might point the way for how the arts should be built into the curriculum at all levels of education. We believe, all researchers, regardless of prior artistic training, can develop artistic sensibilities in data analysis and draw on artistic craft to elicit data and share findings. Likewise, we believe all youth and adults should be encouraged to engage in the arts to the greatest extent possible regardless of whether or not they pursue years of specialized training to become "artists" in the traditionally elitist sense of the term. Contributors to this volume illuminate the varied ways the literary, visual, and performing arts engage collective dialogue and imagination. We hope selections from this volume inspire experienced artist-researchers and beginners alike.

EXPANDING UNDERSTANDING THROUGH ABER

Perception is graded. It develops over time within an individual. Our sensory intake system is not digital; perception is not a faculty that operates in either on or off mode. Perception is not fixed. Two individuals standing side by side do not necessarily have the same experience of perceiving an object. To discern nuance is a desired educational outcome for a developing mind (Dewey, 1934/1989). Perception improves with instruction. It takes training to see and hear delicacy of tone, to attend to subtlety in value, or recognize the qualities that contribute to a sense of intensity. Thus one educational outcome of ABER is improving the objective, perceptual skills that produce qualitative reasoning.

Arts-based inquiry adds to the conversation regarding how researchers learn to perceive and report meaning. Yet as several contributors observe, tensions remain in opening our research to include the arts in methodology. Nevertheless, to continue to push at these tensions is timely work. Currently, throughout the entire educational system, facile definitions of intelligence drive our standardized tests. What is

counted as intelligence is what our current paradigm of psychometrics can measure (Gardner, 1999). Even art curriculum and conceptions of learning in art can fall prey to simplification. It is all too easy to ignore deep structures of thinking (Stiggins *et al.*, 2004).

An awareness of the structure of thinking requires knowing how we move between non-symbolic realms of qualitative meaning to the inscription of symbolic meaning in a variety of forms of representation. These symbolic forms can be linguistic, numeric, visual, musical, and somatic. A demonstration of deep thinking is not a facile surface manipulation of symbols, but a demonstration of the process through which these symbols take significance.

Ultimately, arts-based educational research not only shifts the focus to how we inquire, but also models a new vision of curriculum. Arts-based research demonstrates strategies that might inform our thinking about how we allow students to exhibit their coming to know. These strategies encompass our sensory gathering systems and blend qualitative reasoning with semiotics. The qualities of mind that these schol-ARTists explore lead to qualities of mind, and sensitivities to others, that we surely want instructors and students to demonstrate – beginning in early childhood instruction and through doctoral study. At any level, education should capture the fullness of experience.

Arts-based educational research is capable of reflecting the resonance of lived experience by refocusing attention on the interplay between nonsymbolic and symbolic meaning to form understanding. We begin to create such understandings at birth. We do not outgrow qualitative thought with acquisition of language. The dialogue between non-symbolic and symbolic thinking continues throughout life. It is part of living. The precise perceptions of felt relationships and exquisite attention to nuance often define the highest levels of performance in many professions. Not the least of these is teaching: expert teachers know how to purposely navigate through felt reactions of students to foster learning. Thus, arts-based research holds the promise of improving our understandings of learning and how education in diverse communities occurs.

Arts-based educational research is particularly well suited for understanding – and demystifying – the human relationships that enhance learning. Such research can provide evidence that helps us understand how excellent teaching engages students in the structures of deep learning. The outcome of such learning is personal agency: autonomous individuals who have the capacity to imaginatively shape their own lives by having the courage to write their own stories.

QUESTIONS

1 If the conduct of inquiry requires recognizing the most appropriate tool for the job, when might a researcher consider the arts the most appropriate tool? What distinguishes dance as a tool for understanding from drama, poetry, sculpture, or photography?

2 Describe a study that could take advantage of both scientific and arts-based methods. What skills are required? What kinds of collaborations might take place?

3 Why is generalizability important for research? Should generalizability be a standard that distinguishes research from inquiry? Can arts-based educational research aspire to outcomes that resemble generalizability?

4 How, by assuming the role of both artist and critic, must arts-based educational researchers play "two games at once" as Barone stated in Chapter 3? Why is playing this dual role important? What risks are at stake when arts-based researchers use text to explain art to a scholarly audience? Why have artists tended to leave the work of explanation to critics?

5 What conversations for social change have been started by the literary, visual, and performing arts represented in this volume? What more is needed?

6 Do you consider yourself an arts-based educational researcher? Why or why not?

REFERENCES

Arendt, H. (1968). *Between past and future: Eight exercises in political thought*. New York: Viking Press.

Arnheim, R. (1969). *Visual thinking*. Berkeley: University of California Press.

Barone, T. (2001). *Aesthetics, politics, and educational inquiry*. New York: Peter Lang.

Barone, T. & Eisner, E. W. (1997). Art-based educational research. In R. M. Jaeger (Ed.), *Complementary methods for research in education* (pp. 73–94). Washington, DC: American Educational Research Association.

Bauman, Z. (1992). *Intimations of postmodernity*. London and New York: Routledge.

Behar, R. (1996). *The vulnerable observer: Anthropology that breaks your heart*. Boston, MA: Beacon Press.

Benjamin, W. (2003). The work of art in the age of its technological reproducibility. In H. Eiland & M. W. Jennings (Eds), *Walter Benjamin: Selected writings, volume 4, 1938–1940* (pp. 251–283). Cambridge, MA: Harvard University Press. (Original work published 1939.)

Damasio, A. R. (1999). *The feeling of what happens: Body and emotion in the making of consciousness*. New York: Harcourt Brace.

Dewey, J. (1989). Art as experience. In J. Boydston (Ed.), *John Dewey: The later works, 1925–1953* (pp. 1–400). Carbondale: Southern Illinois University Press. (Original work published 1934.)

Eisner, E. W. (1991). *The enlightened eye: Qualitative inquiry and the enhancement of educational practice*. New York: Macmillan.

Eisner, E. W. (1994). *Cognition and curriculum reconsidered* (2nd edition). New York: Teachers College Press.

Eisner, E. W. (1997). The promise and perils of alternative forms of data representation. *Educational Researcher, 26*(6), 4–10.

Eisner, E. W. (2002). *The arts and the creation of mind*. New Haven, CT: Yale University Press.

Gardner, H. (1999). *Intelligence reframed: Multiple intelligences for the 21st century*. New York: Basic Books.

Holton, G. (1996). On the art of scientific imagination. *Daedalus, 125*(2), 183–208.

Kant, I. (1987). *Critique of judgment*. Trans. W. Pluhar. Indianapolis, IN: Hackett. (Original work published 1790.)

Kuhn, T. S. (1970). *The structure of scientific revolutions* (2nd edition). Chicago, IL: University of Chicago Press.

Lakoff, G. & Johnson, M. (1980). *Metaphors we live by*. Chicago, IL: University of Chicago Press.

Nielsen, L. (2005). *Homepage* 2005 [cited 6 March 2005]. Available from www.iirc.mcgill.ca/collaborators/collabln.html.

Peshkin, A. (1988). In search of subjectivity – one's own. *Educational Researcher, 17*(7), 17–21.

Polanyi, M. (1967). *The tacit dimension*. Garden City, NY: Anchor Books.

Shusterman, R. (1999). Somaesthetics: A disciplinary proposal. *Journal of Aesthetics & Art Criticism, 57*(3), 299–314.

Stiggins, R., Arter, J., Chappuis, J., & Chappuis, S. (2004). *Classroom assessment for student learning: Doing it right – using it well*. Portland, OR: Assessment Training Institute.

Suhor, C. (1984). Towards a semiotics-based curriculum. *Journal of Curriculum Studies, 16*(3), 247–257.

Tyack, D. B. & Hansot, E. (1982). *Managers of virtue: Public school leadership in America, 1820–1980*. New York: Basic Books.

Wittgenstein, L. (1958). *Philosophical investigations* (3rd edition). Trans. G. E. M. Anscombe. New York: Macmillan.

Index